CW01020096

The publisher gratefully acknowledges the generous support of the General Endowment Fund of the University of California Press Foundation.

The publisher gratefully acknowledges the generous support of the Eric Papenfuse and Catherine Lawrence Endowment Fund in Film and Media Studies of the University of California Press Foundation.

The publisher also gratefully acknowledges the generous contribution to this book provided by the Office of the Vice President for Research and the College of Literature, Science, and the Arts Publication Subvention Program.

Videoland

Videoland

Movie Culture at the American Video Store

DANIEL HERBERT

University of California Press

BERKELEY LOS ANGELES LONDON

University of California Press, one of the most distinguished university presses in the United States, enriches lives around the world by advancing scholarship in the humanities, social sciences, and natural sciences. Its activities are supported by the UC Press Foundation and by philanthropic contributions from individuals and institutions. For more information, visit www.ucpress.edu.

University of California Press
Berkeley and Los Angeles, California

University of California Press, Ltd.
London, England

Library of Congress Cataloging-in-Publication Data

Herbert, Daniel, 1974–.
 Videoland : movie culture at the American video store / Daniel Herbert.
 pages cm
 Includes bibliographical references and index.
 ISBN 978-0-520-27961-2 (cloth : alk. paper)
 ISBN 978-0-520-27963-6 (pbk. : alk. paper)
 1. Video rental services—Social aspects—United States. 2. Video recordings industry—Social aspects—United States. 3. Motion pictures—Social aspects—United States. 4. Stores, Retail—Social aspects—United States. 5. United States—Civilization—1970–
I. Title.
 HD9697.V543U5364 2014
 302.23'430973—dc23
 2013033770

Manufactured in the United States of America
23 22 21 20 19 18 17 16 14
10 9 8 7 6 5 4 3 2 1

The paper used in this publication meets the minimum requirements of ANSI/NISO Z39.48-1992 (R 2002) (*Permanence of Paper*).

For my father, Patrick Daniel Herbert (1945–2012)

Contents

Illustrations

MAPS

Acknowledgments

This book is the result of a long and twisty journey, and I am grateful to the companions who helped me along the way. My travels were beyond thrilling, in so many ways, and I could not have done it without them. Jenny Debouzek offered me a job at Alphaville Video for no apparent reason and inadvertently changed the course of my life. Kief Henley made working there strange and fun. For better or worse, my undergraduate mentors Ira Jaffe and Nina Fonoroff guided me out of the video store and into graduate school; Susan Dever in particular pushed me into a life in academia. Gus Blaisdell remains my most important inspiration as an instructor, and Bryan Konefsky showed me how a mentor could become a friend.

Although this work does not derive from my dissertation, the mentors and friends I gathered while in graduate school at the University of Southern California were instrumental to my intellectual and professional development, and I continue to rely on many of them. Marsha Kinder was the best dissertation chair anyone could ask for, and I am deeply grateful for her perfect balance of rigor and warmth; I am proud to be one of her many "children." Priya Jaikumar and Akira Mizuta Lippit were as kind as they were enlightening. Anne Friedberg and David James gave important guidance, feedback, and advice. Dana Polan remains a vital and constant source of inspiration and support. Although my former classmates are now far-flung in myriad locations, I cherish my friendships with Karen Beavers, Bob Buerkle, James Leo Cahill, Daniel Chamberlain, Chris Hanson, Bella Honess-Roe, Carlos Kase, Jorie Lagerwey, Nam Lee, Dave Lerner, Jaime Nasser, Paul Reinsch, Suzanne Scott, Janani Subramanian, Adrienne Walser, and Mary Jeanne Wilson.

My research was generously supported by a Faculty Research Grant from the Horace H. Rackham School of Graduate Studies at the University of

Michigan, two Scholarship/Research Grants from the Dean's Office of the College of Literature, Science, and the Arts, as well as the Department of Screen Arts and Cultures. In addition, I received a grant from the Office of the Vice President of Research and the College of Literature, Science, and the Arts Publication Subvention program to assist with the publication of this book. I have also been the fortunate recipient of support from numerous friends and colleagues at the University of Michigan. I am thankful for all my colleagues who make working in the Department of Screen Arts and Cultures a dream; I especially want to acknowledge Caryl Flinn, Colin Gunckel, Stashu Kybartas, Johannes von Moltke, Yeidy Rivero, Markus Nornes, Terri Sarris, and Matthew Solomon for their kind words, tough questions, and smiles. Richard Abel encouraged me to pursue this project at a critical juncture and was always willing to field my questions. Hugh Cohen, Manishita Dass, Sheila Murphy, Lisa Nakamura, and Aswin Punathambekar provided insightful commentary on various parts of this work, and Giorgio Bertellini's feedback helped me frame many of my core arguments. Phil Hallman far surpassed his duties as librarian and friend in reading and commenting on every piece of writing I threw at him. It was always a pleasure working with the Department of Screen Arts and Cultures' administrative staff. Mary Lou Chlipala, Orlandez Huddleston, Carrie Moore, and Marga Schuhwerk-Hampel were infinitely helpful as I scrambled to keep my ducks in a row.

I had a crack team of undergraduate and graduate research assistants. Bailey Rosser was a sharp sounding board, and Mary Harrel provided excellent assistance that was supported by the Undergraduate Research Opportunity Program (UROP) at the University of Michigan. Likewise, Jacob Mendel's curiosity about the Criterion Collection led a UROP project about specialty video distribution; his enthusiasm was contagious, and his work helped me generate the material for half of chapter 5. In addition to providing research assistance, Jennifer Hessler generously read and commented on the entire first draft of this work while she was busy transitioning into graduate school; I look forward to returning the favor. Peter Alilunas conducted vital research that was supported by two Spring/Summer Research Grants from the Horace H. Rackham School of Graduate Studies. My conversations with Peter helped me deepen my historical research and refine my arguments. Yet no one helped me more than Dominic Czarnota. This book would not, *could not* have been written without Dominic's eager, efficient, and endless assistance. He knows as much about the history of video rental as I do.

I am fortunate to have gained much insight in interactions and exchanges with a broader community of media scholars. Barbara Klinger (along with

Dana Polan) participated in a workshop aimed to help me revise my dissertation, yet her interest in my video research helped inspire my dedication to this project. Fellow video store scholar Joshua Greenberg demonstrated unmatchable generosity by making his entire research archive available to me; this material proved crucial to a number of my historical arguments. Ross Melnick and Elizabeth Affuso also provided me with helpful information and advice. Caetlin Benson-Allott gave superbly sharp and helpful responses to drafts of several chapters, and Chuck Tryon was wonderfully insightful in his reading of half the manuscript. Thomas Schatz and Joshua Neves gave thoughtful commentaries about my work while serving as respondents to various Society for Cinema and Media Studies (SCMS) panels, and Charles Acland asked productive questions regarding my conference presentations as well. Passages and ideas from this book have appeared in previous publications, and I am grateful to the editors and anonymous readers for their feedback. Derek Johnson and Jonathan Gray provided brilliant comments about my submission to *A Companion to Media Authorship* (Wiley-Blackwell), which extends from chapter 2 of this book. Similarly, I am grateful to the anonymous readers who reviewed my submission to *Canadian Journal of Film Studies*, material from which appears in chapter 5. I am grateful also to Jeff Scheible, who (along with Joshua Neves) invited me to contribute to the first issue of *Media Fields Journal: Critical Explorations in Media and Space;* that essay served as my road map for chapter 4.

This book would not have been possible without the patience and generosity of the hundreds of video workers I interviewed, to whom I am most thankful. Although most remain anonymous, in accordance with IRB protocols regarding human subject research, each of these wonderful people made a deep impression on me. The following people agreed to be identified in the book or agreed to be identified as a source but not have their names attached to specific quotes: Philip Anderson, Shannon Attaway, Hadrian Belove, Claire Brandt, Martin Conners, Jim Craddock, Byron Cumbie, Tim Dykes, Ted Engen, Laura Giampino, Ben Himsworth, Danny Kasman, Leonard Maltin, Mickey McDonough, Will Myers, Dan Norem, Patty Polinger, Kevin Shannon, Brian Shirey, Milos Stehlik, Mark Steiner, Cathy Tauber, and Eric Trovinger. Thank you all.

I am deeply grateful to the editorial staff at the University of California Press. It has been extraordinary to work with Mary Francis. More than an editor, she has been a vital interlocutor. Her support for this project preceded the actual writing, and her interest inspired me to pursue it fully. She was instrumental in helping me think about video in the context of con-

temporary digital movie delivery systems. Kim Hogeland showed great patience, intelligence, and good humor in answering every little question I asked. Rachel Berchten was similarly invaluable in guiding me through the production process, and Sheila Berg did astounding work as copy editor. Mary also secured two tremendously helpful reviewers whose interest in this work was matched by their careful readings. Lucas Hildebrand revealed himself as one of my readers and was supremely generous with his time and attentive commentary. He knew (perhaps better than I did) where this book could go and steered me in the right direction at every turn.

I am profoundly thankful for the love, support, and encouragement that I have received from my friends and family. My father, Patrick Herbert, was a model of intellectual curiosity and ethics. Although my mother, Susan Cogar, fretted during my research excursions, she has only herself to blame; she inspired my love of road trips and actually prompted me to look at small-town video stores. My stepparents, Ron Cogar and Liz Buckner, have been limitless with their care and love. Gary and Karla Sampson were wonderfully generous and genial, and I have shared many great conversations and laughs with John Sampson and Carmelita Parraz. My brothers, Charles and Noel, have been great companions and always listened with interest to my thoughts and stories. Charles also discovered the "Videoland" sign that inspired the title of this book and my sister-in-law, Larissa, photographed it beautifully. Ben Rogerson has been a tremendous friend. Anna Sampson has been continually patient, forgiving, and loving; my debt to her cannot be repaid with words. She also gave me the best gift in the world, our daughter, Clara Tarryall Herbert. Clara made my heart grow and makes everything worthwhile.

Introduction

Video Rental and the "Shopping" of Media

A number of commercials appeared on television and the internet in the winter of 2010 claiming that the video rental store had entered the home through cable "on demand" services (figure 1). Paid for by the Cable & Telecommunications Association for Marketing, which represents a consortium of cable providers, these spots used the video store as an analogy: "The video store just moved in. Rent new releases instantly, without leaving your home. Movies on demand, on cable."[1] Each of the ads began inside a video store and showcased the comic banter of two clerks. One was a red-headed teenager, the other an older man who sported a sweater and a beard, perhaps a manager. In one ad, the younger clerk suggests an unconventional reorganization of the shelves to include such genres as "Hot Actress" and "Explosions." "What about Foreign Films?" the manager asks, only to have the teenager reply, "I said that—Hot Actress." In another ad, the manager educates the teen clerk about the power of film comedies, and in yet another he delivers a lecture about family films. Commands from a computer terminal interrupt these moments of friendly repartee, however, requesting a recently released movie, including *Avatar* (2009), *Tooth Fairy* (2010), and *The Wolfman* (2010). The older clerk exclaims, "Push the button!," and the younger clerk hits a large Play button on the wall. A green laser emits from the video store, and the camera follows it into a nicely furnished living room where a family watches the movie begin on their large television set.

These commercials demonstrate the complex and sometimes contradictory processes of technological, industrial, and cultural change. On the one hand, they invoke the video rental store directly, representing it as a public space where people discuss movies and where consumers have the power of choice over movie content. On the other hand, they displace *actual* video

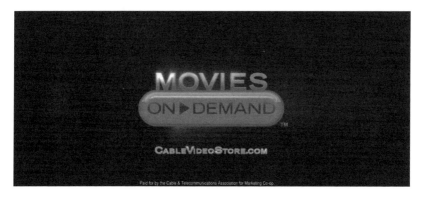

FIGURE 1. This advertisement used the video store as an analogy for cable
Video on Demand services.

stores by offering Movies on Demand, a service that allows people to shop
for and watch movies through the same device without ever leaving home.[2]
Indeed, there are no customers inside the store depicted in these ads, only
clerks, making them inadvertent illustrations of the decreased number of
people who use video stores. While these commercials trade on viewers'
understanding of the social and material space of the video store, they take
such spaces as mere symbols, as anachronistic analogies for another kind of
media distribution that might better serve their desires.

We have entered a moment when movies, like most media, are distrib-
uted and consumed through digital systems, giving the appearance that
movies have become ubiquitous and intangible.[3] According to the industry
and cultural critics alike, Americans are now able to access movies any-
where, anytime, through a wide variety of devices, from Video on Demand
(VOD) to internet streaming services like Netflix. Previously, for most of
the twentieth century in fact, Americans primarily watched movies in
theaters or on broadcast television, where movies were fleeting but memo-
rable experiences.[4] Between these two different patterns of distribution and
consumption, however, was a period in which movies were accessed largely
as material objects, as magnetic tapes and plastic discs. From the late 1970s
until the early 2000s, movies were videos.

Videoland: Movie Culture at the American Video Store offers a compre-
hensive view of this (now residual) paradigm, the "tangible phase" of con-
sumer video. It argues that the material objectification of movies signifi-
cantly altered their social place and value and that these transformations
largely occurred in and around the video rental store. Video stores changed
the way Americans treated movies and thus changed "movie culture," or

the ways in which people socialize around movies and collectively make movies meaningful.[5] From the moment in the 1970s that movies were first made available on magnetic tape, they had a newly physical presence in the world and were treated as material commodities. This transformation made movies more accessible, portable, and controllable, criteria by which consumers weighed the value of entertainment more generally.[6] Emerging out of the theatrical and televisual contexts of the 1960s and 1970s, the video store normalized the idea that movies were commodities much like any other, and to this extent they could be shopped for like books, musical recordings, clothing, or groceries.[7] Caetlin Benson-Allott has shown how different video platforms produce different spectatorial positions in line with historical changes in cultural and political values.[8] Alternatively, *Videoland* demonstrates how video stores situated moviegoers not as spectators but rather as media shoppers who expressed their power through selection and choice. During the era of tangible video, movie culture flowed out from the theater and the living room, entered a public retail space, and became conflated with shopping and salesmanship.

The historical specificity, even contingency, of video stores is clearly demonstrated by the decimation of the brick-and-mortar video rental business. Challenged by changing patterns of media consumption and the "Great Recession" that first struck the U.S. economy in late 2007, the brick-and-mortar rental industry has all but vanished. Whereas video rental generated over $11 billion in 2002, it made about half that amount merely ten years later. Similarly, there were nearly 30,000 video rental locations in the United States in 1989, but as of 2012 there were fewer than 11,000. In May 2010, Movie Gallery Inc. liquidated all Movie Gallery and Hollywood Video rental stores.[9] Blockbuster Video filed for bankruptcy in 2010 and closed all but 500 stores in the United States since that time, down from a peak of over 5,000 around the turn of the millennium.[10] Rather than simply mourn the loss of these places, however, *Videoland* demonstrates how video stores paved the way for the many forms of media distribution that usurped them.[11] Video stores taught us to shop for movies, and, for a time, they seemed the natural place for this to happen—public spaces that led to domestic consumption. But now that digital technologies have made shopping and consumption possible through the same device, and now that these devices are as likely to be found in public as in private, the video rental store no longer appears necessary to the distribution of movies.[12] What is lost in this new context is exactly what this book aims to capture: the ephemeral but concretely physical interactions around movie commodities that were once so common at the video store.

Video has not only been an object in the world, but also an object of study, and *Videoland* draws on and extends the scholarship on video in key areas.[13] Roy Armes asserts, "Video's very versatility and flexibility as a medium repulse any simple attempt to grasp its 'essence' or 'specificity,'" and existing scholarship attests to the fluctuating meanings of this thing called "video."[14] One of the first waves of video studies, which included works by Manuel Alvarado, Julie Dobrow, and James Lardner, grappled with video industrially and sociologically, as though its quick ascension to global popularity demanded a rapid attempt to capture its force with hard facts and data.[15] Other scholars of the 1980s and early 1990s, such as Timothy Corrigan and Anne Friedberg, took more broad-minded approaches, often working through theoretical concerns with medium specificity and postmodernity as they investigated and illuminated how video played a part in a historical shift in media technologies and cultural experiences.[16] Some works have looked at video in nonindustrial contexts, such as with documentary practices, "video art," and "home movies."[17] In two striking essays from the 1990s, Charles Tashiro discussed the technological and material features of videos, primarily video discs, in relation to consumers' subjective desires and experiences.[18] Yet the more prominent strain in recent media studies, beginning in the 1990s and continuing to the present, investigates video as a vital element of the Hollywood entertainment industry; Janet Wasko, Frederick Wasser, Stephen Prince, and Paul McDonald have all produced essential studies on the topic.[19]

Like many of these previous works, *Videoland* maintains that video has been a vital component of both the media industry and Americans' changing cultural experiences. Yet, by working through a slightly different object of study—the video rental store—this book necessarily extends their findings. I am less interested in "video" as a medium or an aesthetic than I am in the spaces in which many people interacted around video objects. And while many of the industrial studies attend to video rental, they do so almost exclusively as an economic and industrial phenomenon; they do not fully attend to the impact that video stores had on media culture more broadly.[20] My interest in "industry" weighs large-scale corporate dealings against the industriousness of the people who made their livings as clerks, owners, and distributors. *Videoland* aims to balance the sociological, industrial, and subject-oriented strains found within the subfield of video studies in order to offer a "culturalist" approach that is in keeping with more recent studies, including those by Lucas Hilderbrand and Barbara Klinger.[21]

This approach also distinguishes *Videoland* from the most dedicated and comprehensive study of video rental stores that currently exists, Joshua

Greenberg's groundbreaking *From Betamax to Blockbuster: Video Stores and the Invention of Movies on Video* (2008).[22] Greenberg provides a rich historical narrative that charts the emergence of video stores in the 1970s and culminates with the corporate consolidation of the rental industry in the early 1990s. His work provides key insights into the ways in which different social agents, such as video distributors, store owners, and video clerks, shaped the space of these stores and interacted within them. Yet Greenberg's methodological approach, which derives from science and technology studies, emphasizes how video technologies were conceptualized and used, where there could have been a fuller investigation of how the cultural conditions of movies changed. As he defines them, video stores are "consumption junctions," where "retailers create the retail space as a reflection of their understanding of the technology they are selling, as well as their assumptions about their customers' preferred understanding of the same technology."[23] Although I agree with Greenberg that the arrangement of a store suggests certain understandings, my interest lies less in how video stores conveyed ideas about video technologies and more in how they altered people's space- and taste-based relations with movie culture.

For Lucas Hilderbrand, "access" is the vital keyword for understanding video's aesthetic, cultural, and even political importance.[24] Along these lines, *Videoland* examines the forms of "access" enabled by video rental stores, which are sweeping. Video stores reconfigured American media at the level of *distribution,* in both industrial and cultural terms.[25] With every rental transaction, video stores made distribution a face-to-face, hand-to-hand process. They made distribution physically tangible, concretely spatial, and intimately social. Moreover, these interactions did not merely distribute videos but also ideas and values about movies. Properly understanding video stores' cultural importance therefore requires that we extend the implications of the term *distribution.* Many works in media industry studies refer to distribution as that sector of the industry that orchestrates the movement of commodities from producers to consumers.[26] However, in critical political economic theory, distribution can refer to the dispersal of wealth in a society.[27] These two meanings of the term—the process by which commodities move from producers to consumers as well as the social allocation of wealth—are best understood when set in relation to one another.[28] This understanding of distribution requires analysis of how forms of exchange bear on value in general.[29] This is particularly important for understanding cultural commodities, such as videos, as their value is so closely tied to the formation of ideas, beliefs, and social identities.

Characterizing distribution in this relational way highlights two issues that are vital to understanding video stores and that operate as keywords throughout this book: space and taste. Timothy Corrigan once characterized post-Vietnam movie culture as a "cinema without walls," in part because home video led to a wider dispersal of power within movie culture.[30] While it is true that video helped reshape the relations of power between movie producers and consumers, it is vital to note that video rental stores also had real, material walls and that this materiality matters. As both material and social places, video stores require spatial analysis.[31] *Videoland* engages in a "cultural geography" of video stores, drawing particularly on the work of David Harvey, whose contributions to this field largely coincide with the era of tangible media. As Harvey explains, "space" can be divided into three categories: real (material), represented, and interior (emotional).[32] In the following analysis, I show how the architecture and internal organization of video stores convey meanings about movies and movie culture, how video stores are situated in relation to their locations, and, further, how the material space of the store intersects with the interior, emotional spaces of the moviegoers and video workers within them.[33] I show how "the video store" is more than just a retail structure with certain architectural features; it is constituted through behaviors and interactions occurring within its walls.

The social character of video stores prompts my analysis of taste. I draw on Pierre Bourdieu's work on taste and distinction in order to coordinate my concerns with space and geography. He asserts that one can classify a social group by the manner in which they classify cultural objects and also shows how cultural tastes align with social divisions.[34] "Taste," Bourdieu writes, "is a practical mastery of *distributions* which make it possible to sense or intuit what is likely (or unlikely) to befall . . . an individual occupying a given position in social space." [35] With this in mind, *Videoland* analyzes the "geographies of taste" encompassed in and circulating through the video rental store. In its organization of movie categories, in its very architecture, the video rental store articulates social divisions in relation to film and media texts. Video stores differentiate themselves from one another by offering different types of movies and, just as importantly, by presenting different systems of movie classification. Yet in such places the taste-values of store workers become enmeshed with the socially oriented tastes of countless browsers and customers, creating a highly fractured, even individualized, geography of movie tastes *and* social values. Further, the "geography of taste" operating within any particular video store comingles with the tastes and values held by the larger community in which it exists.

To fully understand how video rental stores have altered the American geography of taste, they must be seen as historically specific manifestations of contemporary consumer culture.[36] Perhaps the greatest impact of video stores has been the way in which they more firmly aligned movie culture with American consumer culture more broadly. As David Desser and Garth Jowett have asserted, "It is arguable that at the very heart of the cinema may be found the contradictions and paradoxes of twentieth-century consumerism."[37] Certainly, the theatrical paradigm of movie consumption was fully aligned with capitalism, and American television has been so closely associated with consumerism that many critics and historians characterize the two as co-constitutive.[38] In providing a space where movies were shopped for as material commodities, the video store coordinated movie culture with the economic, social, geographic, and cultural conditions of the 1970s to early 2000s. Commonly referred to as the "postindustrial age" or "postmodern era," this moment has been defined by "flexibility in labour processes, labour markets, products, and patterns of consumption."[39] The need for economic flexibility has prompted the decentralization of production, the growth of the "service sector," and a greater emphasis on consumption in the first world.[40] Consequently, this period has witnessed intensified levels of "uneven geographic development," where the flows of capital produce highly differentiated and heterogeneous spaces.[41] Likewise, the social arena has been characterized by greater levels of fragmentation and stratification. In lieu of all these changes, cultural consumption has been defined by personalization, where the diverse tastes of individuated consumers are (supposedly) catered to through an increasing number of target-branded commodities.[42] As Charles Acland writes, "Individualism rules the world of entertainment."[43]

Video rental stores brought the movie industry and movie culture into better alignment with these historical conditions. Indeed, video stores are a crucial embodiment of movie culture's move toward increased flexibility, adaptability, and customization. They were opened in all sorts of buildings in disparate locations, decentralizing movie distribution significantly. Any commercial structure could potentially serve as a video store, from a gas station to a log cabin. Thus video stores have obeyed a "modular" architectural logic of adaptability.[44] Further, they have "localized" movie culture by bringing local moviegoers and video workers into direct contact.[45] In these ephemeral but countless social interactions, these people cultivated a geography of taste within their areas.[46] Finally, video stores catered to, and perhaps even nurtured, the increasingly fractured social sphere of contemporary America, first by promising an ever-expanding selection of movies

that the individual could control and second by personalizing movies through the video shopping experience. Video stores did for movies and audiences what happens in many other retail settings: the matching of a "unique" individual with a particular product that suits his or her taste. In these three ways—modular architecture, localization of movie culture, and the personalization of shopping—the video rental store aligned movie culture with the logics of flexibility and customization characteristic of the contemporary era.

In order to demonstrate how video stores have affected contemporary movie culture, *Videoland* engages in an interdisciplinary methodology that brings diverse research materials into play. As I engage in historical analyses of the video rental industry, the video distribution industry, and the video guide industry, this book aligns with "media industry studies." Yet as Jennifer Holt and Alisa Perren demonstrate in their overview of this growing subfield, media industry studies is a complex area of research, characterized by a range of historical precedents, contemporary methodologies, and objects of analysis.[47] Like many works in this field, *Videoland* draws from trade press documents to support many of my claims about the changing media landscape over the past forty years. More than offering a "by the numbers" economic analysis, however, *Videoland* draws on copious fieldwork and participant interviews in order to put some meat on what could otherwise be a skeletal description of the video business. Aiming to balance historical shifts in the industry at large with an interest in the "production culture" of the people who lived through these changes, I draw much of my information from the numerous interviews I conducted with workers from the video business, including video distributors and producers of video "metatexts," such as *Movie Guide* author Leonard Maltin.[48]

My desire to convey the social and spatial particularities of video store culture compelled me to conduct extensive, firsthand fieldwork at video rental locations, and this research has become central to this book's arguments. From 2008 to 2012, I traveled throughout the United States to document video stores and their workers. In addition to short visits to notable locations via plane, I went on two extended road trips in 2010 and 2011, always with a research assistant back home helping me connect with the store owners and a smart phone to tell me where I was. Over the course of all my journeys, I documented and interviewed workers at over two hundred video stores in over twenty states.[49] I visited stores in large, cosmopolitan cities (New York, Los Angeles, etc.), medium-sized towns with important universities (Madison, Wisconsin; Athens, Georgia; etc.), and rural villages (Hugoton, Kansas; Eva, Alabama; etc.). In addition to visiting

stores in a variety of locations, I chose stores that represented different kinds of ownership; mainly this was divided between corporate chains and independently owned stores, many of which had been in business for more than ten years, and in some cases since the early 1980s. I saw "classic" stores, impressive stores, and genuinely weird stores. I spoke with people from a wide variety of backgrounds, some of whom were extremely loquacious, others more cautious with their words. Almost all of them welcomed the chance to talk about their lives and work and responded warmly to my inquiries. Thus my observations of these stores and conversations with these workers grounds my generalizations about "the video store" in concrete, primary research and inflects my book with a strain of reflexive anthropological analysis.[50] In addition to looking at where video stores are and how they are arranged, *Videoland* examines how the people who work in them characterize their experiences in these places.

I should also confess the "me" in this book's "methodology." Like many Americans, I frequented video rental stores on a regular basis through the 1980s, 1990s, and 2000s. Growing up in the 1970s and 1980s, my experience with movie culture is coterminus with my experience with video. I remember gawking as a child at the lurid covers of horror films in a grubby, carpet-walled mom-and-pop shop. I remember being amazed by the large, clean aisles of a Blockbuster in 1988—and the seemingly boundless selection they offered. I remember ritualistically renting every foreign film available in a Hollywood Video as an undergraduate in the 1990s. Although it may have felt particular to me at the time, my long and intimate relation with video stores was ultimately quite typical. Everyone seems to enter the video store differently, for different reasons and with different tastes, but we share a common experience of shopping for movies.

Just as informative is my work at video stores. I worked at Alphaville Video in Albuquerque, New Mexico, from 1999 to 2002, at which point I moved to Los Angeles to attend graduate school at USC. Working at Alphaville was, for a long time, my greatest professional achievement. It was advertised, and genuinely functioned, as "Albuquerque's best source for fine foreign, experimental, independent, documentary, and gay and lesbian films." On arriving in Los Angeles, I took a job at Video Hut on Vermont Avenue from July until December 2002. Independently owned, Video Hut was mainly driven by the New Release section but also had a frequently visited back room for adult videos as well as a reasonable selection of independent and foreign films, likely to serve the hipster-bourgeois who lived in the area. My experience working at these two very different stores has informed my research questions, my arguments, and, more than

anything, the way I went about my research. I knew that video stores were more than just a collection of movies. I knew that they were constituted by the interactions occurring in their aisles and over their counters. I knew that video stores and the people within them could tell an untold story about American movie culture. Thus I knew that my analysis of video stores required firsthand observation and conversations with the people working in them.

I also know that when I attained a PhD and gained a tenure-track job, I "traded up" on the cultural capital I accrued while working as a video clerk. Working at these video stores allowed me to watch thousands of movies (for free) and provided me with a large, but largely factual and trivial, knowledge about them. Thus in graduate school I was rarely at a loss for a film to cite as an example of this-or-that theory or historical trend. Graduate school gave me the conceptual frames and historical knowledge with which I could discipline my experiences with movies and movie culture at the video store. The forms of knowledge I developed in those video stores are intertwined now with the more official forms of knowledge I gained in seminars, in reading books, and in teaching courses in film and media studies. I may have left the video store, but it has not left me.

And although the video rental industry appears to be in crisis, "the video store" has not really left America either. It is true that there are significantly fewer brick-and-mortar businesses that engage in video rental. Yet for the moment, one can still go into public and shop for a video at one of the numerous Redbox kiosks that have spread across the country. One can browse a Netflix queue or a VOD menu on a television, computer, or mobile phone screen analogously to the way one once browsed the aisles of the local Blockbuster. One can go to a public library and stroll through the open stacks of both books and videos.[51] As a *cultural practice*, the video store lives on in myriad forms and activities. If we have entered an era of "intangible media," where the apparatuses through which we shop for and consume movies appear everywhere, all the time, and yet no place in particular, then this moment is largely inconceivable without the hard-and-fast, tangible context of the video store serving as a precedent. Video stores once dotted the American landscape, constituting a "videoland" that dramatically altered our space- and taste-based engagements with movies and movie culture.

This book journeys through this vast geography of movie culture in six chapters. Although not precisely a "history," *Videoland* offers a historically situated, multidisciplinary analysis of modern movie culture. Rather than adhere to a chronological sequence, these chapters explore the relations of

space and taste at the video store through a number of intersecting zones, not unlike the aisles of a video store. Because the video store is a multifaceted historical, industrial, and cultural phenomenon, fully understanding it requires an array of methodological approaches. Thus this book is divided into three parts, each of which mobilizes a slightly different set of methods, yet aim to overlap and complement one another in total.

Part 1, "The History and Culture of Video Rental," analyzes the impact video stores had on American movie culture by examining their industrial and cultural particularities. Chapter 1, "A Long Tale," presents an industrial and cultural history of video rental, moving from the invention of movies on tape by Andre Blay through the ascendance of Blockbuster Video to the Redbox kiosks of today. This chapter argues that the history of the home video industry demonstrates profound changes in the ways that Americans related to movies. In the same process in which video stores became a normal part of the retail landscape, they simultaneously normalized the idea that movies were tangible, portable commodities. Video stores situated Americans as shoppers of movie content by promoting the idea that diverse tastes could be satisfied by the abundant movie titles now made available to them. Issues of geography were vital to the video rental industry, and video stores created a newly fractured and localized movie culture. Ultimately, the behaviors that video stores encouraged paved the way for the online retailing of movies. Thus the chapter closes with an analysis of how "long tail" retailers, such as Amazon and Netflix, similarly position Americans as shoppers of diverse media commodities.

Chapter 2, "Practical Classifications," engages in an analysis of the cultural geography of the video store and argues that "the video store" is best understood as a set of spatial and material practices. Starting at the level of video stores' architecture and internal composition, the chapter investigates how spatial arrangements suggest meanings about movies and facilitate certain kinds of social interactions; in this respect, the spatial logic of the video store is also a cultural logic. Although industry discourses typically define video stores in terms of their ownership, I argue that it is most appropriate to classify stores by the methods that they use to classify the movies on their shelves. Intertwined with this architectural study is an analysis of the social roles typical of video stores, browsers and clerks. Through their interactions, these figures alter and adjust cultural tastes and values. In these respects, this chapter uncovers how video stores created social roles, power relations, and understandings that were new to the cinema.

Part 2, "Video Stores and the Localization of Movie Culture," draws heavily from my ethnographic research and examines specific video stores

in cosmopolitan areas as well as in small towns. These chapters show how these stores relate to their geographic and cultural surroundings: as localized nodes in the network of media distribution. Just as importantly, these stores and the workers within them demonstrate that the distribution of media commodities goes hand in hand with the distribution of ideas and values. Chapter 3, "Video Capitals," examines independently owned "specialty" stores in a variety of locations. These stores reflect an accumulation of cultural capital that is typical of big cities but not exclusive to them. More important, these stores are linked to other sites of cultural wealth, such as universities. The chapter begins with an extended analysis of Scarecrow Video in Seattle, which holds more than 114,000 different movie titles. I characterize this store as a "video mecca," where the workers revere the collection with religious fervor and hold a dedication to the store that is nearly unshakable. I then analyze a number of specialty stores in the Los Angeles area, including Eddie Brandt's Saturday Matinee in North Hollywood and Cinefile in Santa Monica. In their movie holdings and public profiles, these stores cultivate eclecticism, which has helped them distinguish themselves in a city where "Hollywood" seeks to dominate movie culture. Finally, the chapter examines specialty stores in Bozeman, Montana, and Murfreesboro, Tennessee. These examples demonstrate that specialty stores are most strongly linked to communities that have educated populations and that feature institutions offering more traditional forms of cultural capital.

Chapter 4, "Video Rental in Small-Town America," examines video stores in small towns and rural areas in order to show how they can connect movie culture with a variety of local conditions and cultural concerns. Although many of these stores appear similar and although their workers are remarkably consistent in terms of their insights and worries, as this chapter uncovers, movie culture is highly heterogeneous in small-town video stores. First, I examine the variety of "looks" of these video stores, which range from ultraprofessional to downright funky. Second, I examine the workers at these stores, who demonstrate different kinds of expertise, community connections, and social stratifications. Third, I examine the characteristics of the stores' clientele as described, and perhaps imagined, by the video workers themselves. After demonstrating the limited options for movie consumption in many of these areas, I show how many small-town stores construct a "local" audience that is wide ranging and in constant flux. Finally, I analyze how small-town video stores regularly engage in other types of business activities. The combination of video rental and artificial tanning is particularly prevalent in the American South, but all manner of other business combinations can be found, from dry cleaning to

purebred dog sales. In their totality, then, small-town video stores complicate our ideas about movie consumption in America.

Part 3, "Circulations of Video Store Culture," provides a historical analysis of several ways in which the rental industry and video store culture intersected with "peripheral" industrial and cultural forces. Chapter 5, "Distributing Value," examines video distribution companies and argues that they have greatly influenced the ways in which movies are valued in cultural terms. The chapter begins by looking at three large, mainstream video distributors: Ingram Entertainment, Video Products Distributors Inc. (VPD), and Rentrak. All three companies have treated movies as nearly disposable commodities whose value is created through speed, volume, and "excitement." In their search for economies of scale, Ingram and VPD had to address issues of geographic scope. Meanwhile Rentrak offered a revenue-sharing program to independent video stores, which allowed them to get huge numbers of "hit" Hollywood films and at the same time allowed Rentrak to closely monitor their business operations. Rentrak was crucial to widespread changes in the business and culture of video rental during the 1990s, yet the importance and impact of this company have gone largely unexamined in previous studies. I then contrast the logics of these companies with an examination of the art-minded endeavors of several small, specialty video distributors: Kino Lorber, Zeitgeist Films, and Facets Multi-Media. By promoting the qualities of exclusivity, exoticism, intellectualism, and social activism, these companies have helped create an "art house" in the home. The chapter closes with a discussion of how both mainstream and niche video distributors are contending with the contemporary instability in home video distribution, characterized by the growth of rent-by-mail, video-on-demand, and internet streaming distribution systems.

Chapter 6, "Mediating Choice: Criticism, Advice, Metadata," continues the exploration of how movie culture has been affected by video stores through a historical analysis of movie recommendation guides. Given that video stores radically increased access to films, video clerks were hard-pressed to maintain a firm knowledge of their holdings and advise customers in ways that suited their diverse tastes. Thus the growth of video stores was attended by the publication of texts devoted to helping customers wade through the mass of movies made available on video. Perhaps the most famous is *Leonard Maltin's Movie Guide*, but other examples are *Videohound's Golden Movie Retriever* and the *Blockbuster Video Guide to Movies and Videos*. These texts were preceded by movie encyclopedias such as Leslie Halliwell's, and came about during the popularization of film

criticism in the 1980s, as evidenced by the television program *Siskel and Ebert at the Movies*. These texts serve as indexes for the explosion of movie culture engendered by the home video industry. They also serve a very practical function: they help shoppers shop. More recently, however, traditional film criticism and video guides have been displaced by services found on the Internet. IMDB.com, for instance, has dramatically reduced the relevance of encyclopedic guides such as Maltin's, and the "suggestions" and "recommendations" offered by online retailers, such as Amazon and Netflix, appear to have short-circuited the need for film evaluation in such guides as well. In light of this dematerialization of movie recommendations, the chapter concludes with an analysis of Rovi Corporation. This company, which has remained almost invisible to media scholars, critics, and everyday consumers, has profoundly affected the home video business and culture from its beginnings through the present. In fact, Rovi aims for a certain invisibility by making "metadata," like movie reviews and content descriptions, a seamless aspect of different media interfaces.

Rather than a conclusion, *Videoland* closes with a coda, "The Value of the Tangible," which ruminates about what becomes of videos, video stores, and video store culture after these shops go out of business. The dematerialization of the video store has left in its wake immense volumes of magnetic tapes and plastic discs that now sit in landfills across the country. The buildings that once housed video stores are now left vacant or rented by new entrepreneurs, signifying the material consequences of the elimination of the video rental business. The other side of this coin, however, comprises the many lingering "fans" of video and video culture. While some companies have been releasing movies on VHS for the nostalgia market, others have created remembrances of video culture on the Internet. In these virtual locations, the video store is not simply a set of cultural practices that have been redeployed elsewhere, but rather an object of love, study, and continued discussion.

This book aims to contribute a thoughtful but enamored voice to the discussion on home video. In combination, the chapters that follow present an expansive examination of movies as material culture. Indeed, through a multimodal analysis of the historical, geographic, and cultural aspects of video rental stores, *Videoland* illustrates the complex ways that movie culture expanded and fragmented over the past several decades. It shows how video stores changed the way Americans relate to movies and, just as importantly, to one another.

PART I

The History and Culture of Video Rental

1. A Long Tale

The signs of the collapse of the video rental industry are everywhere. Or at least they were in 2010 and 2011. Driving around Ann Arbor, Michigan, I watched as all the local stores closed for business, from the independently owned Liberty Street Video, down the street from my office, to the various Blockbuster and Hollywood Video locations (figure 2). At the time of this writing, the only places left in town to rent movies are a gas station, the public library, and the Redbox kiosks outside my grocery store and pharmacy.[1] There is almost no indication that there were ever any video stores in Ann Arbor at all. Instead, there are new businesses in these locations or For Lease signs in the windows.

The disappearance of the video stores in Ann Arbor is a local instance of a national trend. But what is remarkable is that these closures appear so unremarkable to so many people. Aside from the occasional article in a newspaper or trade publication, or the odd blog post devoted to nostalgically celebrating rental stores, the waning of the video rental industry seems to have gone unnoticed by the everyday Americans who were once these stores' customers. It is likely that many of these people stopped using their video stores long before the businesses closed; their disinterest made them oblivious to the industrial change they engendered. If the video store was no longer a landmark in these people's minds, then it disappeared as a genuine landmark as well. Perhaps these places were never landmarks in the first place.

Whether they were seen as important or not, video stores were vital components of the mainstream media industry and everyday Americans' lives for nearly twenty-five years. The first video rental stores appeared in 1977, shortly after Hollywood films were first licensed for release on magnetic tape.[2] By 1987, revenue from home video releases overtook the

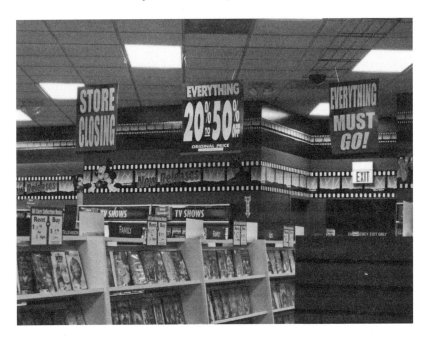

FIGURE 2. The signs of an industry in crisis.

theatrical box office.[3] Whereas there was no such thing as the video store in 1976, there were about 30,000 such places in 1989.[4] As a point of comparison, there were around 22,000 theatrical movie screens in this same year, and many fewer theatrical locations.[5] This represents a profound change in the landscape of movie culture in America over the course of the 1980s, one that would obtain through the 1990s until the rental industry began to fragment and dissipate in the early 2000s. Certainly people still went to theaters to see movies during this era, or watched them at home on broadcast and cable television, but these venues were now just two options among many for accessing movies. Video stores were a common part of the American media landscape. Yet most of these places have disappeared as suddenly as they appeared.

Whereas other chapters in this book look at the internal space of video stores and their place within specific communities, this chapter examines the place of video stores within American media culture at large. The home video industry facilitated and reacted to subtle but deep changes in the ways that Americans related to entertainment in general and to movies in particular. Video rental stores expanded, localized, and fragmented movie culture. In their rapid growth and geographic spread, video stores created a

new abundance of venues in which people could engage with movies and movie culture. They gave people access to movies as tangible, portable objects, and Americans treated them as a new and proper venue for acquiring movies. Video stores were mainly located amid the habitually trafficked retail landscape; in this respect, they made movie culture casual and routine by expanding it into Americans' everyday public spaces. The fact that these locations appeared alongside and similar to bookstores, record shops, and other retail sites that encouraged habitual use meant that video stores were easily assimilated into the cultural geography of diverse locations across the country.

Further, video stores increased Americans' *degree* of access to movie culture. Both Joshua Greenberg and Frederick Wasser have discussed how a diverse population of numerous entrepreneurs opened video stores across the country in the late 1970s and early 1980s.[6] Suddenly, a large number and wide variety of businesses and individuals participated in "the movie business." Just as importantly, video stores gave everyday shoppers a larger number of movie options to choose from. They fostered a conception of media abundance and catered to people's sense of entitlement to this abundance (even if the selection the stores offered was actually quite limited).[7] They appealed to Americans' sense of individualism by appealing to their individualized tastes (even if most people watched a limited number of Hollywood films). Video stores dispersed and fragmented movie culture, turning Americans into media shoppers by catering to their individualized movie desires.

This chapter begins with an examination of the historical, technological, and cultural factors that shaped the development of the video rental business. Americans had long been accustomed to watching movies on television as well as shopping for cultural goods in public retail spaces. Following the technical invention of movies on video, the video store bridged these two activities, thereby conflating movie culture with consumer culture in a new way. Video store advertisements from the 1970s and 1980s illustrate how they catered to and capitalized on American's idiosyncratic tastes in movies, as well as their interest in engaging with movies as part of their habitual shopping routines. Toward the late 1980s and into the 1990s, the video rental industry self-consciously contended with issues of geography and taste, demonstrated by a regular feature in *Video Store* magazine that examined the video business in a specific region in the United States. In this respect, members of the video industry attempted to understand and capitalize on the dispersed and fractured geography of taste they helped create.

The chapter continues with an examination of how video culture was standardized and professionalized in the late 1980s and 1990s, when the corporate video chains like Blockbuster Video, Hollywood Video, and Movie Gallery dominated the industry. The success of these companies indicates how deeply embedded video rental had become in American movie culture. Just like the standardized and unremarkable décor within these corporate stores, the cultural practice of video rental was completely unexceptional in this period. Yet a number of practices and values that video stores helped normalize were intensified in the late 1990s and 2000s in such a way that the traditional, brick-and-mortar video rental industry was undermined. Video rental stores helped create a sense of media abundance, and they helped disseminate a fractured movie culture across America. But the video market itself was expanded and fractured by the growth of the video sell-through market, propelled conspicuously by the widespread adoption of DVD. Suddenly, an increasing number of different retail operations became de facto "video stores," which sold rather than rented movies. Among these many locations, the "big box" discount chains like Target and Wal-Mart became particularly important players in the home video industry.

The fracturing and dispersal of video intensified even more notably through the growth of "long tail" retailers, such as Amazon and Netflix, which offered Americans the ability to shop for media commodities over the Internet. These operations provided greater geographic convenience to people who were already accustomed to having an abundance of movie options to choose from. As these and similar companies began to offer movie streaming and "on demand" viewing services, they continued to disperse and fragment movie culture but in such a way as to bypass the need for the video store at all. The chapter closes with an examination of the video rental kiosks that have appeared across the country, with Redbox serving as the most notable example.[8] Whereas long tail retailers extend the logic of personalized movie shopping into a mobile, digital environment, Redbox continues the place-based logic of the video store while eradicating its socially interactive component.[9] As all these options for movie shopping proliferate and overlap, America now exists as a "videoland" where "the video store" appears in myriad forms and locations.

THE BEGINNINGS OF VIDEO RENTAL

The emergence of the video store was a widespread, diffused, and haphazard event.[10] Like any historical change, the invention of the video store did not happen in a vacuum; particular conditions facilitated the appearance of

these stores and set the stage for their geographic spread and economic success. The historical prerequisites for the specific way in which video rental stores took off in the United States are (1) the normalization of domestic consumption of movies, particularly on television; (2) the advent of movies on a small portable medium, in this case magnetic tape; (3) the synergistic adoption of VCR technology throughout the country, thereby changing the technical infrastructure for movie exhibition on a mass scale; and (4) the normalization of retail stores devoted to cultural goods, like books and musical recordings. Additional factors prompted a rental business model rather than a direct sales one. The initial price point of Hollywood movies on magnetic tape, set around $50 to $70, made videotapes too expensive for general consumers. Further, the Hollywood studios and other early video distributors were often opposed to a rental business model. Yet the entrepreneurs who opened the first video stores maintained that their rental activities were protected by the "first sale doctrine." This component of U.S. copyright law provides that although a copyright holder maintains its rights over the work embedded in a cultural commodity, it does not have control over the commodity itself after it is sold.[11] Ultimately, this did provide the legal basis for the rental model that, for a time, was the norm in the video industry. Moreover, because the Hollywood studios were ambivalent about the rental model, the entrants into this market were typically not people with previous experience in the movie industry; in this respect, the advent of the video rental store decentralized and democratized movie distribution. Rather than an emergence, the beginnings of the video rental industry represent a convergence of social, cultural, industrial, regulatory, and technological activities.

Americans had grown accustomed to watching movies in their homes long before Hollywood movies were made available on magnetic tape.[12] Experiments with film consumption within the home occurred at the very beginnings of the cinema, although these early efforts never amounted to much.[13] Likewise, numerous companies encouraged Americans to watch commercial entertainment in their "home theaters" following the advent of 16mm film in 1923; nevertheless, the use of 16mm film for consuming Hollywood films in the home never became universally popular.[14] Rather, the primary mechanisms for the domestication of commercial entertainment were, first, the radio during the 1920s, 1930s, and 1940s and, second, the television in the 1940s, 1950s, and after.[15] Film historians traditionally cite television as contributing to the decline in theatrical movie attendance from the late 1940s through the 1960s.[16] Yet it is just as important to note that many Americans used television to watch movies. Although the

Hollywood studios initially resisted airing their films on television, a number of them began licensing their films to television networks and individual stations in the 1950s; the actual airing of feature films was inconsistent throughout the era.[17] A turning point occurred in 1961, when NBC regularized the practice of airing major Hollywood movies in prime time with the series *Saturday Night at the Movies*.[18] This experiment was successful enough that ABC began airing feature films in prime time in 1964, and CBS did the same in 1965.[19] Over the course of the 1960s, "total prime-time programming hours devoted by the networks to features increased from 2 hours to over 16 with feature film accounting for over a quarter of all prime-time programming by the 1971–1972 season."[20] Although different kinds of television programming remained popular throughout the 1960s and 1970s, television viewers had abundant access to Hollywood films, recent and old, throughout this period.[21]

However abundant they were, televised movies obeyed the programming schedules of the individual stations and networks. Further, they were interrupted by advertisements and regularly edited to conform to the time constraints of the programming schedule. One way of making unedited movies viewable at the command of the domestic consumer was to place them on a portable, playable format. Yet the technical process of putting Hollywood movies onto a small, portable object was the outcome of a long and twisty period of trial and error on the part of electronics manufacturers, technophile communities, and small entrepreneurs. Numerous technical innovations in video recording technology through the 1950s and 1960s made it possible to record television broadcasts and, more important, eventually made VCRs accessible to a large number of potential customers.[22] A plethora of formats for playing and/or recording video signals in the home were tested by numerous manufacturers across the globe, from Sony's reel-to-reel CV-2000 and their U-matic cassettes to CBS's electronic video recorder (EVR) to the Cartrivision system, developed by Avco and Playtape Inc., which has the distinction of being the first system to make Hollywood movies available for rent on video in North America.[23] Yet none of these systems found a mass market. Rather, early video cameras, recorders, and players were initially taken up during the 1970s by technophiles who were more interested in tinkering with these machines than using them as movie-delivery vehicles.[24]

When Sony initially put the Betamax VCR deck on the North American market in 1976, they promoted it as a "time-shifting" device, as a means for Americans to record television programs and replay them at a later time, thus "shifting" the time of television viewing; VHS was pro-

moted similarly when it entered the American market in 1977.[25] Vitally, the VCR arrived in North America at nearly the same moment that the Home Box Office (HBO) cable channel began airing unedited movies and sporting events without commercial interruption via the Satcom 1 satellite. The simultaneous appearance of the VCR and HBO helped normalize and combine the ideas that movies could appear on TV without interruptions and that Americans could control the conditions of domestic viewing. HBO may have even served as an incentive for people to buy VCRs, with which they could record the unedited movies the station played.

In this context, other individuals quickly realized the capability of VCRs to play prerecorded content.[26] Producers and distributors of adult movies had experimented extensively with using different video formats for exhibition; people working in adult cinema had even established a semiformal distribution network by the mid-1970s, thus presaging and in some ways informing the way the mainstream home video distribution business developed.[27] Yet Andre Blay, of Magnetic Video in Farmington Hills, Michigan, was the first person to successfully acquire the rights to Hollywood films, put these movies on magnetic tape, and make them commercially available in 1977, making him largely responsible for the creation of the mainstream home video business.[28]

Originally, Magnetic Video engaged in the commercial reproduction of 8-track tapes and audiocassettes.[29] The company began producing corporate training videos in the mid-1970s, primarily for the auto companies in Detroit, and these tapes sold for as much as $750.[30] From the start, then, in fact *preceding* the development of the mainstream home video market, Blay used video technologies for the commercial delivery of prerecorded content. Thus Blay saw the VCR and magnetic tape as vehicles for the commercial delivery of recorded content, not as a time-shifting device. After Betamax arrived in North America, Blay sent a letter to numerous Hollywood studios asking to license their films for distribution on magnetic tape. Only 20th Century Fox responded, agreeably, after having already licensed some of its films to RCA for a movie-on-disc format.[31] The studio offered one hundred movie titles for $5,000 each, but Blay could not afford this amount, so the final deal was to license fifty films for $6,000 per title.[32] Given a list of one hundred movies to choose from, Blay cross-checked them with *Variety*'s list of the hundred top-grossing films and chose the top fifty. He writes, "I did not rely on any other criteria such as actors or even the director."[33] Blay's selection had no artistic pretensions and actually reflected the logic of the video industry to come, namely, that it would largely expand on the success a film found in the theatrical window.

Blay broadened movie culture by catering to Americans' divergent tastes and by conflating movies and retail. He initially marketed his tapes to electronics retailers, who Blay required to buy a large batch of tapes, as well as to individual consumers, for whom he devised the mail-order Video Club of America. He promoted the breadth of his selection to both these groups, appealing to a desire for diversity. In describing his decision to release all fifty tapes at once and to highlight the breadth of the selection in early marketing materials, Blay writes, "I wanted to wow them with variety."[34] Blay nurtured the idea that his product would cater to people's individualized tastes in movies, not merely their ability to watch them at home on their own schedules. He made an appeal to taste—popular tastes but divergent. Although his list was limited, Blay offered more choices than the limited selection of films playing at the local theater or on a nightly broadcast. In this respect, he anticipated and facilitated the personalization of movie consumption. Further, by establishing contracts with electronics retailers, he connected movie culture to delivery technologies.[35] He also created a connection between movies and retail practices that had not existed before. People paid for theatrical movie tickets just before the time of consumption; Blay made it possible for people to survey and contemplate their movie options long before consumption would actually occur. He made movies shop-able. Further, through the Video Club of America, Blay created a new and individualized geography for movies. Although people had watched movies on television for years, now they could own movies as material commodities and view them whenever they chose.

As much as Blay's business activities coordinated with Americans' appetite for Hollywood films and their desire for control, he based his business on sales rather than rental.[36] In fact, he made retailers sign an agreement that they would not rent the tapes, as he feared that they would then stop reordering tapes from him.[37] Instead, the rental model was developed in an almost grassroots, populist manner. Many different people from across the country began buying movies on video and renting them to paying customers, greatly diffusing movie distribution. These entrepreneurs' activities depended crucially on the first sale doctrine, which allowed anyone who bought a movie on a VHS tape or laser disc to do whatever he wanted with this object, as long as he did not copy its contents.[38] In this respect, Andre Blay's transmutation of movies into material, portable objects is precisely what made movies rentable and resalable, even if Blay did not foresee or even condone this activity.

George Atkinson is commonly cited as perhaps the first person to begin renting movies on tape; yet the owners of Thomas Video, located at the

time in Royal Oak, Michigan, remember driving across town in 1977 to pick up the first fifty movies available on tape directly from the Magnetic Video duplication center and then renting them.[39] Whoever was first is less important than the fact that the practice of renting movies on tape quickly proliferated. As Magnetic and other companies released more movies on tape, all manner of people and businesses bought videos of Hollywood films and other prerecorded content and subsequently rented them to a general public.[40] Thousands of video rental stores appeared rapidly across the country, greatly increasing the number of venues for people to access movies. Further, these stores changed the way people treated movies. Rather than theatrical or televisual experiences, movies were now objects that people could survey, consider, touch, rent, and watch at home at a time of their choosing.

The growth of the video store significantly decentralized movie distribution, allowing for a number of new entrants into the movie business. In general, there were two types of video stores in the late 1970s and early 1980s: those that added video to an existing retail business, including Fotomats, record shops, and U-Haul stores; and those that opened up for the purpose of video rental but sometimes engaged in other activities, like VCR rental and repair.[41] This latter group would come to be known within the industry as "video specialty stores," indicating that this was their primary function and source of revenue. Greenberg indicates that these stores were opened by an immensely diverse population of people who often had no experience with retail but rather an interest in movie culture.[42] In this moment, American entrepreneurs from a wide variety of backgrounds suddenly had a powerful role in the distribution of Hollywood movies. These "moms" and "pops" attained a new level of access to Hollywood movies, decentralizing the control over media distribution. Their stores altered the space of movie culture, shifting it out of the theater and into adaptable retail spaces. As movie culture entered the space of everyday retail, it did so in a highly disorganized way, clearly indicated by the visual and tactile diversity one could find among the stores themselves. The early video stores were as spatially idiosyncratic as the people who ran them. Some were clean and orderly, while many were quirky, jerry-rigged, and even junky. Often fitted into strip malls, most of these stores had their own style of organization and collection of titles.

Many of the locations that initially incorporated video rental were originally involved in hardware sales. These operations had some difficulty knowing how to market, sell, or rent movies, particularly because movies have overt cultural significance and appeal to people's individual tastes.[43]

This is not to say that people who buy television sets, VCRs, or even refrigerators do not make cultural associations with these commodities or that taste has no bearing on their shopping and final selection. All commodities are cultural. Yet it was the video specialty stores that treated videos as *movies*, as entertainment options. Indeed, while the electronics firms and similar hybrids retreated from the video market in the early 1980s, the independently owned specialty stores found increasing economic success, indicating that the way they framed videos—as portable, controllable movies—aligned with the sensibilities of contemporary American consumers. Although the independently owned, mom-and-pop video specialty stores that proliferated throughout the early 1980s may have been idiosyncratic in their look, organization, and selection of titles, they all capitalized on a similar practice. They encouraged shopping for movies as a habitual behavior among Americans. They normalized the idea that movies were more than just visual experiences to be had at home or in the theater. Movies were now objects in their own right, and Americans could now contemplate and survey them as such.

The spread and normalization of video rental stores coincided with the spread of VCR technologies through the 1980s. Whereas there were only 1.9 million American households with a VCR in 1980, there were 64.5 million ten years later; this represents a shift from about 2 percent of the population to over 70 percent.[44] Thus the increasing presence and use of video rental stores occurred in tandem with the increasing use of the VCR, particularly for watching movies and other prerecorded content. Further, the adoption of the VCR and the practice of video rental were propelled by the changing economics of video technologies and rental. Whereas Betamax and VHS VCRs were initially priced above $1,000, many stores advertised VCRs for anywhere between $400 and $700 by the Christmas shopping season of 1982. By 1986, one could commonly find VCRs for sale between $200 and $300. Along with the decreasing costs of VCRs, the costs of video rental declined. In the late 1970s, video store club memberships often cost as much as $50, and individual movie rentals could be as high as $10 per night. Yet by the early 1980s, many stores had reduced their membership rates to $20 or eliminated them altogether, and some stores offered video rentals for as little as $2 per night. By 1989, the national average to rent a new release movie was a mere $2.46.[45] These numbers indicate that VCRs and the practice of renting movies were initially situated as luxury items and experiences. They appealed to wealthier consumers who wished to have a greater level of control over their media viewing. Yet the downward trajectory of prices made these commodities and practices increasingly avail-

able to everyday Americans, so that shopping at the video store was a common experience for people from a wide variety of social classes and backgrounds.

As a space wherein people shopped for movies, video stores resembled other retailers of commodities that hold analogously powerful cultural significance and associations with taste, like books and musical recordings.[46] Yet the retailing of books and recordings had a longer, if haphazard, historical development than videos. Through the 1800s, many types of dry goods stores sold books, and an increasing number of shops specialized in bookselling by the second half of the nineteenth century.[47] By the 1920s, the "bookstore" was a common feature in most American cities, divided between "big city chains" like Doubleday Duran and small-scale "personal bookshops."[48] These locations were supplemented by the many newsstands, department stores, and drugstores that sold books, along with various mail-order booksellers.[49] Mass-merchant bookstore chains, such as Borders and Barnes & Noble, underwent dramatic growth beginning in the 1960s and culminating in the 1980s and 1990s.[50] Primarily located in suburban malls or shopping centers, these stores offered large, clean, standardized spaces that enticed shoppers to browse unimpeded.[51] Similarly, the market in recorded music began immediately upon the invention of the phonograph, and although "distribution of both recordings and phonographs was initially handled by mail order and outlet chains . . . soon they could be purchased anywhere, from bicycle shops to department stores."[52] By the middle of the twentieth century, one could buy records at chain stores, supermarkets, and appliance stores and through a growing number of mail-order clubs.[53] In the 1980s, the music retail business underwent significant consolidation and became "controlled by chains like Tower Records and Record Bar."[54] Such record "superstores" were large, with 18,000 square feet or more, and offered a huge number and wide variety of cheaply priced recordings.[55]

Thus, by the time the first video rental stores came into existence, there were strong precedents for shopping in public places for cultural commodities. Whereas the hardware and electronics retailers typically positioned videotape as an extension of the VCR, the thousands of "moms and pops" who opened video *specialty* stores positioned videotape more directly as a movie—a cultural good like a book or record. Yet just as much as video stores resituated movies as material commodities to be shopped for, they also participated in a historical shift in the selling of cultural goods more generally, as indicated by the growth of the large, abundantly stocked, rationalized book- and record store chains during this same period. All

manner of leisure activities—reading, listening, viewing—were now made available in a huge number of public retail locations. Video stores were simply the way movie culture conformed to the historical practice of cultural shopping.

THE NEW GEOGRAPHY OF TASTE

The rapid spread of video rental locations throughout the country in the 1980s significantly altered the geography of movie culture. This is partly true because of the way in which video stores aligned movies with retail practices but also because of the way in which they provided a new abundance of viewing options to local moviegoers. Early advertisements for a variety of video stores indicate the way that the industry moved from emphasizing VCR technologies to selling movies and, moreover, that the new abundance and variety of movies on tape would enable individuals to satisfy their individual desires. Video stores did not just create greater levels of access to movies in an attempt to satisfy multiple movie tastes. They actively cultivated this fracturing movie culture by situating Americans as individuals with different tastes.

A 1980 advertisement for the Video Station in West Covina, California, is characteristic of the ways in which video rental was initially conceived and promoted to the public (figure 3). The ad boldly highlights the fact that the store is in the movie business and appeals to readers' individual desires by promoting choice and selection. It lists a handful of specific movie titles, most of which had been theatrical successes and which represent a range of genres. By highlighting the breadth of its selection, the store indicates in its ad that it aims to satisfy a diverse population of renters whose tastes in movies could be quite different: *Alien* (1979) for adult horror film fans, *Muppet Movie* (1979) for kids, *Superman* (1978) for everybody, "and 1000's of others" for all manner of individualized movie tastes. Nevertheless, the ad emphasizes video technologies more than it does movies, with the logos for a number of different hardware manufacturers appearing larger and more boldly than the movie titles. In addition, the ad shows that the store is engaged in technology-oriented activities, including selling blank tapes for TV recording, video equipment rentals for those people without a VCR, and video production of family events.

Alternatively, a Fotomat advertisement from the same year highlights the movies more than the technology. It states, "You can rent our most recent releases (like the ones you see here) for just $9.95. And we have a lot more to choose from . . . Comedies, love stories, sports films, concerts, and

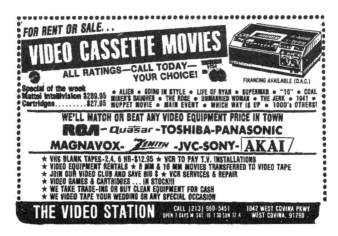

FIGURE 3. This advertisement for the Video Station in West Covina, California, highlights video technologies as well as movie selection.

even educational films."[56] The visual display of specific movies highlights recent hit films in a manner that recalls a theatrical movie advertisement from a newspaper. Although the ad showcases these hit films, it also emphasizes the breadth of its selection in the text: "over 200 great films." Rather than list all the available options, which would be cumbersome for a single advertisement, the ad lists generic categories, appealing to readers' general tastes. Yet even here, the ad stresses the range of genres available, suggesting that the store can satisfy many different tastes. Similarly, the Musicland chain of record stores advertised its movie rental business by visually highlighting a handful of specific movie titles, each of a different genre, including *Fiddler on the Roof* (1971), *Coming Home* (1978), and *The Boogeyman* (1980). "Rent your favorite movies . . . Hundreds of titles to choose from," the ad states.[57] Both of these ads situate video rental as a movie delivery system and make movies the primary draw. Just as importantly, they position readers as potential shoppers by emphasizing the breadth of the selection.

At the same time that video stores appealed to Americans' sense of individuality by offering multiple viewing options, they also appealed to American shoppers' desire for convenience.[58] In addition to highlighting economic affordability as well as the ability to control the time of viewing, video store ads promoted convenience by highlighting geographic proximity. The Fotomat advertisement discussed above details the relatively intricate rental process at Fotomat stores, where customers had to call ahead and

place their orders. Nevertheless, the ad says, "pick up your cassette, usually the next day, at your nearby Fotomat store. Keep it for five days and as many plays as you like."[59] On the one hand, this indicates that one of the appeals of the VCR was that it allowed for repeat viewing, even allowing different household members to watch the same movie at different times. On the other hand, and just as importantly, the ad suggests that moviegoers will not have to go far to get what they desire and that they will not be troubled by going out soon thereafter to return the tape. Somewhat similarly, there are many occasions when a movie or video distributor would appeal to shoppers' desire for geographic convenience when advertising specific movies. An advertisement for Disney's video release of *Sword in the Stone* (1963) from 1986, for instance, lists a number of stores across the state of Michigan. A 1981 advertisement from Warner Home Video states, "Rent *Superman* on Friday, Return him Monday!," and then tells readers to call a toll-free number to find the nearest "official Warner Home Video store."[60] The opposite page lists the names, addresses, and phone numbers for over thirty video stores throughout southeastern Michigan.

Even this limited sample of advertisements suggests the ways in which video stores created a new geography for movie culture. Video stores provided a new abundance of movie viewing options for domestic consumers. The stores appealed to a desire for options, even if in actuality people rented a select number of mainstream hits. Further, they localized this supposedly diverse range of tastes by providing access to movies in a more geographically convenient way than movie theaters. By 1985, there were around 21,000 video specialty stores in the United States.[61] More important, they saturated the local retail landscape. In a report from 1985, more than half of video store owners stated that their nearest competitor was less than a quarter of a mile away, and this level of saturation held steady through the rest of the decade.[62] In 1989, there was an average of 4.6 video stores operating within three miles of any other store throughout the country.[63] Video stores were part of everyday Americans' habitually used public space; and their advertisements indicate that they promoted this characteristic as a selling point. They became the material and spatial embodiment of Americans' desire for selectivity and geographic convenience in movie viewing. They particularized movie culture at the local level, on a national scale.[64]

Many different individuals opened video stores, and many more used them. But their idiosyncratic experiences and practices were actually quite generalized. Over the course of the 1980s and into the 1990s, the video industry became increasingly organized and professionalized. As part of

this process, industry participants self-consciously contended with the strange new intertwining of taste and space that video stores had created. Alongside a plethora of newsletters and magazines aimed at both video technology enthusiasts and the emerging group of video store owners, *Video Store* magazine began publication in July 1979.[65] Originally the magazine focused on video technologies, but it increasingly addressed business issues of concern to video store owners. One of the most practical issues that industry participants faced was geography, and *Video Store* throughout the 1980s and 1990s had a recurring section called "Regional Reports" that detailed the video business in specific cities and regions. In the early 1980s, each month this section featured a detailed description of a specific video store in a specific region.[66] Running about two columns in length and often accompanied by a photograph, the articles provide a record of the individual practices of video store owners from the period, which turn out to be quite typical of the general conditions of the industry at the time. The November 1981 issue, for instance, describes Video America in Idaho Falls, Idaho. The store dealt in video hardware as well as movie rentals. It required a $30 membership fee and offered 350 different movie titles, "none of which are X-rated."[67] The store occupied just a thousand square feet. Similarly, the issue from February 1982 gave an account of the Video Depot in Hacienda Heights, part of a Southern California franchise that had twenty additional stores at the time.[68] The April 1982 issue examined Captain Video of Lake Oswego, Oregon, and found that *Caddyshack* (1980), *Airplane!* (1980), and children's movies were the most popular choices among the five hundred they offered.[69]

In compiling and publishing these individual tales of experimentation, success, and struggle, *Video Store* helped create a network of knowledge that surpassed the local experiences of each store and reader.[70] Although each of these stores may have been perceived as unique or particular, the phenomenon of video rental was national, and this magazine sought to create a national understanding of the industry's many local instances. In this manner individual readers could potentially change their operations based on what they heard "worked" in another location. The magazine declared this goal in the mid-1980s, when it began to open the section with the following passage:

> Every month, our staff interviews a variety of retailers so that we might provide a forum for accurate and timely assessment of the marketplace. The business expertise shared in these pages is intended to provide industry comrades with useful marketing and merchandising information as well as practical solutions to common problems.[71]

Thus, like the formation of the Video Software Dealers of America (VSDA) and the annual conventions this group held, *Video Store* aided in disseminating information across the otherwise heterogeneous group of video store owners, helping to make this group integrated and professionalized.[72] Unlike a trade organization or an annual trade show, however, *Video Store* did so not through centralization but rather through material dispersal. More important, the magazine helped normalize video rental store practices by providing solutions to "common problems" encountered by individual stores, including pricing issues, local competition, content selection, store layout, and theft protection, among other concerns.

As the rental industry matured in the late 1980s and early 1990s, *Video Store* examined the video industry within a select region more than it detailed specific stores. These articles described the economic and demographic conditions of a specific city, its historical and cultural milieu, and assessed the rental habits of its citizens. The November 1988 issue, for example, describes the intense level of competition in the video business in St. Louis, Missouri, drawing from interviews with local store owners and public officials.[73] In addition, it describes the size of the labor force in the city, the jobless rate, and the average income per household.[74] The report on San Francisco from May 1990 took a pointed interest in the particularities of the local video market. It discusses the area's comparatively high real estate prices and lack of strip malls, factors that made it difficult to open and maintain a video store there.[75] However, the article claimed that the earthquakes and fog typical in the area prompted people to go out less than in other cities, thus making them more inclined to rent movies.[76] The article states further, "In general, San Francisco residents are sophisticated, and knowledgeable about movies," and according to one local store owner, their "video habits reflect specific tastes and interests."[77] The particularity of the population's tastes is manifested geographically, as the article states that "retailers find that they have to take each neighborhood as a separate entity addressing characteristics and quirks that may exist only in that area."[78]

Thus this article not only provides details about the economic context in which video stores operate in the region, but the cultural climate as well. Although somewhat vague in its analysis, it tries to contend with the new geography of movie culture that video stores helped shape. Along such lines, the feature on Atlanta, Georgia, from October 1991, describes how police had raided a number of video stores carrying adult movies in their attempt to enforce local obscenity laws. Rather than challenge these activities, as had been done in other cities in the country, the story reported that many local store owners reduced or selectively curated their adult sections

so as to appease law enforcement officials. One store owner explained, "This is the Bible Belt, you know," implying that a broader moral attitude in the area mitigated against a particular genre of videos and thus put pressure on the economic situation for the relevant stores.[79] Likewise a report from 1990 states, "Detroiters . . . like video. With a passion. They . . . rent videos like there is no tomorrow."[80] This report describes how movies on tape were invented in the region and goes into great detail about the economic and demographic conditions in the area, providing a broad social and cultural picture of the place. In addition, it makes a number of assertions about the local population, calling it "perhaps one of the nation's most racially conscious big cities."[81] Yet it does not detail how race affects the video business in the area. In terms of cultural consumption the article states, "Detroit's 1.72 million television households harvest a bumper crop of couch potatoes," where "72.5 percent of households own a VCR," and, further, that "movies—particularly action-adventure and horror flicks— enjoy robust theatrical runs" in the area.[82]

This story, like the others, considers social, economic, and technological issues in its attempt to provide a broad portrait of the geography of movie taste and consumption in a particular region. These regional portraits from *Video Store* in the early 1990s do not so much try to create or maintain a network of knowledge to support other store owners but rather assess how video has affected and been integrated into the cultural and economic fabric of a particular city. On the one hand, they indicate the lingering interest in regional specificity on the part of industry workers. On the other hand, they testify to the fact that video stores had become such a common, even ubiquitous, feature of the American landscape that their regional specificities could be broadly observed.

BLOCKBUSTED

From the late 1980s through the 1990s, video stores were a primary location of movie culture in America. Video rental was a standard practice, and it largely occurred within the standardized spaces of the corporate rental chains like Blockbuster Video, Hollywood Video, and Movie Gallery. There had been efforts to franchise and standardize video stores from the very beginnings of the industry, but these efforts were intensified and became dominant through the second half of the 1980s. Whereas mom-and-pop figures gained sudden access to the means of distribution from the late 1970s through the 1980s, the period of the late 1980s on was defined by a recentralization of ownership and power in the chain of movie distribution.

Blockbuster, Hollywood Video, and a few other chains dominated the market by the 1990s.[83] Yet this corporate consolidation and spatial standardization could not eradicate the newly democratic, socialized, and individualized movie culture experienced by video shoppers. The hegemony of the corporate video chains was actually predicated on their appeal to customers *as* individuals, who could express their power through movie selection. The chains made the practice of video rental so conventional, so standard, that it became the standard in a wide variety of locales. Although Americans may have held divergent tastes in movies, a huge number of them found that their tastes could be met by the choices offered at a corporate store. Rather than eradicate local movie cultures, these corporate stores enveloped and accommodated them.

The growth of Blockbuster and the other corporate chains altered the place of the video store within American culture in several fundamental ways. First, Blockbuster took a particular approach to the design of the video store space. These stores were big, brightly lit, had wide aisles, and put their videotapes (not just the cover boxes) on the shelves throughout the store. They did not offer adult videos, nor did they rent VCRs or other technologies. Thus Blockbuster differentiated itself from the majority of the independently owned stores that it competed with by providing a large, uncluttered, family-friendly space for the easy perusal of movies. It professionalized the video store space.[84] If the mom-and-pops had already normalized the idea that magnetic tape was a movie delivery device, then Blockbuster crystallized the idea that the video store was a *movie* store.

Second, Blockbuster appealed to Americans' desire for movie choices by offering more titles than other stores. However uniform the space of the video store may have been, these corporate stores treated individual browsers and customers as diverse. Typically, each Blockbuster held around ten thousand tapes available for rent.[85] In fact, franchise participants had to stock at least seven thousand movies as part of the agreement.[86] This surpassed by far the holdings of the average independently owned stores at the time. Whereas video stores had an average of 2,395 videos in 1985, this number increased to 3,600 in 1989, largely because of the growth in Blockbuster superstores.[87] Indeed, the number of stores carrying fewer than 2,000 tapes dropped by 8 percent from 1988 to 1989 while the number of stores carrying 5,000 or more tapes grew by 4 percent.[88] Thus, even if Americans increasingly rented a limited number of hit films, they demonstrated a preference for stores with large selections.

Third, Blockbuster grew at an incredibly rapid pace, necessarily entailing a geographic spread across the country. The company expanded through

franchises, opening new company-owned stores, and buying local stores and chains and transforming them into Blockbusters. Whereas there were only 94 Blockbuster locations in 1987, by 1991 there were over 1,600 stores operating in forty-four states.[89] This rate of expansion held for many years, so that by 2001 there were 5,374 Blockbuster stores in the United States and many more around the world.[90] In this respect, Blockbuster's numerical growth and geographic spread entailed a standardization of the video rental space throughout many parts of the country; just as Blockbusters quickly became ubiquitous, so was the vision for the video rental store they projected. This was a self-conscious endeavor on the part of the company's leaders, who not only likened themselves to McDonalds rhetorically but also hired a former member of McDonalds' upper management. Through the standardization of this large, clean, and professional space for movie shopping, Blockbuster was able to create a uniform video culture that overcame local geographic and cultural particularities. Ron Castell, senior vice president of the company, said in 1991 that he aimed to standardize Blockbuster stores so completely that customers would have the same experience, "whether it's in Las Vegas or Pocatello or Kalamazoo."[91] "We want to be ubiquitous," he added.[92]

Although Blockbuster remained the industry leader throughout the decade, Hollywood Video and Movie Gallery modified the Blockbuster model in interesting ways. Hollywood Video offered a similarly enormous, well-lit, and clean space for browsing but differentiated itself by offering more titles and genres than Blockbuster, averaging between twelve thousand and fourteen thousand tapes per store.[93] Hollywood Video stores typically carried a larger selection of foreign films than Blockbuster, and some locations had a small "Cult Classics" shelf where one could find titles like *Eraserhead* (1977). Hollywood Video thus tried to encompass a wider range of movie tastes than Blockbuster, even if new releases comprised the majority of their income. Alternatively, Movie Gallery distinguished itself by putting stores in "under-served" markets, particularly rural towns with smaller populations.[94] Although Movie Gallery stores typically had fewer titles than Blockbuster or Hollywood, they broadened the reach of the corporate-style video store. They situated "big video" in small-town culture. Further, unlike both Blockbuster and Hollywood, Movie Gallery carried sexually explicit adult movies.[95]

The corporatization of the rental industry occurred amid a process of corporate consolidation within the larger media industry during this period, when hardware manufacturers like Sony and Matsushita bought content distributors like Columbia and Universal. Under Ronald Reagan's fiscal

policies of the 1980s, which either ignored or undermined the limits on corporate consolidation, there appeared to be no end to a cycle of mergers and acquisitions in the media industry.[96] In 1994, Hollywood Video became a publicly traded corporation, and in this same year, Blockbuster was acquired by Viacom, a conglomerate that owned a host of other media-related businesses and companies, including Paramount Pictures and the MTV and Nickelodeon cable networks. Eventually, in 1999, Viacom purchased the CBS Corporation, making their parent company, National Amusements, a vertically and horizontally integrated media conglomerate with vast assets in television and film production, distribution, and theatrical, television, and home video exhibition.

Bolstered by the corporate financing they attained in the mid-1990s, the corporate video rental chains pushed down on the mom-and-pop shops. Yet the mom-and-pops were also squeezed from below by the increasing number of video rental sections at convenience and grocery stores, which offered astoundingly low rental rates. Even as the grocery stores dispersed video rental farther throughout the retail landscape, they also displaced "the video store" by making movies an (inexpensive) addition to already defined retail spaces. Squeezed from both the top and the bottom, the mom-and-pops were greatly diminished in number during the late 1980s and the 1990s.[97] By 1998, Blockbuster accounted for about 30 percent of the entire video rental market.[98] Blockbuster and the other corporate chains served as the "real" video stores, positioning both the remaining independent stores and the hybrid operations as secondary alternatives.

Video store culture had long been dominated by Hollywood films when Blockbuster rose to industrial dominance. As Janet Wasko wrote in 1994, "Despite the claim that home video is revolutionizing America's viewing habits, the most common type of cassette rented or purchased is a movie. A Hollywood movie."[99] The studios' effort to block VCR technologies through litigation in the *Universal v. Sony* case had been decided in favor of the electronics manufacturer in 1984, and all the studios had already opened divisions devoted to distributing their movies on video.[100] Further, the studios standardized the practice of releasing recent theatrical hits through the early 1980s, helping to foster a "New Release" mentality among video store owners and shoppers alike. Hollywood augmented this practice and achieved an even greater presence in the video store in the later part of the 1990s, when the corporate chains intensified their efforts with "copy depth" of the latest Hollywood hits. In this process, video stores would carry a huge number of copies of a limited number of mainstream Hollywood films. This endeavor was made financially possible through revenue-sharing deals

made directly with the studios or through pay-per-transaction video distributors like Rentrak.[101] By the late 1990s, when Blockbuster and Hollywood Video offered select Hollywood hits "guaranteed in stock," the video store operated like a contemporaneous movie theater, with "New Releases" dominating and "opening weekends" driving customers into the store.[102]

The 1990s witnessed the standardization of the video store space in terms of architecture (the large, clean store design of the corporate chains), geography (as the corporate chains became the "norm" in many parts of the country), and taste (with large numbers of Hollywood movies). This alteration in video store culture occurred in the context of an expansion and standardization of retail spaces more broadly in the 1990s. The book world, for example, was overtaken at this time by "superstores" like Borders and Barnes & Noble. Like Blockbuster, these enormous, well-organized stores appealed to customers' desire for options by offering as many as 125,000 different book titles.[103] Somewhat similarly, Hastings Entertainment rebranded its stores as "entertainment centers" in 1991, offering books, music, games, computer software, and videos for sale and rental, under one roof, in mid-size markets in the western United States.[104] The multimedia superstores like these connected the video store to a broader range of leisure commodities and a wider arena of consumer culture more generally. Although they did not engage in video rental, the large big-box discount chains like Target and Wal-Mart and the electronics stores like Circuit City and Best Buy all underwent substantial growth during this decade, offering an abundance of books, magazines, music recordings, and videos for sale, in addition to a wide array of other gadgets and goods.

The Suncoast Motion Picture Company illustrates an alternative trajectory for video retailing in this period, yet one that ultimately succumbed to the same fate as other brick-and-mortar corporate chains. Started in 1986 by Musicland Group, which also ran the Musicland and Sam Goody music retail chains, Suncoast distinguished itself from other video retailers by engaging exclusively in video sell-through and by being located in indoor shopping malls.[105] Featuring neon lighting, abundant television monitors playing movies, and well-organized displays of videos for sale, Suncoast stores were welcomed by shopping mall developers, who appreciated that its stores diversified the shopping options for mall patrons and enlivened the mall space with glitzy design features.[106] Suncoast offered a wide range of movies but primarily sold cheaply priced "catalogue" movies as well as non-Hollywood fare like sports and exercise videos.[107] Its stores also carried niche genres that appealed to fans and collectors, including Japanese animation.

Suncoast's business model depended on a distinct cultural geography for movie shopping. Once the video rental store normalized the notion that there were a plethora of video options available for individual Americans to choose from, a portion of these people became video collectors, much as Andre Blay had originally intended. In addition to those people who recorded movies from broadcast or cable television, a significant number of collectors chose to purchase videos that they held affection for and/or that they expected to watch numerous times. Being located in shopping malls, Suncoast stores made movies part of the same shopping environment that many Americans utilized, flaneur-like, to entertain themselves and to find clothes, cosmetics, athletic shoes, and so on. Further, the malls Suncoast occupied were largely in suburban locations, thus giving people in these areas a variety of video options they might not find at their local rental store. Moreover, Suncoast's placement in malls necessitated that they engage in sell-through rather than rental, as indoor malls are not used in the same casual and habitual manner as strip malls. Shopping malls entail a trip, a planned outing. It seems unlikely that anyone would ever have wanted to go to the mall, find parking, and stroll through the large galleries simply to return a video. Rather, the grandeur of indoor malls suggested that the movies at Suncoast were special items worthy of ownership, and the flashy interior of Suncoast stores simultaneously created a space for Hollywood glamour within these malls.

Initially this model proved successful, and the Suncoast chain expanded from 15 stores in 1988 to 260 stores in 1993.[108] Yet growth stagnated by the mid-1990s, prompting Musicland to open a number of "media superstores" that sold a wide variety of different media products.[109] These endeavors succumbed to the competition from the big discount chains as well as online retailers of videos and other media, however, and Suncoast and Musicland encountered serious financial difficulties at the turn of the millennium. Following a series of corporate acquisitions, which included several years in which Best Buy owned both Musicland and Suncoast, their eventual corporate parent, Trans World Entertainment, began closing most of the stores in the late 2000s.[110] Given that Suncoast sold a considerable amount of older, catalogue films and other niche genres and given that they were located in malls and thus required a special shopping excursion, it makes sense that they quickly fell victim to the plethora of video options offered by online retailers like Amazon.

For a moment, however, Suncoast expanded the geographic range of video shopping at the same time that it obeyed the corporate logic and spatial standardization typical of video rental stores in the 1990s. From a

certain perspective, this historical shift toward corporatization, professionalization, and standardization might signal an end to a lively video store culture, as Blockbuster and the other corporate chains put an end to the experiments with home video retailing.[111] They seemed to perfect them. While it is true that the CEOs of these companies were more concerned with money than movies and while it is true that the corporate stores valorized Hollywood's hit films, this era represents a certain "golden age" of the video store from the perspective of browsers and customers. Blockbuster and the corporate stores appealed to many people by offering choices, appealed to the very notion of choice. They placed movies into wide, easily browse-able aisles in large spaces. In this respect, Blockbuster, Movie Gallery, and Hollywood appealed to an individualistic but pseudodemocratic impulse on the part of browsers. As the apparently neutral space of the corporate store promised to treat everyone as an equal, it allowed individuals (or couples or families) to quickly and easily find what *they* wanted, to express their taste in cultural goods.

The era of the corporate video store is also the era in which video rental practices were most normalized among everyday Americans. A report from the VSDA situated video rental centrally within Americans' leisure world, stating that "100 million people . . . rented a video at least once [in 1996]. That's more people than bought or rented a CD-ROM, visited an amusement park, or attended a concert, live sporting event or the theater."[112] At the end of the decade, there were over 18,000 video stores.[113] Of these, Blockbuster had over 5,000 stores, Hollywood had 1,800, and Movie Gallery 1,300.[114] In addition to all these independent operations and corporate stores, well over 8,000 grocery stores provided cheaply priced video rentals. Video rental was, in every sense, a common practice in the 1990s.

A DIGITAL DIVIDE

The advent and adoption of the digital versatile disc (DVD), also known as the digital video disc, for watching movies in the late 1990s had an enormous impact on the media industry as a whole but created volatility in the rental industry.[115] Appearing as a digital file embedded on a small, plastic disc, the movie on DVD had material properties that helped expand and fracture the market for video commodities but ultimately hurt the brick-and-mortar video rental business. Specifically, the relative cheapness of DVDs (to produce and, consequently, to purchase) and their diminutive size allowed for new patterns in the distribution and retailing of movies on video. While these same qualities made DVDs conducive to the established

video rental business in several respects, they also enabled a number of competing businesses and business models to flourish, specifically, the sell-through market at big-box stores and the rent-by-mail system of Netflix.

Numerous disc-based media platforms for movie viewing had appeared since the 1970s, yet they largely failed as commercial endeavors; even the marginally successful laser disc format was relegated to a small market of devoted collectors and educational institutions. After years of technological innovation and after technical and regulatory standards were set, consumer DVD players entered the American market in spring 1997.[116] Paul McDonald, among others, has pointed out that the Hollywood studios' initial response to DVD was not entirely positive, but they supported it wholeheartedly once the economic viability of the format became apparent.[117] Although there were only one million DVD players in American homes at the end of 1998, more than 24 million households had a DVD player by 2001.[118] In addition, DVDs created new levels of profit, as they were significantly cheaper to produce than VHS and thereby offered a greater marginal return for each unit. This allowed the studios to price DVDs between $20 and $30, which made them viable for a sell-through market in addition to or even in lieu of the rental market. Indeed, Barbara Klinger has described how DVD was largely adopted as a sell-through commodity, serving individual collectors who built media "libraries" of their own.[119] Although DVDs were advertised to consumers as offering better picture and sound quality than VHS, as well as "bonus features," it was ultimately the comparatively low price of DVDs that affected the way in which they were integrated into the American media landscape.[120]

DVDs turned out to be an economic boon for the studios because they expanded the sell-through market for videos and thus gave studios a greater share in overall revenue gathered from the home video market. Of course, the Hollywood studios had successfully experimented with creating a sell-through market for VHS previously.[121] After Paramount found enormous success by offering *Raiders of the Lost Ark* (1981) and *Star Trek II: The Wrath of Khan* (1982) at lower than standard prices, by the mid-1980s, they and the other studios had developed a "two-tiered" pricing system for all home video releases.[122] Whereas many titles would be released at $70 or more and intended for the rental market, certain videos would be released at between $20 and $30, aimed at individual consumers.[123] In addition to certain theatrical hits, many of these sell-through tapes were kids' fare and other genres susceptible to repeat viewings.[124] Although the studios intensified these efforts in the mid-1990s by pricing certain tapes as low as $12, they still generated more revenue from rental than sell-through sales for

most of the decade. This ratio changed in the millennium, hastened by the adoption of DVD. In 1996, Americans spent $8.7 billion on renting videos and $7.5 billion on purchasing videos.[125] As of 2001, the overall market for home video was $18.7 billion, and rental revenue constituted only $8.4 billion of this amount.[126] The sell-through market in 2001 was the biggest to date, and DVD generated $5.4 billion of this revenue, outpacing VHS sales for the first time.[127]

This shift in video consumption habits also entailed a shift in video shopping habits. "The video store" was no longer located just in America's many rental shops but was now diffused throughout the retail landscape, greatly increasing the geographic convenience of movie shopping. Most notably, the big-box electronics stores like Circuit City and Best Buy and the discount chains like Wal-Mart, K-Mart, and Target became the primary venue for video commodities.[128] In 1997, at the same time that they supported the DivX disc-based format for movie viewing, which was ultimately unsuccessful, Circuit City began promoting and selling DVD players.[129] Quickly thereafter, both Circuit City and Best Buy began selling movies on DVD alongside their wide selection of electronic devices. By mid-1998, merely a year after the introduction of DVD players, Best Buy had sold over one million movies on DVD.[130]

In that same year Best Buy expanded the amount of floor space devoted to DVDs and carried as many as fifteen hundred different movie titles; the electronics chain sold more DVDs that any other retailer in 1999 and 2000, accounting for about 20 percent of all DVDs sold in the United States.[131] Similarly, Wal-Mart redesigned the electronics sections in many of its stores to make room for large, attractive displays of DVDs leading up to the holiday season of 2001.[132] Here, one could shop for movies much in the way one could at a Blockbuster or Hollywood Video, only now surrounded by stereos, clothing, and groceries, and with ownership rather than rental as the outcome. Further, Wal-Mart primarily carried a limited selection of mainstream Hollywood hit films and refused to carry NC-17 titles or anything that wasn't "family friendly," much like Blockbuster had done more than a decade earlier.[133] As of 2001, Wal-Mart generated over $3 billion in video sales, and Target generated nearly $1 billion.[134] In this same year, Wal-Mart sold more DVDs than any other retailer in the country, beating out Best Buy for the first time.[135] Simply in terms of revenue, Wal-Mart became the biggest "movie theater" in the United States. Although some cinephiles collected and fetishized movies on DVD for their high visual quality and bonus features, most DVDs were collected by Wal-Mart shoppers looking for inexpensively priced mainstream films.[136]

A 1997 VSDA report was optimistic about DVD as a rental format, say-
ing, "The rental habit is deeply ingrained in American consumers, and that
habit is unlikely to go away completely simply because movies are recorded
on discs rather than cassettes."[137] Yet rental stores struggled to adjust to
DVD technology and the increasing importance of the sell-through market.
The small size and cheap price of a DVD were somewhat beneficial to rental
stores, as they could now hold more items on each shelf and afford to buy
more copies of individual titles. Further, they could recoup the cost of the
disc much faster than a high-priced VHS tape. Yet the shift in platform also
meant that stores had to restock themselves, duplicating the titles they held
on VHS and buying both a VHS and a DVD copy of new releases. Many
independently owned video stores closed for business during the late 1990s,
as they did not have the financing necessary to engage in such a massive
overhaul of their stock. The corporate rental chains, however, did not face
this dilemma and quickly integrated DVDs onto their shelves. Hollywood
Video entered the market first, making DVDs available for rent in all four-
teen hundred of its stores in 1998.[138] By the Christmas season of 2000,
Blockbuster had fully committed to renting DVDs and even featured DVD
rentals prominently in advertisements.[139] A year later, the company began
reducing the number of VHS tapes it carried in stores to make more room
for DVDs.[140] Movie Gallery integrated DVD more gradually, as the custom-
ers they served in smaller towns were slower to switch from VHS; neverthe-
less, the company made more revenue in DVD than VHS by 2003.[141]

By the mid-2000s, all the major rental chains were in narrow straits
because of the increasingly fractured and dispersed home video market.
Both Movie Gallery and Blockbuster tried to compete with Wal-Mart and
Target by devoting larger areas in their stores to DVD sell-through in
2002.[142] In this same year, however, Blockbuster announced that its profits
had been much lower than expected.[143] Hollywood Video diversified its
operations by opening thousands of "Game Crazy" stores-within-stores,
which sold and rented video games, in the early 2000s.[144] Yet the company
incurred losses with this endeavor, which were compounded by the weak-
ening rental market, so that in 2004 it also reported lowered profits.[145] With
the entire home video market thus in flux, Blockbuster and Movie Gallery
each vied to buy out Hollywood Video in the middle of the decade; Movie
Gallery succeeded in executing this takeover in 2005.[146] Yet this continued
corporate consolidation of the video rental market, a process that had been
ongoing since the mid-1980s, contrasted with the *decentralization* of video
shopping that accompanied the rollout of DVDs. Video rental stores of all
types—corporate, independent, and even those that were part of grocery

stores and other hybrid operations—were now significantly displaced by the myriad other locations where one could shop for videos for purchase, from the big-box stores to 7–11s. If the video store had normalized the idea that Americans could shop for movies as material commodities in retail spaces and if the corporate stores had standardized this activity, then they also anticipated and facilitated the apparent media abundance and ubiquity of video shopping Americans encountered in so many other places in the 2000s. The video store appeared to be everywhere, making video rental stores appear strangely anachronistic in their way of doing business.

LONG TAIL

The video rental industry was not only fractured and marginalized by the intensification of the sell-through market in retail stores, but also at least as much by the "long tail" retailers of video commodities on the Internet. First published in the popular technology magazine *Wire* in 2006, Chris Anderson's article "The Long Tail" examines retailers that sell material and digital commodities from the Internet, such as Amazon, and companies that exist solely on the Internet and sell digital files, such as iTunes.[147] By the mid-2000s, the long tail that Anderson discusses had been in operation for some years; Amazon started selling books in 1995 and music recordings and videos in 1998.[148] Yet Anderson's celebratory tone speaks to the zeal many felt about online retailing in the mid-2000s. While companies like Amazon, Apple, Rhapsody, and others found new economic efficiencies by offering shopping experiences online rather than in brick-and-mortar locations, they also promised greater access to a wider range of media products than everyday shoppers had before. Indeed, Anderson's chief observation about the long tail of media is that American shoppers were actually buying obscure books, music, and movies. Among other things, his article is a celebration of American diversity in taste.

In suggesting that individual tastes in movies could be met through the abundant choices they made available, long tail retailers extended the logic of the large video stores of the 1980s and 1990s. By positioning Americans as shoppers of diverse media commodities, long tail media retailers appealed to people's sense of individualism and entitlement. When Amazon first began selling videos online, it offered more than 60,000 different titles, and by 2000, it had more than 100,000 different movies for sale.[149] American shoppers responded quickly and enthusiastically, so that in 1999 Amazon accounted for over 50 percent of all online video sales—which still took material form at the time.[150] Nevertheless, most revenue generated by long

tail retailers comes from book, music, and movie "hits" rather than obscure titles.[151] Although long-tailers may appeal to people as idiosyncratic and highly individualized in their tastes, the majority of shoppers may not have such distinctive tastes.

In addition to their breadth of selection, long tail retailers extended the spatial and geographic reach of movie shopping. Anderson notes that the reason these companies could offer so many different products is that they did not have to house them in the same place they displayed them; no bookstore could hold all of Amazon's books, and a video store would be hard-pressed to contain all its movies.[152] Just as important, long-tailers turned to the Internet as the "space" where shopping occurred, making any American with an Internet connection capable of shopping wherever he or she lived. The showroom was in the living room, the bedroom, the den, wherever. Although shopping had occurred in domestic spaces for over a hundred years, with printed catalogues, mail-order retailers, and shopping channels on television, Internet-based retailing gained acceptance about as quickly as the Internet itself. Cultural commodities, such as books, music, and videos, were particularly susceptible to this shift, given that their material properties made them durable and easily portable.

Netflix stands as the most important game changer in the long-tailing of movies, particularly as they integrated online shopping with a broad selection and capitalized on the portability of DVDs. Founded in 1997, the company initially sold and rented movies through its website, which were delivered and returned through the U.S. Postal Service. Customers found it difficult to return videos "on time" through the mail and would regularly accrue late fees as a result. Thus in 1999, Netflix introduced the "subscription" model for rentals, whereby customers would pay a monthly fee and be able to keep discs as long as they pleased; different pricing plans allowed customers to keep a different number of movies out at a time.[153] This generated an industry-wide rhetoric about "no late fees," which was quite heated and pitted Netflix quite directly against brick-and-mortar rental stores. Blockbuster experimented with subscription services as well as rent-by-mail options.[154] Doing so, however, highlighted the fact that Netflix did not just offer a new breadth of movie options but also surpassed the geographic barriers of public shopping. The late fee was always an economic manifestation of the geography of video rental, as it was the price one paid for not going back to the public space of the store "on time." In extending the process of video shopping into the home, Netflix also had to overcome the temporality of delayed distribution; whereas video store customers were once the agents of their own media distribution, now the local mail-

FIGURE 4. Internet users can browse the Netflix interface much in the way they once browsed video rental stores.

man was a movie distributor, one who obeyed a regular but inalterable schedule. The subscription pricing model allowed Netflix to overcome the geographic boundaries of the rental process.

Customers shopped for these discs through the company's website, which listed all the available titles and allowed customers to put their selections into a "queue." This queue ranked the order in which customers wanted discs delivered and indicated how long a delay customers might expect in getting them. The website facilitated a type of "browsing" analogous to that done in a video store. Instead of a shelf or an aisle full of titles, now the computer browser surveyed a two-dimensional screen with thumbnail pictures representing the videos (figure 4). The website made the movies searchable according to a number of different criteria, such as title, director, performer, or genre. In this respect, the Netflix website provided a two-dimensional representation of a vast virtual space that contained all the information shoppers might need to make their selections. Navigating this space could be somewhat tricky, given the breadth of the options. Whereas Netflix had 14,500 titles available in 2002, by 2005 it had over 55,000 and in 2009 over 100,000.[155] To mitigate the chaos of this selection, Netflix personalized the movie shopping experience by allowing users to rate films on a five-star scale, and the company used a specialized patented software to use these ratings, as well as viewing history, to make recommendations of other movies to watch. In this respect, Netflix not only virtualized the space of movie shopping but also desocialized the mechanism for movie recommendations, individualizing this process even more.

Amid his celebration of long-tailers, Chris Anderson writes that Netflix "has, in short, broken the tyranny of physical space."[156] But he does not simply mean the physical space needed to house the commodities for sale or rental. "What matters is not where customers are, or even how many of them are seeking a particular title," he writes, "but only that some number of them exist, anywhere."[157] Here Anderson unwittingly indicates how Netflix more truly emulates and intensifies the transformation of movie culture initiated by the video rental store. It combined the domestic consumption of movies with the domestic *shopping* of movies. By broadening the points of access where Americans could engage in personalized movie shopping and by broadening the range of video titles available, Netflix dispersed and particularized movie culture much more than the video store ever did or could. Netflix amplified this process when it introduced Internet streaming services in 2007, which allowed participating customers to watch movies on their computers. In 2009, Netflix was also commonly embedded in Internet-connected TV sets, game consoles, and DVD players.[158] Like "on demand" services provided by cable companies, Netflix streaming allowed people to shop for and consume movies directly through their Internet-connected televisions. Similarly, Amazon.com began a VOD service in 2006, and iTunes began selling and "renting" movies as digital downloads through its interface in 2008.[159] Completely bypassing the need for public shopping and the material video commodity, these on-demand and streaming services initiated an era of intangible shopping for intangible media.

Much of the celebration of Internet and cable delivery for media texts entails a celebration of American consumers' ability to overcome the boundaries of material space. The fact that Netflix, iTunes, and similar companies are now available through portable Internet-connected devices like smart phones and digital tablets compounds this, making media shopping and consumption possible, ideally, anywhere one has such a device and an Internet connection. Anderson's article suggests that online retailing obliterates the need for physical stores and reaches across all space to every American; it envisions a world where everything is available and shopping is everywhere. The truth is more complex, of course. Many Americans do not have access to broadband Internet or cannot afford cable or an iPad. Moreover, the material infrastructure and labor needed to support this supposedly intangible media is quite elaborate. Consumers still interact, physically and materially, with the computers and other display devices through which they shop for and access movies. What is lost is the sense that the media themselves are material. Further, Netflix and Amazon have distribu-

tion centers throughout the country. Indeed, many who subscribed to Netflix in the early 2000s will recall waiting days for a movie to arrive in their mailboxes; this problem was particularly intense for popular films. Consequently, Netflix had to expand its number of distribution centers rapidly throughout the decade, so that in 2013 it has hundreds of such locations and customers regularly get their movies within a day of ordering. Nevertheless, this indicates how the apparent ubiquity of digital media relies on a tangible infrastructure of distribution.

In fact, the present moment of intangible media entails a hodge-podge of material objects, technologies, platforms, and spaces that consumers engage according to their divergent desires and competencies, as well as their particular social, geographic, and economic situations. A survey of video consumers illustrates the range of forms and possibilities for video access in 2010:[160]

Rent a physical copy (like a DVD) by mail, via a subscription service like Netflix 42.6%

Rent online via a subscription service like Netflix streaming service 31.7%

Streamed from a non-subscription-based Internet website (e.g., Hulu, abc.com) for free 30.7%

Rent a physical copy (like a DVD) from a kiosk (like Redbox) 29.2%

Rent a physical copy (like a DVD) from a store (like Blockbuster) 23.3%

Borrow a physical copy (like a DVD) from a friend or relative 19.8%

Purchase a physical copy, like a DVD 19.8%

Via free download from an Internet site 19.3%

Purchase via video on demand from your TV provider (e.g., your cable company) 12.9%

Paid a fee to stream from an Internet website 9.4%

Purchase via download from an Internet website 6.9%

Purchase a physical copy (DVD) that comes with a digital code to download into your digital library 5.4%

None of these ways in which Americans access videos necessarily cancels out another; for many years Netflix users still went to video rental stores, and cable subscribers regularly stream movies through iTunes or Amazon.com. Some people still buy DVDs at Wal-Mart, yet they might also rent a DVD at the Redbox kiosk in front of the store.

Of all these options, Redbox perhaps best embodies the strange admixture of materiality and digital technologies in the contemporary geography of video.[161] As of 2013, Redbox has over 42,000 video rental vending machines operating in more than 34,000 locations, typically in front of grocery stores, pharmacies, and other highly trafficked retail structures.[162] This is more kiosks and locations than there ever were video specialty stores, which peaked in the late 1980s at about 30,000. One can rent a limited selection of DVDs, Blu-Ray discs, and video games directly from these kiosks, or one can shop for movies through the company's website, which allows customers to reserve a particular title before they arrive. Thus the company continues to align video rental with habitual, public retail activities and, further, continues the practice of renting movies as material commodities. Yet it expands this geography by facilitating virtual shopping in addition to place-based shopping, even while it delimits the geography of taste by offering just two hundred different titles in each kiosk. In 2012, Redbox partnered with the cell phone company Verizon to provide video streaming services as well. Here we see a single company attempt to navigate and reshape the strange, highly differentiated geography of contemporary movie culture by engaging in both place-based and virtualized shopping and consumption.

CONCLUSION

Contemporary movie audiences are as fragmented by their choices in video technologies and delivery platforms as they are by the specific movies and genres they consume. Before this moment, the video rental store helped to disperse, localize, and particularize movie consumption in the United States. The current options in the means and methods of movie access expand and intensify this process, further fragmenting and particularizing the American geography of media taste. They do this so intensely and extensively, in fact, that they have largely displaced the video rental store as a component of the movie distribution system. Of course, the current decline in the brick-and-mortar video store business has its precedents; the widespread closure of independently owned stores in the late 1980s and late 1990s attests to this, as do the various doubts voiced during the 1990s and 2000s that Blockbuster Video could sustain its growth and business model.[163] Yet there is no doubting that video stores closed more rapidly and in greater numbers during the Great Recession than ever before. Some people still use video stores, to be sure, but most do not. And while the video store altered the geography of movie culture in America during the 1980s and 1990s in ways that we con-

tinue to experience today in mutated form, the disappearance of these locations necessarily entails a reduction in the behaviors and interactions they facilitated. The following chapter examines the video rental store as a dynamic site of interaction. If the video store trained us to be shoppers of movies and to suit our desires through individual choice, then it did so through particular architectural and social arrangements that engendered particular material and spatial practices. Any historical understanding of the video store's effect on movie culture necessarily requires a social and spatial account of these places.

2. Practical Classifications

There are many ways one might answer the question, What is a video store? As in chapter 1, one might use trade materials and other print sources to formulate a history of the video rental industry. Yet video stores are cultural institutions as much as they are profit-driven businesses. Once movies were transformed from theatrical experiences into material commodities, people organized them in ways that created social roles, power relations, and understandings that were new to movie culture and specific to this historical juncture. The video rental industry has encouraged people to approach movies as commodities to be assessed and evaluated in public and in advance of private consumption; people shop for movies. Vitally, video stores position themselves as the site for this activity. They are material spaces as well as social spaces where certain behaviors take place.

Accordingly, this chapter argues that "the video store" is best understood as a set of spatial and material practices. Video stores are interactional spaces where people interrelate either directly with one another or through material mediation, through the architecture of the store and the commodities within it. In this respect, this chapter answers the question, What is a video store?, through an analysis of the cultural geography of video rental. By "cultural geography," I mean the physical arrangement of these places as well as the forms of interaction that occur within them. Further, these material and social spaces interact with an interior, emotional space.[1] Understanding the complex intersection of these material, social, and interior spaces is vital to understanding the video store more generally. Mapping the cultural geography of video rental stores in this manner accounts for the experiential, rather than purely industrial, aspects of the phenomenon. It uncovers how video stores are produced through social dynamics. It reveals how video stores generate certain kinds of knowledge

about media and about media producers and consumers. Although emphasizing the spatial and social aspects of video stores may appear to set aside questions of their chronological development, this approach has historical significance. Studying the entanglement of physical space and social behaviors shows how "space," in a larger sense, is produced through human activity. If the video store facilitated new forms of interaction around commodities and other people, then it is worthwhile to note these interactions in their specificity. Many of these behaviors and practices seem as plain as day and commonsensical; part of the power and historical specificity of the video store was that it made movie culture more prosaic and routine. Thus my analysis examines this site of movie culture precisely as mundane. As many of the behaviors and interactions within the video store were unremarkable and ephemeral, my aim in this chapter is to recover as much as uncover these vital but unrecorded phenomena.[2]

Joshua Greenberg has drawn from interviews and trade publications to provide a robust analysis of various spatial and social aspects of video rental stores from their emergence to the 1990s.[3] Yet Greenberg's methodology does not allow for a full analysis of the ways in which space, taste, and power interrelate within the video store and consequently influence movie culture. This chapter examines these issues. Beginning with video stores' architecture and internal composition, I investigate how spatial arrangements suggest meanings about movies and facilitate certain kinds of social interactions. Although industry discourses typically define video stores in terms of their ownership, as either corporate or independent, I argue that it is most appropriate to classify stores by the methods that they use to classify the movies on their shelves; this is how people actually engaged with these places. In this, we find three divisions: corporate, corporate-model independent, and specialty stores. Whereas corporate and corporate-model independent stores prioritize a temporal use of their spaces, specialty stores promote refined notions of film artistry.[4] Intertwined with this architectural study is an analysis of the social roles typical of video stores, specifically, browsers and clerks. Browsers are those figures who stroll through the aisles and contemplate the choices before them. Clerks, meanwhile, guide browsers through the shelves and aisles. As clerks help browsers find a movie, cultural tastes become defined through the social interaction between salesperson and shopper.

APPROACHING THE STORE

Video rental stores obey a flexible, "modular" architectural logic that has been endemic to general social and economic conditions in the United

States since the 1960s. This modularity is a manifestation of video stores' alignment with the geographic flexibility and customization typical of contemporary consumer culture. Video stores are modular in the first instance because, from their early days to their contemporary incarnations, they have occupied buildings and structures that could be used for a wide variety of purposes. As Greenberg has noted, videos were integrated into all manner of businesses during the beginnings of the video rental industry.[5] There is no essential building construction that makes something a "video store" rather than, say, a record shop, a book shop, or some other space. For the most part they have appeared in strip malls, alongside and similar to all manner of retail operations. The corporate stores, such as Blockbuster and Hollywood Video, were larger than most independent stores, commonly around 10,000 square feet.[6] Nevertheless, even these spaces were unremarkable, large glassy boxes.[7] Because their overall structure is inconsequential, video stores have been able to exist within and alongside other businesses. In the present moment, also, this means that once a video store has gone out of business, the structure is available for other sorts of activity.

As modular retail spaces, video stores distinguish themselves from other businesses through their signs. Yet just as video stores made movie culture more spatially flexible, video store signs are also highly variable, ranging from neon, "professional"-looking signs to hand-painted ones. Some signs mimic theatrical marquees; others simply try to convey excitement in their use of bold colors, fonts, and lighting. Many other items typically attend the store's front. There are frequently posters for movies. At a number of independently owned stores, there are hand-painted murals or other modifications that relate to movie culture. It is typical to find community bulletin boards or fliers posted near the entrance to independently owned stores (figure 5). One finds lost-and-found posters for animals, advertisements for upcoming cultural events, classified advertisements, and the like. Thus the exterior of many video stores presents an admixture of the official movie industry with indications of community activities that have little to do with movies. Their outward appearance illustrates the way they bring movie culture into the commonplace realm of the local landscape.

The outward appearance of video stores is also marked by the fact that they make movies available for rent. Like all movies, the movie on video is an experiential good, one that cannot be evaluated until it is consumed.[8] Unlike theatrical movies, however, the video takes an objective form, the tape or DVD, which makes the movie portable in both time and space. Thus video stores must coordinate a complex flow of goods across time and space, and they have material features that testify to this process. Like any retail

FIGURE 5. Video stores regularly have bulletin boards where one can find advertisements for local goods, services, and events. (Three Forks Video Shop, Three Forks, MT.)

business, video stores display their hours of operation. Unlike a movie theater, which displays the fixed show times for individual films, the video store accommodates flexible shopping patterns that coordinate with the varied patterns of consumption that home video makes possible. Video stores typically open later than many other kinds of businesses and usually stay open later. Weekend evenings are particularly busy, and stores commonly stay open latest on Friday and Saturday nights, when people schedule movie nights at home. Tuesdays can also be exceptionally busy, as those are the days that new movies have traditionally been released on home video. Although prompted by the hours in which patrons are most likely to shop for videos, this temporality also dictates the kind of people who might work there: hourly wage shift workers with reasonably flexible schedules.

Because video stores are defined primarily by renting rather than selling movies, the discs and tapes must return to the store. They circulate through time and space, radiating out from the store and getting pulled back as if by the force of gravity. But this circulation creates a potential conflict. Customers have the freedom to watch the tape whenever they choose, but

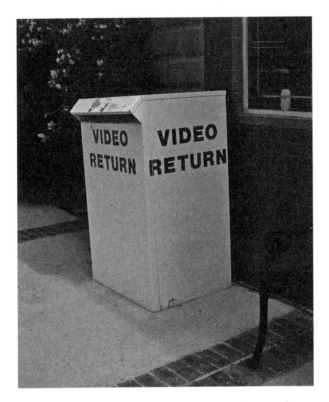

FIGURE 6. Video drop-boxes indicate how videos circulate through time and space, even beyond the operating hours of the store. (G&L Video, Gordon, GA.)

they might wish to return the tape at a time when the store is closed. Hence the drop box. There are a wide variety of drop boxes used at video stores (figure 6). There are self-contained metal boxes placed within a few yards of the store entrance. Other stores have drop slots, which are either part of the front door itself or in a nearby window or wall. These drop boxes and slots indicate how video rental connects the retail space to the domestic space; they show that consumption does not happen on-site and, further, that it does not necessarily happen in relation to the video store's hours of operation. Video stores facilitate a multistage process, involving rental, viewing, and return, and the video drop box is a physical manifestation of the possible discrepancies in these phases. There are many reasons why one might need or want to return a movie when the store is closed, both practical and emotional. Perhaps you are driving by the store on your way to work before they open, or after an evening out when the store is closed.

Perhaps your movie is overdue and you feel too embarrassed to face the clerk. Perhaps you don't want the clerk to ask you about paying your late fees. The video drop box facilitates the circulation of the commodity beyond the limits of the store's hours and with no need for direct interaction. Indeed, these fixtures offer material proof of the sociality of the video store, even when that sociality is not direct or face-to-face.

ARCHITECTURES OF CLASSIFICATION

The advent of the video store gave Americans a new level of access to an abundance of movie viewing options. Although the individual renter had control over the consumption of a specific movie, it was the video store that had to contend with the vast number of movies that were put on a video format. Video stores had to hold all these objects and simultaneously make them accessible as movies. This meant video stores dealt with movies in a profoundly material and spatialized way. And indeed, one of the clearest ways that video rental stores have altered the way we conceive of and interact around movies is through the spatial arrangement of video commodities within them. As the primary goal of the video store is to extract money from customers, store organization is primarily determined by profit motive. Thus we have the rationalized partitioning of these stores into aisles of shelves, an apparently neutral demarcation facilitating customer evaluation and decision making.[9] The floor plan for a video store in Brooklyn, shown in figure 7, indicates the second way in which video stores obey a customizable, modular architectural logic. Just as any structure could potentially house a video rental business, the internal structure of the video store is likewise malleable and adjustable.[10] Here the space is divided into areas with specific kinds of videos for rent and sale. But if we take away the labels of the specific genres of films, this becomes a site for almost any retail transaction. Video stores are no more or less special than any retail space. They differ only in that they hold movies.

Since the early days of video stores, there has been concern with how to arrange the videos. In some cases, owners built their own shelves. There also have been a plethora of companies specializing in selling shelves for video rental stores. These companies regularly advertised their products as customizable. One advertisement that appeared in the January 1987 issue of *Video Store* emphasizes "total merchandising flexibility" and tells the reader not to "allow existing walls to restrict you."[11] This indicates the high variability of store spaces that they sought to cater to as well as the desire for individualization by the rental store owners. In order to contend with the architectural particularities of their buildings, store owners adjusted the internal layouts.

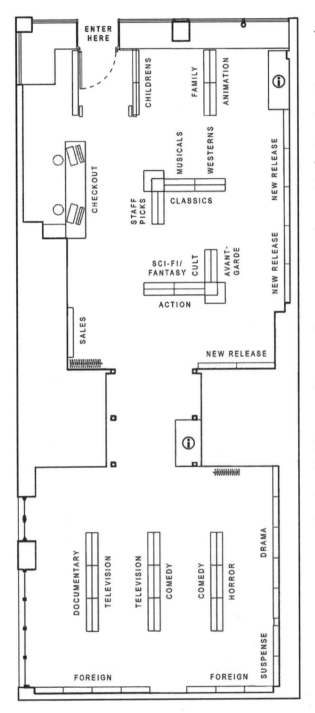

FIGURE 7. Video stores are internally adjustable, like many other types of contemporary retail spaces. Map by James Leet. Courtesy of Videology, Brooklyn, NY.

FIGURE 8. Video stores both store and display videos, making them similar to archives and museums.

Even with this modularity, video stores had to deal with the specificity of the video commodity. Another ad from the same issue of *Video Store* gives a pointed indication of the multiple logics simultaneously at work in video arrangement. This ad promises a shelving system that "solves all your storage/display problems" (figure 8). This statement takes what could be two distinct problems, storage and display, and combines them. Video stores store; they hold things. But in storing videos in particular, the video store aligns with the archive, particularly the film archive. This has been part of their appeal. As an archive that aims for maximum use, the video store is arranged to make its holdings accessible and appealing. This is done through display. In order to gain the attention of potential customers, the video archive also functions as a gallery, where the objects can be evaluated before they are taken from the premises.[12] While some stores place actual videos on the sales floor, others merely display the boxes that hold videos; in either case, video stores typically display the cover art for each movie. As a surface, then, the shelves and aisles function as both an *archive* and *museum of advertisements*.

Because any structure or commercial building can function as a video store, internal organization appears to matter most. To the extent that they hold movies, commodities with overt cultural significance, video stores are analogous to bookstores, record shops, or libraries with "open stacks."[13] Unlike a bookstore or a library, however, the commodities in the video store cannot be sampled on site. As Greenberg has stated regarding early video stores' displays, "The boxes, usually featuring still images as well as a short

description of the movie or other content, served as placeholders—signifiers referring not to a specific cassette, but to the idealized text encoded therein."[14] The video boxes serve as advertisements for future cinematic experiences, which one must *qualitatively* assess in advance. However rational they may seem, the shelves and the aisles in a video store necessarily, if implicitly, make claims regarding the aesthetic value of their wares.[15] Indeed, the advertising function of these covers seeks to create a sense of value that might not ever be found in the film, either because the cover misrepresents it or because it elicits a desire that is never satisfied.

Video stores suggest aesthetic judgment most directly through the categorization of movies within them. Traditionally movies are sorted according to some similarity drawn among the different titles; the exceptions to this are stores that are organized strictly according to alphabetical order. In grouping videos according to a principle of similarity, video stores resemble grocery stores or clothing stores; just as it would make little sense to place oranges next to toilet paper, it seems not to make much sense to place *The Philadelphia Story* (1940) next to *Predator* (1987). The similarities among different movies can be based on a number of criteria. Aisles and shelves can be arranged according to a generic distinction ("Adventure," "Documentary"), a theme ("Holiday Movies," "Religious Movies"), an era ("Classics," "Silent Films"), technological differences ("VHS," "Blu-Ray," "Television Shows"), a production-oriented, pseudoindustrial marker ("Independent"), or an individual associated with the movie ("Directors," "Actors").

In all these variations, video stores exhibit an *architecture of classification*.[16] These aisles and shelves are material, spatial manifestations of ideas about how movies should be organized and thus conceptualized and understood.[17] Spatial divisions suggest conceptual divisions. Size can suggest importance. The number of titles on a shelf can convey importance too, along with a level of consistency. Arrangements suggest associations. Vitally, in the areas that offer thematic and generic divisions, video stores give material, spatial form to otherwise aesthetic principles and thereby take what might have been understood as a quality of the object itself and externalized it, making it a fact before the fact. Video store aisles and shelves do not just organize movies, then, but also make claims about the qualities of their wares. Although not exactly ranked hierarchically, video shelves show discrimination and therefore suggest evaluation.

In making these different systems of classifications, video stores participate in a larger process whereby movies accrue social value and, in turn, distinguish their own cultural position. Although it is commonplace to oppose "corporate" and "mom and pop" or "independent" video stores, such divisions do not

account for the ways in which video stores have actually been used. Rather than categorize video stores strictly according to their histories, their ownership, or their location (although all these factors certainly do differentiate many stores from one another), it seems most accurate to provide a *practical classification* of video stores, based on the way in which they themselves categorize their product.[18] Dividing them in this way helps illustrate the experiential ways that people engage with different types of stores. Not only does it draw linkages that might not otherwise appear among seemingly different video stores; it also facilitates an understanding of the ideological framing of movies and people within the space of the stores. From this perspective, there appear to have been three types of video stores in the recent past: corporate chain stores like Blockbuster and Hollywood Video, corporate-model independent stores, and specialty or boutique stores.[19]

Although the major corporate chains held more video titles than the average independently owned store and thereby appealed to Americans' desire for viewing options to suit their particular tastes, internally these stores organized movies into broad categories and thereby fostered a sense of generality among the individual movies and, ultimately, shoppers' movie tastes and desires. At Blockbuster or Hollywood Video, the largest section of the store is "New Releases," which typically occupies much of the outer walls (figure 9). This allows such stores to display multiple copies of the same hit titles, to connect these movies to the advertisement posters that line the walls, and to entice customers to stroll through the entire floor space, or at least most of it. On these walls, we find titles arranged in alphabetical order, flowing across the store with no differentiation among genres, stars, or directors. Since the late 1990s especially, one could typically find an abundance of the most contemporary hit Hollywood films, films that did well at the theatrical box office and that have recently been released on video;[20] occasionally, one will find a handful of offbeat, independent, or straight-to-video titles here as well. After a few weeks have passed, there are typically fewer videos of each title, as they have been either sent back to the distributor or sold to customers. With this emphasis on new releases, corporate chains foster a "newer is better" mentality that eschews formal criteria as a means of categorizing movies; they foster a logic of timeliness rather than of aesthetic quality. The presumption is that their customers are there for the latest thing, irrespective of genre. Novelty is the primary criteria of judgment in a sphere almost entirely determined by the temporality of the market. If, on the one hand, customers wish to browse, they can wander past many titles and survey the latest the movie industry has to offer. If, on the other hand, customers already know what they want, then the alphabetical arrangement of the titles will get them quickly to their

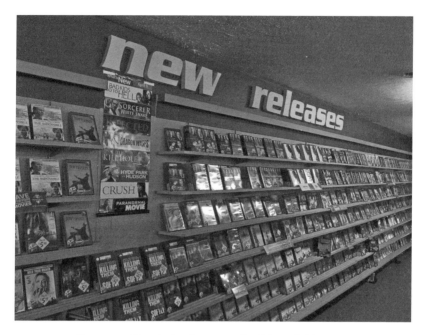

FIGURE 9. Corporate video chains devote much of their shelf space to new releases, promoting speed and novelty rather than artistic distinction.

choice. Further, in displaying multiple copies of the same hit films on New Release walls, corporate video stores suggest that uniformity and familiarity are what the browser seeks. Faced with a literal wall of like titles, the browser confronts a spatialization of the culture industry's "constant reproduction of the same thing."[21]

Beyond the extensive New Releases section, everything becomes an "old movie," no matter what year the film was released. The corporate store organizes these titles quite broadly. There are qualitative categories like "Comedy," "Horror," "Drama," and "Action," and these aisles and shelves are typically placed in the middle of the space.[22] Generic hybrids often get corralled into whatever genre they appear most aligned with. Although these categories signal a formal connection among the films, they implicitly indicate a vague sense of how one might feel while watching the film. "Comedy" equals laughs, "Drama" equals catharsis, "Action" equals excitement, and so on. This labeling transforms the industry-generated generic classifications into a user-based system. It aims for emotional generality as a means to generate economic efficiency, creating an architecture of emotional efficiency. For all that corporate stores' generic arrangements may overlook

important distinctions among individual films, they simultaneously encourage the browser to approach these films for their intended effect. But due to the broad generalizations under which these effects are labeled, these stores suggest that browsers have a limited palette of emotions and desires.

There are also sections that cater to specific demographics. This includes the "Kids" or "Family" sections, where content is diverse but universally aimed at child viewers. However, even these sections are so broad-based as to efface formal particularities of the films, leaving a wide range of titles unaccounted for. And so in corporate stores anything that is not a new release or easily coded in an emotional or age-based register is relegated to the categories "Foreign" or "Special Interest." Generally, "Foreign" encompasses anything that does not feature English dialogue; it does not differentiate genres, stars, directors, or country of origin. "Special Interest," on the other hand, appears to be a multigeneric placeholder that can include everything from documentaries to wrestling videos to Japanese animation. "Special Interest," in fact, stands in opposition to the general tastes and interests that these stores presume most customers have. With new releases and broad genres dominating, corporate stores displace a certain kind of artistic distinction with a generalized populism.

Many independently owned stores and small chains emulate this corporate model—in their system of categorization if not in their cleanliness. They similarly emphasize new releases, which likewise take up the bulk of the space on the outer walls of the store. Beyond the new releases, however, corporate-model independent stores typically demonstrate a more complicated system of categorization. In turn, this suggests that these stores offer a more complex, more particularized vision for movie culture. Although they also have broad-based genres like horror, comedy, or drama, which serve as "emotion zones" connoting what browsers should feel at the moment of consumption, these corporate-model independents will also have a range of sections that make a number of formal, industrial, or historical differentiations among movies. In part, the increased number of sections and the level of product differentiation that these stores offer result from the flexibility of independent ownership; these stores do not have to obey corporate rules and regulations. In this, such stores respond more accurately to the desires of the owners, the clerks, and, most important, the customers. Thus they are notable for their relative uniqueness in terms of the specific categories that they offer.

One can find "Directors" sections in a number of such stores. The specific directors, however, are wide ranging, including recognized directors of the classic Hollywood era or contemporary directors with a brand name, such as Steven Spielberg. It is most common for these stores to focus on

male, European figures in these sections, creating a confluence of auteurism and Eurocentrism. Similarly, one can find sections devoted to particular actors and actresses from a range of historical periods; once again, the particular actors or actresses vary considerably, from stars of the classic era to contemporary idols. In some of these stores, you can find classic genres such as "Westerns" and "Film Noir," as well as sections devoted to particular eras, such as "Silent Films" or "Classics." One genre that is featured at many corporate-model independent stores is documentaries; generally these sections contain hits, particularly the films of Michael Moore, as well as a few Oscar winners from the 1980s and 1990s. A number of such stores have "Cult Classics" sections, which feature a smattering of camp, avant-garde, and/or "paracinematic" titles.[23] Conversely, one can usually find a section devoted to Oscar winners, in some cases subdivided by year or decade. These stores might also have a shelf called "Employee Picks," a section I discuss in detail later in this chapter.

One of the most notable ways that corporate-model independent stores differ from the corporate chains is their inclusion of sexually explicit adult movies. Except for Family Video and Movie Gallery, corporate stores refused to carry adult films. Yet a report from 1989 found that nearly 70 percent of all video stores carried adult titles (although this percentage was remarkably lower in the American South).[24] These movies are almost always held in a section proverbially known as the "Back Room" because it is separated from the general floor space of the store (figure 10).[25] This area might be separated by a curtain or a door, and a sign reading Adults Only or No One Under the Age of 18 Allowed can usually be found at the threshold. If video stores have spatialized conceptualizations about movies, then this is a space of special and guarded knowledge.

There are (at least) three characteristics of the Back Room that make it remarkable within the larger logic of the video store. First, as it is located in a special, semihidden space, the Back Room attempts to provide privacy within a public space and thereby indicates ambivalence toward the genre of videos located there. Indeed, many stores that offer adult titles appear to walk a fine line between normalizing these movies and acknowledging the semi-illicit feelings that browsers may feel in this section. Back Rooms are often as well-lit, clean, and orderly as any other section in the store. Yet they also are typically more cramped, with more shelves to block one's view of others in the section, and a number of stores provide opaque plastic bags to hide the videos when they are brought into the main floor space of the store. Thus, while these stores may suggest that adult movies are simply a genre like any other, they simultaneously accommodate the browser's

FIGURE 10. Adult movies are found in "the Back Room," a
guarded, pseudoprivate space in the public space of the video
store. (Video Hut, Los Angeles.)

(possible) shame or desire for anonymity. Second, pornographic materials
are commonly organized into highly-specified categories, although there
can also be a large "New Releases" wall within this section.[26] Back Rooms
may be organized by production company or, more commonly, by criteria
that describe the bodies of the performers and the actions in which they
engage. Thus one can find such sections as "Latin," "Ethnic: Black," "Big
Tits," "Blow Jobs," "Lesbian," "Transsexual," and on and on. These designa-
tions do not so much draw on any formal similarities among the videos but
rather indicate elements of the pro-filmic content.

Third and finally, Back Rooms are remarkable in terms of the revenue
they generate. Because the corporate chains have not carried such material,
independent stores have relied on this section as an item of distinction;

Frederick Wasser has asserted that one of the primary ways that independent stores could compete with the corporate chains was by offering adult movies.[27] One report stated that the average video store that carried such material made about 9 percent of their revenue from it, while it made up only 7 percent of their stock.[28] Yet other historical reports suggest that adult movies could comprise anywhere from 20 percent to 25 percent of a video store's overall revenue, and several clerks and owners I interviewed between 2008 and 2012 claim they once made 30 percent to 40 percent of their revenue from pornography.[29] In this respect, Back Rooms are spatially marginalized within the store, yet absolutely prominent in terms of its economic operation.

As a type, then, corporate-model independent stores provide a greater level of diversity and specificity among their categories. This organization acknowledges a more diverse range of tastes and existing knowledge regarding media than is found at corporate stores. In this respect, corporate-model independents position movies as a popular form of entertainment but one that is subject to semiparticular tastes. The diversity found among and within such stores does not necessarily align with "educated" or academic understandings of film aesthetics or history. Thus in a number of small-town stores in this category, discussed at length in chapter 4, one finds a range of genres and distinctions that fall outside judgments of "art" or even of "cinema" as an aesthetic medium. In some stores, one can find "Hunting and Fishing" sections that depict people engaging in those activities; in others, one can find a "Wrestling" section, which has tapes that feature professional wrestling matches. This shows that corporate-model independent stores recognize and cultivate the distinct but not necessarily distinguished tastes of their customers. They put forth a vision of movie culture that is relatively fragmented, even stratified, and comprised of a population of distinct individuals; this contrasts with the push toward uniformity and "the new" found at the corporate chains. No matter how much corporate-model independent stores may emulate their corporate counterparts, they typically acknowledge and even facilitate "difference" among their browsers. These stores' "shortcomings" facilitate a bit of diversity in movie culture.

The third type of video store, the specialty store, in addition to being independently owned, distinguishes itself by offering a wide selection of movie titles and a much greater number and variety of categories.[30] If the corporate stores aim for depth, then these stores aim for breadth. It is at the specialty stores that one finds the most elaborate and occasionally unconventional systems of organization. Not only do they have more sections than corporate-model independents, specialty stores offer classificatory schemes that are highly disciplined, to the point of particularism. The specific movies found

in specialty stores and the ways in which they are organized indicate three subdivisions in this type: the cult store, the video art house, and the alternative store.[31] The cult store carries a plethora of camp and paracinematic titles, whose value is derived from their lack of mainstream or highbrow cultural approval.[32] Video art houses primarily carry foreign and independently produced American films that have earned cultural prestige in some other cinematic sphere. The alternative store presents an anti-Hollywood and anticorporate cultural space by valorizing anything outside of mainstream Hollywood, whether on the high or low end of the cinematic spectrum of prestige. "Good" here is different, whether it is good or bad.

Although each specialty store has its own method for making categories, all exhibit eclecticism and particularism. Whether holding refined or reviled cinema, or both, the specialty store is obsessed with categorization; it demonstrates something like "taxophilia," a pure joy in differentiating and naming. Given each store's categorical specificity, no two specialty stores are the same. In many cases, particularly in art house and alternative stores, movies are organized into many categories and subcategories that are found in established sites of film artistry, including film festivals, art house theaters, and university classes and academic writings. Indeed, these types of stores appear to internalize, valorize, and distribute considerable cultural capital regarding the cinema.[33] There are sections devoted to "refined" film genres, such as "Documentaries" and "Experimental Cinema." We also find historically based cinematic categories such as "American Silent Films" and "Classic Drama." Specialty stores commonly have sections based on social interests and topics that do not get regular representation in the commercial media. Thus the documentaries in such stores are frequently organized by topic, such as "World History" or "War Docs." Further, many specialty stores have "Gay and Lesbian" sections, which have narrative films with queer characters or themes. Foreign films, in particular, have a strong presence at specialty stores, creating a semicosmopolitan space within the mundane and local space of the store—the world in a box. These foreign sections are usually subdivided according to nation and/or language. National cinemas are sometimes further subdivided by genre, era, and director.

In fact, almost all specialty stores organize a substantial number of their movies—highbrow or lowbrow—by director. In this respect, these stores articulate the conceptual category of the auteur in spatial form. Just as importantly, the division of videos by director aligns with and even compounds the particularism seen at specialty stores in general, as there are many more individual filmmakers than there are easily identifiable genres. The world of cinema suddenly becomes as particularized as the finite but

immense number of individual filmmakers. There are a wide variety of specific auteurs that can be found in any given store, and one specialty store may have a section devoted to an auteur that no other store has. Among American directors, one can find George Cukor, Abel Ferrera, and Spike Lee; and it is common to find shelves for well-recognized foreign directors like Ingmar Bergman, as well as lesser-known Europeans such as Krzysztof Zanussi. These stores frequently have sections for noted female directors, such as Chantal Akerman and Leni Riefenstahl. And they often devote shelves to directors from all over the filmmaking world. It is not uncommon to find sections for Mohsen Makhmalbaf or Ousmane Sembène, for instance. Of East Asian auteurs, the Japanese perhaps get the best representation, with sections for canonical figures like Kurosawa Akira as well as contemporary directors such as Kore-eda Hirokazu and Miike Takashi. Further, specialty stores commonly offer a large selection of Hong Kong action films, which also are sometimes organized by director. By representing female and non-Western directors, specialty video stores circumvent the masculinism and Eurocentrism that has characterized a considerable amount of auteurist criticism. Just as they broaden the variety of movies available for rent, these stores also extend the range of figures that represent cinematic artistry.

In fact, at cult and alternative specialty stores, auteurism provides the means for an inclusiveness that cuts through many existing cultural hierarchies.[34] Thus one finds that many specialty stores subdivide their "Cult Movies" sections by director. In addition to the expected names like Russ Meyer and Ed Wood, one also finds shelves for such directors as Al Adamson, Herschell Gordon Lewis, and Doris Wishman. It is common at cult stores to have shelves devoted to directors who specialized in horror films, particularly low-budget ones, and so there are stores with shelves for Mario Bava and Amando de Ossorio, among others. In this regard, auteurism functions as a mechanism by which "trash cinema" appears on an equal footing with "art cinema." Indeed, the inclusion of directors whose films have not been consecrated by cinematic elites indicates how these stores bend the rules of auteurism away from a pantheon of "great directors" toward a more eclectic selection. Whereas the film critic Andrew Sarris developed the notion of the auteur as a means of distinguishing the great directors from the rest, here the auteur is subjected to a process that elevates those directors who have made trash and demotes the "masters" of cinema to the level of the trash makers.[35]

In their totality, specialty video stores demonstrate the overt deployment of auteurism as a generally accepted cultural and commercial

category. In this, the evaluative and hierarchical tendency of auteurist criticism gives way to an indiscriminate, nearly uncritical celebration of the film director in general. The auteur at the video store, it seems, is an auteur simply by having directed a number of films that can be placed alongside one another on a shelf. Yet the appearance and arrangement of the "Auteur" sections at video stores suggests a continued faith in the role of human subjectivity in the filmmaking process. In this way, specialty stores have helped disseminate a certain kind of auteurism while they have simultaneously reshaped the pantheon of auteurs.

This auteurist tendency within specialty video stores is merely part of their overall particularism regarding movies, which in its total effect suggests an educated, even academic treatment of cinema. Through detailed organization, they materialize and valorize a significant amount of cultural capital with regard to film. While some specialty stores infuse the otherwise humble retail space with the prestige and pedigree associated with the masterworks of cinema, other stores give lowbrow cinema refined treatment through a detailed and sophisticated organizational scheme. Based on these practices, one could see such stores as de facto film schools, as the shelves and aisles lead customers through a thoughtful and precise selection of moving image art—even when this selection challenges the very boundaries of artistic quality. On the one hand, these stores resonate best with browsers and customers who hold a similar amount of cultural capital in these areas. On the other hand, they can be seen as disseminating some degree of this capital, where cultural knowledge is traded for cash.

BROWSERS

Video stores do not just organize and distribute movies; they organize and distribute values as well. Yet these meanings are not simply immanent in the shelves, aisles, movie labels, and video boxes within the stores. Rather, people create these meanings through concrete practices. Just because a video store is organized in a particular way does not mean that the people who enter it are determined by this architecture. People enter video stores with their own "internal architecture," their own embodied knowledge regarding the meaning and value of movies. They have taste. In this respect, the apparently neutral arrangement of videos on shelves and in aisles takes on strategic importance. The video store leads individuals toward a video commodity, and if successful these individuals move that commodity elsewhere. As a "museum of advertisements," the video store combines the logic of the archive and of the gallery to entice people to an activity. Like so

FIGURE 11. The video browser contemplates a future. (Video Stop, Pocatello, ID.)

many contemporary public retail spaces, and in contrast to movie theaters, video stores facilitate browsing.

Video browsers are propelled by their desire to watch a movie; they are driven by speculation (figure 11). As there is no material record of all the desires and speculations that have propelled video browsers, they remain subjects of speculation. As a spatiality all its own, browsing connects the interior of the subject, the layout of the store, and the specific videos that the browser surveys. "Distribution" is not an abstraction here but a concrete, somatic phenomenon. Browsers participate in the movement of commodities from production to consumption by seeking them out and attaining them. This movement entails the distribution of values as well. Browsers assess whether this shelf, this category ("New Releases," Comedy," or "Truffaut"), or this video will be able to satisfy their desires. In this process, browsers physically enact their personal understandings about the value of movies. The gap between the material space of the store (the aisles and shelves) and the interior space of the browser (their emotions and desires) produces a movement that has as its goal the closing of this gap. The browser engages in a taste-based movement that brings material space and personal subjectivity into concrete relation.

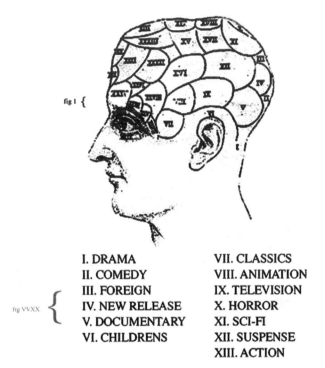

fig I {

ftg VVXX {

I. DRAMA	VII. CLASSICS
II. COMEDY	VIII. ANIMATION
III. FOREIGN	IX. TELEVISION
IV. NEW RELEASE	X. HORROR
V. DOCUMENTARY	XI. SCI-FI
VI. CHILDRENS	XII. SUSPENSE
	XIII. ACTION

FIGURE 12. Video browsing connects material space to our internal, emotional space. Graphic by Tania Trelles. Courtesy of Videology, Brooklyn, NY.

Charles Tashiro has analyzed the video collector in somewhat similar ways, saying, "the logic of collecting is built on the shifting sands of personal desire, then justified through a rationalizing structure. The structure may remain invisible to the outsider."[36] Browsing begins with an inversion of this logic, as the invisible desires of the browser infiltrate the semirational and material structure of the video store, the collection. The browser rewrites the cinematic canon through hunting and borrowing, eventually arranging his or her "collection" of viewing experiences over time and across space. Like Michel de Certeau's city walker, the browser "writes" the video store through a "rhetoric of walking," which may be delimited but cannot be determined entirely by the aisles and shelves within the store.[37] The trajectories of the browser are potentially countless. Even if one could chart the infinite ways that different people walk through the video store, the interaction between the interior hopes of the browser and his or her actual path remains forever invisible. There is no way to map browsing (figure 12).

This connection between the material space of the store and the subjectivity of the browser makes the temporality of browsing similarly complex. The objects that the browser surveys serve as advertisements for future moments of cultural consumption. Thus the aisles, shelves, and individual videos are touchstones for speculation; they are possibilities. This makes browsing a critical time with a pressured temporality. The browser spends his or her time imagining another time, a future. "What movie should I watch? Where will I be then? What will I feel like, and how will it make me feel? What will it mean? Will I like it? With whom will I watch it? Will *they* like it?" And so on. This sense of expectation, of hope, explains why it sometimes takes so long to choose; it explains why sometimes the choice is made not to rent a movie at all. It also explains why browsing with others—the family, a date—can be so troubling. Not only must one coordinate one's tastes and hopes with the space of the store, but one must contend with the tastes and hopes of others. A future must be planned together.

Admittedly, not everyone browses in a languid or deliberative fashion. There are people who go into the store knowing exactly what they want. Although not exactly browsers, these people remain shoppers whose movements are guided by their existing tastes and their hopes for future media consumption. Browsers may peruse, sampling a film or two before making a judgment about the quality of that section of the store. This process might lead the browser to return to this shelf on another occasion so that he might master this oeuvre. Or the browser may go to some other section, seeking out other genres, countries, or directors. Or perhaps the shopper cannot find what she wants on the shelf she expects it to be. In these cases, the browser engages in a quiet but anxious "classification struggle" over the proper designation of the specific title.[38] "That film ought to be here," the browser thinks. At this point she may ask a clerk if the film is actually "in," and if so, where it can be found? In these cases, the architecture of the store has made a claim of meaning and value that does not connect with the meaning and value the browser assigned to the movie before entering the store. This does not mean that the browser must accept the store's designation; she may continue to classify the title in her own way. However, what does occur is an internal adjustment to the space of the store. The browser must acknowledge the existence of this other classificatory scheme, to which she will have to adjust herself if she is to properly navigate the store and find the desired item. Indeed, with repeated browsing in the same store, a browser may fully internalize its logic although still disagree with it. Similarly, whether browsing or rushing through, there are plenty of times that one cannot find what one wants. Perhaps the movie has already been

rented. In this case, the logic of the video store aims to send the browser to something else, perhaps something similar, perhaps something unexpected, discovered in the act of browsing. In other cases, none of the options appeal to the browser. The video store aims to facilitate all these actions, holding the videos on reserve for the leisurely browser or the driven shopper.

Indeed, the video store aims to accommodate a wide variety of wishes and subjectivities. Ideally, anyone with money should be able to enter and make use of the video store. This is precisely what makes "the browser" such a powerful social role. "The browser" is an interactional category, one that comes about through particular forms of behavior and interaction. This makes "the browser" and "the shopper" social placeholders, categories that accommodate all manner of differences and social statuses that might occupy them. "The shopper" category is powerful because it appears universal. This universality aligns with the market mentality of the video store in the first place; ultimately aimed at a commercial transaction, the video store obeys the logic of money, the universal equivalent. Like any other shopping space, the video store engages people in ways that overcome social differences in order to support capitalism. At the same time, however, this space flatters individuality and individualism, addresses individuals *as* individuals, by making it seem as though people get to be "themselves" by choosing commodities based on their supposedly individual tastes. In this way, the universality of the shopping experience gives way to the particularism of the individual shopper. "The browser" is designed to be plural, diverse, and yet simultaneously particular and individual.

Thus the video store represents a profound alteration in the way people interact with movies. In moving through the aisles, in evaluating the video boxes, and in selecting a movie to rent, the browser marks his or her individuality through a declaration of taste. These declarations make the video store a space of cultural performance. As Bourdieu asserts, tastes in cultural goods are linked to social status;[39] this suggests that the physical movement through the video store and the browser's choices of movies constitute a movement through *social* space. When evaluating movies to rent, the browser contemplates how to expand or contract his or her existing taste and thereby either affirms or adjusts his or her social status. This is an invisible, implicit, and largely unconscious process. Yet this invisibility indicates the force of social status in the United States; as a society, we have constructed ways to have supposedly classless interactions. The video store makes us undifferentiated with regard to shopping for movies and simultaneously particular through our individual movements and choices. This analysis prompts the question, what would a video store look like if it were

arranged not by genres, auteurs, or national cinemas but rather by class, gender, or generational zones? From the perspective of the browser, video stores have been organized this way—covertly.

CLERKS

The other half of the human equation at the video store is composed of clerks and managers. There are the stereotypes: the proverbial mom and pop, the aloof snob, and the dimwitted teenager who might as well be working in fast food, among others. But just as "the browser" is a social placeholder that has encompassed and accommodated a range of different social identities, so too have there been a wide range of individuals who have worked in a video store sometime within the past thirty years. (Chapters 3 and 4 examine specific workers at specific stores, demonstrating some of the diversity that character- izes these figures.) Like the browser, the video clerk is a social role that comes about through specific practices and interactions. *The Store Training Manual for Guest Service Representatives at Hollywood Video*, from 2003, details the basic and ideal qualities of video store workers.[40] As this document illustrates, many of the video clerk's duties are the same as those of any retail worker. They include friendly customer service, knowledge of the store's layout and wares, maintaining the store's orderliness and cleanliness, and being accurate and efficient when ringing up customers at the register. Broadly, then, clerks perform roles that are simultaneously social, spatial, and economic. They must interact with patrons, help them find what they seek, and take money from them in exchange for this good. However, many functions of the video clerk are determined by the specific commodities offered in these stores (vid- eos), by their spatial arrangement (on shelves of movie categories), by their pattern of consumption (rental), and by the particular social interactions that occur around these commodities.

Because the video is a physical object and because video stores arrange them on shelves, the video clerk has a deeply material and spatial relation- ship with movies. This relationship aligns the video clerk with the role of the librarian. Clerks need to know where a specific title is located so that they can help browsers find things and so that they can place video stock on the correct shelves. Consequently, the clerk is prone to internalizing the organi- zational scheme of the store; indeed, it is likely that the clerk will think of any given movie in terms of its place in the store, thus combining a spatial association with whatever mood or genre the clerk has already associated with that movie. Further, because video stores are primarily defined by the rental of movies rather than the sale of videos and other commodities, they

FIGURE 13. Melted VHS tapes are the customer's
responsibility and the clerk's frustration.

function as lending institutions and require their employees to coordinate
the return of borrowed objects. Clerks must empty the returned videos from
the drop box every morning and periodically throughout the day; they must
check these movies in to the store's catalog or database; they must return
these videos to their proper place in the store; they must collect late fees that
have been applied to a customer's account if there are any. They must set
aside and reserve movies that a customer has requested over the phone.
Finally, clerks are responsible for the material condition of the videos. They
must ensure that the tape or disc in the box is the correct one and that the
video is from this store and not another.[41] They must ensure that the video
is in good condition. This can mean dealing with videotapes that have melted
in a hot car, with videotapes that have been chewed up by a malfunctioning
VCR, or with DVDs that have been scratched (figure 13).

 Like any retail worker, the video clerk engages in social interactions as
part of the job. Clerks serve as the human embodiment of the video store,
its social representative. Browsers may, in fact, like or dislike a video store
simply because they like or dislike the clerks working there. A substantial

portion of the Hollywood Video manual encourages the clerk to achieve "exceptional guest service" and describes how to do this: greet patrons when they enter, minimize patrons' wait in line to check out, "personalize the experience for every guest," and thank patrons as they exit.[42] In terms of "personalization," the manual suggests, for instance, that if the clerk observes a group of friends in the store, they should "offer suggestions for scary movies and snacks."[43] More flexibly, and thus dependent on the intuitive capabilities of the individual clerk, the manual emphasizes that clerks should ask customers questions, listen to their answers, and summarize what they have heard. The aim of this is to help the clerk make suggestions about what movies the guest should rent, so as to satisfy the guest and secure a commercial transaction. While encouraging the clerk to be friendly and responsive to customers, the manual states that the video clerk must balance interpersonal interaction (greetings, farewells, and conversation) with economic efficiency (minimizing the wait in line).

What has made the video clerk an important aspect of the changing cinema culture over the past thirty years is the way in which he or she synthesizes issues of taste, space, and economics. The video clerk is expected to have some knowledge of movies. Yet the expertise expected and required of a clerk varies considerably. Clerks at specialty video stores typically hold a comparably detailed knowledge of film aesthetics and history (see chapter 3). The cultural positions of such stores are aligned and supported by the cinephilia of their employees, making cinephilia a job requirement. Alternatively, clerks at corporate stores are not required to have a deep knowledge of film history or even strong tastes. Illustrating this, a specialty store in a college town in the American Midwest includes a quiz in its job application, and many of the questions require detailed knowledge of film history in general and knowledge of nonmainstream Hollywood films in particular.[44] A quiz in the Hollywood Video manual primarily requires clerks to know what genres are in the store and how individual films fit into them.[45] Clerks at corporate-model independent stores, meanwhile, can demonstrate an incredibly wide range of knowledge, from hypereducated to nearly ignorant about film history and aesthetics.

Whatever expertise a clerk may have about cinema, this knowledge always intersects with the physical space of the store and the social interaction with browsers. Minimally, clerks need to point browsers to the proper shelf for a video; to the extent that they help guide browsers' movements, the clerk wields spatial authority over the store in particular and over movies in general. In telling a browser where to find a video, the clerk functions as a guide through cinema, to whatever extent "cinema" exists in a given

store. Yet just as often as not the clerk must guide browsers in terms of taste; and indeed, clerks are expected to have knowledge about the inventory that is simultaneously commercial and evaluative. In this, the video clerk can function as a knowledge broker.[46] Unlike the ticket taker at a movie theater, where the patrons have already made their selections, video clerks are regularly asked such questions as, "Can you make any recommendations?" "What have you seen lately?" or "Is this movie any good?" Clerks also solicit interaction with browsers, prompting discussions about the browser's desires and tastes with the aim of helping them find something to rent. The Hollywood Video manual, for instance, says that clerks should ask such questions as "What kind of movie are you in the mood for?" "Do you like comedy, action, romance . . . ?" or "Who's your favorite actor?"[47] This makes the clerk an arbiter of taste as well as a knowledge broker.

Importantly, the Hollywood Video manual indicates that it really does not matter whether the clerk successfully guides a customer to a good movie or even whether the clerk has distinctive tastes. It states, "Guests appreciate suggestions even if they do not accept them. By offering suggestions, the guest knows that you were listening and that you want to help."[48] Thus, what matters is that the clerk interacts with the customer and wants to help him or her. Yet in those cases when the clerk makes an appropriate suggestion, he or she engages in a complex process of assessing the customer, internalizing a message about the customer's tastes and desires, and making an intertextual connection or aesthetic judgment that leads the customer to a specific movie. By helping to guide browsers' movements toward movies, the clerk gives shape to a collection of his or her own, based on his or her tastes and ability to accurately gauge the desires of customers. This is an ad hoc, improvised canon. The collection of movies suggested by the clerk is prone to diversity, even inconsistency; the "oeuvre" is in constant rotation. Although the clerk might have firm tastes and attitudes, they must be adjusted to the titles available in the store and the apparent needs of the customer. Indeed, this interaction goes both ways: the browser evaluates the taste of the clerk while the clerk simultaneously evaluates the taste of the browser. As a space of interaction, the video store facilitates these ephemeral moments in which aesthetic tastes get articulated, negotiated, and reformulated. At the video store, in other words, taste and choice get defined through an overtly social process.[49]

The clerk manifests his or her cinematic tastes and spatial authority most concretely in the "Employee Picks" shelves found at numerous independent and specialty stores (figure 14). In these spaces, clerks do not need to adjust to the tastes of browsers but rather offer their own tastes as a clearly demarcated selection of movies. In filling these shelves, clerks draw from the cultural

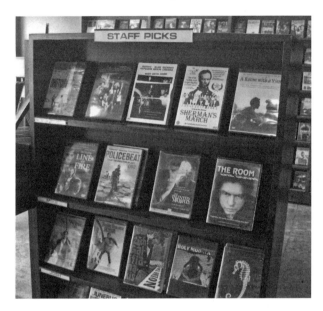

FIGURE 14. Video clerks make their tastes materially
evident in the "Employee Picks" shelves found in many
video stores. (Videology, New York).

capital accrued by the film titles that they select. These shelves make recom-
mendations and, further, endorsements and even claims of ownership. The
names of the clerks operate like a genre or even the name of an auteur. In this
regard, through the "Employee Picks" shelf clerks seek to endow certain
movie titles with some prestige and simultaneously accumulate cultural
capital of their own. And just as different clerks have different tastes and
recommend different movies, the individual "Favorites" shelf is typically
characterized by disparity among titles. In instances where clerks seek to dem-
onstrate the range and richness of their tastes, the logic of these shelves is not
necessarily one of homogeneity or formal excellence but rather of eclecticism
and even surprise. In this way, the name of the clerk takes on the power of a
signature, which expands the breadth of the cinematic canon and simultane-
ously provides an order to the diversity contained on the shelf.

THE LAST INSTANCE: COUNTERS AND CUSTOMERS

Ultimately a trip to the video store ends at the checkout counter, a threshold
separating clerks and browsers, video store and world. These special places
synthesize the spatial and cultural operations of the video store with its basic

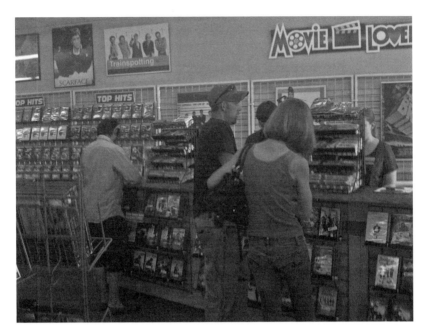

FIGURE 15. Checkout counters are thresholds that must be passed for video consumption to occur. (Movie Lovers, Bozeman, MT.)

economic function. The checkout counter exerts a distinctly disciplinary power over people's relationship with money and movies, affixing the social identities of clerks and customers as well as the relations between them. Signaling its mixed cultural and economic purposes, the video checkout mimics the look and purpose of a movie theater ticket booth and the circulations desk at a library (figure 15). The counter is typically attended by movie posters and calendars of upcoming video releases. Commonly, candy, popcorn, and other snacks associated with movie consumption are placed on or near the counter. Further, there are frequently displays of new and previously viewed videos for purchase, along with a wide variety of "impulse purchase" items such as toys or stuffed animals. Some stores have a video guide at or near the counter, such as *VideoHound's Golden Movie Retriever*, if such guides are not already placed elsewhere in the store. In addition, the area around the checkout counter usually has printed descriptions of the store's membership requirements, rental policies, and prices. Some stores have a suggestions box where customers can request certain movie titles. At independently owned stores, one can occasionally find a "Do Not Rent" list of customers who have been barred from the store because they have out-

standing late fees, have stolen items in the past, or have passed a bad check. Also at independent stores, it is typical to find workers' personal items, such as photographs of family members, and objects that indicate the store's connection to the larger community, such as community awards, news stories about the store, Buy Local signs, and the like. Like the exterior of video stores, then, their checkout counters present a mixture of movie culture with items of more direct concern to the particular store and its workers.

A vital component of the video checkout counter is the ledger or database that keeps track of the store's movies and its customers. Like the counter itself, this mechanism serves multiple functions. In the early days of the video business, workers kept track of movies and customers in written ledgers or on index cards, but many stores increasingly used a computerized system to accomplish this; a 1989 report states that nearly 60 percent of all video stores used computers to track their customers and inventory, and this percentage certainly grew over time.[50] The range of computerized platforms is varied, from those written for and used at a single store to those bought from an outside vendor to those that connect the individual store to its video distributor. The February 1987 issue of *Video Store* lists dozens of Point-of-Sale (POS) systems and takes note of their features, which speak to the multiple needs of the video rental business. They include charting customer frequency, title performance, high and low renters, and genre performance; tracking and calculating late charges; tracking reservations; calculating depreciation; tracking and flagging frequent/infrequent customers; calculating POS rental and transaction prices; calculating sales tax; tracking sales of software, hardware, and accessories; creating management reports and summaries; tracking employee hours and performance; and printing invoices, mailing labels, and bar codes.[51] The Hollywood Video manual indicates that the POS systems at these stores performed many of these functions.[52] As a comprehensive system, then, these POS terminals document customers, movies, and economic activity.

An even more disciplinary item attends the checkout counter of many video stores: the security gate. Greenberg notes that early video store owners placed videotapes behind the checkout counter and only cover boxes in the store in order to prevent shoplifting.[53] By the late 1980s, however, videos were more typically placed among the open stacks of the aisles, particularly at corporate chains like Blockbuster Video. To prevent theft, these corporate stores, along with well-financed independent stores and large hybrid operations like grocery stores, placed magnetic tags in the boxes of their videos that would sound a loud and obnoxious alarm when they passed through the gate unless a clerk had disarmed them.[54] Exiting the

video store thus entailed more than just checking out at the counter but also getting checked out, invisibly but physically, by the security gate. From the browser's perspective, security gates reinforce the idea that the movie is not theirs but only theirs to borrow and that the video store or maybe the larger media industry wields the real and legitimate power over it. The security gate creates a moment of submission to the logic of copyright and private property. There is no surer sign of the internalization of this logic than the strangely embarrassing moments when the alarm goes off by accident. The loud beeping makes every customer a possible criminal, causing shame and defensiveness in the people who set it off and curiosity and anxiety in bystanders. Just the anticipation of this sound makes the security gate a charged threshold.

Indeed, the entire checkout area disciplines all the people within the video store. When browsers approach the counter to rent something, these former wanderers get locked into a new and purely economic position: "customer." The Hollywood Video manual indicates the ways in which the customer, or "member," is acknowledged and documented. In order to rent at these stores, one must be at least eighteen years old, live within twenty-five miles, have a working telephone number, and show two forms of identification, one of which is typically a credit card.[55] In this respect, the video store turns the individual into a set of rationalized, statistical, and economic data. At Hollywood Video and many other stores, these data are transformed into yet another form of identification, the membership card.[56] The amount of detailed information required of the customer accords with the video store's status as a profit-driven lending institution; unlike movie theaters or most other kinds of retail shops, video stores must identify customers fairly rigorously, through phone numbers and credit cards, so they can track who has what video. Further indicating the shift from browser to customer, the POS system at the video store creates an archive of individuals' rental histories.[57] In this manner they record the historical trajectories of a customer's tastes in movies. Yet this is ultimately a faulty archive of the larger experience of the video store, as these POS systems record the customers' final rental choices but not the browsing that culminated in these choices.

The counter affects the video clerk as well. Like any retail worker, the video clerk spends most of his or her time standing behind this counter. In its configuration, the counter designates the clerk *as a clerk* and thus as available for interaction but simultaneously as "special." The counter allows the clerk to literally and figuratively stand between the video shopper and the shopper's viewing experience. For this reason alone, the counter

endows the clerk with a margin of power. Checkout counters are often slightly elevated above the rest of the store, raising the physical stature of the clerk and providing him or her with a clear view of the aisles. In these places, the clerk functions as both media archivist and librarian. In stores that do not place videos on their shelves but rather empty boxes that customers must exchange for the videos, the clerk serves as a genuine gatekeeper. In stores with open stacks, the clerk is singly responsible for allowing the customer to take the tape or disc; in stores with security gates, the clerk makes it possible to move the videos beyond the gate and thus is the only person allowed to pass the movies into the outside world.

Yet the counter simultaneously curtails the clerk's individual agency. For the clerk, the counter makes the rental process a simple commercial transaction. Rather than serve as a knowledge broker or an arbiter of taste, the clerk now operates as a simple money handler. The Hollywood Video manual emphasizes that clerks are required to be accurate in handling money and that they are responsible for having balanced cash drawers.[58] Not only must clerks charge customers for the movies they rent, but they must collect fees that have accrued on items not returned on time. The Hollywood Video manual acknowledges the delicacy required in asking for payment of late fees, telling clerks to remain calm and friendly during such interactions despite any frustrations that the customers might express.[59] Even in this commercial transaction, the social character of the video clerk serves an economic purpose. The clerk behind the counter is gatekeeper, archivist, librarian, and salesperson. At all times and in each of these roles, the clerk is a figure of social interaction. Just as the trajectories of the browser will remain forever invisible and unrecorded, the clerk's innumerable conversations and fleeting interactions will also evaporate in time.

CONCLUSION

Video stores provided new levels of access to and control over movie content and also reshaped our interactions with these commodities and with one another. The role of individual human agency cannot be understated in this process. Although the Hollywood studios garnered vast revenues from their sales to video stores, many individuals earned their livings working in these places. Just as importantly, video stores allowed the everyday American shopper to move toward their movie desires, however cheap those may seem to us now. Somewhere between media production and consumption, everyday Americans browsed untethered. Although chapter 1 located the video store squarely within the history of American movie cul-

ture and consumer culture, most people who used video stores did not experience them historically but rather as nebulous spaces of taste and hope. Parallel to this, video clerks had a new and concretely spatial relationship to movies, where taste and space intertwined. These ephemeral interactions with videos and with one another remain a historical reality of the video store. Yet this analysis of the altered distribution of movies and values about movies remains in the abstract, a spatial generalization. In the next two chapters, which make up part 2 of this book, I analyze specific video stores of different varieties in a number of locales. Moving through major cities, a few suburbs, and many small towns, I demonstrate the precise ways in which video stores have localized movie culture and articulated themselves in their immediate geographic and cultural contexts.

Video Stores and the Localization of Movie Culture

3. Video Capitals

When I was conducting research for this book and told friends and colleagues what I was doing, they would regularly ask if I had visited such-and-such video store in this-or-that town. This was "their" store, which they said was "the best." In some cases I had actually visited the store, but more commonly I had never even been to the city where it was located. These interactions did not simply demonstrate that my friends and colleagues had strong emotional connections to video stores, but that they had strong feelings about a specific store in a particular place—"the best" store in Tucson, Portland, Bloomington, or wherever. Perhaps this is unsurprising, as many people in my social circle are cinephiles, or at least interested in the arts, and hold an affection for sites of movie culture. These friends and colleagues would regularly say that their store had "everything" or, at the minimum, "a great selection." They didn't just love video stores; they loved a *specialty* video store in their area.

As discussed in chapter 2, specialty video stores feature a selection of movies that is historically deep, geographically expansive, and generically diverse. The owners and clerks at specialty stores typically exhibit a high level of knowledge about cinema history and aesthetics. Such stores can be found in disparate parts of the country, from Thomas Video in suburban Detroit to Wild and Wooly Video in Louisville to I Luv Video in Austin. Every metropolitan area seems to have one, or to have had one. This chapter investigates a handful of specialty stores and attends to the ways in which they have articulated themselves in their larger geographic and cultural milieu. These examples illustrate that although specialty video stores can appear in a variety of locales, each one interacts with a distinct cultural context. I begin with Scarecrow Video in Seattle, which as of 2013 is the biggest and perhaps the best video store in the country. I then analyze

several specialty stores in the Los Angeles area: Eddie Brandt's Saturday Matinee in North Hollywood, Vidiots in Santa Monica, and Cinefile Video in West Los Angeles.[1] Finally, through an examination of two specialty stores in smaller towns, the Movie Dungeon in Bozeman, Montana, and Video Culture in Murfreesboro, Tennessee, I demonstrate the geographic range of specialty video culture.[2]

My contention is that these specialty stores operate as "video capitals," a phrase that indicates their geocultural specificity and invokes the concept of media capital discussed by Michael Curtin.[3] Curtin uses this phrase to characterize various cities that have extremely strong media production industries, including Hollywood and Hong Kong. He elaborates that two senses of the term *capital* underlie his notion of "media capital": "capital as a center of activity and capital as a concentration of resources, reputation, and talent."[4] Thus a "media capital" is both a form of accumulation of media wealth and resources and the location that facilitates and is formulated through this process.[5]

Analogously, the specialty stores examined in this chapter have centralized a significant amount of "video capital." They frequently hold a large number of videos and, more important, a much greater range of movie titles than one would find at a typical corporate or independently owned store. In addition, these stores consistently exhibit a highly detailed, comparatively sophisticated understanding of movie history and aesthetics. They demonstrate this sophistication through the elaborate movie categories they use to organize their wares. They also employ cinephiles with a passion for film history and aesthetics. By centralizing a wide selection of movies and workers devoted to movie knowledge, specialty stores materialize and socialize a significant amount of cultural capital with regard to movies.[6] Yet the version of cultural capital regarding movies that these stores accumulate and circulate resembles the "subcultural capital" Sarah Thornton describes in her analysis of English club cultures in the 1980s and 1990s.[7] In her formulation, subcultural capital valorizes cultural tokens, competencies, and attitudes that oppose an amorphous cultural "mainstream." Individuals and social groups can cultivate and circulate subcultural capital to distinguish themselves as both hip and oppositional. Crucially, Thornton asserts that subcultural capital involves competencies that, almost by definition, cannot be learned in formal educational settings and, further, that subcultural capital does not transfer into economic capital as easily as traditional cultural capital.[8]

Similarly, most "video capital" defies the economic and cultural logics of Hollywood, where new releases and mainstream films earn the highest

rewards. If the video rental store, especially in its early phase, democratized movie distribution to some degree and gave everyday entrepreneurs the ability to exploit Hollywood films for their own economic benefit, then these video capitals demonstrate how the breadth of titles made available on video have also created a flow of economic and cultural power that is parallel, and sometimes in direct contrast, to the mainstream American media industry. Where the Hollywood studios—and some video stores—might reduce the value of all movies to the dollar (per night), these stores and their workers cultivate and trade on nuanced *qualitative* senses of value for diverse and eclectic movies. What specialty stores might lack in economic power they compensate for with eclecticism, diversity, and a passionate fandom for alternative media. Indeed, the people who own and run these stores typically have a sense of mission and faith that their stores are sites of alternative culture. These people characteristically take an ambivalent stance toward official forms of culture. Although most specialty store workers have university degrees and a significant number have studied film in college, their tastes and ideas about film and culture put them at odds with the mainstream. In fact, their diverse and divergent tastes constitute a significant portion of their video capital. Their knowledge and competency in film and media is largely fact-based and can even appear trivial, although hints of "theory" slip out in many of their discussions. Whether they gained their initial educations in cinema in a university setting or not, they exemplify and even celebrate an autodidactic type of cinema knowledge that arises from their mundane work at the video store. Indeed, these workers exhibit a striking dialectic: they possess extensive knowledge and apply it in a humble retail setting. This tension fuels the oppositional, subcultural, "hip" stance that these people take toward movie culture. It is a mark of distinction.

Although specialty stores differ considerably from the "regular" video stores in their areas, they nevertheless coordinate their operations with their social and cultural surroundings.[9] The specialty stores discussed below have served and responded to the tastes of a specific "audience" that is delimited by geographic, social, and cultural factors. In this interaction, these video capitals have localized a particular brand of movie culture within their respective areas. By "localized," I mean that these video stores and their workers have adapted to, coordinated with, and contributed to the geographic and cultural contexts around them. "Localization" is part of the overall tendency of flexibility and customization typical of video stores and home video culture.

In the case of specialty video stores, this localization entails a significant concentration of (sub)cultural capital regarding film history, aesthetics, and

intellectualism more broadly. These stores have accumulated disciplined and refined conceptions of movies and movie culture and distributed these values among populations amenable to them. Supporting and supported by a community of cinephiles and intellectuals, these stores are typically located in cities, suburbs, and towns with highly educated populations. Further, specialty video stores are located in communities with additional sites of cultural wealth, such as art venues and, crucially, universities. That is to say, the rarefied, distinctive, and alternative movie culture that specialty stores localize is notably linked to social and institutional contexts in which more official forms of cultural capital circulate. This situates specialty stores and their workers in yet another dialectical situation: they offer cultural goods and attitudes that oppose mainstream culture within a community that otherwise values conventional forms of edification and leisure. These stores may function like informal film schools, but they are consistently positioned and self-positioned as lying outside or even beneath the official cultural apparatus of their locales.

SCARECROW VIDEO: VIDEO MECCA

With over 114,000 unique movie titles, Scarecrow Video has been the largest video store in the United States for a number of years. The store operates out of a two-story structure with around 8,300 square feet and is located several blocks from the University of Washington in Seattle (figure 16). The ground floor features a large section of videos for sale as well as a small coffee bar, which was added in early 2012 in order to lure more casual traffic into the store. Videos line the walls, from floor to ceiling, on both the first and second floors of the building. Throughout the ground floor tall wooden shelves are organized in a zigzag formation to maximize the available floor space.[10] The second floor is "open air," so that one can look down onto the first floor (figure 17). There are a few puffy chairs and tables on the second floor for customers or workers to sit and relax; otherwise the second floor comprises small rooms and nooks that are packed with movies—niches of niche cinema. Like other video stores, Scarecrow has largely replaced its VHS tapes with DVDs. Yet it still offers more than 17,000 movies on VHS because these titles are available only in that format. Despite its substantial footprint and square footage, the store is literally overrun with videos.

Although packed with videos in a labyrinthine fashion, the store reflects a balance of spacing issues and rental patterns in its organization of movies. Because of spatial limitations as well as the mental and physical labor it

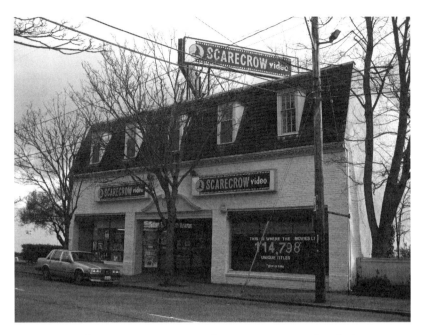

FIGURE 16. This unassuming structure houses Scarecrow Video, the largest video store in the United States.

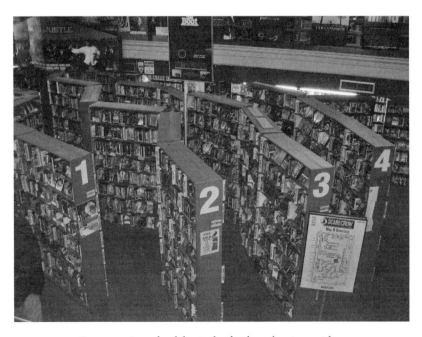

FIGURE 17. Scarecrow is such a labyrinth of videos that it provides maps, seen at the bottom right of this photo, to help browsers navigate the space.

would take to reorganize any section of the store, Scarecrow's layout has not changed much since it moved to this location in 1993. In general, the largest and most easily accessed parts of the store are devoted to sections with the largest inventory or with movies that are rented most frequently, while the smaller, tucked away areas hold genres with a smaller inventory of movies that are rented less frequently or that customers are likely to seek out. Like most specialty video stores, Scarecrow organizes its movies into highly specified sections, many of which have numerous subdivisions. Most of the wall space on the ground floor is devoted to foreign films, subdivided by country of origin. All of the major cinema-producing nations are represented here, from Argentina to Sweden, but there are also sections for lesser-known national cinemas, including Bulgaria, Syria, and Zimbabwe. The zigzagged shelves in the middle of the store hold movies by innumerable directors from all over the filmmaking world. There is also a New Releases shelf in the middle of the space, along with a Family shelf, on top of which is an extensive collection of film and video guides. The second floor of the store is composed of sections for different movie genres, a number of which are relatively obscure and playfully labeled, for example, "Psychotronic," "Bang!," and "Vroom."

The number and variety of Scarecrow's video holdings would make it seem the paradigmatic example of the specialty video store, like a materialization of the Platonic ideal. Yet these same qualities make it totally anomalous; there is no video store anywhere that does what Scarecrow does. If all the specialty stores analyzed in this chapter are video capitals, then Scarecrow is a video mecca. Since it opened in 1988, the store's reputation has grown apace with its collection. A story from 1990 in the *Seattle Times*, for instance, discussed thirteen video stores across Seattle, Scarecrow among them; it noted that the store had "the best foreign film selection in the city," as well as "all 49 of Alfred Hitchcock's films, a large selection of silent films and plentiful imports from Canada and Japan."[11] By 1993, Scarecrow's reputation led another writer to assert, "What Ballard means to computers and Macy's means to holidays, Scarecrow means to video."[12] By the mid-1990s, "Scarecrow's fame was widespread," and in 1999, *Video Business* stated that Scarecrow, along with Kim's Video in New York and TLA Video in Philadelphia, had become a "landmark" as a result of its "eclectic approach to video purchasing."[13] In 2001, *Premier* named Scarecrow the "best video store in the country."[14]

Scarecrow's collection has made it more than a simple landmark; rather it is a destination with deep cultural significance. One writer referred to Scarecrow as "the Alexandria Library of offbeat flicks" that "draws pilgrims

from points near and far."[15] A Scarecrow worker estimated in 1993 that the store had 22,000 customers, some of whom came from "as far away as Alaska, Canada, and California."[16] Numerous celebrities and public figures associated with movie culture have visited the store since it opened, including Bridget Fonda, Winona Ryder, John Woo, Bernardo Bertolucci, and Roger Ebert, and these visits were referred to regularly as "pilgrimages" in the press.[17] Perhaps the most famous visitor was Quentin Tarantino, who walked miles to the store from his hotel room across town and incurred a severe sunburn along the way.[18] Further, Scarecrow carved a space for itself in the imaginations of specialty video clerks in far-flung parts of the country. Byron Cumbie, former owner of Video Culture in Murfreesboro, Tennessee, made a point of visiting Scarecrow Video while on vacation in Seattle. Scarecrow is more than a video store and more than a landmark; it is cultural symbol of video store greatness.

George Latsios, by all accounts a movie fanatic with an idiosyncratic personality, was the man who shaped Scarecrow's collection and its cultural status. Born in Greece in 1958, Latsios grew up without television, but he and his family attended the local movie theater every Sunday.[19] After he and his family moved to Pennsylvania when he was ten, Latsios dreamed of opening a movie theater; he became an avid collector of movies when he was nineteen, following the advent of home video.[20] In 1983, after graduating from Pennsylvania State University and getting married, he and his wife, Rebecca Soriano, moved to Seattle.[21] Latsios entered the video business in 1986, making his personal collection of Italian cannibal films and other obscure genres available on consignment at a small video store near the University of Washington.[22] Two years later, he and Rebecca opened Scarecrow Video as an independently owned business. Located in the Latona neighborhood, about two miles north of the university, Scarecrow initially held around six hundred movie titles.[23] In 1993, the store moved to its current location on Roosevelt Avenue to accommodate his collection, which had grown to eighteen thousand titles.[24]

From the very beginning, George Latsios aimed to make Scarecrow the "absolute best video store in the world," one that reflected his own tastes in obscure movies and also served the eclectic tastes of Seattle moviegoers.[25] Joshua Greenberg, James Lardner, and Frederick Wasser note the inventiveness of the early pioneers of the video rental business.[26] Although he did not invent video rental, Latsios's contribution to video culture seems similarly profound. He reconceived the scale, scope, and status of the video store well after video stores were already common across the country. Latsios's passion for quality cinema can even be seen in the name of the store, which

derives from two sources. First, and perhaps in an acknowledgment of Latsios's lack of commonsense, Scarecrow is named after the *Wizard of Oz* character who desires a brain. Second, Latsios named it Scarecrow as a way of scaring off "bad movies," having been told by his grandmother that scarecrows kept bad things away from crops.[27] Thus the offerings at Scarecrow were always aimed at creating a sense of "value," where value is based on eclecticism and distinction. Latsios's commitment to the store bordered on fanaticism, leading him to travel "to Japan and across Europe in search of rare videotapes."[28] According to one Scarecrow worker, "George bought *everything*," and indeed, the store largely reflected a completist mentality during the years that Latsios ran it. By 1995, it was reported that the store had 26,000 videos, and by 1997, the collection had grown to 34,000, making Scarecrow one of only eight video stores in the country to have more than 25,000 movie titles at that time.[29] In an effort to make the store even more of a center for cinema culture, the owners installed a theatrical screening space on the second floor of the building; this theater was eliminated some years ago.[30]

Although Latsios had a passion for making Scarecrow the best video store in the world, he did not have a prudent sense of economics. By the mid-1990s, Scarecrow was deeply in debt; in 1997, Latsios filed for bankruptcy.[31] Rebecca Latsios explained, "When there were a lot of good movies coming out, we were bad about paying taxes."[32] The tax burdens were compounded by medical expenses when George was diagnosed with a brain tumor in 1995.[33] Rather than slow down after his diagnosis, Latsios devoted more time to the store and spent money somewhat recklessly.[34] Debt eventually forced him to put Scarecrow up for sale, albeit with great regret.[35] As one longtime Scarecrow worker recalls, those were "very tense times." The store was rescued when it was sold to two Microsoft employees and Scarecrow customers, Carl Tostevin and John Dauphiny, in 1999.[36] Although neither of them had worked in retail before, they felt compelled to "save" the store and continue its mission.[37] Latsios continued to work at the store for a few months in order to facilitate the transition but eventually returned to Greece, where he died in 2003.[38] Despite this loss, Scarecrow survived the difficult times of the late 1990s. With its visionary founder gone, Scarecrow's new owners aimed to "keep George's dream and legacy alive."[39]

George Latsios created the idea that Scarecrow had a mission and a legacy to uphold, and the current owners and workers continue in this spirit. Having spent three days observing Scarecrow's operations and interviewing more than ten of its workers, I can say that these people demonstrate a devotion to the store that transcends its material and economic functions.

Collectively, these people treat Scarecrow as something greater than it is, perhaps actually making it something greater than it is. Like religious acolytes, Scarecrow's employees treat working at the store as a "higher calling." "I will never have another job like this, ever," one clerk declared, "It is a special place . . . like a second home." Another clerk, who has worked in video stores intermittently since the early 1980s, stated, "It's a crap video store job, but it is the best crap video store job in the world." When asked what he liked about his job, a particularly committed clerk said that he felt "blessed" for having the chance to work at the store. "This place is church to me," he said. The store's director of marketing expressed having a feeling of comfort simply when walking into the store, stating that the library-like stacks and aisles of videos made the store feel "homey" to her.

Scarecrow's workers regularly speak in reverential terms about the collection itself. The buyer for the store asserted that Scarecrow represents the best movie collection in the world, perhaps better than the Library of Congress. A floor manager said that, in addition to interacting with customers, he liked having "access to this archive of film, which is unparalleled as far as I can tell." He also said that if he won the lottery, he would give half his winnings to the store to ensure its future. Similarly, a clerk said that he worked at the store so that he could have "unlimited access [to the collection] for as long as possible." He stated that he liked "getting to play with my toys [i.e., movies] all day" and that working there has allowed him "to devote all my time and essentially my life to something I adore."

In fact, these workers show a devotion to the store that appears unshakable. Although there was 95 percent turnover in Scarecrow's workforce during the "tense times" of the bankruptcy and sale, most of the current employees have been there for eight years or more.[40] Some workers have been there for as long as twenty years; "the new guy" has worked there since 2005. A number of the workers, mainly the clerks and floor managers, discussed the fact that they did not make much money (a number of Scarecrow's clerks have second jobs). "I don't like working in retail, I like being in this place, . . . and I manage to make a living at it," said one clerk. He followed this up by saying, "The emotional payoff is what works for me. I certainly don't make as much money as I'd like to make. But who does?" One worker admitted, "No one here has gotten a raise in a while," but added that this was "okay" because all the workers loved movies, and, more practically, they are provided with health insurance coverage. Some workers speculated about what life would have been like had they chosen a different line of work. The buyer, for instance, who has worked at Scarecrow since 1992, watched a number of acquaintances earn fortunes working at

Amazon.com, which has its headquarters in the city. But he expressed satisfaction at being "dug in" at Scarecrow. "I could have made more money had I worked elsewhere," he said, "but the payoffs [working at Scarecrow] are great." Another worker said, "What I gained from [working here] is going to a job every day that I don't hate. . . . That is priceless."

In addition to having a deep emotional connection to the store and its collection, Scarecrow's workers have formed deep bonds with one another. Everyone that I spoke with described the sense of social connection among the store's workers. The store's accountant, perhaps the most pragmatic-minded worker I spoke with, described the employees as a "club." A floor manager said that Scarecrow's workers are "all friends," and another described how employees regularly hang out, drink beer, and discuss movies outside of work. One clerk said that she liked being surrounded by "like-minded" people. More strikingly, there are two married couples working at the store. In fact, George Latsios officiated at the wedding ceremony for one of Scarecrow's clerks, having been ordained on the Internet earlier that day. A handful of Scarecrow workers said that they were "a big family," and, indeed, the level of social and emotional bonding among these people is surprisingly deep, making "family" seem like more than a metaphor.

Many of Scarecrow's workers are from Washington, particularly the Seattle area. But others come from across the country, including Illinois, Pennsylvania, and Michigan. Many of these transplants had heard about Scarecrow before moving to Seattle, and a few of them even aimed to work there on arriving in town. The store's workers range in age, as far as I can tell, from their mid-twenties to their early fifties. Despite the diversity among them, however, most Scarecrow workers have a background in film and media culture that informs their work. A number of them have worked in video stores since the 1980s, and a few others worked at movie theaters. Several clerks had taken film classes in college, and at least two had degrees or certificates in filmmaking. In a few cases, the workers had no formal training in film studies but rather had participated in a somewhat rarefied "film scene." For instance, Kevin Shannon, the general manager at Scarecrow, remembers watching movies endlessly on television and attending numerous double features as a kid in Seattle. As he got older, he would rent 16mm prints of classic films from the library to watch at home, and he and his brother, who eventually became a film critic, regularly attended screenings of classic and foreign films at the repertory theaters in the area. Similarly, Mark Steiner, the buyer for the store, ran a cinema club that screened 16mm and 35mm films when he was a student at Michigan State University in the 1980s.

Thus all these people came to Scarecrow with a significant interest in and knowledge about cinema. Most of them, however, claim that their "real" film educations were attained by working at the store. One employee stated, "I look at the things I used to be interested in and I liked to talk about then, and I feel that I was naive. I am a lot smarter now, at least about movies." Similarly, the buyer for the store said that the cinema education he has gotten from working at Scarecrow leaves him "speechless." One worker described his interview for his job: it involved being questioned by six people about film history and then asked to play "the potato game," where one makes as many cinematic connections to an actor or film as possible, not unlike the "Six Degrees of Kevin Bacon" game. This potential employee was asked to demonstrate a quick ability to draw from a wide range of film history facts in order to prove his ability to contend with the store's holdings and the cinematic knowledge already possessed by its workers.

Scarecrow workers draw on and accumulate their video capital in their daily routines, recirculating and building this capital through their interactions with one another and with Scarecrow's patrons. In addition to talking about movies while socializing outside of work, these people "talk movies" all day long with one another, refining their knowledge during intermittent, semicompetitive conversations. One worker said that working at Scarecrow was "like playing a game of trivia all day." And just as these workers build and refine their knowledge of cinema, they appear to refine their tastes in movies and genres. There seems to be a social force that pushes these people toward increasing particularism in their tastes, sometimes to the point of obscurantism. "Everybody who works here is some sort of movie cultist," said one clerk. Almost everyone I spoke with reiterated this sentiment. "We have all of these crazy people working here, and they are into their own thing," said a member of upper management. "I have a great resource with this staff."

This statement also suggests how the workers at Scarecrow incorporate their knowledge of and tastes in movies into their daily work. More than one worker acknowledged that some customers are overwhelmed on first entering the store, confronted by its size and arrangement and abundant supply of movies to choose from; one worker referred to the wide-eyed "Scarecrow look" that some customers get. (I was a bit dazed myself.) Other workers acknowledged that the store's arrangement of videos into so many categories can make browsing difficult and unintuitive—"especially for 'normal' people," said one worker. Another clerk stated, "I thought [the store's organization] was great, because if you're into a director, here's all

their films, or here's some really specific genre. It makes sense to me." But he added, "If you were used to going to some normal video store, it really might not. But that's why we have people here to help with that." Thus the clerks are perhaps more vital to the operation of Scarecrow than at other stores; because they are internally "aligned" with the material organization of the store, they are able to assist the numerous browsers and customers who are not. Scarecrow's accountant posited that the clerks contributed significantly to the value of the Scarecrow experience, saying that the film knowledge of the clerks helps "educate the customer." More than simple clerks, Scarecrow's workers help guide browsers through the space and, ostensibly, endow them with a new and better understanding of cinema. Some clerks suggested that the space of the store could provide an educational experience simply through its organization. One clerk stated, "Hopefully people get used to [the organization] and see the logic in it and actually like it." Maybe, he continued, it could "help them appreciate the films and help them see films they might not have seen otherwise."

Given the scale and complexity of Scarecrow's operation, the workforce is large and has a rigorously defined managerial structure. As of early 2013, there were twenty-seven employees, including ten full-time floor staff and seven people in administrative positions. There were also a number of part-time clerks and managers, as well as a handful of people working at the coffee bar. Although the store had managers during the time that George Latsios ran it, one longtime Scarecrow worker admitted that "George was an autocrat" who made decisions unilaterally and often refused to take input from others. During the period that the store was in bankruptcy, the store's accountant implemented a new managerial structure, which is still in place today, in order to streamline the store's finances and appease the lawyers and judges overseeing the store's repayment plan. This accountant holds an MBA and has overseen Scarecrow's finances since the mid-1990s. Where the other workers might be motivated by cinephilia, the accountant is driven by an economic logic. "My thing is money," she said. The store's general manager, who has worked at Scarecrow since 1995, oversees all large-scale, "big picture" issues (figure 18). In addition to dealing with staffing and the store's bottom line, the GM stays abreast of the state of the video business, anticipates and reacts to problems that affect the store's operations, and explores innovations in Scarecrow's business model.

There are three administrative-level workers who contend intimately with Scarecrow's vast collection. As mentioned, Mark Steiner has worked at the store since 1992 and has been the store's buyer since 1993. According to him, the store had about 10,000 movies when he started, and it now has

FIGURE 18. Kevin Shannon is Scarecrow's general manager. He makes strategic decisions amid stacks of VHS tapes and DVDs.

over 110,000 titles.[41] The store has two inventory managers; one handles all the acquisitions, and the assistant organizes all the movies within the space of the store. The primary inventory manager functions in many ways as an acquisitions librarian might at a major public or university library, processing every video that enters the store. This includes entering information about each movie into a computer database as well as sorting individual titles into one of the store's many categories. Thus this position entails making value judgments about the "meaning" of a movie so that it can be placed on the proper shelf. The inventory manager appears to use two methods to make these decisions. First, she makes associations between the video being processed and other videos in the store; if it is like the movies in a given section, she places it with these similar titles. Second, she anticipates where customers who would watch the specific film would most likely look to find it. In this respect, the inventory manager synthesizes her understanding of the existing collection with individual movie titles *and* with projections about the desires of Scarecrow's browsers. The assistant inventory manager is responsible for placing all arrivals on the proper shelves and maintaining the physical placement of the videos around the

store. If the inventory manager knows *what* all the movies are, then the assistant knows *where* they are. For him, perhaps more than any other person, the importance of all these movies, all these genres and categories, is primarily a spatial matter. Finally, Scarecrow has a marketing coordinator who manages all the store's advertising, promotions, partnerships, sponsorships, and related cross-promotions. In addition to creating and placing all the store's advertisements in print, on radio, and online, this person runs the Scarecrow website and organizes DVD reviews, which are written by members of the Scarecrow staff and published in a weekly newspaper.

One of the most significant ways that Scarecrow has localized movie culture is in its partnerships with other cinematic institutions in Seattle. In addition to hosting various film series and filmmaker visits in its theatrical space, in the 1990s the store organized a film series at the OK Hotel, where they screened sex hygiene films and other cult movies.[42] It also has a partnership with a local gay and lesbian film festival. Most significantly, Scarecrow has maintained a year-round partnership with the Seattle International Film Festival (SIFF), helping to foster a city-wide movie culture with a particular interest in foreign cinema. For years the store has donated money to Cinema Seattle, the nonprofit that organizes the festival, and it has cosponsored visits by renowned filmmakers such as Peter Greenaway and Todd Haynes.[43] In addition to monetary support, Scarecrow provides free video rentals to SIFF staff.[44] Scarecrow promotes the festival in advertisements in the store and in the newsletter.[45] In exchange for this support, Scarecrow receives festival perks, including free passes and advertisements at festival screenings.[46] Although the relationship between Scarecrow and SIFF has experienced moments of tension, their ongoing mutual support has helped to create a "virtuous circle" of both economic and cultural capital.[47] As one writer put it, Scarecrow "changed the landscape of the city and helped fuel the perception of Seattle as a movie lover's paradise."[48]

Although Scarecrow grew out of George Latsios's expansive vision for video culture, which its current owners and employees sustain, it intersects necessarily and vitally with Seattle's larger cultural milieu. Scarecrow simply could not exist were there not a cinephilic population in Seattle large and enthusiastic enough to support it. Although the larger metropolitan area has a population of over three million, Seattle is a small city, with a population of just over 600,000. More important, it is a wealthy and well-educated city. The median household income is around $60,000, and over 50 percent of the population holds a bachelor's degree; 20 percent of the population has a graduate or professional degree.[49] When asked about

Scarecrow's location in the University District, Kevin Shannon said that he did not think there was a "direct relationship" between the two institutions. He stated that college students are not consistent in their rental habits, but North Seattle has a large number of university alumni and "educated people" in general. In his estimation, Scarecrow caters to people who wield significant official cultural capital.

The buyer similarly claimed that the store serves the high number of "educated people" in the area. He even asserted that Scarecrow's collection was a reflection of Seattle's tastes. "Look at the biggest sections," he said. "This is a perfect extension of the city." For instance, he said, the large "Anime" and "Hong Kong" sections reflect the city's high percentage of East Asian people as well as a general interest in Asian culture among Seattle's residents. Similarly, he said, "Seattle is filled with Anglophiles," and consequently Scarecrow has a huge number of British films and TV series. Thus, however much Scarecrow has served as a mecca that draws browsers and pilgrims from a wide area, it would appear that the store is deeply embedded in the social and cultural context of Seattle and the University District more specifically. Although employees estimated in 1999 that "70 percent of Scarecrow's core customers travel more than five miles to rent movies at the store," Carl Tostevin's wife, Mickey, stated that now Scarecrow is "mostly a local business."[50] She said that around 2006 they surveyed the transaction records looking at customer's addresses and found that about 60 percent of their revenue came from customers who lived within one mile of the store, 30 percent from the greater Seattle area, and the remainder from people who lived more than fifty miles away. Although this is still a high number of "destination" shoppers for any local store, these figures do indicate a concentration of activity within a small geographic area.

All this suggests that Scarecrow has intersected with and even shaped Seattle's cultural identity in important ways. The city is most prominently known for a handful of things: it is home to Boeing, big tech industry centered on Microsoft, and long tail retail giant Amazon. Yet the city's association with these and other high-tech businesses is intertwined with an alternative subculture, most notably represented by the grunge music scene in the late 1980s and early 1990s. (Kurt Cobain and Courtney Love frequented Scarecrow in the early 1990s.)[51] Scarecrow contributes a cinematic element to Seattle's association with a vibrant, nonmainstream, nonconformist culture. This association is further augmented by the fact that Something Weird Video, the largest distributor of camp, exploitation, and mondo videos, has operated out of Seattle since the company's inception in 1990. In

many respects, Seattle has been an underrecognized cultural capital, where the high finances of its high-tech economic base mix with a cultural economy that valorizes music and movies from outside the mainstream. Given its current owners and its immensely diverse movie selection, Scarecrow Video embodies Seattle's economic and cultural admixture.

Despite its cultural significance, Scarecrow has experienced some of the economic difficulties that have plagued the video rental industry at large. Very few of the store's clerks mentioned any problems, and the store appeared to do brisk business during my visit in February 2012. Yet almost all the store's upper management spoke in somewhat gloomier terms, acknowledging that business is not what it once was, especially since a "boom" time in the early 2000s. Mainly these people related this decline in revenue to their daily work. For instance, this new economic reality has forced the store's buyer to become more careful choosing titles; although he never really bought "everything," despite George Latsios's desires, more recently he has been pondering whether a video will make its money back in rental revenue, something he rarely considered before. In conversations with Kevin Shannon following my visit, he stated that the store's employees offered to take a pay cut in light of the declining rental revenues, but Scarecrow's owners refused this offer. Instead, all the workers got a small raise after the state of Washington raised its minimum wage. Some workers have left the store since I visited in 2012, and these positions have not been filled.

Most interestingly, it appears that Scarecrow's cultural status has had an ironic effect on its contemporary economic situation. Many workers acknowledged that Scarecrow is beloved by its customers and held in high regard throughout the city. Some workers stated they were treated "with respect" in public when people discovered they work at the store. Yet several upper-management staff members said they are finding that people say "I love Scarecrow" but do not actually rent movies at the store; it is a landmark in these people's minds but not in their daily lives. As one worker put it, "People really do value us, but they don't necessarily spend their money here"; and another stated, "Everybody thinks everybody else is coming in." One worker said that because so many other video stores have closed in the area, people assume that Scarecrow must be doing extremely well because they are still in business and no longer have this competition. This suggests that Scarecrow's prominence as a cultural institution could actually have *harmful* effects on its continued financial success. The store lives more in the virtual space of people's memories and imaginations than it does in their daily activities, and this virtual prominence threatens the store's continued existence in material space. To whatever extent it operates as a cul-

tural symbol, or even as a video mecca, Scarecrow Video is tied to a real, money economy. Religious sites maintain their holy status through the continued support of devotees and a steady flow of pilgrims. It remains to be seen how Scarecrow's intangible "spirit" will continue operating in the new economic reality of the video industry, where there is an increasing emphasis on ubiquitous shopping and intangible consumption.

CITY OF QUIRK: SPECIALTY VIDEO STORES IN THE LOS ANGELES AREA

An examination of specialty video stores in a conventional media capital like Los Angeles further illustrates how video capital runs parallel and sometimes counter to mainstream movie culture. Yet these businesses still coordinate their operations with the media industry in general and with Hollywood in particular. Los Angeles, of course, is an immense and complicated city. The second largest city in the United States, it is characterized by incredibly rapid growth during a relatively short historical period, an enormous geographic spread, extreme disparities in wealth, and significant ethnic diversity. In fact, Los Angeles's size, complexity, diversity, and cultural volatility has made it an important touchstone in the development of the field of cultural geography, serving as an eminent example of postmodern space.[52]

Despite the city's complexity and fluctuating cultural identity, it remains strongly associated with the American media business and all its cultural baggage; Los Angeles and "Hollywood" are regularly conflated. Admittedly, for all that Hollywood has operated as a global industry, the city of Los Angeles remains vital to its operation.[53] Not only is Los Angeles central to the industry's managerial-level coordination of labor and finances, over 100,000 people throughout the greater Los Angeles area ("the Southland") work in some facet of the movie business, indicating that the movie magic of Hollywood is a prosaic, lived reality for many people in this city.[54] Allen J. Scott, in particular, has looked at the geographic and economic relations between Hollywood and Los Angeles, observing how the geographic clustering of the major film studios in this region has engendered the growth and clustering of companies that, in their coordinated totality, constitute "Hollywood."[55] Servicing the studios through subcontracted labor, these specialized companies (talent agencies, prop houses, digital effects firms, etc.) dot the Los Angeles landscape and employ a large number of local residents. Moreover, Los Angeles is home to the world-famous film schools at the University of Southern California, the University of California,

Los Angeles, and the American Film Institute. The city is not only home to the production culture of the American movie industry, but also a significant part of its "reproduction culture" comprising thousands of industry aspirants.

Partly as a consequence of this centralization of media resources and labor, the Los Angeles mediascape is characterized by clustered media consumption. With a huge number of theatrical screens, including a comparatively high number of repertory and art house theaters, Los Angeles offers a perpetual wealth of cinematic offerings. And although the home video industry decentralized movie distribution in a general way, Los Angeles has also been deeply affected by the video rental industry. As Lardner, Wasser, and Greenberg have detailed, Los Angeles is likely the site of the birth of the video rental business, when George Atkinson opened his video rental store a mere month after Andre Blay first made Hollywood movies available on magnetic tape.[56] Atkinson educated a huge number of budding entrepreneurs in the business of video rental and even franchised his video store, the Video Station, throughout the Los Angeles area and beyond.

Although it is difficult to quantify the number of video stores in Los Angeles during the 1980s, many people who lived there at the time testify to a legion of stores in the area. A *Los Angeles Times* article from 1986 quipped, "Video stores have been popping up around Southern California like toadstools after a rain. Most are small, neighborhood operations."[57] Similarly, a video industry veteran, who spent the early 1980s opening 20/20 Video locations throughout the area, states, "There were video stores on every corner in Los Angeles . . . video stores everywhere you went. And they were all doing business." Likewise, Vidiots owner, Patty Polinger, recalls that "there were zillions of video stores" when she opened her store in 1985. The success of video rental stores in Los Angeles is somewhat unsurprising, as the city is infamous for its sprawl. Unlike New York and other densely structured cities, Los Angeles is spread across an enormous geographic area, interwoven by countless roads and freeways jammed with traffic. It makes sense that video stores would be popular in such a context, as they provide people with a casual and convenient means of accessing movies without the need for a lengthy excursion.

Largely contrasting with "Hollywood," Eddie Brandt's, Vidiots, and Cinefile have been important parts of the video culture in this city. Although these stores distinguish themselves from contemporary Hollywood movie culture, they interconnect with much of the same social and cultural realm that produces Hollywood. As Los Angeles remains central to media produc-

tion in the United States, these stores serve a customer base more aligned with the production and circulation of media products than populations found in other cities. Indeed, whereas specialty video stores are characteristically located in areas with educated populations and a number of traditional cultural institutions, Los Angeles offers a particularly large community with a vast amount of cinematic knowledge and a preponderance of important and official cinematic institutions. In this respect, the subcultural capital circulating through these specialty video stores contrasts not only with the culture of the city at large but also with the official cinematic culture of Los Angeles. Thus these stores largely appeal to the large population of cinephiles living in the city but offer them nonmainstream forms of media. But these two realms overlap considerably in Los Angeles. Thus, in addition to cinephiles and intellectuals, these specialty stores have also served as resources for media industry workers. Even as they distinguish themselves from the mainstream movie culture in the area, each of these stores differs from the others. Sometimes this is the result of generational differences, both in terms of the age of the owners (Eddie Brandt was born in 1920, while the cofounders of Cinefile are members of generation X) and in terms of the era in which they opened for business (Eddie Brandt's began renting movies in the 1970s, Vidiots in the 1980s, and Cinefile in the late 1990s). These three different "video generations" are not only constituted by their owners' relationship with movie culture but also by the ways in which they serve a local Los Angeles renting population.

Eddie Brandt's Saturday Matinee is a modest business set amid the urban sprawl of the San Fernando Valley. The hand-painted murals on its exterior, featuring quirky renditions of characters and moments from Hollywood films, are perhaps the only indication that this structure has some relation to the movie business (figure 19). Its interior is overrun with racks of DVDs and shelves of stacked VHS tapes. And if it appears unassuming and even a bit haphazard, this is likely the result of its somewhat haphazard history; Lucas Hilderbrand has called Eddie Brandt's an "accidental institution."[58] Originally opened in 1968 as a thrift store, Eddie Brandt quickly began selling movie memorabilia as an extension of his personal hobby collecting such material.[59] Brandt grew up in Southern California and worked at various movie theaters before spending some years in media production, first with Spike Jones and then as a writer for Hanna-Barbera cartoons.[60] Although the business of selling movie posters, lobby cards, and other material grew through the 1970s, Brandt ventured into video rental in 1978.[61] In the mid-1980s Brandt made more money in film stills than in video rental, but his wife, Claire, recalls that as video

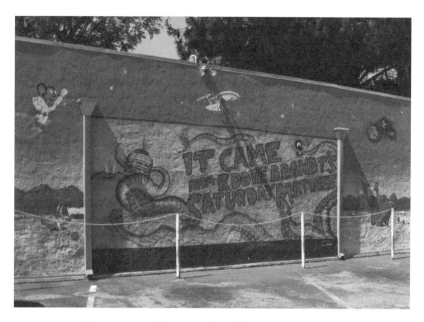

FIGURE 19. This zany mural distinguishes Eddie Brandt's Saturday Matinee from the sprawl of the San Fernando Valley.

rental accounted for an increasing amount of the store's revenue, the amount of space devoted to videos grew, displacing the thrift shop material and pushing the movie memorabilia into the expansive back offices.

Brandt aimed to differentiate his store from more generic video stores from the start and let his tastes for classic Westerns and other genre movies help shape the collection. Due to the idiosyncratic and somewhat obscure tastes of the owners, over time the store accumulated an incredibly large and wide-ranging selection, with strong holdings of classic, B genre pictures as well as an immense number of television programs; a 1991 story reported that the store had "an entire shelf of 1930s and 1940s shorts," as well as fifteen hundred silent films.[62] The store has an immense number of VHS tapes to this day, including many movies and programs that were never released on DVD. In fact, a major part of Eddie Brandt's appeal is that the owners and managers dedicated themselves to finding rare or out-of-print materials, no matter what the cultural "value" of that material may be.[63] Eddie Brandt's holdings include a huge number of movies and television programs that never got a commercial home video release; the value of these texts derives more from their (video) scarcity than it does aesthetic accomplishment or cultural renown. A vast number of these are movies

that the owners recorded off of television, and many others are recordings of classic television, referred to as "loaners" but effectively bootlegs. The store makes this semisecret treasure trove of around seven thousand unique video titles available for free to customers; if you rent a movie from their official selection, you are able to take one of the bootlegs home at no charge.[64]

Eddie Brandt's Saturday Matinee offers an enormous collection of videos. By 2002, it was estimated the store had over 59,000 video titles, and in 2009, the store offered 55,000 VHS and 14,400 DVD titles.[65] In combination with its immense holdings of movie memorabilia, which includes three million posters and "22 tons of lobby cards," Eddie Brandt's constitutes a significant cinematic archive.[66] Although the store has many foreign films and documentaries, it differs from most other specialty stores in being dedicated to American-made cinema and, vitally, television. Here, historical depth and rarity are valued more than exoticness, obscurity, or refinement. Also, unlike many specialty stores, Eddie Brandt's does not feature detailed or highly particularized movie categories. Instead, its videos are categorized according to such general descriptors as "VHS," "DVD," "Movies," and "Television." Rather than cultivate distinction based on rarefied notions of cinematic or cultural quality, Eddie Brandt's distinguishes itself primarily by being comprehensive, with more mainstream, historical, and subcultural fare.

Assembling this collection in North Hollywood has proven strategic to the store's financial and cultural operations. Like Scarecrow Video in Seattle, Eddie Brandt's has been referred to as a "mecca" and has inspired numerous pilgrimages by everyday cinephiles as well as media celebrities like Hugh Hefner and Quentin Tarantino.[67] Claire Brandt asserted in 1996 that the store had customers who lived as far away as Oceanside and Santa Barbara, roughly forty and eighty-five miles, respectively, demonstrating how wide an area the store served at the time.[68] Just as much as Eddie Brandt's Saturday Matinee might cater to the movie consumption habits of local cinephiles, both famous and not, the store's location in the Los Angeles area has served the reproductive needs of the media production industry. Indeed, Eddie Brandt's is widely heralded as a cultural memory databank for media industry workers, students, and experts, prompting one writer to call it "an unofficial Hollywood research library."[69] Screenwriters, animators, set designers, and all manner of other industry workers have patronized this store with the specific purpose of gleaning ideas for their own work.[70] Beyond these many individual cases, Disney, Universal, and other major studios use the store as a reference library so frequently that they

have corporate rental accounts.[71] The studios regularly use the store's collection to examine films that they plan to remake or otherwise borrow from.[72] All this suggests that Eddie Brandt's helps perpetuate the Hollywood production system, even if to a small degree. By storing and making available countless American films, cartoons, and television programs, Eddie Brandt's produces a certain historical vision of "Hollywood," which in turn has helped the media industry reproduce itself.

Whereas Eddie Brandt's Saturday Matinee began operating at the beginning of the video rental era and has a collection that demonstrates an appreciation for classic film and television, Vidiots, in Santa Monica, opened for business amid the explosive growth of mom-and-pop video stores in Los Angeles and across the country. Founded by Patty Polinger and Cathy Tauber in 1985, Vidiots positioned itself as a specialty store from the start by offering a rarefied understanding of "quality cinema." This distinction results from the tastes and strategic thinking of its owners. Before opening Vidiots, Tauber worked as office manager for Frank Zappa and Polinger worked in international distribution at MGM; in other words, both women worked at the fringes of the mainstream media industry. Frustrated with these jobs, the two women saw the booming home video industry as a means to gain autonomy. Their tastes ran to "good film" and edgy culture more broadly, and they were unsatisfied with the video rental stores in the area, but they knew nothing about the retail business. After reading a story in *Esquire* about New Video, a specialty video store in New York, they researched this store as well as Captain Video, a specialty store in Berkeley, and hired the owner of Captain Video to help them organize their store and make arrangements with distributors.[73] Within months of quitting their jobs and opening Vidiots, the press was already discussing the store as a key resource for obscure video titles, and it has maintained this reputation ever since.[74]

Like Eddie Brandt's, the exterior of Vidiots has hand-painted, cartoonish murals of characters and scenes from recognizable movies, while the interior is somewhat unremarkable; one writer described Vidiots, accurately, as a "nondescript store featuring concrete floors and wire racks with handwritten shelf talkers."[75] Yet if the look of the store is ordinary, Vidiots is remarkable for its video collection and its system of movie classification.[76] In many respects, in fact, Vidiots is a prototypical specialty video store. It offers an abundance of classic, silent, foreign, and contemporary American independent films and is organized primarily by director (figure 20). It blends highbrow sections, such as an extensive collection of Shakespeare adaptations, with lowbrow cult movies, in such sections as "Shag" and "Joe

FIGURE 20. Vidiots expands the range of video rental culture by offering experimental films, among many other obscure genres.

Bob Briggs." Some sections suggest a certain antiauthoritarian mentality and a taste for political activism. Vidiots features especially large selections of music films, including "Punk" and "Reggae" subsections; an extensive collection of experimental films, including works by Stan Brakhage, Nina Menkes, and Harry Smith; as well as a substantial area for gay and lesbian films. Vidiots' "Documentary" section is one of their largest, and is organized by director (one of the very few stores I have seen divide documentaries in an auteurist fashion) or by subject matter. Sections here include "Harun Farocki," "Frederick Wiseman," "Noam Chomsky," "Native American," "Philosophy," "The Environment & Hemp," "War Docs," and "9/11," among many others.

Although specialty stores around the country have comparable holdings and categories, these same qualities make Vidiots particularly distinguished in Los Angeles. Not only are many of these films produced outside the Hollywood system, but many of the genres (experimental, political documentary, etc.) actually seek to undermine the hegemony of Hollywood cinema in particular and mainstream culture in general. David James has characterized the nonindustrial cinematic productions in Los Angeles as comprising a number of "minor cinemas" that together pose a dialectical negation of Hollywood's aesthetic and geographic relations with the city.[77] Along these lines, Vidiots works alongside the art house theaters and community-run screening spaces that exhibit such non- and anti-Hollywood

films within Los Angeles to help sustain this "minor cinema." As much as it relies on the centralization of media capital in this city, and thus is intertwined with Hollywood and its production culture, Vidiots counter-poses the cultural priorities of that industrial formation, helping foster a minor cinematic culture in the area.

From its beginnings, Vidiots was positioned as a social and cultural center as much as a video store. For several years during the 1980s, the store featured an espresso bar, which not only lured patrons who were not inter-ested in video rental but also provided an opportunity for customers to loiter, socialize, and discuss cinema. Indeed, the store has long been associ-ated with discussion and debate among the owners, clerks, and customers.[78] A story from 1988 stated that Vidiots was "a multimedia headquarters for the avant-garde, a place to have heated discussions."[79] Vidiots' owners and managers regularly held cultural events in the location. Although a handful of these events celebrated mainstream media figures, such as Paul Verhoven, they more typically upheld a punk rock, avant-garde, or anti-Hollywood mentality. The store hosted a polka party for Les Blank in 1986, for instance, and the advertisement for this event referred to him as a "renegade inde-pendent filmmaker."[80] Similarly, Vidiots hosted a discussion and reception with the filmmaker Kenneth Anger later that year; the advertisement for this event noted both his "underground" films and his books about Hollywood scandals.[81] More recently, the store has been the location for the annual PXL THIS festival, which features works made on the PXL-2000, the low-resolution video camera originally intended for kids but taken up by numerous lo-fi video artists.[82] They have also held events for perform-ance artists, poets, and musicians, including the punk band X and a spoken-word performance by the actor Viggo Mortensen.

In having this selection of videos and hosting such events, Vidiots became an important landmark in Los Angeles.[83] Polinger recalls getting customers from Santa Barbara and other far-flung parts of Southern California, saying Vidiots "was a destination." Like Eddie Brandt's, Vidiots attracts a large number of film students and media professionals, including actors, cinematographers, and production companies, who use the store as a research archive.[84] They also get business from advertising agencies that want to appropriate certain film moments and cinematic styles in their work. Thus, despite its anti-Hollywood leanings and thoroughly eclectic selection, Vidiots appears to have become a resource for the reproduction of Hollywood itself. Further, the store has been patronized by a number of film critics who live or work in the area, including Joe Mortgenstern, Richard Schickle, Kevin Thomas, and Kenneth Turan; the owners remember

John Powers being a particularly chatty customer. Like these critics, who make their livings being educated about and critical of Hollywood films and cinema more broadly, it appears that Vidiots sustains a view of cinematic quality that does not subscribe to the total domination of Hollywood, from the geographic center of that industry.

Cinefile, in West Los Angeles, extends this logic further. Whereas Eddie Brandt's amassed an eclectic and "classic" selection of videos over its long history and Vidiots curated a relatively highbrow and distinguished collection that set it apart from the independent and corporate stores of the 1980s and 1990s, Cinefile distinguishes itself in its self-consciously anticorporate, antiauthoritarian attitude toward movie culture. The store's eccentricity appears to be generational. Store founders Hadrian Belove and Philip Anderson are both members of generation X, having been born sometime between the late 1960s and early 1980s, and grew up with the video store as a common feature of their worlds. Whereas Anderson studied filmmaking at the Rhode Island School of Design, Belove gained his film education exclusively through his years of work at different video stores, a career he began immediately after high school. Both men worked in video rental as an extension of their aspirations to become commercial filmmakers. Both men worked at Vidiots, in fact, an experience that helped expand and shape their tastes in movies toward increasing comprehensiveness and obscurity. After leaving Vidiots, Belove worked as a film editor and Anderson worked as an art preparer in galleries around the city, a job that he says influenced the design and organization of Cinefile. The two men decided to go into business for themselves and opened Cinefile in 1999 with two other former Vidiots employees, who later left Cinefile.[85] (As of 2008, Anderson was the sole owner of the store.)

Although Cinefile has all the standard highbrow cinematic fare that one would expect from a specialty store, the store tends to lean more toward the lower end of the cinematic spectrum than, say, Vidiots; in this respect, Cinefile is an alternative store (see chapter 2), but with its abundance of trash and paracinematic titles it displays a certain strain of the cult store.[86] Vitally, Cinefile opened just as DVD technology was being promoted by the industry. Although both Belove and Anderson observed that many video stores in the area were going out of business at this time, perhaps because their owners would not or could not invest in DVDs, their business activities as *new* video store owners were actually augmented by this technology. As DVD was sold at a cheaper price than VHS, the two men were able to assemble a large and eclectic collection of videos more rapidly and inexpensively than they would have if VHS had been their only option. By focusing on

DVD at the moment of its adoption by media consumers, Cinefile distinguished itself from stores that were more reticent to make this transition. Further, by amassing an eclectic selection of DVDs with particular strengths in trash cinema, Cinefile distinguished itself even from those video stores that did offer DVDs. Both Anderson and Belove discuss the fact that DVD allowed the store to grow as rapidly as it did, and Belove notes further that the high "quality" of DVD, meaning its resolution, made the technology appealing to cinephiles and, by extension, made the store appealing to this same population. In this respect, DVD served the store's cultural and commercial purposes.

Like Eddie Brandt's, Cinefile specializes in movies that aren't simply obscure, in terms of tastes, but also rare on video, including a large number of imports released outside the United States.[87] Because many of these imports are not Region 1 discs designed for the North American market, Cinefile sells region-free DVD players or helps customers find sources that do.[88] Belove stated that because buying imported DVDs is expensive, the store actually lost money on these titles. But it is the *lure* of rarity that gives them value; Belove said that the imports serve as "advertising for the rest of the store."[89] In addition, Cinefile's collection has a considerable number of bootlegs; according to Belove, acquiring these bootlegs was one of their primary goals and means of distinguishing themselves from Vidiots.[90] In cases where the copyright on a title is "murky," Cinefile loans the video at no charge.[91] In fact, the store has a host of nonindustry videos and home movies that it also offers for free. Anderson, who asserts that "most of the people who work here are collectors" of such nonconventional video material, takes pride in collecting and making available all manner of discarded or forgotten pieces of everyday video culture.

Cinefile's system of movie classification distinguishes it even more than its collection. Much of the store is organized by director and national cinema, but a host of sections are so specialized and particular that they most likely exist only here. In fact, Cinefile specializes in devising categories that challenge most cinematic conventions. Many sections found at specialty stores might appear absurd to the average video browser, like the "Hilljaxploitation" section at Plan 9 Film Emporium in Bloomington, Indiana, or the "Leviathans & Behemoths Who Threaten the Orient" section at Movie Madness in Portland, Oregon. Cinefile has sections that extend this tendency into the realm of deliberate absurdism. Among their more playful categories, they have a section called "Pregnant Men," which includes such films as *That Man Is Pregnant!* (1980) and, unsurprisingly, *Junior* (1994). Simply calling attention to such films by creating a section

FIGURE 21. The workers at Cinefile exhibit taxophilia, which compels them to classify everything, even the unclassifiable.

devoted to them provides a means for the store, and its customers, to simultaneously celebrate and ridicule the silliness of the Hollywood system that produced them. Somewhat similarly, the store has a section devoted to films that feature the actor Patrick Swayze called "Swayze Persuasion." Although many video stores feature sections for actors, they are typically more popular or acclaimed than Swayze. Further, the naming of this section suggests an irreverent camping of this actor in particular and of stardom more generally.

Extending this irreverence, the auteurs area of the store features an "Alan Smithee" section, the pseudonym conventionally credited to directors who wish to disassociate themselves from their films.[92] With such films as *Stitches* (1985), *City in Fear* (1980), and *A River Made to Drown In* (1997), this section creates a link among works from different genres and forsaken by their makers. In doing so, the store levels a subtle critique of the auteurist mentality that generates the directors' sections found throughout the rest of the store and which is typical of specialty video stores more generally. It upends the value system that generates the system of classification in which this subsection is found. Perhaps the fullest expression of Cinefile's attitude toward cinematic value, and toward the system of values that produces the shape and look of the typical video store, is a small section in the store labeled "Holy Fucking Shit!" (figure 21). Here one finds films that have been universally hated by critics (*Gigli*, 2003),

FIGURE 22. Cinefile sells T-shirts that take the names of great directors and make them resemble logos for punk rock and heavy metal bands. Here the name Ingmar Bergman is printed in the style of the logo for Iron Maiden.

that are culturally and industrially imponderable (*Heart Beat*, a collection of music videos by the actor Don Johnson released in 1987), or both (*Mad Dog Time*, 1996). The name of the section asks the browser, "Can you believe it?," and thereby calls into question the very logic of such divisions. An absurdity, this section points to the absurdity of the videos within it and classifies the unclassifiable as such.

With sections like these, Cinefile refutes standard systems of cinematic classification and presents a playful critique of the logic of "the video store," of Hollywood, and of the systems of cultural valuation that occur in those places. Cinefile puts the very idea of the video store in quotation marks. Anderson states, "You recognize that certain things are being marketed toward you, like the auteur stuff," implying that the classification system at Cinefile opposes the promotional logic of the industry. Although he says that "there's a part of it that is done to educate people[,] . . . showing people that there are these different genres," he also admits, "It really is confusing. It is not helpful at all. There's a line that we have certainly crossed."[93] Here the impulse toward "culture jamming" even impinges on the economic functions of the store by confusing customers rather than servicing their commercial activity. However marginal, and however marginal its cultural impact, the store's classification practices indicate a refusal of existing cultural hierarchies. The store evinces a punk rock, slacker mentality that makes a mockery of the popular and unpopular culture around it even while it relishes in that same culture and offers no way out of it.[94] Yet another indication of Cinefile's position on cultural value can be seen in the T-shirts it sells, which feature the last name of a renowned auteur transposed into the recognizable logo of a punk rock or heavy metal band from the 1970s and 1980s (figure 22). Thus Herzog appears in the likeness of a classic Danzig logo, Von Trier appears like Van Halen, and Bela Tarr like Blag Flag. These mishmashes of heavy metal and art house are synecdoches

for Cinefile itself: celebrations of cultural works from significantly differ-
ent registers, brought together by people who grew up loving both, yet
knowing one was "legitimate" and the other was not.

Through these endeavors, Cinefile has created a niche for itself even
among the niche video stores in Los Angeles. Yet it, too, is imbricated in the
fabric of that city.[95] Like Eddie Brandt's and Vidiots, Cinefile is a "destina-
tion" store for cinephiles.[96] Although it is located less than five miles from
Vidiots, the owners of both stores state that they do not really compete
with one another. More important, Cinefile is located next door to one of
the most prominent art house theaters in Los Angeles, the NuArt, which
Belove and Anderson acknowledge was a strategic choice on their part.
Although the two businesses typically do not collaborate on events, the
workers at the NuArt get free rentals at Cinefile, while the clerks at the
video store can see movies at the theater for free. More strategically, both
locations appear to have augmented their individual appeal by drawing cus-
tomers from the other.[97] As Belove put it, "You have an art house theater
next door that changes its program every week, so you constantly have a
new batch of film buffs."[98] With these two businesses sitting side by side,
they have created a cinematic oasis among the strip malls, gas stations, and
7–11s that otherwise make up this stretch of Santa Monica Boulevard.
Indeed, along with Eddie Brandt's Saturday Matinee and Vidiots, Cinefile
Video contributes to and complicates the cinematic and cultural landscape
of Los Angeles. Although these stores present alternatives to contemporary
mainstream Hollywood culture, they survive as a consequence of the geo-
graphic clustering of that industry. Their continued success speaks to the
heterogeneity of cinematic tastes among cinephiles living in the heart of
the culture industry.

SATELLITES OF LOVE: SPECIALTY VIDEO OUTSIDE CITIES

The examples discussed above might suggest that specialty video stores are
typical of larger cities, but similar stores can be found in locations with
small populations. "Video capitals" appear to indicate that rarefied and/or
cult tastes in movie culture are more generally linked to educated popula-
tions, however small and localized they may be. In addition, specialty video
stores are typically located in towns or suburbs where there are universities
and other sites for cultural activities, such as museums and performance
spaces. Although these specialty shops appear to be part of the subcultural
infrastructure of these towns, meaning that they are not part of the official
cultural apparatus and appear to be different or odd within the town's

milieu, they nevertheless appear to require a population that values more traditional forms of edification and cultural expression.

The Movie Dungeon in Bozeman is a good example of this. Bozeman has a population of 37,280, 98 percent of which is white.[99] Bozeman's residents are highly educated and economically comfortable. The median household income is $41,705, and over 50 percent of the population hold a bachelor's degree; nearly 20 percent hold a graduate or professional degree.[100] The "smallness" of this town should be contextualized in the larger expanse of Montana. Although it is only the fourth largest city in the state, Bozeman represents the largest concentration of people within at least a forty-mile radius. It is "town," as in "going in to town," for a widely dispersed population living on the ranches around it. Bozeman is also the center of a large number of important cultural institutions. It is home to Montana State University (MSU), which has over 12,000 undergraduate students and nearly 2,000 graduate students and employs over 3,000 people.[101] In many ways, in fact, Bozeman is a college town, where a significant portion of the population attends or works at the school; in addition, this population is typically more left-leaning in its politics and has an appetite for more refined forms of leisure. Although many of Bozeman's cultural sites are related to tourism and outdoor activities due to the proximity of Yellowstone National Park, the city also features the Emerson Center for the Arts and Culture, which serves as an art exhibition space as well as an arts education facility. The Bozeman Film Festival (BFF), which has programmed independent and foreign films at various theaters across town since 1978, has recently operated out of the Emerson Center.[102]

Ben Himsworth grew up in Bozeman, and after attending MSU as a film student he opened Bad Taste Used Music and Movies in 2004. Initially the store sold music, but as these sales declined he focused increasingly on video sales and rentals. In 2008, he renamed the store the Movie Dungeon and relocated to the basement of a local record shop. Although the store has a large selection of documentaries and foreign films, it specializes in horror and cult films (figure 23). Himsworth states, "I turned my hobby into my business," suggesting that this store is an extension of his personal tastes and inclination toward media collection. Although he sees "a gold rush at the beginning of each semester," he says that college students only make up about a quarter of his business. Instead, high school students, "who are stuck here," and "guys in their late twenties or early thirties that have disposable income" are his regular patrons. Whereas the high school students frequently buy and sell the video games that the store stocks, the older men frequent the store for its Blu-Ray selection. Himsworth specializes in this

FIGURE 23. The Movie Dungeon offered the moviegoers of Bozeman, MT, a wide selection of offbeat video titles.

high-resolution format and offers, in his opinion, the best selection of Blu-Rays in town. He sees this technology as particularly important to the clientele he tries to cultivate, namely, the cinephiles in the area for whom a video's visual quality is as important as a movie's narrative or formal features.

As of 2012, the store relocated and rebranded again; it is now called Snow Day Video Games and Movies, focusing more on video games.[103] Himsworth's changing business priorities appear to be individualized and localized instances of large-scale industrial shifts; he moved away from music sales just as the traditional record industry collapsed and placed more emphasis on video games and high-definition video formats in the face of the crisis in video rental. Yet the ongoing success of Himsworth's operation speaks to the existence of a thriving and commercially viable alternative media culture in the city. The Movie Dungeon and Snow Day Video Games and Movies have brought together a community of retro video gamers and high-end/lowbrow video aficionados. Although this population is small, it provides the store with enough business to keep it running. Of course, Himsworth's passion and vision for culture were vital to his business, as

economic incentives alone could not propel stores like these. He has been, to some degree, a central figure in broadening Bozeman's movie culture. Beyond running these various stores, Himsworth has been an active promoter of nonmainstream movies in Bozeman for many years. He estimates that he organized and promoted over two hundred film screenings, mainly of cult films and 1980s action films, at a second-run theater associated with MSU, which sometimes gathered over one hundred attendees.

An analogous example of this kind of localization of specialized movie culture is Video Culture, which operated in Murfreesboro from 1994 to 2011. Located about thirty miles southeast of Nashville, this suburb has a population of 108,755, 78 percent white and about 17 percent African American.[104] The median household income is $45,158, and over 30 percent of the population hold a bachelor's degree.[105] This suburb is culturally overshadowed by nearby Nashville, home to a large music recording industry as well as an abundance of related cultural venues and events. Nashville is a "young" and "hip" city in a region that is otherwise construed as lacking cultural edginess. Nevertheless, Murfreesboro houses a number of institutions that have helped nurture an intellectual and culturally adventurous population in the town. Murfreesboro is home to the largest undergraduate university in the state, Middle Tennessee State University (MTSU), which has over 26,000 students and over 2,000 full-time employees.[106] Further, the town has an annual jazz festival, a handful of museums that focus on local history and culture, and the Center for the Arts; opened in 1995, the Center hosts theatrical performances, fine arts exhibitions, and arts and crafts educational programs.[107] Thus, although Murfreesboro is not exactly a typical college town, it does feature a significant number of venues for local and "high" culture, serving a population with a relative high level of education and wealth.

Video Culture's co-owner, Byron Cumbie, first started working in video rental when he was a student at MTSU, where he minored in film and majored in music recording engineering, intending to work in the Nashville music industry. He recalls that the video store where he worked would regularly get requests for cult movies that the owner refused to carry; he remembers many students requesting *Eraserhead* (1977) in particular. "Anyone under thirty was looking for these movies," he says. When this store was bought by Movie Gallery, Cumbie opened his own store in 1994 with the aim of specializing in this material. "We were very low budget, very 'indie,' from the get-go," he says. Although the store had numerous mainstream films, including a sizable wall of rew releases as well as large sections for such conventional genres as comedy, action, and horror, it had

numerous sections for nonmainstream movies. It had a substantial collection of foreign films placed in a section called "Cinema Internationale," documentaries, and independent films, along with sections for anime, cult classics, performing arts, and Shakespeare. In addition to the Skittles, Tootsie Rolls, and previously viewed DVDs that one finds for sale at many video store counters, Video Culture displayed psychedelic candles, incense, quirky action figures, and other items one might find in a head shop. When I visited, the owner's dog observed me patiently, lying next to a mini-fridge behind the counter.

The name of the store reflected the ambitious, even utopian aspirations of its owner, who says, "The name, Video Culture, came out of one of those late night college brainstorming sessions. . . . We thought we'd invented this concept." Cumbie's initial interest in running a specialty store did not derive from cinephilia on his part but rather his desire to serve the eclectic tastes of the local community, whether they liked "Fellini or Troma." For many years the store was located blocks from the university and got a lot of foot traffic; college students in particular were important for the store. Cumbie, who says that he "grew up in the sticks," states that much of his clientele were MTSU students who had "escaped their small towns" and wished to "explore weird movies and culture" during their college years. "Without the college," he elaborated, "we would not fly in this town because it is still conservative, still Bible Belt. It's Tennessee, you know." Video Culture illustrates that a specialty video store can be embedded in and supported by only a portion of a community. The store's existence testifies to a local population interested in offbeat cinema, yet one that stands in striking contrast to the cultural norm in the area. In fact, after Video Culture moved in 2006 to a location more removed from the university and the center of town, Cumbie says he got more "traditional, family types" as customers. Even so, he maintained the store's atmosphere to the extent that he could. He says, "We have a lot of conservative customers, but when they come in here they get exposed to a lot of liberal talk and liberal thought." This balancing act could even be seen in some details within the store. Among its wide selection, Video Culture had a "Same Sex" section, a novel description compared to other video stores that carry queer media. This marker suggests a somewhat equivocal stance toward such movies, as they are not clearly outed as gay or lesbian. This naming might even suggest that the owner adjusted (slightly) the expression of his values in relation to the moral framework of the town.

Video Culture's position as an "outsider" in Murfreesboro had real economic effects. According to Cumbie, some people in the city took offense

at its selection of sexually explicit material and made complaints. From that point, the owners were harassed by law enforcement, which sought to recategorize the store as an "adults-only bookstore," which would be subject to strict zoning regulations.[108] Although the store only carried around two hundred such movies, publicity from the lawsuit prompted its insurance company to drop its coverage. Thus when the lease was up in late summer 2011, just months after my visit, the owners decided to "move on and do something else" rather than contend with continuing difficulties.[109] Although cinephiles in the area may still find movies suited to their eclectic tastes, perhaps through Netflix or VOD, the local fans of alternative movie culture have lost a physical location that manifested these shared values.

CONCLUSION

Whether celebrating the most refined forms of cinema or camping the lowest forms of cinematic detritus, all the stores described in this chapter—Scarecrow, Eddie Brandt's Saturday Matinee, Vidiots, Cinefile, the Movie Dungeon, and Video Culture—have made a space for a broad range of cinematic expression. To the extent that these stores have nurtured and served people with eclectic tastes for refined, obscure, and/or trashy movies, they have helped sustain a movie culture that contrasts with mainstream Hollywood. Yet the fate of Video Culture indicates that video culture has moved away from the video store enough that specialty stores like it face a troubled future. Whether or not people have eccentric tastes, fewer and fewer have a taste for shopping at *any* video store. As this economic loss jeopardizes the existence of specialty video stores, it consequently threatens the cultural activities that these stores support.

Responding to this, the owners of Vidiots have latched on to the notion that their store is a cultural center; they have opened a space adjacent to the store called the Annex, where they offer film appreciation classes and lectures by media professionals and scholars.[110] Although Vidiots has operated as a venue for cultural activities since it opened, it appears that this function has become even more important given the store's declining video revenue. In this case, there appears to be an inversion of the cultural process that historically occurred within specialty stores. Whereas in the past specialty stores cultivated and dispersed movie knowledge through their business operations, here there is the deliberate fostering of movie knowledge with a hope of sustaining the business: video culture without the video.

Hadrian Belove left Cinefile in 2007 and began programming film screenings and cinema-related events at the Silent Film Theater in Los Angeles under the name Cinefamily.[111] One writer described Cinefamily as offering "aggressively idiosyncratic programming" and insinuated that Belove's background with Cinefile informed his "quirky" curatorial choices.[112] Cinefamily offered a "membership" payment service akin to the Netflix model, where customers paid a monthly fee for unlimited access to screenings, and thereby emulated and competed with contemporary video rental practices.[113] Indeed, Cinefamily extends the logic of the specialty video store and remanifests it within a theatrical space. The programming at Cinefamily conforms to the same conflation of highbrow and lowbrow movies typical of the specialty store, with each screening offering an eclectic choice, like a video pulled from an "Employee Picks" shelf. Belove even borrowed a number of the ingenious categories devised by Cinefile and made these programs at Cinefamily screenings, including "When Animals Attack" and the catchall generic grab bag, "Holy Fucking Shit!"[114] In addition, Belove and his partners endeavor to create forms of contact and interaction resembling those found at a specialty video store. Besides personally introducing film screenings, Belove has been known to serve barbecue and beer from the theater's patio.[115] Moreover, Cinefamily regularly programs Q&A sessions with media professionals and hosts more informal events like potlucks and dance parties.[116] However diverse and informal Cinefamily's activities may be, as of 2013, it stands as an important institution for alternative cinema in Los Angeles; it operates as a 501(c)3 nonprofit and receives ongoing support from a growing base of members, including a handful of celebrities.[117] One article from late 2012 asserted, "Cinefamily has become a pillar of the alternative film exhibition scene in Los Angeles[,] . . . a hub of activity with its heady mix of new and retrospective movies, a particular blend of the highbrow, offbeat and way-out."[118]

In creating a new venue for a lively alternative movie culture, the Cinefamily project suggests that the taste cultures nurtured by specialty video stores must mutate and migrate if they are to carry on through the era of home video closures. Yet the movie culture that Scarecrow, Eddie Brandt's, Vidiots, Cinefile, the Movie Dungeon, Video Culture, and all the other specialty stores have fostered represents only a fraction of the tastes, values, and activities that have animated video stores more broadly. These specialty stores have been exceptional and have relied on being exceptional. More common have been the Blockbusters, the Hollywoods, and the legion of independently owned stores where most Americans rented their movies. Culture has existed in those spaces too. But the

movie culture of these locations is more mundane, prosaic, and less con-
nected to sophisticated tastes. It is common. In the next chapter I explore
the localization of movie culture at independently owned video rental
stores in small towns across the country. These places are no less cultural
than the specialty stores discussed above, and they are no less vital to the
cinematic landscape of their areas. The exact forms of this culture and the
activities that generate it, however, couldn't be more different.

4. Video Rental in Small-Town America

In his examination of rural moviegoing possibilities and habits in the early twentieth century, the film historian Robert Allen asserts, "Writing the 'rural' experience of moviegoing into American film history ... is necessary if we are to adequately conceptualize ... the relationship, past and present, between cinema and place more generally."[1] Allen's work is part of a larger effort by film historians to look beyond major cities as sites of media culture.[2] Although this body of scholarship draws on archival materials to present a richly contextualized portrait of historical audiences, questions remain about how a contemporary population of rural Americans access movies and engage with movie culture. Moreover, as a consequence of its historical frame, the existing scholarship on rural moviegoing focuses on theatrical experiences and conditions.

This chapter expands the narrative about rural moviegoing through an examination of video rental stores in small towns and rural areas.[3] During a series of road trips conducted throughout 2010 and 2011, I gathered data that support two related kinds of analysis: historical and social insights about these stores and their workers and reflexive ethnographic analysis, which takes these workers' understandings as the object of study.[4] Perhaps more than in the previous chapter, my analysis here is driven by the way video store employees described themselves and their activities. Therefore, unlike the existing historical scholarship, which coordinates trade press and other print materials with statistical information about rural areas, this chapter makes claims about these people *and* about their perceptions and self-perceptions.

Due to the geographic spread of rural and small-town video stores and the idiosyncratic personalities of the workers, gathering the research for this chapter was characterized by a healthy dose of happenstance; there

were moments of tremendous luck as well as unforeseen difficulties. One moment during my tour of the American South in May 2011, for instance, illustrates how my research method affects my analysis. Having already driven through Tennessee, Georgia, and a large part of Alabama, I was making my way down the western edge of Alabama to look at stores in Mississippi. Only weeks earlier, tornadoes had ripped through the area; I personally saw many torn roofs and busted video signs along my route. I don't know whether it was a result of the tornadoes, but I found it difficult to use my iPhone and Google Maps throughout Alabama and Mississippi. More than once my phone assured me that I had reached my destination when clearly I was not yet there. In one such moment, my phone told me I was in front of a store, but I was parked at an intersection of dirt roads with forest on both sides. I called the owner yet again to check the address. The woman on the other end of the line agreed that I was there. "No," I said, and looked at the pine trees that flanked my car. "I am in the middle of nowhere." "That's right," she agreed, "we're in the middle of nowhere." "Fine," I said, "but I am in a different middle of nowhere."

This phrase, "a different middle of nowhere," introduces two of the key terms that guided my analysis of video stores in small-town America: *different*, not what you are used to, not what you expect, defined by alterity; and, tied to this difference, *nowhere*, indicating a geography of nonmemorable nonlandmarks. Consequently, this chapter argues that video stores in small towns throughout the United States constitute *a geography of difference*. Any attempt to describe these stores confronts a complexity that is simultaneously industrial and cultural. Like the stores and workers examined in chapter 3, small-town video stores and workers function as localized nodes in the network of media distribution. Also like the stores and workers described in chapter 3, these stores and workers demonstrate that the distribution of media commodities goes hand in hand with the distribution of ideas and values about movies and culture. Small-town stores differ significantly from specialty stores, however, in the exact ways in which they are localized and the values that they accumulate and disperse. On the one hand, all the examples I discuss function as "small-town" stores, so there are commonalities among them. On the other hand, and in keeping with the "uneven geographic development" characteristic of capitalist-produced spaces,[5] each store is aligned with the individuated social and cultural milieu of the specific town in which it operates. Although small towns and rural communities in the United States may not be as subject to the rapid flux of capitalist development and "creative destruction" as major cities but instead to durable local traditions and powers, each of these towns and the video

stores in them appear to have been shaped as relatively distinct localities.[6] Therefore, as I demonstrate, these stores interweave movie culture with a wide variety of local conditions and concerns.

THE MATERIAL CHARACTER OF SMALL-TOWN VIDEO

Independently owned video stores in small towns almost always fall under the "corporate-model independent" category, as they organize their movies in broad genres and typically emphasize new releases. But each of these stores appears distinctive in its material character and style. Many are so clean and "professional"-looking that it is difficult to differentiate them from their corporate chain counterparts. For instance, Spotlight Video in Interlochen, Michigan, occupies a large, freestanding structure with abundant windows and high ceilings; its interior features orderly white shelves and well-maintained posters for the latest Hollywood movies. Movie Time Video in Jasper, Georgia, looks exactly like a corporate store, and in fact it occupies a former Movie Gallery location. Although the front of the building has a sign that reads Movie Time Video, a billboard-style sign for Movie Gallery still stands at the edge of the parking lot.

Some of these stores look more like "classic" small-town retail locations. Throughout the Midwest and Great Plains, for instance, many stores occupy the first floor of two-story brick buildings on or near the town square. Other video stores, however, occupy unique, even quirky buildings. Uptown Video in La Juanta, Colorado, which is part of a small chain in the area, is located in a structure that obviously was once a church (figure 24). There is a video store in Wyoming that is housed in a building that also operates as a motel. The building is clad in long, horizontal wooden planks, with short, pointed, vertical boards lining the roof, giving it the look of an Old West trading post. During my visit, there was a man touching up the paint on the front of the building, which was otherwise peeling in many places. The video rental area of the business is located to the side of the main entrance, and the videos are stocked on unsanded wooden shelves. Also in this room is a card table with magazines strewn on it, a number of mismatched chairs, and a parrot in a cage. The character of this location is best illustrated by a comment made by the owner. When asked if there was anything particularly difficult about running this video store, she replied that semis regularly used her unpaved parking lot to turn around and that she didn't appreciate the amount of dust this threw into her store.

The diversity of style and appearance among many small-town video stores appears to result from each store's particular "fit" in its community.

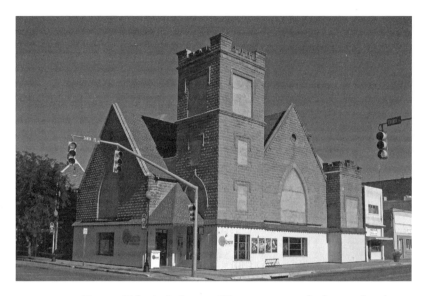

FIGURE 24. Uptown Video in La Juanta, CO, operates out of a former church.

The locations are typically chosen because the rent is affordable and because they are near other retail stores. In general, the stores conform to the overall look of public architecture in that area. Yet the independent entrepreneurs who run these stores adapt the exteriors according to their own needs and sensibilities. Indeed, these stores are often particular and even unique because they have been physically maintained or modified by the wide range of personalities who own them. The generalization "small-town video store" is quite difficult to sustain, as the surfaces of these places display great heterogeneity.

The owners and workers in small-town stores often alter and personalize the interior of these spaces; these modifications are analogous to the "tactical spaces" among media professionals in Southern California described by John Caldwell.[7] Although the store space is public and aims to be inviting to consumers, workers often individualize it and mark it as their own. Sometimes these are simple indications of the owner's personality. Dollar per Day Video in Ellisville, Mississippi, had a remarkable quantity of paraphernalia lining the walls near the checkout counter, including a sheet of computer paper hung above the counter that stated, "Girls are like typewriters . . . press the wrong places and you get terrible words." In part this personalization relates directly to the video rental business. Film Fest Video is a small, independently owned chain in northwestern Pennsylvania, and

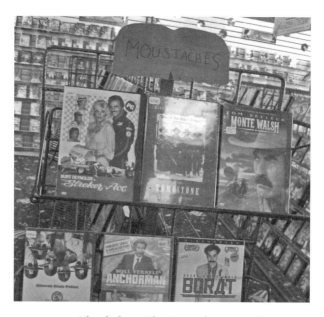

FIGURE 25. The clerks at Film Fest Video in Franklin, PA,
have organized movies by playful categories such as
"Moustaches."

its Franklin store is a good example of this. While the store looks orderly
and professional, its organization offers a number of playful innovations.
There are signs for major Hollywood films along the "New Releases" walls
that have been hand-painted or handmade with sheets of fabric and con-
struction paper. Further, the workers at this store have assembled humor-
ous movie sections such as "Moustaches" and "Lions, Tigers, and Bears"
whose movies feature these elements (figure 25). Similarly, Paradise Video
in Kathleen, Georgia, had a "Dumbest Movies" section. The workers at both
stores have altered these spaces, constituting a creative rethinking of main-
stream cinema. Although they do nothing to reject the mainstream
Hollywood industry, these little interventions create a prosaic response to
it. The workers make Hollywood familiar by situating it in their own terms.
 Other modifications signal the workers' personal lives or the store's con-
nection to a larger community (figure 26). One can find photographs of fam-
ily members and customers, trophies for sporting achievements, and similar
paraphernalia. Many fliers near the front door or the counter advertise local
commercial services, such as at Bitterroot Video in Hamilton, Montana,
which had signs advertising firewood and eggs for sale. Similarly, one can
occasionally find notices about upcoming social events, such as rodeos, fairs,

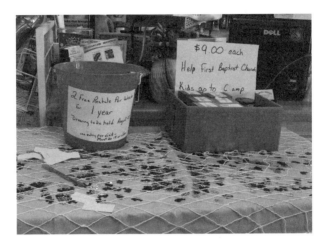

FIGURE 26. Community organizations make themselves
materially evident in small-town video stores. (Last Stop
Video Shop, Medicine Lodge, KS.)

and even funerals. Video Hits and Games in Rawlings, Wyoming, had a cou-
ple of signs supporting candidates for the county attorney and commissioner
positions, while Park Plaza Video in Anaconda, Montana, had a sign support-
ing the local Relay for Life organized by the American Cancer Society.
Humphreys' Main Street Video in Jeffersonville, Ohio, had an advertisement
for the Summer Reading Program at the local library and a certificate from
the Academic Booster Club recognizing the store's support.

These cases suggest that small-town video stores play an important role
in the social life of the town, at least for a certain number of residents. As
public places that get habitual traffic, these stores have become informal
public institutions. They aren't "homey" just for their owners and workers
but also for a larger population of moviegoers for whom the whole town is
homey. Evinced by their material character, these stores seem to operate as
hubs in the towns' social networks. They are informal hubs, to be sure, and
it is unlikely that anyone relies on these places to become aware of local
events. But as shared public spaces, they provide ample material proof of
social connections that have almost nothing to do with movie culture. Yet
the population that circulates through this space is there for movies. Thus
in combining video commodities and movie posters with personal photos,
advertisements, and awards, these stores make manifest a localization of
movie culture. They make movies homey before they enter people's
homes.

THE SOCIAL CHARACTER OF SMALL-TOWN VIDEO

If the material character of these stores suggests certain kinds of social behaviors, then the owners and clerks make this a lived reality. Small-town video workers demonstrate a range of competencies, all of which intersect with their individual characteristics, with their positions within their communities, and with the business of video rental. In other words, these workers physically and mentally link the movie business with the social fabric of the town. As opposed to the workers described in chapter 3, small-town video workers are defined by living and working in a small-town store; this is the force field that circumscribes the media landscape in which these stores operate and their workers' knowledge and experience. Indeed, "small town" was a phrase that these workers consistently used to define themselves and their work; it was an important form of identification for them. This is not to say that these workers were not diverse but rather that the diversity among them, in terms of social stratifications and forms of knowledge, was articulated through this common characteristic.

Many workers defined small-town life by contrasting it with the "big city." These towns are not "fast-paced." They don't have "those problems." A woman, originally from Wyoming, described how she had had lived in Minneapolis and Denver after graduating from college but preferred small-town life and moved back to Wyoming. Likewise, a man in central Ohio had lived in Columbus for a time but returned to the small town, where, he said, the people are "more trusting." A Pennsylvania woman characterized her town by saying, "This is still an area where I don't have to lock my car at night [and] . . . our house is never locked. It's that kind of a place." Although many people characterized themselves and their towns in ways that might reaffirm clichéd notions about small towns serving as bastions of America's social and moral fabric, this form of self-identification appeared to serve an important emotional and social function. It is a means of claiming that they are socially connected in a satisfying way (figure 27). In these towns, I regularly heard comments like "Everybody knows everybody" and "Everybody is nice." Unlike in large cities, one woman said, you can walk around her town and people will wave at you; it is the kind of place "where you walk into the grocery store, and the manager comes up and shakes your hand and says, 'I haven't seen you in a couple of days. What's up?'" A woman in central Michigan said, "I have a lot of friends here. . . . [T]here are customers that if they don't come in, I'm calling them, because you get used to seeing them every day."

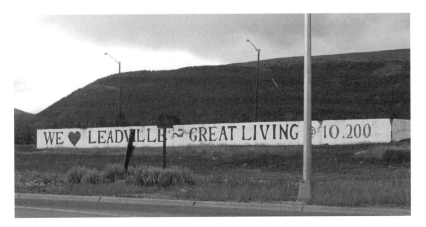

FIGURE 27. Many small-town video workers express a deep sense of connection to their town and fellow townspeople.

In fact, these workers consistently situated themselves as central to the town's social network. "Customers aren't just customers," said a store owner in Wyoming. "They are our neighbors, our friends." Although some clerks in larger cities would sometimes claim to have a good knowledge of the local renting population, the small-town clerks overwhelmingly defined themselves and their stores as vitally integrated into the town's social life. It appeared to be a defining characteristic of small-town clerks that they viewed themselves this way, as though a town's small size made these stores even more important to its public life. They prided themselves on localizing movie culture. A woman in Pennsylvania said of her store, "A lot of times it's the meeting ground where people come in and talk with each other. . . . We're the local entertainment." Further, small-town video store workers often situated themselves as *personally* central to the sociality of the town through their interactions with browsers and customers. A woman in central Iowa said of her clientele, "I might be the only person they talk with the whole day," and continued by saying that her job was "almost like being a bartender." Indeed, many small-town video workers likened themselves to bartenders, and at least two had worked as bartenders previously. As a woman in Ohio put it, "I feel like a bar owner sometimes, where I listen more than I talk." This comparison seems apt, as both bars and video stores invite people to come together and loiter around a commodity, giving people an excuse to socialize in the process. In a similar gesture toward their social function, many video workers compared themselves to therapists. A woman in Kansas stated, "I should have been a psychiatrist or a

psychologist or something. I hear everybody's life story. . . . They just tell me I am easy to talk to, and I listen to them."

When asked about the topics of their conversations, the usual response was, "Everything." When pressed, these workers were at a loss about the precise nature of their conversations, or they answered in general terms. As an Ohio man put it, the "biggest form of entertainment around here is gossip." Combined with the intensity with which these people claim to be social hubs, the vagueness suggests the mundaneness and the ephemerality of the conversations. The responses also suggest that video store chitchat is so regular that it appears noteworthy and definitive and yet so utterly common that it is nearly imperceptible in its details. Despite this apparent ordinariness, however, small-town video workers do mention certain conversation topics that recur. People talk about the weather, of course, as well as families, illnesses, deaths, local politics, high school sports, vacation plans, and local restaurants. This suggests that the conversations in small-town video stores build and sustain a flow of information about the local social scene; they serve as a "community building" practice, where shared experiences are acknowledged in order to cohere or integrate a group of people who otherwise may be diffused and dissimilar.[8]

Although conversations sometimes touched on personal matters, these workers asserted that they disliked and tried to avoid discussions that were too intimate. A male clerk in Alabama said that he hears about people getting divorced and "who's cheating on who." But he characterized such conversations as "stuff you don't want to talk about, stuff you're like 'That's interesting—now go away,' stuff I don't want to know." Similarly, a woman in Iowa exclaimed, "People tell me about their sex lives! It's like, I did not want to go there!" In their negative reactions to these personal and intimate conversations, the workers imply that they prefer their social interactions to be casual and fleeting. For all that they serve as a knowledge hub, the clerks prefer that this knowledge remain at the broad level of the town's social scene and not delve into individual customers' intimate issues. The video store is a casual place for casual interactions. Whatever knowledge might be accumulated within these stores or disseminated by them, it is typically a mundane and trivial knowledge about the town's residents and activities.

While this may suggest that these small-town stores and their workers help build and integrate the local community, there are those individuals who do not fit in. Speaking in somewhat philosophical terms, a store owner in the mountains of Colorado asserted, "There is no such thing as 'community,' only individual successes and individual failures." A different man in Colorado, who described himself as a "right-wing, radical libertarian,"

said that although he liked living in his "slow-paced" town, he was different from the people around him, who, he asserted, held liberal political views. He also stated that he would regularly discuss his political views with his patrons, often to their consternation and his amusement. Somewhat differently, a woman in Kansas, who moved from a town in which she felt welcome to a town in which she did not, said, "My husband has a theory about that. He thinks that [this town] was started by ranchers, while [the town we previously lived in] was started by farmers." In these cases, the high level of social interconnectivity of the small town served to alienate the individual video store owners. Small towns are *small*, making the individual who is not included in its fabric that much more aware of it. Where for some the public space of the video store is a shared place of fellows, for others it is a theater of one's difference.

There also appears to be a generational divide in these workers' feelings about working in a small-town video store. Although workers appearing forty and older consistently speak in positive terms about working in a small town, they do not hold this attitude when it comes to their adult children, nor do the people in their teens and twenties claim this affection. A woman in Tennessee characterized this generational dynamic by saying, "I grew up here and then I left. I've come back . . . I have children now. Growing up I wanted to leave this place so desperately. But it's so nice to have children here because it's such a small town and everybody knows you." On a sour note, a twenty-seven year old worker in Tennessee said of his town, "It holds you and takes everything from you." A young man in Alabama stated, "If you want to make money you got to get out of town. . . . I'm at the end of my line working at the video store. Moving on." Indeed, these people connect the video store to small-town life by describing the need to escape from both spaces. People of both generations characterize the video store as an unworthy career choice for a younger generation. A middle-aged Georgia man, who had inherited his store from his mother, stressed that his children were getting good educations that he hoped would enable them to avoid both manual labor and retail work. Likewise, a young woman who worked at her parents' store in central Georgia stated that she was attending college so that she could get a better job and get out of the small town. Thus many parents and younger people view small-town life as socially and economically confining for working-age young people and view larger cities as sites of opportunity that should be explored during a certain stage in one's life. In this respect, the connection to the video store signals a strong connection to the small town, and the small town signifies a lack of upward class mobility for people in their teens, twenties, and thirties.

ARTICULATING THE SMALL TOWN AND
THE VIDEO BUSINESS

Video store workers' entrenchment in their towns affects their relations with the media business and movie culture. In more academic terms, these people coordinate the cultural capital they hold regarding the movie business with the cultural and social capital they have accrued in relation to the town's social and cultural scene.[9] As Joshua Greenberg has described, many video store owners in the early days of the industry were simply entrepreneurs who came from a variety of backgrounds, and many of the people I spoke with conform to this assessment, particularly those who opened their stores in the 1980s.[10] There are some exceptions to this, however, such as a woman who has run a combination movie theater and video store in Nebraska since the mid-1980s. Not only is she is a member of the National Association of Theater Owners (NATO), but she sits on its North-Central regional board, has attended the association's national conventions, and reads its emails and other publications regularly; she feels "up on it," in terms of the media business, as a result. But a woman in central Iowa is more typical of the small-town video workers I encountered. Before opening her store in 1989, she said, "I had a background in retail, but as far as movies—not so much."

In many cases, small-town video workers integrate their work at the video store with other occupations and life demands, which are strongly linked to class and gender. In this respect, these people's experiences with "the media industry" are highly personalized, inseparable from their personal backgrounds and social identities. A significant number of stores that I visited were opened or run by women, many of whom used their work at the video store to augment their household incomes or, if unmarried, to achieve economic independence. For instance, a woman in Montana said the job was good because it was flexible and allowed her to raise her children; her husband works in the family plumbing business that his grandfather opened. Alternatively, a female clerk in Kansas said that she got her job twenty years earlier because of "a bad wheat crop," which devastated her family's farming endeavors. When asked what the best part of her job was, a Pennsylvania woman, who had owned and run her store since 1990, said it was "the feeling of satisfaction of being a woman and fully operating a business . . . it gave me a big boost to my ego." In fact, her success in the video business made her the primary breadwinner for her family, allowing her to take otherwise unthinkable vacations and to support her husband in his own business ventures.

FIGURE 28. A former truck driver, Tim Dykes, runs Video City in McRae, GA. In his spare time he performs as an extra in Hollywood productions that shoot in the area, including *The Crazies* (2010).

Other small-town video stores were operated by men who appeared to range in age from their mid-fifties to mid-sixties. Several of these men had taken over the business from their mothers. For example, a store in southern Georgia was opened by a woman in the 1980s, and she successfully ran it for many years. At the same time, her son worked as a truck driver and raised his own children. Eventually, the woman died, and the son took over the store (figure 28). A similar process took place with a family in north central Alabama. The matriarch of the family ran two video stores from the 1980s through the 1990s until she retired. Now her son, who had previously worked in construction, runs one of the stores, while his son, her grandson, runs the other store about ten miles away. In this, we see that video stores were initially marked by female entrepreneurship, which contrasted with the masculine wage labor within the family, and that this gendered division of labor changed from one generation to the next. Even in cases where middle-aged men were the primary operators of video stores, they used this work to augment or get out of manual labor. A man in central Pennsylvania, who was retiring from the video business, had previously worked as a coal miner, while

a man who opened a movie theater in Kansas in 1979 and added a video store to the operation in 1984 continued to work part-time in the nearby gas fields for many years, work that he said was quite "stressful." In all these cases, working in video retail provided a means of diversifying income and, eventually, for men to exit jobs that were more physically taxing.

As a consequence of this embodied and site-specific relation to the movie business, most small-town video workers discuss movie culture in terms of how the rental industry has affected their lives and businesses. When asked what changes they had witnessed in their businesses, for instance, the workers almost always talked about the change in home video formats. Although this topic was also addressed by video workers in specialty video stores, those in small towns were not interested in how a format affected the aesthetic quality of the movie content but rather in how it related to economics and store functionality. In cases where they had worked at the store for many years, the workers would talk about the battle between Betamax and VHS as well as the relatively high price of VHS tapes during the 1980s and 1990s. Strikingly, the range of prices that they mentioned varied considerably, from "$50" to "$100," indicating that although their memories may not be precise, they all considered these products expensive. Similarly, a man in Mississippi talked about renting video disc cartridges in the 1980s and grumbled that "the needles for those players cost the store $49.95." Almost all the workers discussed the change from VHS to DVD. Many owners had already sold their stock of VHS tapes or were in the process of doing so (figure 29). This sometimes caused them consternation, as they sold these tapes at a price far below what they had initially paid. The workers said that the advantage of DVDs was that they were cheaper to obtain than VHS tapes and that they took up less shelf space. The downside, they regularly stated, was that customers regularly scratched DVDs, making them unusable.

In some cases, the workers discussed the shift from VHS to DVD as something that had been done to them by "the industry," and many workers made statements that positioned themselves outside "Hollywood" and the mainstream media industry. They made statements that suggested that "the industry" was alien and even opposed to them. Although this opposition links these workers to their specialty store counterparts, they did not oppose "Hollywood" or "the industry" in elitist or countercultural terms. Instead, they positioned "the industry" as a necessary evil. On the one hand, "the industry" made and provided access to entertaining movies, which the workers could use to make a living. On the other hand, "the industry" sought profit at all costs and did little or nothing to support the individual rental store. As evidence for this, some workers mentioned

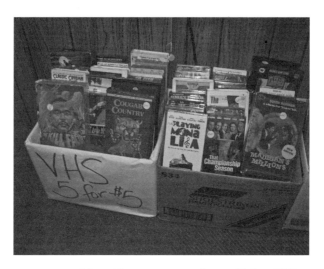

FIGURE 29. Most video store owners have sold their VHS tapes or are in the process of doing so.

"deals" that the studios cut with corporate chains like Blockbuster and Hollywood Video. Analogously, a man in the mountains of central Idaho stated, "I hate some of the politics with the studios. They play around with the release windows. The release schedules kind of stink. Sometimes they'll release a movie to Pay-per-View even before we get it. That's frustrating!" When criticizing "the industry," these workers would also suggest that the people making large-scale industrial decisions were inflexible, inept, or too caught up in short-term goals. A woman in Pennsylvania stated, "When the switch came to DVD, anyone could go to a Wal-Mart and buy a movie." The change in format from VHS to DVD facilitated sell-through of videos, which from this perspective served the interests of the industry at large but diminished the appeal of the individual video store.

In fact, one of the most common ways that these people discussed their work was in regard to the financial difficulties the video rental industry currently faced, both at a national scale and at their particular stores. (Perhaps this is unsurprising, given that my interviews were conducted in 2010 and 2011.) When introducing myself, I would tell these people that I was researching a book about video rental stores. The response I heard more times than I can count was, "You mean a book about the death of video stores?" or "You mean about how there aren't any left?" A Tennessee woman reminisced, "This used to be the big thing, to rent videos. Now it's a dying art." It was common to hear about the diminishing business of small-

town stores in relation to changes in the larger infrastructure of media distribution both at a national scale and at a local scale. A store owner in Mississippi cited "Netflix, satellite, bootlegs" as the cause for his business's difficulties. A woman in Kansas stated, "When Netflix started, it hurt . . . and now Redbox. It has really made a difference." Speaking in broader terms, a man in Alabama stated that "video stores are going to be obsolete." As local instances of a national industry, these entrepreneurs thus faced a general economic trend individually. The people did not appear naive about their prospects, and their attitudes ranged from stoic to melancholy. And when they weren't experts in the rental industry as a whole, they were absolutely experts about their stores, the only industry that really mattered.

In one noteworthy encounter, I was interviewing a somewhat reticent, middle-aged man in western Michigan who tried to sell me his store five times during the course of our short conversation: "$30,000 and you can have it all—lock, stock, and barrel," he said. In another surprising interaction, I entered a store in southwestern Pennsylvania and introduced myself to the female owner, only to have her tell me that she had decided *that morning* to close her business within the month. For her, this decision prompted an emotional reflection on her life, her career, and her connection to her town. (This is the same woman who was so eloquent about being a female entrepreneur, quoted above.) Rather than express a sense of defeat or of personal loss, this woman expressed regret that she could no longer serve her customers; this sentiment verged on a sense of guilt that she was abandoning her community. She said, "I printed out my [closing] signs today, and I've been agonizing about hanging them up." For her, closing her video store meant giving up a connection to her fellow townspeople, ending a career of fleeting but meaningful social interactions.

SMALL-TOWN GEOGRAPHIES OF MOVIE TASTE

For all that they see themselves and operate as social hubs in their small towns, these workers are also, ultimately, in the movie business. They balance a knowledge of the town with a knowledge of video. In synthesizing these knowledges, these owners and clerks *embody* movie culture in that town. But as one might guess from the preceding analysis, this is a populist, popular, and simultaneously local and localized cinema culture. Unlike the workers at specialty video stores, many small-town video workers are not typically cinephiles with refined knowledge of cinema history or aesthetics. Small-town video workers who claim an avid interest in movies are typically "movie buffs" whose tastes usually encompass a wide range of

mainstream films and genres. For instance, a woman in Tennessee stated, "I like the girl movies."[11] Just as commonly, however, many small-town video workers claimed not to watch movies very much at all. A Montana man who has owned his video store since the 1980s said that his son was the "real" film buff in the family. "It used to be I enjoyed watching films," he added, "but I kind of got burnt out on it." Many times movie viewing does not fit with the lifestyles of these workers, as they are too busy with other things. "I try to watch as many as I can," said a woman in central Michigan, but "it's hard to find time to watch them." A female clerk in Montana stated, "I have no leisure time."

These conditions inform the workers' interactions with their browsers and customers. Among all the other topics these workers talk about with their customers, they talk about movies, and like clerks in any video store, they are required to give recommendations on a regular basis. But as a consequence of their lack of distinctive tastes, which results in part from not being able to watch many movies in the first place, these workers commonly integrate their movie discussions and recommendations with their social position in the town. That is to say, instead of recommending titles based on their personal preferences, small-town video workers make suggestions based on their knowledge of the rental history of the person before them and/or as a calculated synthesis of the feedback they have received from other customers. "I get to know the customers, what type of movies they like, and I know what to recommend to them," said a young clerk in Pennsylvania. Likewise, a woman in Kansas said that she suggests movies within genres for which the customer has already shown a preference; horror films present a difficulty for her, however, as she refuses to watch them. With such movies, she stated, "I can tell them what's been recommended by other people." Similarly, a woman in Montana stated, "I have to follow my other customers' recommendations because I don't get a chance to watch every movie out there," and a store owner in Pennsylvania said that when she is asked for a recommendation, "I can say, 'So-and-so says this is pretty good.'" These conversations suggest a complex process in which the individual video worker centralizes a network of tastes and values, which spans the social field of the town, and then focuses this knowledge into *one* suggestion for *one* renter. Using Bourdieu's language, these workers transform accumulated social capital into cultural capital, turning their social interactions into concrete assertions of taste and value.[12]

This process necessarily involves some knowledge and understanding of the social field of the town itself. As described above, these workers almost unanimously self-identify as "small town" and describe their communities

in the same fashion. In fact, when asked about their towns and their clientele, small-town video workers frequently characterize these populations as typical and average and yet simultaneously as diverse. An Idaho man described his customers as the "average working person," and a Mississippi man similarly said that his customers were the "average Joe, you know." On the flipside, a Wyoming man stated that his customers were "a pretty mixed group . . . a real mixture," while an Alabama man said, "I get to see a wide variety of people," and a Mississippi man said his clientele was composed of "all kinds of people—doctors, lawyers, plumbers, roofers." These claims, which combine typicality with diversity, make it seem as though small-town video workers have difficulty thinking and talking about social difference and stratification. In this respect, these workers are like most Americans.

A number of these workers did make reference to particular forms of social difference within their towns, often in offhand remarks during the interview process. Any sense of belonging requires a sense of identity, and identity is as defined by difference as it is by similarity. These workers' assertions of difference and particularity demonstrate how their social identities are the product of a very particular social field, a *specific* small town in a specific part of the world. For instance, a worker at a store in Wyoming, which is located on the edge of an Indian reservation, discussed the fact that she serves a community that "operates mostly on a poverty level" but mentioned that a video store just twenty miles away, in what was locally referred to as a "tree-hugger town," served a different clientele. Similarly, a woman in Tennessee said, "We get the poor people . . . and people who make good money." A man in Idaho said that his clientele "is more middle income." He also said, "We have a large Spanish-speaking population, and I really like that."

In many instances, these workers linked their observations about social stratifications to movie tastes and forms of consumption. In fact, it seemed easier for them to talk about movie preferences and consumption habits than social differences, or to discuss social difference *through* a discussion of taste and consumption. Perhaps this is unsurprising, as contemporary American culture typically avoids acknowledging class differences even while it maintains them. Moreover, video rental stores typically try to accommodate as wide a range of patrons as possible; they aim to be nondiscriminatory spaces where individuals can distinguish themselves by finding a movie that they desire. Yet individual selections have social associations, and the owners and clerks at the stores occasionally make these connections. Often workers did so in a general way, saying that certain genres were popular "in the area"; these genres were typically as broadly defined as the area itself, such as when a woman in Alabama stated that

"people like horror movies in this area," or when a Nebraska woman said that "family movies" rent best because the town "is a real family community." Other alignments were made that were more particular and suggested further social divisions. A man in Mississippi, for instance, stated that "older cats come in to buy the classic VHS," while a man in Montana said that high school students rented classics and foreign films because they were "studying those subjects." Similarly, a clerk in Idaho said, "A lot of the older customers and schoolteachers will rent the artsy stuff."

In these assertions, the workers began to parse the diversity of their towns by having observed customers' patterns of cultural consumption. As much as these comments were part of a discussion about the town, they were also assessments of a store's clientele; knowing these differences was part of getting to "know the customers." Knowing the customer is part of good customer service generally, and these small-town video stores are no exception. Thus the clerks' linkage of social and cultural knowledge serves vital economic interests. Like all video stores, the success of small-town video stores necessarily entails that the clerks integrate social, cultural, and economic considerations. Yet this process appears more intense at small-town stores, perhaps because they pride themselves on being integrated in their communities.

Sometimes small-town video workers made social and cultural alignments that were quite specific or that conformed to conventional categories of social identity. A male store owner in Kansas said, "For several years we never bought any horror movies because they wouldn't rent. But we got a lot of Mexicans. . . ," at which point his female clerk quickly added, "They like that kind of stuff." A man in Mississippi, meanwhile, said, "Our demographic is probably 80 percent black. We have a lot of stuff average stores might not have—'urban movies.'" This man's use of the industry euphemism for films featuring African Americans seemed odd given the small town in which his store is located and the rural surroundings; it suggests that he has internalized a conception about market segmentation developed by movie producers and distributors. A man in central Ohio sounded as though his years of working at a video store had equipped him with a sociological view of his town. "In this area, I do rent a lot of horror movies, but that's just a certain class of clientele," he said. He elaborated by saying that teenagers rented horror films "for sure," as well as "the lower-income people, or maybe not lower income but lower education level." He continued, "The higher education level, the more money you have, the higher quality of the movie. I wouldn't even say higher quality, but critics' choices. . . . I found out a long time ago that if all the critics love a movie, it's probably not going to rent well for me. Not in this locale."

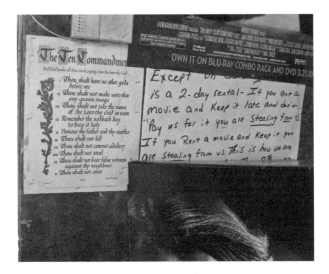

Figure 30. Thou shalt not return your movie late.

Economic considerations dictated that these entrepreneurs be aware of what their clientele disliked as much as what they liked, and they aligned these taste values with social differences. A man in Georgia stated, "Things like *King's Speech* [2010] and *Black Swan* [2010] don't do well in [this town]." Similarly, a woman in Iowa said that "a lot of people don't like" foreign films or "anything that is too intellectual," while a man in Michigan said of foreign films, "I think we got one in here one time, and it rented maybe one time." This same man had removed the store's holdings of adult movies when he bought it from the previous owner. His explanation: "This is a town with—we used to have two bars. We're down to one bar. But it's got twelve churches." Similarly, a female store owner sixty miles away had eliminated her store's selection of adult films because hers "is a very big church town" (figure 30). A number of video workers characterized their regions as uninterested in any movie dealing with homosexual themes or characters. "I didn't get *A Single Man* [2009]," said a woman in Iowa, "because I don't think they'd rent anything with gay people. . . . They didn't rent *Brokeback Mountain* [2005]," and a man in Kansas similarly stated, "*Brokeback Mountain* was never in this store." A female owner of a store in central Alabama said that she had recently gotten the film *I Love You Phillip Morris* (2009). "I started watching it," she said, "and it just blew my mind and I had to cut it off." At this point in the interview, however, another female clerk chimed in and said that she liked the movie. However, this

FIGURE 31. Hunters watch hunting videos in Michigan and Pennsylvania.

clerk acknowledged that she did not expect this film to rent well because of the gay characters. "You gotta remember where we're at," she said.

This last comment suggests that this clerk holds a strong and particular view of the local population's tastes and viewing habits. Simply by working at this video store, she has apprehended something of the movie culture in her area. In keeping with this, a number of small-town video workers made comments that demonstrated an extremely high degree of localization of film culture. A woman in central Michigan, for instance, said, "We got lots of hunters around here, and when deer season rolls around, about October, they'll start coming in, and [the hunting and fishing videos] go right off the shelves. The deer hunters rent them.... I honestly think it just gets them a little psyched up, ready for deer hunting season" (figure 31). Somewhat similarly, a man in southern Kansas noted that "farmers don't rent nothing in the summertime" because they are too busy working. Alternatively, he said that the "town people" rent all year long. A man in Mississippi, who owned a pizza parlor that had only recently ended its video operation, said that there were two groups of people in his area, neither of whom rented movies. First, there were the more affluent people who lived in subdivisions; they could afford cable and high-speed Internet, so they got their

movies that way. Then, he said, "you got your 'Joe-Bob,' living out in the woods or in a mobile home, sitting off some dirt road." He suggested that such people, who he referred to as "country people," were too poor or technically inept to bother with home video at all.

Rather than align a social type with taste, the last two workers observed how social characteristics frame people's access to particular media technologies and platforms. Along these lines, a number of small-town video workers asserted that although they might be doing less business than in the past, they had faith that their store still served the kind of media consumers found in the area. Such discussions were typically framed by contrasting themselves with Redbox, Netflix, and other "new media" delivery platforms. A woman in Iowa, for instance, said, "We have a lower income here. You don't have people who can do [Netflix]." She also said, "I've had customers say they'd never do a Redbox. They don't trust it." When asked about this lack of trust, she explained that it came from the residents' distrust or lack of credit cards, which Redbox requires. Similarly, a man in Tennessee said, "A lot of people in this town don't have the capability of having movies streamed to their house," although he did not mention whether this was for economic or technical reasons. In either case, this man was like a number of other small-town video workers, showing an understanding that his store was part of a larger landscape of movie viewing possibilities and that the appeal of his store was as determined by the social characteristics of the surrounding population as it was these other movie distribution options.

In the aggregate, the workers' comments suggest that the "audience" for their small-town video stores is actually quite diverse, although perhaps not in the way that the workers claim. Rather than having diverse populations in terms of conventional categories such as race, class, gender, generation, and so on, these towns have *distinct* populations. Concomitantly, these video stores coordinate themselves with a highly localized cinematic community of video browsers and customers who are defined by their social characteristics as well as by their access to and taste in movies. In this assemblage, these people represent and constitute part of the cinematic geography of their areas. Vitally, this knowledge is commonly held and integrated by the workers at these stores. They are experts in the local movie culture. Even in moments when they are not aware of this authority, it is part of their daily business activities. And just as the small-town workers have observed and described numerous genuine differences and particularities among their patrons, this localized audience is multifaceted. In comprising a localized, "small-town" cinematic community, in fact, these people demonstrate how complex a local audience can be.

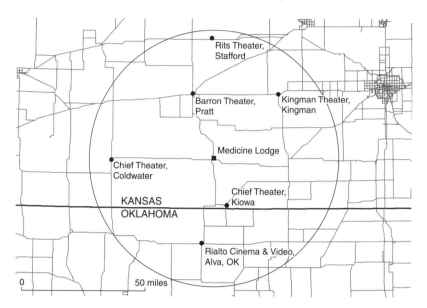

MAP 1. There are only six movie theaters within a fifty-mile radius of Medicine Lodge, KS. Map by Nicole Scholtz.

THE RANGE OF THE LOCAL

Much of the complexity of small-town video culture derives from the physical geography in which the local cultural geography occurs. The aptly named Last Stop Video Shop, located in Medicine Lodge, Kansas, illustrates this vividly. Medicine Lodge is located at the southern edge of central Kansas, where U.S. Route 281 intersects with U.S. Route 160. The store itself is located on the first floor of a two-story brick building on the town's Main Street. The town is quite small, spanning perhaps a mile from end to end, with a population of 2,009, 96 percent white. The median age is forty, and the median household income is $34, 259. Roughly 10 percent of the population holds a bachelor's degree.[13] All this suggests an ethnically homogeneous, working-class population, with a high number of retirees. The geographic remoteness of this town suggests that the town's residents make up the majority of the Last Stop Video Shop's clientele. Further, this location likely provides movies to the majority of the farmers and ranchers who live in the surrounding area, as other options for moviegoing in the vicinity are dramatically sparse. There is no movie theater in Medicine Lodge, although there is a drive-in theater about a mile east of town that is open during the summer. There are only six theaters within a 50-mile radius, the nearest of

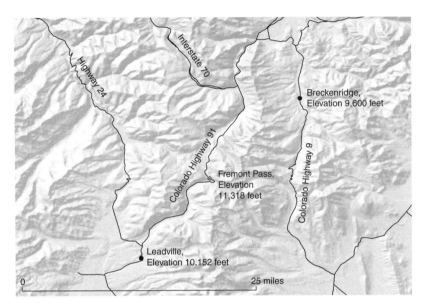

MAP 2. The nearest movie theater to Leadville, CO, is in Breckenridge, a forty-one-mile drive. Map by Nicole Scholtz.

which is 19 miles south, in Kiowa; two of these theaters are only open on weekends. Similarly, there are only six Redboxes within a 50-mile radius. All this suggests that Last Stop Video Shop is a vital component of the cinema culture in this town and for the people in the vast surrounding area (map 1).

The Movie Company, a video store in Leadville, presents a somewhat different picture. Situated along U.S. Route 24, Leadville is located at an elevation of 10,200 feet in the mountains of central Colorado. It has a population of 2,878 people, 34 percent of whom are Hispanic.[14] There is no theater operating in Leadville, but there is a Redbox. Within a 50-mile radius there are eight movie theaters and eighteen Redboxes. But the nearest theater (as the crow flies) is actually a 41-mile drive away in Breckenridge. This winding route ascends more than a thousand feet at Fremont Pass, at which point it crosses the Continental Divide, and then descends more than two thousand feet on the way to Frisco, which lies between Leadville and Breckenridge (map 2). Alternatively, Leadville moviegoers might continue north from Frisco on Interstate 70 and go to the multiplex in Dillon. In either case, it takes about an hour to drive to a movie theater from Leadville. Thus this town's movie culture is strikingly limited by the media infrastructure of its surroundings, and this infrastructure itself is circumscribed by the larger geographic conditions of the area.

It is not only the stores in the Great Plains and Rocky Mountains that are distanced from other towns and moviegoing options. Ellisville, Mississippi, has Dollar Per Day Video to serve local movie watchers but no movie theaters. In fact, there are only two theaters within a 50-mile radius of the town, one 7 miles north and another 21 miles south; both of these are located along Interstate 59. Similarly, G&L Video in Gordon, Georgia, is the only video store in town. There are seven movie theaters within a 50-mile radius, four of which are near I-75, which bypasses Gordon twenty miles to the east. Finally, there is Humphreys' Main Street Video in Jeffersonville, Ohio. Although there are thirty-eight movie theaters and nearly 140 Redboxes within a 50-mile radius, the closest theater is a 21-mile drive, and the nearest alternative venue for videos is a Blockbuster Express kiosk 12 miles to the southeast. In fact, the vast majority of the theaters and kiosks are located in Columbus, which is 40 miles to the northeast, and in Dayton, located 37 miles to the west. These examples suggest how "the local," as both a general population and a cinematic community, is not only tied to geographic and infrastructural conditions but also to *human* geography, that is to say, where people are located. The local audience cultivated and served by these stores can only be defined relationally, just like the category "the local" itself.

In some cases, small-town video store owners regulate how "the local" is defined. A woman in Iowa, for instance, said she no longer accepted customers who did not live in town because in the past out-of-towners did not return their movies on time. Yet, in contrast to such efforts at geographic regulation, many small-town video workers served a "local" clientele that was quite wide-ranging. Many workers said that their customers came from the "surrounding towns," and a woman in Wyoming said that her store served the people in the entire county. A man in Idaho guessed he got customers from as far as 50 miles away, while an Ohio man estimated people traveled up to 11 miles to rent from him; he speculated that this geographic span has grown in recent years as video stores in surrounding towns have shut down. A woman in Nebraska stated she had customers from 20 miles away for whom she added an extra day to the rental period. This last example offers an interesting glimpse into how small-town video stores generate and coordinate the circulation of both people and videos. They aim to connect people with videos, yet the people they serve are often mobile or distant or both, while the store itself remains fixed. But the rules of the store, in terms of its lending policies and pricing, can sometimes be altered to accommodate the clientele. In this respect, these small-town stores facilitate a wide-ranging circulation of material commodities, which

conforms to the mobility of the (sometimes distant) patrons. All these stores indicate that "the local" is not only a relative term; it is also characterized by internal flux and shifting outer edges.

The geographic complexity of these stores is compounded by the flow of people passing through their towns. One woman in Pennsylvania noted that she had a customer for many years who worked as a trucker hauling garbage long distances, and her shop was located along his route. He would stop at her store during his trips, rent some movies, watch them on a VCR in his cab, and return them some time later. A number of other video stores serve seasonal tourists, "migrant leisure." A store in Breckenridge, Colorado, for instance, was one of the very rare small-town video stores with an extensive selection of art house and foreign-language movies. The owner said these were rented by upper-class Americans and international visitors who came to the area for skiing and other recreational activities. A store owner in central Michigan said, "We get some out-of-towners because we have the lake"; these people would often rent VHS tapes because they only had VCRs in their cabins. Likewise, a woman in Pennsylvania said that some of her customers were from Pittsburgh, vacationing at the nearby lake. In these cases, the local geography generates a circulation of people into and out of the town, which in turn creates a perpetually shifting "local" audience.

HYBRID SPACES

One store in eastern Colorado actually facilitated the mobility of people by selling Greyhound Bus tickets and serving as a bus station. The clerk said that in addition to renting movies and selling bus tickets, the store made much of its money from selling Lotto tickets. This indicates the final type of complexity seen among small-town video stores, namely, the diversity of business activities in which they engage. Many small-town shops were not video stores at all, if that means exclusively making money through the rental and sale of videos.[15] Yet in each instance, these other activities demonstrate several conditions of the media industry as it exists in these towns. A number of the clerks in these shops asserted that they began other businesses as a reaction to the diminishing revenue generated by video rental. This reverses one tendency of the early home video industry, when all sorts of businesses that had nothing to do with media suddenly began engaging in video rental.[16] By situating video rental alongside a range of other businesses, these stores position movies in a larger context of consumer culture. Here Hollywood films are treated as mundane

FIGURE 32. Video and tanning combination stores can be found throughout the country.

commodities just like any other. Their value is made comparable to used clothing, tobacco, or a cup of coffee. In these respects, the diversity of businesses operating alongside video rental shows how these stores have localized movie culture in subtle but profound ways. By situating video rental alongside these other business activities, these stores show how "Hollywood" can become closely associated with a wide variety of local commercial and cultural purposes. Further, these shops demonstrate the localization of the media industry by disengaging from it; as they seek alternative forms of revenue, these shops show how "Hollywood" is taking on new forms in these areas.

 One of the most common business hybrids is video rental and artificial tanning (figure 32). Although this may initially seem like a strange combination, it makes economic and cultural sense, particularly in light of the cultural significance of suntans.[17] Attaining a suntan became a fad among Americans as early as the 1920s, and over the course of the century suntanned skin came to signify youth, beauty, and enough wealth to engage in leisure activities.[18] The widespread commercialization of artificial tanning at specialized salons began in the United States during the 1970s and blossomed during the 1980s.[19] The origins of the video/tanning combination are somewhat murky. A marketing magazine put out by Sun Ergoline, which specializes in artificial tanning, states, "It is common knowledge that Sun Ergoline pioneered this unusual ... business combination ... in 1992."[20] Ted Engen, president of the Video Buyer's Group (VBG), proposes an alternative account of this business combination. Since it was established in the early 1980s, the VBG has helped independently owned video stores

get information about trends in the industry, and much of this information is gathered from members of the VBG itself. According to Engen, sometime in the 1990s a video store owner told him that he had been successful with a combination of tanning and videos. Although he was highly dubious about this arrangement, Engen told other members of the VBG about the experiment. Soon enough, video stores around the country were finding success with this strange combination of revenue streams. According to this account, the adoption of the tanning/video business model was both bottom-up and top-down: bottom-up, in that it came from the innovation of an individual business owner; top-down, in that the success of this model was promoted from a central point in a semiformal industrial knowledge network.

Economically, tanning works well alongside video rental because it allows businesses to even out revenue over time. Over the course of a week, most rental transactions occur on Fridays and Saturdays, while tanning keeps money coming in during the rest of the week. In the longer term, tanning helps regulate the flow of revenue over the course of a year. The tanning business is most active during the winter and spring, from January until as late as June; this offsets declines in income from video during this period. A clerk in Kansas discussed how these economic factors are linked to cultural issues: "The tanning is basically seasonal . . . Christmas dance, Christmas formal. . . . People getting started off with their tan before summer gets here." Further, these combination stores link business activities that are used in a similar pattern. As the Sun Ergoline magazine states, "Tanning salons do best when they are located near other businesses that are considered daily or weekly 'destinations' such as dry cleaners, restaurants, video stores, beauty salons, grocery stores, etc."[21] In this respect, tanning and video rental function as similarly habitual practices in the realm of consumer culture. Further, as the tan indicates leisure, artificial tanning gives people the look of leisure in a time-efficient way. Thus stores that combine video and tanning offer two forms of leisure culture. Whereas movies give people leisure through looking at images, however, artificial tanning gives people the look of having leisure time even when they do not.

Video/tanning hybrid stores can be found throughout the country, from Michigan and Ohio to Iowa and Colorado. Yet the combination of video and tanning seems especially prominent in the American South. In fact, it is one of the few regional markers I could discern among small-town video stores. While small-town stores across the country commonly engage in diverse business activities, the majority of hybrid stores I saw in the South engaged

in tanning and no other activities, suggesting that the economic and cultural logics of video/tanning are particularly functional in this area.[22]

Outside the American South, however, one can find a plethora of different business combinations that include video rental. In rare instances, a video store was attached to a movie theater, allowing a single operation to serve both theatrical and domestic movie cultures.[23] Such was the case with the Ritz in Thermopolis, Wyoming, and Movie Place Video/Rivoli Theater in Seward, Nebraska. A handful of video stores engaged in electronics sales and repair. Rather than align videos with movie culture, such operations frame videos as primarily technological commodities. In connecting video rental to the retailing of media technologies, these stores resembled many of the stores from the early days of the video business, as Greenberg has discussed.[24] Video Kingdom in Ogallala, Nebraska, is part of a small, independently owned franchise in the region that historically did electronics and video rental. Yet the Ogallala location is the last remaining Video Kingdom to continue video rental, and, according to a clerk there, only "20 percent" of their business was video, while the rest consisted of electronics sales, including televisions and cellular phones.

More commonly, small-town hybrid stores engage in activities that have little to do with cinema or media technologies. It is common to find video rentals at a small town's grocery store. Ken's Village Market in Indian River, Michigan, for instance, has the look of a clean, modern grocery store and has been renting videos since around 1990, according to a manager who has worked there since the early 1980s. Similarly, Dubois Super Foods in Dubois, Wyoming, is a large grocery store with half an aisle dedicated to DVDs for rent, labeled the "Entertainment Center." Although these cases appear to corral video rental into locations dedicated to groceries, there are many more small-town "general stores" that do a bit of everything, offering both groceries and video rental alongside a wide variety of options. Circle D Foods in Grand Lake, Colorado, has a number of shelves of videos alongside bait and tackle gear. Angler's Roost, outside of Hamilton, Montana, has a large rack of DVDs for rent in the center of the store (figure 33). This store, which appears to serve the shopping needs of both the local population and tourists passing through, offers a wide selection of commodities and services, including groceries, maps, clothing, guns, and raft rentals. Finally, the Sagebrush Hotel in Wamsutter, Wyoming, in addition to doing video rental, is a hotel, grocery store, hardware store, and auto repair center.

The variety of commodities and services offered by general stores are practical in the context of a small town or rural area; that is, they offer one-stop shopping, serving the practical and cultural wishes of a largely

FIGURE 33. You can buy a gun and rent a movie at Angler's Roost, outside Hamilton, MT.

working-class population. Along these lines, C.J.'s in Eva, Alabama, offers video rental and artificial tanning as well as carpet and floor materials and installation services, while Main Street Video in Cortland, Ohio, sells custom kitchen countertops and also does installation. Jiffy Rental Center in Riverton, Wyoming, not only rents videos, but also industrial machinery, tractors, and other vehicles for construction and farming. In these cases, the video rental store is situated alongside a variety of commodities and services that align with manual labor, selling work and play under the same roof.

In addition to video and machine rental, Jiffy Rental Center has a large area devoted to a café with 1950s-era decor that serves espresso drinks, ice cream, and milkshakes. Indeed, a number of video stores are also cafés, presumably to increase foot traffic and to inspire impulse purchases among video customers. Some of these shops model themselves on espresso bars found throughout the country. Nebraska Land Video, for instance, has a café called the Java Hut, and Star Video in Estes Park, Colorado, offers video rental and artificial tanning as well as espresso drinks and fruit smoothies at the On-the-Go Espresso coffee bar. Although it did not look like a modern café, Big Butte Video and Laundry in Arco, Idado, offered espresso

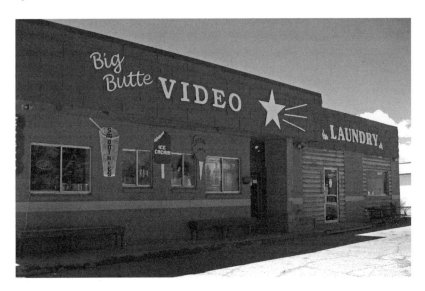

FIGURE 34. Before it closed, you could watch a movie and drink a cappuccino while your clothes dried at Big Butte Video and Laundry in Arco, ID.

along with videos and a coin-operated laundromat (figure 34). According to a customer, one could watch a movie for free while washing one's clothes. Other cafés are more like traditional coffee shops or diners. At one such operation in Tennessee, the female clerk stated, "We have our lunch crowd, and we deliver ... to the little factory over here," indicating that the customers for the café were not the same as for video rental. In this case, the addition of food service broadened the appeal of the business to a wider segment of the population.[25]

These cafés aim to increase shopping options for video customers as well as to draw people who are uninterested in video rental. A similar logic extends to a wide range of commodities and services in a number of other hybrid stores. Yet the rationale for the exact commodities and services is less apparent than it is with food or coffee. Sometimes the particular business choices seem random. The video store/café in Tennessee mentioned above, for instance, also rents tuxedos; when asked about this, the clerk said, "Anything that you can do under the same roof to make money." A video store in Kansas began selling used children's clothing a few years earlier, which the clerk said was "something to supplement" the loss of video revenue. Video Row in Chanute, Kansas, was half video store and half tobacco shop, while Movies N More in Evart, Michigan, had an immense selection of knickknacks for sale, including porcelain cat figurines and dream catch-

ers, and an entire room devoted to yarn. It is vital to note that these additional business ventures are perfectly rational to the people who run these shops; whatever the precise form a combined business takes, it is a manifestation of the everyday life of these workers and their community. It is yet another way that these stores and these workers incorporate movie culture into their mundane and habitual practices, a sign that they have localized and even personalized movie culture.

Other seemingly odd business combinations occur as an outgrowth of the personal tastes of the store owners. Much like the way small-town stores are often personalized with signs, photos, and other paraphernalia, these business combinations are physical manifestations of the owner's sensibilities. These forms of personalization, however, serve a direct economic function. In addition to video and tanning, a store in Nebraska offered a large number of wooden signs that had been handcarved by one of the store's owners. These signs displayed such sayings as "Always Kiss Me Goodnight" and "I'm so far behind, I thought I was first," and the clerk said that they sold quite well. Somewhat similarly, a video store in Georgia had a small kennel of purebred puppies for sale, including pugs and yorkies, which ranged in price from $299 to $399. In this case, the owner of the store began breeding dogs as a hobby and integrated the dog sales into the video store. The owner said that her clientele for video was "almost nonexistent" and that although the dog sales helped, she was not sure it generated enough money to maintain the business.

CONCLUSION

This may be the ultimate context for all these small-town video stores: the bottom line, which is increasingly making video stores unfeasible. It was a palpable truth that my research trips to look at small-town video stores were circumscribed by the concurrent changes in America's moviegoing habits and the technical infrastructure that enables them. More than once during my travels I entered a town where I expected to find two video stores. What I found instead was that one, which had solely done video rental, had closed down, while the surviving store had a diversified revenue base. In the face of this hybridity, it makes a nice rhetorical conceit to say that there is no such thing as the small-town video store, meaning a business that makes its money solely through video rental. But the conceptual cleverness of this conceit is rendered shallow and disingenuous in the face of the genuine economic hardship that many of these small-town video workers have experienced in the past few years. From the man in Michigan

who tried to sell me his store to the woman in Pennsylvania who, on the morning that I visited her, decided to close her shop, these people were living the actual failure of their stores. When a philosophically minded store owner in Colorado asked me about my project, its goals, and my methods, I told her that it was difficult to make generalizations about a cultural phenomenon based on limited observation and, moreover, that it was hard to take a snapshot of something that is undergoing radical change. "You don't have to tell me," she said. "I'm living it." Her store is now closed.

In fact, a significant number of video workers posed questions at some point during our interviews. Sometimes this would be as casual as asking me what notable things I had seen in other stores, but in other cases the issue seemed more serious, as when store owners asked me for advice about how to improve their businesses. Walking into their stores as an assistant professor in Screen Arts and Cultures at the University of Michigan must have positioned me as an "expert." Not only did such moments highlight the practical place of privilege I held in relation to these people, but they also dramatized the ethical complications of ethnographic research. Any expertise I may have had was eventually tossed out the door in the face of these people's expertise and knowledge, which was the object of analysis in any case.

This chapter has shown how small-town video stores have operated as localized nodes in the network of media distribution. Their very particular relation to their towns is seen in all kinds of ways, from their physical appearance to the different businesses in which they engage. But the workers at these stores, the owners and clerks, demonstrate how concretely *social* the operation of these stores has been. These video workers have lived and breathed the media industry, helped define its very existence, in these small towns. In doing so, they have learned much about the cultural geography of their towns and simultaneously helped circulate this knowledge throughout the community of video renters. If these small-town video stores have "reduced" the value of Hollywood movies to something comparable to a cup of coffee or a bundle of yarn, then these small-town video workers have also endowed all these objects with the value of their time, thought, and labor, so much of which entailed fleeting and casual interactions with a wide-ranging and complex local audience.

Circulations of Video Store Culture

5. Distributing Value

Video stores made movie distribution a concretely physical, spatial, and socially interactive process. They also reshaped the cultural values associated with movies. Corporate video chains reinforced the "newer is better" mentality occurring at America's multiplexes, while numerous independent stores in small towns and suburbs across the country transmuted Hollywood glamour into a mundane object, much like any other cheap commodity. Cinephilia, meanwhile, took a turn for the exceedingly eclectic and obscure at the country's various specialty video stores. In all these cases, the video store altered movie culture by placing movies on video in new spatial and social contexts. But videos did not arrive in rental stores out of the ether but through an elaborate material and social infrastructure comprising content producers, distributors, duplicators, and wholesalers. Paul McDonald, Frederick Wasser, and Janet Wasko have all examined video distribution from an industrial perspective, while Joshua Greenberg has examined how video distributors altered Americans' cultural treatment of video technologies.[1] This chapter builds on their findings to provide a detailed account of how the industrial actions of select video distribution companies affected video rental culture and movie culture more broadly.

In the traditional theatrical context, "distributor" typically refers to "companies that distribute and sometimes produce films for release in many markets"; this generally means Hollywood studios.[2] These companies hold the rights to the films they release, whether they produced them or acquired them from an independent production company. Their business lies in exploiting the copyrights to these films as extensively as possible. In the context of home video, these same companies are better understood as content suppliers or manufacturers, to the extent that they hold the rights to the film property that they exploit on video, among other

venues.[3] Yet the Hollywood studios initially refrained from distributing their movies on video themselves, allowing a number of independent companies to enter this emerging field.[4] A new sector of the media business open to new entrants, home video distribution adopted a model based on the music business, where the Hollywood studios and other content providers worked through wholesalers to bring their product to retailers.[5] Because of the way it developed historically, home video distribution has had important structural and practical differences from traditional movie distribution. Although some companies held temporary licenses to exploit a movie on a home video format, and were officially distributors, often they merely served as wholesalers, hired by a studio or other distributor to get their videos to retail markets.

Because Hollywood initially resisted licensing movies for home video and because there was a demand for video products, many early video distributors gained their foothold by releasing "side-stream" content, such as workout tapes and children's programming.[6] As the video distribution industry grew, it underwent a confusing number of mergers and acquisitions and a proliferation of sublabels.[7] All the Hollywood studios finally opened in-house video divisions by the early 1980s, yet their efforts largely served as defensive responses to the large number of independent distributors and music distributors that had already entered the video market.[8] And the Hollywood studios did not always work in-house to get their content via magnetic tape to retailers, thereby maintaining a space for independent video distributors and even subdistributors, or middle middlemen.[9] The relationship between these video wholesalers and Hollywood was never easy, as Hollywood sought control over the home video market; the late 1980s and early 1990s were fraught by struggles between content suppliers and wholesalers. As a consequence, wholesalers limited the number of suppliers that they dealt with while simultaneously the number of video wholesalers decreased either because they merged or went out of business.[10] Further, Hollywood studios instituted a two-tiered pricing scheme in an attempt to squeeze out video rental stores and the other video distributors and to overrun the video market with their own newest releases.[11] Whereas many videotapes were still priced at $80 or more, a number of blockbuster hit films were priced from $10 to $30. This made such films amenable to direct sales to individuals rather than exclusively to video stores. While the mainstream wholesalers dealt with both types of tapes, their profit margins were much smaller on the sell-through tapes, thus privileging Hollywood's economies of scale and creating incentives for wholesalers to likewise consolidate into a handful of big companies.

Through these maneuvers, then, Hollywood studios gained control over the home video distribution sector, with the mainstream wholesalers serving as merely one of their distribution conduits.[12]

Thus we find a clear historical trajectory, beginning with the proliferation and flux of independent wholesalers in the late 1970s and ending with corporate consolidation in the early 1990s. What is missing from this narrative, however, is an elaboration of how particular companies and individuals worked within these structural changes to circulate specific, sometimes divergent, values around movies and movie culture. As Joshua Greenberg has argued, early video distributors "invented" home video, as they were the first to conceive of using magnetic tape to play Hollywood films.[13] Greenberg has shown that in the first days of home video the companies that licensed Hollywood films and put them onto magnetic tape had to instruct retailers "how to set up and display merchandise, how to advertise, and even how to interact with customers."[14] In this account, home video distributors served as knowledge brokers between content providers and individual retailers, who did not just deliver commodities in a top-down chain but also circulated understandings in a broad industrial network. It is beyond the scope of Greenberg's project to examine the companies and agents in home video distribution in great detail. Alternatively, I take the particularities among them as vital to understanding the complexity and diversity of values operating in video stores and in the realm of home video more generally. Just as the video store created certain values for movies and genres, the companies and social agents working in home video distribution created values for movie culture.

As middlemen in an industrial network, these distributors and wholesalers had to coordinate with the needs and desires of content providers, retailers, and potential consumers. Their economic success required an alignment between different social fields in which cultural goods accrue particular values. Along these lines, Bourdieu has described how taste values, or "dispositions," operate in the world of cultural production and circulation. Looking primarily at book publishers, Bourdieu differentiates between "large-scale" and "restricted" cultural production.[15] Whereas large-scale production "submits to the laws of competition for the conquest of the largest possible market, the field of restricted production tends to develop its own criteria for the evaluation of its products."[16] This process of value creation resonates with a larger social sphere. For both the commercial and art-minded cultural producer, Bourdieu writes, the "ultimate and often indefinable principle behind his choices finds itself continually strengthened and confirmed by his perception of the selective choices of authors and

by the representations authors, critics, the public and other publishers have of his function within the division of intellectual labor."[17] This characterization is particularly useful in suggesting how video distributors coordinate their business decisions with a conception of their *social* place, which in turn suggests how taste and value get developed through essentially social activities.

This chapter begins with an examination of three "large-scale" home video distributors: Ingram Entertainment, Video Products Distributors (VPD), and Rentrak. All three companies have treated movies as nearly disposable commodities whose value is created by speed, volume, and excitement. However, these companies have different business models, which has affected how Hollywood product appears in video stores. In their search for economies of scale, Ingram and VPD had to address issues of geographic scope; in this respect, they demonstrate the value of space more generally. Further, their promotion of Hollywood movies created associations between videos and other material commodities. However, because films that have been successful at the box office "sell themselves," the mass-sales firms Ingram and VPD have tried to create value for B-grade movies. Rentrak, on the other hand, has offered a revenue-sharing program to independent video stores and, at certain moments, to the corporate chains as well. This practice allowed these stores to greatly increase the number of hit Hollywood films they carried on their shelves at one time. At the same time, Rentrak implemented systems that allowed them to closely monitor the business operations of these stores. In these activities and practices, Rentrak played a vital role in the changing business model and cultural disposition of video rental stores during the 1990s; the importance of this company cannot be understated.

I contrast the logics of these companies with the art-minded endeavors of several small, "restricted" video distributors: Kino Lorber (formerly Kino International), Zeitgeist Films, and Facets Multi-Media.[18] Kino Lorber provides an eclectic mix of foreign films and silent film classics, while Zeitgeist focuses on documentaries and a handful of auteurs. Facets is a special case. In addition to distributing specialty videos, with particular strengths in international, documentary, and children's films, Facets operates as a genuine cultural institution in the city of Chicago. Despite these differences, however, all three companies expand, refine, and complicate "quality" home video by drawing on and redeploying qualities of exclusivity, exoticism, intellectualism, and social activism. Through the promotion of these values, these companies have drawn on refined notions of film artistry to help create an art house in the home. The chapter closes with a

discussion of how both mainstream and niche video distributors are contending with the contemporary instability in home video distribution, characterized by the growth of rent-by-mail, video-on-demand, and Internet streaming distribution systems. As home video is increasingly made intangible, all these companies face new challenges, which they are meeting according to their previously established logics.

LARGE-SCALE VIDEO DISTRIBUTION

Mainstream home video wholesaling underwent significant consolidation through the 1980s, evidence that this sector increasingly prioritized and capitalized on economies of scale. This consolidation only continued as time went on, so that by 2001 only five mainstream wholesalers remained: Baker & Taylor, Flash Distributors, Ingram Entertainment, VPD, and WaxWorks.[19] By 2005, two of these companies, Ingram Entertainment and VPD, accounted for 70 percent of all home video distribution sales.[20] As these two companies developed through the 1980s and 1990s, their commercial practices contended with geographic and cultural issues in interesting ways. The historical development of Ingram and VPD demonstrates how geography was a fundamental factor for wholesalers, particularly as their search for economies of scale entailed an extension in geographic scope. At the same time that they showed geographic flexibility and expansion, Ingram and VPD facilitated and reacted to video's economic devaluation during this period.

Ingram Industries was founded in 1976 by Bronson Ingram after his initial attempt in business failed; he had sought to enter the sewage transport business but was charged with bribing officials in Chicago to secure business contracts.[21] Ingram recovered quickly and assembled a large and diversified private company based in Nashville. In addition to book distribution, Ingram Industries ran a barge company, a real estate company, and an auto insurance company.[22] Ingram entered video distribution with the formation of Ingram Entertainment in 1980, a subsidiary based in LaVergne, Tennessee.[23] As Wasser notes, Ingram Entertainment bought Commtron, a larger company that was based in Des Moines, Iowa, in 1992.[24] This made Ingram the largest home video wholesaler in the country, yet there were concerns that increased market share alone would not help the company.[25] Among other issues, there was debate about the two companies' different "operating philosophies."[26] Whereas Ingram had a wider dispersal of "local stocking branches," Commtron had more centralized facilities.[27] Thus in its attempts to achieve economies of scale, Ingram contended with two difference approaches to geography, centralized versus decentralized.

VPD faced similar issues. Founded in 1980, VPD operated for years as a regional video distributor headquartered in Sacramento, serving retailers throughout California.[28] In 1989, the company's internal management bought it from its founding owner with the support of the Vista Group, a diversified investment company located in Connecticut.[29] While this move was seen as indicative of the tendency toward consolidation during this period, it also indicated video distributors' new approach to geography: rather than serve specific regions, as VPD had done, companies became more national in scale.[30] Later that year, VPD joined with the St. Louis–based distributor Sight & Sound (S&S), which primarily served retailers in the Plains, the Midwest, and the South, to form a holding company, Home Entertainment Distributors (HED).[31] Although VDP and S&S would maintain independence from one another, this joint venture made HED the fifth largest video distributor at the time and expanded the geographic reach of both companies from "purely regional" to "super-regional."[32] Although VPD CEO Tom Shannahan stated, "We don't want to be a highly centralized company," he also said, "We want to create a distribution company that has national presence but that has all the attributes that make regional distribution work," by which he likely meant knowledge of local markets.[33]

These examples highlight the fundamental importance of geography in the development of home video distribution. The locations of these companies' headquarters, LaVergne, Des Moines, and Sacramento, demonstrates that although video wholesalers had become vital components of the American media industry, their position as middlemen did not require being based in Los Angeles. Indeed, these companies relocated a substantial segment of the media industry out of the nation's cultural capitals, New York and Los Angeles. They dispersed cinematic distribution at the same time that they carved out an industry niche, analogous to the way in which video stores across the country dispersed movie culture out of the theater and into the retail landscape as well as the living room. Within the structure of Commtron, Ingram, and VPD, individual distribution representatives were assigned specific regions.[34] In these respects, even "national" or "super-regional" wholesalers paid attention to the particularities of certain regions in the United States, allowing such companies to respond to geographic differences in media consumption. The Hollywood studios structured their home video divisions similarly, as in some cases their video sales representatives were assigned certain geographic regions.[35] The critical role of geography can be seen in the occasional rift between content suppliers and wholesalers. Such was the case when RCA/Columbia cut off its product from VPD in 1988, only to reinstate the distributor the following year after

retailers complained and the logic of imposing "territorial restrictions" proved economically disadvantageous.[36] Thus these companies show that geography was a necessary consideration in creating economies of scale, particularly in the face of industry-wide consolidation; by associating geography with value, they assigned value to space itself.

Both Ingram and VPD underwent transformations during the 1990s. Although VPD's revenues doubled from the early to mid-1990s, the company was troubled throughout the decade.[37] In 1997 it was still referred to as "a relatively small company."[38] Whereas other companies consolidated, none of VPD's efforts to buy other companies came to fruition.[39] The need for geographic responsiveness hit VPD particularly hard during the Teamsters strike against UPS in the 1990s, which VPD used to ship their videos. At the time, CEO Shannahan rented hotel rooms throughout the country and asked retailers to drive to these locations to pick up their movies.[40] Aside from this temporary crisis, the company continued to seek greater geographic range, prompting *Video Store* editor Tom Arnold to say, "They want to establish themselves as a national player."[41] Aiming to enhance its reach into the Midwest in particular,[42] the company opened eight new distribution facilities in various parts of the country between 1997 and 1999.[43] By 2000 the company maintained its headquarters in California and also operated distribution centers in Rancho Cordova and Ontario, California; Seattle; Atlanta; Oklahoma City; Des Moines; Jacksonville; Albany, New York, and Toledo.[44] Ingram, meanwhile, was split from its parent company in 1995 after the death of Bronson Ingram.[45] Ingram's son David took over the company and ran it as an independent operation with over one thousand employees.[46] The company maintained its headquarters in LaVergne and a substantial workforce in Des Moines (former headquarters of Commtron), as well as twenty-one other locations throughout the United States.[47] Although the company would continue to serve video rental stores, they also sought to expand their reach into the "grocery, drug, and department store segments."[48]

This last detail about Ingram's "place" indicates an important element of most mainstream video wholesaling. These big wholesalers situated the video commodity, and thus movies generally, as having value comparable to any other type of good. Movie culture was no more special than anything else that could be delivered to and sold at a grocery store or pharmacy. The wholesalers' quantitative, economic treatment of videos had a qualitative effect on movie culture. Bronson Ingram's initial attempt in business was transporting sewage; instead, he moved books and movies. However much one might like to think that cultural commodities like books and movies are

special, in this treatment, they are simply objects, no different from garbage, that must be moved from point A to point B. Even after Ingram Entertainment became independent from Ingram Industries, the company associated movies with other commodities; in particular, the company sought to expand its products to include audio books, used tapes, and CD-ROMs.[49] Although these other commodities are similar to video to the extent they are objectified cultural texts, the fact that Ingram shipped and promoted them alongside videos raises questions about how the company valued *movies*.

One can see the way that these wholesalers created value through the particular movies they sold and in the ways they promoted them. Certainly by the early 1990s, the big wholesalers made the vast majority of their money with Hollywood movies.[50] Seemingly, then, these companies would have an interest in promoting mainstream Hollywood hits. As one of their practices, video distributors would create "promotions" for upcoming Hollywood titles. One distribution worker commented that his company would send beach balls to a video store along with a movie that had a beach theme, while another remembered sending inflatable alligators to video stores that ordered *Crocodile Dundee* (1986). With such practices, these distributors sought to create a sense of excitement around the release of a film on video, which was conveyed by associating the movie with other material commodities. Here we see how a time-sensitive economic activity around a movie generated an association of that movie with other commodities; notions of speed and excitement were corralled into a greater logic about the social place of movies within consumer culture. Similarly, a longtime distribution worker described how mainstream wholesalers would offer "awards" to retailers who bought a certain number of videos. In these cases, store owners and workers were personally given prizes (he mentioned "a Blu-Ray player") for ordering a large number of a specific title. These promotions further associated movies with consumer culture, and, more important, they indicate that bulk and volume were key priorities for mainstream wholesalers.

Video distribution workers also assert that Hollywood films that have been hits in theaters sell themselves on home video. According to one longtime distribution worker, retailers would ask for Hollywood hits by name. With these films, she said her job "was not selling"; instead, she "just took orders or managed freight shipments from UPS." What she had to actively promote was anything that was "independent" or that made "under $5 million at the box office." Thus, in addition to administering the purchase and movement of videos, mainstream wholesalers like Ingram and VPD did

much of their business distributing and promoting B-movie titles. One news article characterized this practice by stating, "Selling videos such as 'Jurassic Park' is the easy part. Where Sacramento-based Video Products Distributors Inc. earns its Oscar is by convincing video retailers to carry the obscure movies that barely made it to theaters."[51] As noted, many video distributors have traded in non-Hollywood material since the early days of the home video industry, and this practice continued through the 2000s.[52] Throughout the entire era of home video, wholesalers have treated these videos differently than A pictures and thereby cultivated an alternative value for home video more broadly. For B movies, distributors such as Ingram rely on "star power and good box art."[53] In many cases, these companies will place the images of stars on the video box, even when the actor or actress is known only for television work.[54] Both wholesalers and retailers capitalize on seasonal shifts in consumption patterns as well, promoting B movies during the back-to-school shopping season of August and September as well as the holiday shopping season in November and December.[55]

B movies have been important enough to Ingram that the company opened its own distribution label for such fare in 1989, Monarch Home Entertainment.[56] Monarch has distributed such material as the yearly compilation *Highlights of the Masters Golf Tournament* and the *Jungle Book* (1967) imitation, *The Adventures of Mowgli* (1998).[57] Monarch also distributed a number of direct-to-video comedies aimed at kids.[58] These examples suggest just how diverse the range of B videos can be. Further, these examples show that, while mainstream wholesalers created value by extending the geographic range of their distribution efforts, they also spread particular notions about the value of movies. Hollywood hits were associated with cheap trinkets or promotional prizes, or they simply "sold themselves." B movies were given star treatment. In both cases, these wholesalers promulgated the idea that movie culture and (cheap) consumer culture were coterminous.

RENTRAK

Two industry changes occurred in the 1990s that strikingly affected the way in which videos were "valued" at the level of distribution and thus changed the landscape that Ingram and VPD navigated: first, the growth of "revenue sharing" through the company Rentrak and, second, the advent and adoption of DVD. Rentrak's business operations altered much of the way the entire video rental business worked, engendering a significant renegotiation of the meaning and value of home video. Consequently, its

relation to other distributors, Hollywood studios, and home video retailers has been one of intense competition and odd alignments. What became Rentrak originated as a video rental store in 1977, the National Video Corporation, which began franchising video stores in 1981.[59] This franchise expanded rapidly through the 1980s, making it "the first in the nation to succeed in stringing together a nationwide video chain."[60] By April 1988 there were 531 National Video stores in the franchise, making it the largest chain in the United States.[61] Although the sheer buying power of such a large operation might have given the company leverage over movie content providers, in fact the individual franchisees found it difficult to maintain a large stock of video titles, which remained high-priced.[62] As a solution, National Video instituted a revenue-sharing system in 1986, called the Pay-Per-Transaction (PPT) model, among its many locations.[63] In September 1988 the company sold its video stores to West Coast Video Holdings, Inc., and changed its name to Rentrak Corporation.[64]

Emerging out of a corporate chain of video stores, this company had already enacted a "bigger is better" mentality regarding home video, much like its rival Blockbuster Video. Having seen how the American media industry rewards economies of scale, the company continued its efforts to standardize and rationalize the home video industry. Defining itself now as a video distributor, Rentrak accomplished this by commercializing the PPT system it had innovated at National Video, making this system available to any retailer that paid for access to it; in order to be part of the PPT system, individual store owners had to pay Rentrak an "application fee." With the consolidated buying power of a widespread group of individual participants, Rentrak was able to obtain video titles from content providers for a much-reduced price and then get these videos into individual stores for a small fraction of the price offered by other wholesalers, like Ingram or VPD.[65]

In its corporate documents, Rentrak never referred to selling videos to individual stores. Instead, Rentrak charged an "order processing fee" or a "handling fee," which served as an up-front cost for the video. One source reported, "Under PPT, the studios sell movies to Rentrak for roughly $6. Rentrak then resells the movies to retailers for about $8"; another source cited $10 as the price.[66] This fee varied considerably from title to title, depending on popularity and expectations for future rental revenue. Beyond the processing fee, Rentrak extracted a percentage of the rental fee, called a "transaction fee," that each store charged each customer. In this manner the stores "shared" the revenue generated at each commercial transaction with Rentrak. In turn, Rentrak would "share" a percentage of the processing and transaction fees with the rights holder for each video

title. A news article described this process: "In PPT, a retailer returns $1.25 of every $2.50 rental to Rentrak, which keeps 25 cents and gives $1 to the studio that released the video."[67]

With this system, Rentrak significantly changed the relation between the Hollywood studios and the individual video store and created a particular sense of value for Hollywood films and other movies. Whether $6 or $10, the price at which they offered videotapes was significantly lower than the $50 to $100 offered by other distributors during the period.[68] This made Rentrak especially appealing to those store owners who sought large numbers of movie titles. Indeed, Rentrak's system emphasized volume over selection, copy depth over title breadth. Unlike Ingram and VPD, however, Rentrak's PPT system provided a mechanism for the Hollywood studios and other content providers to extract revenue from video stores much in the same way they might a traditional movie theater.[69] Because each PPT participant was turning over a percentage of each rental transaction, they were enticed to prioritize those films that would likely generate a large number of rentals in a short time. In other words, this system encouraged video store owners to choose films that had already proven successful at the box office. A store owner from California stated, "Rentrak is great if you want to cherry pick the hits. If you purchase everything they have it's like betting the house . . . you will not do as well."[70] In addition to promoting volume, this system emulated the "opening weekend" mentality that increasingly guided megaplex exhibition during the 1990s.[71] But in the realm of video, where movies are objectified commodities, the rapid cycling of hits created a rapid devaluation of the particular tape after it had passed its moment of novelty.

In the 1990s, Rentrak negotiated the multiple and often divergent interests of the Hollywood studios, independently owned video stores, and the corporate video chains.[72] Although it took just a couple of years for Rentrak to gain a substantial number of PPT participants and to prove its economic clout, the company struggled for years to make deals with the Hollywood studios.[73] The studios that resisted did so because they thought that Rentrak's model devalued the video commodity in the minds of retailers and, subsequently, consumers.[74] Devaluation, either real or perceived, presented a particularly thorny issue for the studios, given that they relied on wholesalers and corporate chains to buy a huge number of their movies. A turning point arrived when Disney agreed to release its movies through Rentrak, which was especially important given Disney's huge presence in the home video market.[75] By the mid-1990s, Rentrak had contracts to distribute movies by Disney, Fox, and MCA/Universal.[76] Although some studios still resisted

Rentrak because the company required exclusivity clauses, Rentrak's deals with Disney, Fox, and Universal endowed them with substantial power over individual video stores by serving as the gatekeepers for mainstream movies.[77] Simultaneously, Rentrak was also in a position to prioritize the cultural and economic desires of the Hollywood studios.

Somewhat similarly, Rentrak's PPT system initially put them at odds with the corporate video chains. By the early 1990s Blockbuster Video was a huge presence in the home video business with substantial industrial leverage and did not really need Rentrak; revenue sharing simply did not promise to be as profitable as their existing system. As a result, Rentrak became more aligned with independent video stores. Rentrak appealed to small independently owned stores because the company allowed such operations to have movie volume and title depth comparable to the corporate stores. But the PPT system linked independent stores quite intimately with the Hollywood studios, blurring the boundary between Hollywood and video store, between corporate and independent. By 1995 the Movie Gallery chain joined Rentrak, and in 1998 Blockbuster Video made an agreement with Rentrak as well.[78] With the addition of these major corporate chains, Rentrak became fully integrated into the corporate model of home video retailing, linking major Hollywood studios to corporate and independent stores alike. Whether dealing with the corporate stores or independents, however, Rentrak's logic was the same: sell high volumes of hit movie titles. In this way, the company did not just distribute these commodities; it associated them with the notion that there was an endless bounty of a limited selection of movie titles.

Like VPD and Ingram, Rentrak's position as a middleman between content providers and video stores allowed it to insinuate itself into the economic structure of the industry. Rentrak also served as a courier of knowledge between producers and retailers. Like Ingram and VPD, Rentrak promoted the sense that videos were "products" like most others. Novelty and bulk were both Rentrak's economic model and its cultural logic. Further, like VPD and Ingram, Rentrak's position as middleman allowed the company to distribute knowledge and values in a two-way flow between producers and retailers. Unlike other distributors, Rentrak's knowledge-gathering system was extremely rationalized and systematic. One of Rentrak's major innovations was its Rentrak Profit Maker (RPM) software, which Rentrak required PPT participants to install in their point-of-sale computers. The RPM software functioned as an information relay between individual stores and computers at Rentrak. It allowed individual stores to order videos directly through their POS computers rather than over the phone or through

a mail catalog. More important, the software transmitted information about the stores' commercial transactions to Rentrak. This allowed Rentrak to calculate how much revenue was being generated, and thus how much revenue needed to be shared with themselves and the content providers. It also provided information about the performance of specific movies in specific stores. In other words, the RPM software gave Rentrak copious amounts of market research data. Rentrak not only acted as a knowledge broker *to* video stores but also became a broker of knowledge *about* video rental stores.

Rentrak's emphatic promotion of hit Hollywood films affected Ingram and VPD in the late 1990s, particularly as they had to respond to corporate video stores' concomitant emphasis on copy depth. Primarily, in fact, the drive toward copy depth during this moment was promoted and facilitated by the Hollywood studios, which by the late 1990s had developed a number of deals to sell their product directly to the major video store chains and other video retailers. Copy depth was also promoted by Rentrak, which could service stores' desires for copy depth with its revenue-sharing system.[79] Yet mainstream wholesalers like Ingram and VPD were still forced to buy and supply a large number of a limited range of titles, making their economic exposure considerable.[80] In their attempts to serve the desires for copy depth, Ingram and VPD saw their profit margins sink due to the rapid devaluation of hit movies.[81]

At the time, the mainstream wholesalers expressed hope that they would remain competitive with the adoption of the DVD format.[82] But the effect of DVD on the home video industry was complex and significantly relocated and revalued video commodities. DVD videos were cheaper than VHS, and this comparatively low pricing made DVDs amenable to the sell-through market in addition to or in place of the rental market.[83] Although the price of DVDs decreased overall revenues for Ingram, the sheer volume of DVD sales provided VPD with an economic windfall, as retailers and customers rapidly switched to the new platform.[84] One distribution worker asserted, "The beginning of DVD—it was like the early days of VHS."[85] Wholesalers had such hope for DVD, in fact, that they offered "DVD starter kits" to retailers, aimed to make the DVD more enticing.[86] With such promotional activities, distributors acted as they had in the early days of video, "educating" retailers about how to include video commodities within their walls and creating excitement about a technology as a means of engaging with movie culture anew.[87]

Yet, DVD was largely adopted as a sell-through commodity.[88] Just as importantly, and as discussed in chapter 1, the adoption of DVD meant a dramatic relocation in the dispersal of home videos. Big-box stores like

Target and Wal-Mart now became major forces in the retailing of videos and in the dispersal of movie culture generally. In 2002, VPD CEO Shannahan acknowledged that the increased direct sales of DVDs from studios to retailers meant that there was an overall "shrinking pie" for video wholesalers.[89] Shannahan estimated that "only 10% of all studio revenue and 40% of video revenue from the rental channel flow through distributors," while the rest was handled directly by the studios themselves.[90] Similarly, David Ingram acknowledged in 2005 that mass merchants like Wal-Mart were able to sell DVDs at "disturbingly low prices," lower even than the prices offered by Ingram, thus encroaching on their business.[91] Indeed, the price of DVDs offered at big-box stores made them susceptible to "sideways selling," which is when a retailer or rental store buys a video from another retailer rather than a wholesaler.[92] More than anything, this dispersal of large volumes of DVDs created a new sense of media abundance and reinforced the idea that novelty and newness were the criteria on which a movie's value was based. The sheer bulk of DVDs being shipped through wholesalers or to big-box stores meant that there were more returns of unsold product; this prompted VPD to open a center specifically devoted to handling DVD returns in 2001.[93] Shannahan claimed that this rapid turnover in product actually benefited video rental stores, as they could capitalize on the market for previously viewed videos.[94] Even so, such resale activities merely spoke to the overall devaluation of video commodities during this time. Video stores now served as secondhand video thrift shops.

Thus in the 1990s and 2000s, mainstream video wholesalers had cheapened video commodities, both perceptually and economically. To whatever extent these companies have been geographically flexible in the past, increasing their economic scale through geographic reach, they now operate in a media landscape composed of a multitude of retail outlets and sites of movie consumption; these factors have only contributed to the cheapening of videos and further associated movie culture with consumer culture at large. Further, the economic and geographic scales of these companies are intertwined with their near-complete reliance on Hollywood movies and Hollywood's vision for movie culture. The increased consolidation of the video wholesaling sector has been attended by wholesalers' increased access to and promotion of Hollywood films. By 2002 Ingram and VPD were the only two companies distributing movies for all the major Hollywood studios.[95] At this same moment, VPD and Ingram had exclusive rights to distribute movies for Columbia, while Universal was distributed only by Ingram, VPD, and Rentrak.[96] In addition, a deal with Warner Home Video

gave Ingram and VPD access to Warner's vast market research data on the rental business, including contact information for "every rental store in the nation."[97] Just as these wholesalers have consolidated and the video wholesale market has contracted, the Hollywood studios have gained even more ground in defining the value of videos and movie culture.

RESTRICTED VIDEO DISTRIBUTION

In contrast to VPD, Ingram, and Rentrak, a handful of video distributors have cultivated and circulated more refined notions of cinema artistry. In doing so, these specialty distributors have played a critical role in shaping the historical shift of quality cinema from the theater to the home. As James Kendrick and Barbara Klinger have discussed, the most prominent among them is the Criterion Collection, which has created a pseudocanon of cinema based on exclusivity and eclecticism.[98] Featuring lush, attractive packaging as well as abundant "extra features," including essays by critics and scholars, Criterion's DVD releases convey cultural significance and formal elegance. However, Criterion has not been the only player in this arena and the senses of "quality" they have cultivated constitute only part of the larger distribution of attitudes regarding home video.[99] A significant number of companies have operated in the area of non-Hollywood video distribution, including Something Weird Video, New Yorker Video (sister to New Yorker Films), and Video Search of Miami, and each has added a slightly different flavor to the mix. In focusing on Kino Lorber, Zeitgeist Films, and Facets Multi-Media, I do not mean to suggest that these are the most important examples. Rather, examining the similarities and differences between these companies illustrates a range of practices whereby "quality" has been created and dispersed in the home video arena. Some of these companies were able to distinguish themselves amid the chaos that characterized the early days of home video distribution by drawing on and capitalizing on certain established forms of cinematic quality. Indeed, these notions of quality allowed these companies to contend with changes in the technological and cultural conditions around them. In this way, their promotion of marginal, rarefied, and even elite movies served an important economic function. The stability of each firm's mission assisted them in creating and maintaining additional business endeavors, including theatrical distribution and exhibition. Perhaps most important, these companies were instrumental in converting highly refined notions of cinematic quality from one industrial/cultural arrangement to another, from theatrical to domestic distribution and exhibition.[100]

Kino began in 1976 as a distributor of silent and classic American films to the art house theaters of the time. They released respected foreign films as well, as they were licensed to release Janus Collection titles in theaters. Donald Krim bought the fledgling company in 1977. After earning a law degree, Krim worked in the "nontheatrical" department of United Artists, handling film rentals to college campuses and similar nontraditional venues.[101] This provided Krim with experience getting films to audiences, marketing nonconventional theatrical releases, and with audiences that had a taste for such fare. Kino's focus was classic films, those that had earned prestige previously through awards or critical acknowledgment, such as films by Charlie Chaplin and Alfred Hitchcock. By the time Kino started its home video distribution division in 1987, it was already associated with quality cinema, "quality" here meaning American films from the past that remained historically important or aesthetically impressive, as well as foreign films, both classic and new. Vitally, the company upheld the notion that movies are made for artistic rather than solely for commercial or entertainment purposes and transferred this notion from celluloid and the art house theater onto magnetic tape and the VCR. Art house in your house.

Although newer and smaller than Kino, Zeitgeist Films has operated in an analogous manner and carved a comparable cultural space for itself. The company was formed in 1988 in New York, when, according to a producer there, the art house market remained viable, even if it was small and facing serious challenges. Unlike Kino, Zeitgeist operates primarily as a theatrical release company, with home video being a necessary but adjacent element of its ventures. One producer at Zeitgeist acknowledges the company's mission and stature by saying it does "boutique on a budget." The company typically releases only about six movies in theaters each year. Nevertheless, as it eventually distributes all its theatrical releases on home video, as well as a handful of titles for which it does not handle theatrical release, it remains an important name in the specialty video market.

Thus Kino gained economic viability and cultural prestige, even economic viability through cultural prestige, by offering comparatively "better" titles than the contemporary Hollywood films and B movies offered by other distributors during this era. Kino helped invent the idea of a domestic art cinema, and Zeitgeist has followed suit as it navigates both the traditional and home theater markets. Just as they distributed movies, these companies distributed an idea about what counts as quality cinema. Yet distinction does not guarantee success. The operators of Kino and Zeitgeist had experience in the art house theatrical market. Their innovation was attempting to bring this conception to a new technology and into a new

social pattern of use. But the specific qualities of value that these companies cultivated and circulated had to resonate with specific retailers and customers, all of whom had to have faith in the value of "restricted" cultural production.[102] These specialty distributors fostered exclusivity, cosmopolitanism, intellectualism, auteurism, and social activism, qualities that resonate with elite and (historically) academic conceptions of film-as-art. Although these qualities of "quality" often overlap, they are identifiable in specific, concrete techniques undertaken by these distributors. Further, these distributors used their accrued cultural capital to move from one technology to another and from one social use of media to another. In this respect, they have not just coordinated with a social formation, but altered it.

In addition to their cultural impact, it is vital to note the geographic component of these companies' activities. Mainstream wholesalers decentralized movie distribution; they moved it out of Los Angeles and circulated a low- to middle-brow conception of movie culture throughout the country. In contrast, Kino Lorber and Zeitgeist operate out of New York. The vision for cinema culture fostered by these companies works alongside the more rarefied notions of "culture" circulating in this cultural capital, where one can find countless institutions for live theater and the fine arts. These distributors' "restricted" mode of cultural circulation generates a refined notion of movie culture, which is similar to that found in specialty video stores across the country. However geographically dispersed, such specialty stores have been typically located in places with other institutions of "official" cultural capital. Thus, although these specialty distributors have been located in a large, cosmopolitan city renowned for its cultural offerings, they have served a widespread clientele. Despite their economic marginality compared to the mainstream wholesalers, these companies conveyed "restricted," exclusive, or cosmopolitan notions of cinema, which in turn coordinated with a numerically small but geographically dispersed network of like-minded video store owners.

What Bourdieu calls "restricted production" aligns most readily with the quality of *exclusivity*.[103] The Criterion Collection has developed this strategy quite remarkably, as they only have around seven hundred film titles under their banner as of 2013. But Kino and Zeitgeist also take an exclusive approach. Kino distributes a broad range of titles, including silent classics (the films of Buster Keaton), American independent cinema (*Daughters of the Dust*, 1994), and "The Best of World Cinema" (*Himalaya*, 2000). Similarly, Zeitgeist has released numerous documentaries (*Manufactured Landscapes*, 2006), some experimental animation (*Phantom Museums: The Short Films of the Quay Brothers*, 1979–2003), and art films from around

the world (*Irma Vep*, 1996). This range of titles and genres could convey a sense of inclusiveness rather than exclusivity. Yet these companies' releases nevertheless fall within rather strict parameters: non-Hollywood fare with pretensions of refinement. Certainly, some of the selectivity that these companies demonstrate results from economic conditions. They simply do not have the financing to acquire and release "big" films or even art house crossover hits, which are generally handled by larger specialty distributors or even a specialty division of a Hollywood studio. But the economic situation of these companies is not the only determining factor here, as a number of other small video distributors have carved a space for themselves with trash cinema and horror films, such as Something Weird Video. Although circumscribed by economic necessity, Kino and Zeitgeist promote a *rarefied* cinema.

In the case of Kino, this exclusivity derives partly from the company's relationship with film archives and preservationist institutions. Kino has been able to "branch out," in the words of one company employee, into American independent and contemporary world cinema because it has such a solid base in silent film classics from across the world. Although they lost access to the Janus Collection films to the Criterion Collection, Kino operates similarly to Criterion by relying on a stable base of classics that can be sold and resold on a regular basis, such as *Battleship Potemkin* (1925) or the boxed set *The Movies Begin*, which features a vast number of films representing all manner of early cinema. In the latter case, as well as with such collections as *Edison: The Invention of the Movies*, Kino's historical relationship with the Motion Picture Collection at the George Eastman House proved especially important.[104] The company worked with this archive and others, including the Library of Congress and Museum of Modern Art in New York, to obtain high-quality prints of films that have been previously consecrated. As Kino has successfully promoted these titles in the home video market, representing its interests and those of their institutional affiliates, these institutions have helped Kino with subsequent projects, creating a virtuous circle of status and quality.

Another way that these companies maintain a sense of exclusivity is through their access to international cinema at film festivals and the distribution markets that occur there; moreover, this process conflates the sense of exclusivity with that of *cosmopolitanism*. Kino Lorber regularly sends representatives to the festivals at Cannes, Toronto, and Sundance, and Zeitgeist likewise sends scouts to these festivals and others that cater in international art cinema, such as Berlin. This is not surprising, as the markets at international film festivals have served as crucial links between the production and consumption of world cinema for many years. The point,

however, is that by entering these markets and engaging in these social arenas, these companies position themselves in competition with larger distributors, such as the specialty divisions of the major Hollywood studios, which often focus on theatrical distribution. Even more important, participation in these festival markets aligns these video distributors with a stratum of cinema culture where select films gain early approval and cultural distinction. This puts Kino and Zeitgeist in a privileged position to internalize and subsequently disseminate the values regarding cinema fostered at these festivals.

Another way in which these companies uphold and disseminate a distinguished vision for home video culture is through their adherence to national cinema and auteurist approaches to movies. In this respect, they align their commercial activities with conceptions of cinematic value developed among film critics and scholars; in this way these companies appeal to an intellectual approach to cinema more generally. Kino promotes itself by offering "The Best in World Cinema," and indeed, it distributes films from every inhabited continent; they have particularly strong offerings of films from France, Russia, and the United States. Further, Kino distributes a handful of films by such renowned figures as Claude Chabrol, Sergei Eisenstein, and F.W. Murnau, along with dozens of other notable but less recognized directors. Similarly, Zeitgeist distributes a small but specific selection of celebrated world cinema auteurs. Two of the most notable are Atom Egoyan and Guy Maddin; Zeitgeist provides video distribution for the majority of Maddin's films in particular. These companies' auteurist treatment of films can sometimes have direct economic benefits; because Zeitgeist simply does not have much money to devote to the production of extra features, they rely on the filmmakers themselves for "bonus" material. On the one hand, this renders their relationship with select directors intimate; on the other, and as a consequence, the intellectual and creative singularity of these directors is reinforced by their involvement in the DVD production and marketing processes.

James Kendrick argues that the Criterion Collection constitutes a video archive of "important" films that is able to consecrate its selected releases as important films, prompting consumers to evaluate the merits of *The Seventh Seal* (1957) in relation to *Armageddon* (1998) and the *Beastie Boys Video Anthology* (2000).[105] What is the criterion, indeed? Alternatively, Kino and Zeitgeist leave little question as to why their films hold value, particularly intellectual value. Kino does not constitute an archive but rather provides access, for a price, to existing film archives and their efforts at film preservation and restoration. Moreover, the very name of the company—Kino—

invokes the legacy of silent-era Soviet filmmaking, knowledge of which is foundational to any academic education in film and media studies. Although Derek Jarman may not command the same recognition as, say, Kurosawa Akira, Zeitgeist's adherence to an auteurist approach to their titles demonstrates a general faith in film-as-art (hence the need for a film artist) and a pseudoacademic impulse to categorize films according to a preconceived shared sensibility. Most blatantly, perhaps, Zeitgeist reveals an intellectualist approach to home video in its release of documentaries about contemporary philosophers and social theorists, including *Derrida* (2002) and *Žižek!* (2005).

The intellectualism disseminated by these companies is also internal to them, as a general working philosophy and institutional objective. Many if not most of the producers and other employees at Kino and Zeitgeist have degrees in film and/or media studies. These people regularly stated that their educational histories helped propel them into their current vocations. Moreover, they all asserted that this educational background informed their day-to-day work. The intellectual pedigree embodied in these companies coordinates with and flows outwardly through their sales to educational institutions. Milos Stehlik, cofounder and director of Facets Multi-Media, recalls that the video transition of the 1980s devastated the market for 16mm film rentals, which teachers at both high schools and universities frequently relied on. As a result, instructors across the country, particularly in film and media studies, relied on video and video rental to support their classes. In this respect, the sense of value upheld and materialized by Kino, Zeitgeist, and Facets was recognized and reaffirmed by like-minded people in the academy. In the case of Kino, it is the company's strength in silent cinema that makes it particularly valuable to universities with film history courses. One Kino employee stated that the company's silent film packages, for instance, are "tailor-made for college classes"; one thinks immediately not only of the Edison shorts or *The Movies Begin* but also of Kino's releases of such film history standards as *Intolerance* (1916), *Metropolis* (1927), or *The Thief of Bagdad* (1924). The company regularly markets directly to academics and librarians specializing in film and media studies, conventionally by mailing advertisements and catalogs or, more commonly recently, through promotional emails.

All this suggests that these companies help create and sustain a virtuous "circle of belief," if not an outright homology, among different social fields.[106] In turn, there appears to be a particular geography of taste operating through these distributors and into select video stores. There is a shared sense of the value of cinematic art in academic settings, film festivals, and

among cinephilic video store owners. Kino and Zeitgeist harmonized with these social fields and helped to deliver these senses of cinema into the video store, into the home, and even back into the classroom. Academic libraries, media departments, and individual instructors constitute a big market for Kino's releases, in fact. These companies thus have social effects, which constitute a kind of *social activism*. Zeitgeist demonstrates a vaguely left-leaning but vehemently anticorporate, anti–big media agenda through its release of select documentary films, a disposition that accords with its position vis-à-vis the mass media. Titles such as *The Corporation* (2003), *Manufacturing Consent: Noam Chomsky and the Media* (1992), *A Place Called Chiapas* (1998), and *Trouble the Water* (2008) attest to Zeitgeist's strategic commercialization of activist media production.

Even more than externalizing and projecting a particular political agenda, however, these companies demonstrate activism in the social field of independent media that they inhabit. In addition to the formal education that many employees at these companies have attained, a large number of them have circulated within a larger indie media sphere where cinephilia was a functioning ideology. During or after getting their college degrees, a number of these people worked at independent video stores. As with many current and former video store workers, they remarked on the social inter-actions occurring at the video store as important elements of this position, making it more than just a job and closer to a vocation. One producer admitted to being a film buff: "guilty as charged." Another distribution employee asserted that working at an independent specialty video store was vital to engendering a sense of cinematic breadth and eclecticism as collec-tive values. "People who worked [there]," he stated, "felt very passionately about films, and that was the place to be to be around people who felt simi-larly." The strength of this harmonization is demonstrated by the fact that the primary sales representative for one of the companies was once the buyer at one of the largest and most respected independent video stores in the country. Here, an exact reversal of roles reflects the commensurability of the mentalities shared by each position.

This shared sensibility of media quality—for the sake of quality—regu-larly guides the choices and activities of these companies, making "quality" a de facto mission and operating logic. More often, however, this activism is informal and internalized. Given the financial constraints on both Kino and Zeitgeist, they cannot afford conventional market research or intense pro-motion of their product. Instead, they must gamble on the possibility that their clients and customers share their taste. At Kino, this can mean trying to repeat the success of one of their hits, such as with their continuing line

of restorations of German silent classics, among them *Metropolis, Die Nibelungen* (1924) and *Nosferatu* (1922). Zeitgeist similarly has to do a bit of guesswork in predicting what will work for the company, but this guesswork is offset by past successes as well as the cultural capital that gets embodied by the individual employees and institutionalized through their decisions and actions. Although Zeitgeist generally distributes documentaries, select auteur films, and independent art cinema, it is often chance and a producer's taste that guides the selection of the company's film titles. In the words of one Zeitgeist producer who formerly worked at Criterion, one simply has to "believe" in the movies that they choose; they must feel a passion for them, or the uphill battle against the economic limitations of niche cinema would be overwhelming. As Zeitgeist has no formal market research tools, the workers there claim to "know" their market, basing their assumptions on past successes. Here the circle of belief functions as a taste-based business model. The company's faith in art cinema goes hand in hand with the faith that it shares this taste with its customers. It trusts that it will have customers because its employees are the kind of people who would be its customers.

FACETS MULTI-MEDIA

Whereas Kino Lorber and Zeitgest Films somewhat informally instituted themselves as bastions of quality cinema in the realm of video distribution, Facets Multi-Media engaged in video distribution as merely one part of a broad-based and self-conscious attempt to elevate cinema culture in the United States. As a hybrid business and cultural institution that engages in theatrical exhibition, film festivals, video rental, video wholesaling, video distribution, and film education classes, Facets formalizes many of the otherwise implicit agendas and ideologies found among other specialty video distributors and video stores. The company was founded in 1975 by Milos Stehlik and Nicole Dreiske as a film exhibition center in Chicago, which focused on international and American art cinema, non-Hollywood children's films, and experimental live performance.[107] Like Kino, then, Facets began in the days before the VCR became a viable option for media consumption, and so initially framed cinematic "quality" in ways that derived from a theater-based context. By the early 1980s, however, Facets expanded to include an adjacent video rental store that specialized in art films as well as the distribution of art cinema titles on video. From the start, Stehlik says, he treated movies on video as "cinema," which in this context elevates movies to a realm of superior quality.

When discussing the early development of the company, Stehlik states that their location in Chicago was somewhat fortuitous, as in the 1970s it was home to a lively cinematic culture. Stehlik notes that the film critics Roger Ebert and Gene Siskel began appearing on a local PBS program devoted to discussing cinema around the same time that Facets went into business; this program soon became nationally syndicated and eventually morphed into the hit show *At the Movies*. In Stehlik's opinion, this program indicates how movies began to be taken more seriously in Chicago and across the country. Stehlik cultivated a sense of quality cinema in the video store component of Facets Multi-Media by offering a broad and eclectic range of foreign and American independent films, making this rental store an important site of movie culture in Chicago. Yet in 1983 the company sought to surpass its geographic placement by providing a rent-by-mail system to individuals. In this way, they served a more dispersed clientele and provided art cinema on VHS and DVD to customers without a specialty video store in their vicinity.

Perhaps more vitally, Facets entered the video wholesaling business. They handle over seventy thousand different video titles, including movies from Kino and Zeitgeist, among many others. The company has specialized in foreign and independent cinema as well as videos devoted to the fine arts. Facets has been instrumental in distributing exclusive, cosmopolitan, and intellectual notions of cinema through its catalog, which generally follows logics of national cinemas and auteurism. For many years a print publication, the catalog has existed solely on the Internet since 2007. Although the catalog is accessed differently as a result, the logics about "cinematic quality" initiated in the print catalog have obtained in the transfer to digital format. Facets' catalog is quite particularist in its categorization. In the "European Cinema" division of the online catalog, for example, one finds a plethora of subdivisions, organized either by recognized directors, such as Tony Gatlif or Agnes Varda, or by subregion within Europe, such as Irish cinema or Norwegian cinema.[108] This highly refined partitioning of cinema accords with the impulse toward taxonomy found in scholarly approaches to film and other visual arts. In this respect, Facets has helped disseminate conceptual categories one might use to organize the otherwise unruly mass of non-Hollywood cinema. In fact, many specialty video stores across the country adhere to the same forms of categorization found in the Facets catalog.

In addition to wholesaling a huge number of movies for other specialty distributors, Facets distributes a selection of titles under its own label. Stehlik says that Facets takes a "curatorial" approach, seeking out and filling holes in the home video landscape. He opposes this with what he calls

the "clearinghouse" models adopted by Amazon and Netflix. In practice, this means that Facets might release a single film title that is not already available, but more often it means releasing films produced in areas of the world that are underrepresented in the North American market. Whereas Kino offers "The Best in World Cinema," Facets has carved a niche *in* niche home video by distributing films outside the more recognized national cinemas. As of today, "Facets Video hosts three exclusive video lines: Accent Cinema, a world cinema label that has particular strengths in Europe; Cinemateca, a Spanish world cinema label that features films from Spain and Latin America; the Facets Video label, a world cinema label that has particular strengths in Middle Europe, the Middle East, and American independents."[109] They acquire "between twelve to eighteen films annually for exclusive release on the Facets label; [and] another twenty for exclusive distribution, and four to five thousand new titles every year for nonexclusive distribution."[110] Shaped by both taste and economic constrains, Facet's video releases are quite exclusive, which Stehlik readily admits. He states, "It is very difficult [for Facets] to distribute independent features that aim at a broad, middle-brow audience and which emulate Hollywood films or television. There are other distributors that are perfectly capable of moving these films into the marketplace."[111]

Although its distribution efforts are culturally marginal, Facets has successfully integrated them into a more comprehensive effort to operate as an institution aimed at cultural improvement. Facet's emphasis on children's media, a genre that the company has promoted almost since its beginnings through the Chicago International Children's Film Festival, testifies to the company's promotion of media for enrichment rather than entertainment. In 1996 it released the *Facets Non-Violent, Non-Sexist Children's Video Guide.*[112] Stehlik proclaims that media education should be a mandatory element of public education and should begin quite early in children's curricula. Facets offers film appreciation classes at its Cinémathèque on a regular basis, including such courses as "Cinema and Surveillance" and "Odd Couples: The Buddy Comedies of Billy Wilder." Such classes distribute the means of appreciating films at the same time that the company aims to capitalize on people's appreciation of films. Facets cultivates the very same social field that, ideally, will trade economic capital for the cultural capital they sell.

This is not an easy process, of course, and it requires long-term dedication, vision, and constant maintenance. Whereas successful large-scale commercial endeavors in the cultural industries get reinforced by large amounts of financing, small-scale distributors of cinema culture such as Facets often

work with minimal economic support, and this puts strains on their ability to grow or sustain themselves. "You have to build your own infrastructure," says Stehlik, "if you want to do something in mainstream culture." Facets has been fortunate to the extent that it has formalized its status as a cultural institution. Officially, Facets is a nonprofit 501(C)3 organization.[113] Its institutional status has been recognized by the National Endowment for the Arts, the Illinois Arts Council, the John D. and Catherine T. MacArthur Foundation, the Chicago Community Trust, and the Academy of Motion Picture Arts and Sciences, all of whom support Facets with funding. The website for the National Film Registry provides a link to Facets below the question, "How do I obtain DVD's or videos of National Film Registry titles?"[114] These affiliations attest to Facets' importance and create vital links between this company and more official cultural institutions. Given the company's broad approach to creating an erudite, non-Hollywood cinema culture and given its institutional coherence and durability, Facets has made a noteworthy impact on quality cinema in the era of home video.[115]

THE NEW LANDSCAPE OF VIDEO DISTRIBUTION

In a 2010 *Los Angeles Times* article, the head of Home Entertainment at Sony Pictures acknowledged that DVD sales were declining rapidly, that Redbox was causing industry confusion, that Blu-Ray was likely never to have the same impact as DVD, and that digital downloading showed "nice growth."[116] Since 2004, when Chris Anderson first discussed the "long tail," by which digital and semidigital distribution systems facilitated the proliferation and economic feasibility of niche media, there has been a proliferation of new means for the dissemination and consumption of moving images.[117] This has caused as much confusion and experimentation as was seen in the early days of home video, as the Hollywood studios and other content providers assess new technological and economic possibilities. As discussed in chapter 1, Redbox and other video kiosks spread rapidly across the United States during the Great Recession of 2007–9, so that at the time of this writing there are over forty thousand Redboxes in the country—more than the number of video stores at their peak.[118] Further, despite some public relations blunders in 2011, Netflix served 23 million members through its streaming services in 2012.[119] It was also reported in 2011 that Netflix accounted for 32 percent of all Internet bandwidth during peak hours of use.[120]

These changes in the sites of movie access have deeply affected the Hollywood studios, the mainstream video wholesalers, and the specialty

distributors. For the most part, the dispersal of DVDs in Redbox kiosks and the dematerialization of movies through VOD and streaming services have prompted a downward spiral in video's economic value. At first glance, the growth of Redbox would appear to bolster wholesalers like VPD and Ingram, as Redbox obtains its DVDs from these companies. But a worker at one of these companies stated that the kiosk business hurt the overall media industry because it "brought down the perceived value of video." Not only did this comment suggest how perceptions of value and "real" economic value are intertwined; it also signaled that Redbox's pricing affected the entire media industry. Analogously, an executive working at the Home Entertainment division of a major Hollywood studio stated, "From my perspective, the deals that the Hollywood studios have cut with Netflix on their streaming model I think are some of the single worst business decisions that the studios have ever made in the industry of home entertainment," due to the fact that it keeps people from going out and spending money on new releases. However convenient Netflix has made movie viewing for consumers, it seems that it has simultaneously created incentives for consumers to be choosier—and thriftier—in their media consumption, thereby driving down the value of video even further.

Art-minded video distributors have responded to the widespread growth of Redbox, VOD, and Internet streaming in their own ways. Lucas Hilderbrand has shown that IFC Films, in particular, has cultivated a multiplatform delivery strategy for independent cinema and that the company situates VOD centrally to their operations.[121] Although Facets and Zeitgeist have taken somewhat cautious approaches to these delivery systems, Kino has worked with Amazon, Hulu, and iTunes to bring its movies to viewers. A particularly interesting model for the distribution of art cinema in an age of intangible media is MUBI (formerly The Auteurs), a streaming media website.[122] On this website, one can stream both classic art house films and contemporary prestige pictures. Established in 2007 with funding from Goldman Sachs, the company was conceived as an outlet for "underdistributed films." The goal was to overcome geographic barriers for people who like art cinema, so that one could watch "*In the Mood for Love* [2000] in a café in Tokyo on your laptop," for instance.[123] In practice, this geography is delimited by whether or not MUBI has licensed a particular film in a particular country. While the MUBI website claims that it functions in every country in the world, and apparently Antarctica as well, the selection of movies one finds on the website will be different in each country.[124] Further, the original intent was for MUBI to make such movies available free, yet individual movies actually cost $3 each; as of 2013 MUBI also

offers a subscription price of $5 per month. Unlike other distribution models, MUBI does not ask for a minimum from the rights holders in payment for putting the movie online, and they split the revenue fifty-fifty with the rights holder of any film that gets streamed. Notably, MUBI partnered early on with the Criterion Collection, which allowed it to distribute a selection of Criterion films. Since that time, Kino Lorber also partnered with MUBI, and one can stream a number of their films as well. These partnerships aim to expand the technological bounds of quality cinema by drawing on existing cultural wealth, which could also establish MUBI as a new site for the production of cultural wealth.

In terms of a practical cultural logic, MUBI exists in the realm of the long tail but in a significantly different way from an operation like Netflix.[125] According to one MUBI employee, the company takes a "strategic approach" by being very selective about titles and offering only a restricted number. In this respect, MUBI, like Criterion or Zeitgeist, aims to create a sense of value out of exclusivity. This is difficult on the Internet, of course. One worker at MUBI stated that, as of 2009, the website largely functioned as a tool of discovery rather than a tool of viewing for most visitors; by 2013, this was no longer the case. Further, the social networking and chat forum features on the MUBI website allow for interactions around media that are not immediately reduced to commercial transactions. In this way, the website distributes both movies and a discourse around them; given its infrastructure, MUBI may indeed indicate how notions of restricted, exclusive, and prestigious forms of media wealth could circulate more widely. Art cinema: from the art house to your house; and now, if we are to believe the techno-utopian hype, art cinema everywhere and nowhere in particular.

MUBI's online chat forums highlight the continuing importance of discourse about movie culture even as videos are becoming dematerialized. The dematerialization of movies through VOD and streaming has shaken up the ways in which videos are valued. Information *about* movies and movie culture appears to have been commodified in this same moment. Fully demonstrating this trend, Rentrak now operates primarily as a market research firm, commercializing information about the media industry rather than profiting from media itself. As an outgrowth of its RPM software, which monitored commercial activity in participating video stores, Rentrak developed the Home Video Essentials software, which gathered information about commercial activity, that Rentrak subsequently sold to participating Hollywood studios.[126] As part of this deal by which Rentrak would commercialize information, Ingram and VPD would handle the material shipment of video commodities. In this respect, Rentrak profited

from a dematerialized set of information while Ingram and VPD were left to contend with the increasingly tumultuous material world of video distribution; they were the hands to Rentrak's brain. The company also created Box Office Essentials software to track movie theaters, and six Hollywood studios quickly signed contracts to use the service.[127] Further, Rentrak paired with Comcast to provide the cable company with data about its VOD service in 2004.[128] This move was characterized at the time as "Rentrak's latest initiative in the business intelligence and tracking arena as it transitions from being a company primarily devoted to selling revenue-shared VHS and DVD movies to retailers."[129] In 2010, Rentrak bought Nielsen EDI from its parent, the Nielsen Company, making it the most important firm in the area of media industry data collection.[130]

Rentrak's trajectory, from video store chain to video distributor to market research firm is the rare story of long-term success in the home video industry. More important, however, its trajectory vividly illustrates the shifting economic and cultural priorities within video culture, from the concrete, physical space of the video store to the widespread distribution of movies and values as a distributor and now to broker of knowledge. All the video distributors discussed in this chapter, from the "large-scale" wholesalers like Ingram and VPD to the "restricted" distributors like Kino, Zeitgeist, and Facets, cultivated and circulated knowledge and values around video commodities. By creating value out of knowledge itself, Rentrak has taken this process to a certain logical extreme.

This raises a number of important questions regarding the circulation of ideas and values about movies and movie culture. The social interactions in the video store distributed knowledge and values about movies, and video distributors had qualitative effects on video stores and movie culture as well. But where else and through what other pathways have information and notions of value pertaining to the video store circulated? What sites of discourse have been affected by the video store and the ways in which it changed movie culture? That is, how have these avenues for the circulation of knowledge and value been affected by the video store, and, subsequently, how are they affected by the processes that are making videos "intangible" and video stores obsolete? I address these questions in the next chapter.

6. Mediating Choice

Criticism, Advice, Metadata

Historically, the video rental store provided Americans with a new abundance of movie options as well as new levels of control over movie consumption. This apparent plentitude created notable shifts in the perception of movies, as Americans now had to select from a number of different venues for watching a movie, in addition to choosing a particular film. Along with pay cable, video rental stores fractured the movie market even as they expanded it beyond the movie theater and broadcast television. Movies of all varieties appeared (seemingly) everywhere, all the time. The value of the individual movie title was suddenly less about scarcity in exhibition and more about being distinguished from the mass. Video stores trained Americans in the ways of movie shopping, but the sheer number of options sometimes made it difficult to choose, difficult to know what was worth watching.

Hand in hand with the growth of these shopping options, a small but prolific industry of video recommendation guides sprang to life in the 1980s and 1990s. Numerous movie shoppers and video clerks bought thick publications, like *Leonard Maltin's Movie and Video Guide*, which typically cataloged over ten thousand different movie titles. In combining descriptive information with critical evaluations of a huge number of movies, these guides served a practical function: they helped shoppers shop. Of course, film critics had been serving similar purposes for theater audiences for many years, and similar guides had appeared earlier to help television viewers decide which movies were worth watching on TV. Building on these traditions, the video guides of the 1980s, 1990s, and 2000s provided information about an incredible number of movies, in fact more than the typical video store could hold. In this respect, the size of the guides points to the inevitable limits of any video store's inventory due to physical space.

Further, the guides document movies that many individuals never watched or had access to; for many people, the guide itself was an important form of access, however virtual, to the vast number of movies that it described. Thus these guides do more than index the abundance of movies made available on video. They index the changing value that movies held with the advent of video and of the video rental store. Specifically, they signal a new valorization of choice and selection. Indeed, Americans valued this sense of media abundance and choice perhaps more than they valued any particular film, genre, or director.

This chapter charts the history of movie recommendation guides from the beginnings of film criticism to the present moment of "intangible media." This history demonstrates that as Americans have encountered increased access to movies and have adopted new methods for viewing them, there has been a concomitant transformation in the means and methods for sifting through movie viewing options. Before home video, broadcasters had already made it a common practice to present feature films on TV, providing Americans with convenient access to more movie choices. Thus Steven Scheuer's *Movies on TV*, which first appeared in 1958, aimed to account for this abundance and provide Americans with the ability to discern what to watch. Extending this trend, the institutionalization and normalization of the video rental store in the 1980s and 1990s prompted the growth of the printed video guide genre, which took the conventions of the earlier guides and retooled them for video renters. Video stores promised convenient access to a large number of movies, reshaping movie culture toward a celebration of abundance and choice. The video guides of the 1980s, 1990s, and 2000s reflect and support these values through their twin objectives, to catalog and evaluate a huge number of movies.

More recently, movie recommendation services have undergone the same digitalization as the videos themselves. Indeed, digital mechanisms for providing movie information and evaluations actually precede the digitalization of videos and, in fact, have now been integrated into the very same digital platforms through which we access these movies. In many respects, "the video store" has been virtualized in a digital media landscape. A number of companies, like Amazon and iTunes, provide mechanisms and services that serve as the virtual shelves of this store and even act as video guides as well. Through a detailed examination of the immensely important but little-known company Rovi Corp., which has pervaded and altered video culture in deep and powerful ways, this chapter shows how the digitalization of media is entangled with a digitalization of information about that media. As movies are now treated as "data" in a digital space, Rovi

capitalizes on "metadata," or data on movie data. Yet perhaps this technical change in movie recommendation sources, from print to digital form, merely highlights an underlying truth: movie reviews and encyclopedias have always operated as "metadata." As a peripheral discourse to media, metadata in any form marks the contours of movie culture in any given moment. Previously, when printed video guides were the norm, they marked the abundant choices of tangible videos and Americans' concomitant desire for choice. Now that this metadata largely occurs in a digital world the where the "metatext" is part of the same apparatus as the text, it provides both the literal and figurative gateway through which Americans find and select their movies.[1]

FROM CRITICISM TO COMPENDIUM

The first public discussions of cinema appeared in print at the same time movies were first exhibited. Critical evaluation of individual films followed soon thereafter, almost entirely in film trade publications. Jerry Roberts cites the *New York Daily Mirror* as having one of the earliest sections devoted to reviewing films in 1908.[2] *Variety* began reviewing movies in 1907, and *Motion Picture World* began doing the same in 1908.[3] In 1910, the *New York Morning Telegraph* was the first American newspaper to devote a page to movies, and film reportage became a common feature of many city newspapers over the next decade.[4] Film reviewing, however, was a bit more haphazard in the 1920s and 1930s, appearing sporadically in newspapers, monthly magazines, and trade magazines. Yet by the mid-1930s, the professional status of "the film critic" was well enough established that writers from a handful of New York–based newspapers formed the New York Film Critics Circle.[5] By the postwar era, most daily newspapers in large cities had a regular film critic.[6] Further, there were an increasing number of magazines devoted entirely to evaluating films and reporting on cinema culture during the postwar era, for example, *Film Quarterly* (first known as *Hollywood Quarterly*), *Film Culture,* and *Film Comment.* These and similar publications aimed to provide readers with a wide range of educated opinions and intelligent analyses of contemporary and historical cinema.

For many people, there was a "golden era" of film criticism in the United States from the late 1950s through the 1960s, one that coordinated with widespread popular cinephilia.[7] A host of critics with a wide range of styles, including Manny Farber, Andrew Sarris, and Pauline Kael, among many others, gained national reputations for their reviews in various periodicals,

from daily newspapers to monthly magazines. In this moment, the figure of "the film critic" took on new levels of cultural prestige, and the reviews were often as debated as the films themselves. In addition to writing in weekly and monthly print publications, many of these people published books of film criticism, either as compilations of previously published reviews, such as Manny Farber's *Negative Space* and Pauline Kael's collections, or as new book-length studies that extended their periodical work, such as Andrew Sarris's *The American Cinema*.[8] These book-length publications endowed film criticism with a new permanence. Whereas before film reviews were as fleeting as the movies themselves, now cinephiles and general readers had access to a durable material commodity that they could own and return to at their leisure. If before cinephiles solely fetishized their experiences at the theater, now they could also fetishize an object that evaluated those experiences, a material embodiment of cinematic thrills and disappointments.

There was an increasingly encyclopedic tendency among film books during this time. In part, this was an outgrowth of the fan magazines that had cropped up in the 1910s and 1920s, which featured photographs and documented facts about different films and performers.[9] *Screen World,* in particular, became an important resource for readers who wished to have factual data about movies. It began publication in 1949 and was published annually thereafter. With each edition, readers found an extensive list of the films released that year. Each entry included the credits for the director, writer, and producers of the film, along with a list of the actors in all the primary roles. Actor head shots and production stills accompanied each entry, so in fact the bulk of the book is devoted to black-and-white photographs.

Even books of film criticism took a turn toward the encyclopedic, balancing breadth of coverage with critical evaluation. Although intended as a critically informed film history, Sarris's *The American Cinema* demonstrates an interest in both cataloging and evaluation, a practice that all subsequent movie recommendation guides (and online services) would sustain. Sarris's book is divided into a series of entries dedicated to specific film directors, first listing the title and year for each of their films and then evaluating the quality of these films. Dana Polan discusses how the very form of the book appealed to certain kinds of contemporary fans: "The sheer massiveness of his [Sarris's] lists became a clarion call for viewers to turn passive reception into active investigation[,] . . . a veritable score card of viewing accomplishments and future screening goals."[10] Polan thus connects Sarris's cinephilic inclination to collect directors with the cinephilic tendencies of a generation of readers in the 1960s and 1970s, indicating that

the impulse to amass movie-viewing experiences corresponds with a "checklisting" of accomplishments.

Regardless of how cinephiles chose to engage with Sarris's book, its form testifies to the two main impulses that would carry through analogous publications to come, *coverage* and *evaluation.* Sarris's book and the encyclopedic film publications that followed did not just cater to people who had watched a lot of movies; they actually generated curiosity and enticed people to watch more. Yet because these encyclopedic publications covered more movies than most people had access to or could actually watch, they quickly began to serve a novel function: they gave people virtual access to movies that were otherwise unavailable. They served as records of the movies themselves, turning cinematic experiences into written information to be browsed and contemplated at leisure.

Although not precisely an encyclopedia of movie reviews, Leslie Halliwell's *A Filmgoer's Companion* in many ways was the blueprint for the later encyclopedic film books. First published in 1965, this massive reference tome quickly gained a reputation as being "invaluable" to film fans.[11] Halliwell aimed the book at a cinephilic readership, opening his introduction by saying, "This book is for people who like movies."[12] He also signals the larger mediascape in which contemporaneous casual fans and devoted cinephiles accessed movies: "Especially it's for those who enjoyed the golden ages of the thirties and forties, now revisiting us on television."[13] Here he suggests that the new "archive" of film history provided by television coordinated with an avid fandom in the era and, vitally, that this type of fan would be interested in an encyclopedic presentation of information about those movies.

He invokes his intended reader when he states the aims of the book:

> Everyone who watches films, whether on TV or the big screens, frequently thinks of something he'd like to check: a star's age, a director's name, what else that funny little fellow with the moustache has been in. To find out the answer to this sort of question it's sometimes been necessary to consult upwards of a dozen fairly inaccessible volumes. This book aims to bring all the available sources together while at the same time excluding inessential or dated information.[14]

Thus Halliwell aims to provide a single source for all the metadata that contemporaneous film fans might find interesting. He assumes that such viewers have curious minds, and because the films do not declare this type of information themselves, he provides the means to appease this curious viewer. Although not a "browser" in the literal, spatial sense, the readership

Halliwell envisions is composed of people who wish to stroll through the facts of film history.

The book is hundreds of pages long, with entries devoted to actors, actresses, directors, musicians, writers, individual films, genres, themes, and characters, among other categories. It also provides alphabetical lists of individual films, fictional characters, and themes at the end of the book, for readers to scan before delving into the main text. Each entry about a performer provides at least a few of his or her credits, and each discussion of a theme or fictional character likewise provides a list of films. In this respect, the book lends itself to and perhaps even encourages "hyptertexting," where a reader might hop from entry to entry, from page to page, based on some commonality among them. The curious viewer becomes the curious reader, the curious surfer of historical facts. The size and breadth of the book lends itself to more than a single fact-check but rather to browsing, surveying. In his review of the third edition, Charles Champlin wrote, "You can no more look up one item than you can eat one potato chip."[15] From this perspective, Halliwell's encyclopedia did not appease curiosity; it generated it.

Halliwell's guide is riddled with critical commentary. Having worked as a film reviewer for many years, Halliwell developed a humorous critical voice that often defied common opinion.[16] Providing appraisals of actors, actresses, directors, and movies that he liked and disliked, Halliwell created not just an encyclopedia of facts but also a record of his own tastes. Even the structure of the book suggests evaluation, as the author declares from the start, "The more important the person, the longer the entry. . . . As to the list of credits, the aim has been to give the first important picture, the most recent, and a sampling of the more significant titles in between."[17] In these respects, Halliwell's *Companion* engaged with and sustained the issues of cataloging and evaluating that attended the movie guides that followed.

In 1977 the author published *Halliwell's Film Guide,* which documented movies in a manner that has become more conventional. Organized alphabetically, the guide lists films and provides a single-sentence description followed by a single-sentence evaluation. It also lists the people who worked on the film as well as technical aspects, such as running time. Halliwell writes in the introduction, "I have tried to include every film which seemed likely or worthy of remembrance by the keen filmgoer or student, whether with affection for its own sake as good entertainment, for showcasing memorable work by a particular talent, for sheer curiosity value or for box office success."[18] Thus Halliwell maintains a level of curatorial power over the eight-thousand-entry selection and bases his choices on a number of

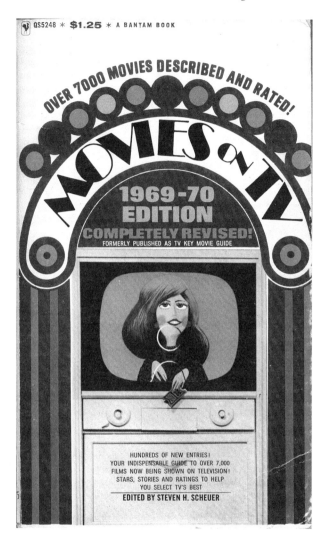

FIGURE 35. Steven Scheuer's *Movies on TV* helped remediate Hollywood film for television viewers. The cover of his 1969–70 edition depicts a woman selling a movie ticket out of a television screen.

different criteria. Even while it flirts with comprehensiveness, the encyclopedia maintains some level of critical intervention.

Yet as a compendium of capsule descriptions and reviews of thousands of films, Halliwell's guide is predated by Steven Scheuer's *Movies on TV* (figure 35). This publication was an extension of Scheuer's "TV Key," a

column of capsule movie reviews syndicated in newspapers across the country. Although not as recognized as Halliwell's *Companion* or *Guide*, this publication is more historically significant for several reasons. First, it codified the formula for the capsule-review book genre, which even Halliwell emulated, and, more important, provided Leonard Maltin with the format for his own book. Second, it overtly addressed a televisual movie-viewing audience, a population that had a new abundance of films available to them. If Sarris's *The American Cinema* appealed to cinephiles and Halliwell's *Companion* appealed to trivia hounds, then Scheuer's book appealed to a more general audience that, by the 1960s, waded through copious movie-viewing choices on television.

Originally published as *TV Movie Almanac & Ratings* in 1958, Scheuer's guide was designed explicitly for television viewers. As noted in chapter 1, television networks aired an increasing number of Hollywood films throughout the 1950s, so that by the 1960s it was common to find Hollywood films, new and old, playing every day of the week. Television viewers were, to a significant degree, movie viewers. Scheuer's guide stands as an index for this transformation of the airwaves and of television viewers. In the preface to the 1969–70 edition of the guide, Scheuer writes, "In the past few years, virtually every good film—and thousands of poor ones—made during the 1950's and mid-1960's has now been made available for showing on TV."[19] Scheuer then extols the artistic and cultural significance of this phenomenon: "Both serious students and casual fans of the art of motion pictures are still indebted to television for one continuing blessing—TV continues to provide a previously undreamt of opportunity to examine at one's leisure and with little expense, virtually the entire history of a major American art form."[20]

Scheuer thus positions television as an invaluable film archive that can appeal to either rigorous or casual users. Hence he positions his book as a tool by means of which different kinds of viewers might navigate this boundless treasure trove. His claim that viewers may do this "at one's own leisure" is an overstatement, as movies appeared on television according to the schedules of the stations and networks. In fact, his book seeks to help viewers make the most of their time, both in terms of seeking out movies to watch and in terms of deciding whether the movie playing on a particular evening is worth watching. But the issue of value is still amorphous here. While Scheuer declares his own position as an arbiter of taste, referring to cinema as an "art form" that "has had a profound impact on the habits and attitudes of audiences around the world," the book itself addresses potential viewers with a wide range of tastes and viewing

expectations.[21] Scheuer's guides range in length from four hundred to six hundred pages and feature capsule reviews for more movies than most people could watch in a lifetime.[22] The sheer abundance of reviews speaks to the book's attempt to appeal to a broad spectrum of curious viewers.

Scheuer's entries are organized alphabetically and provide the title of each film, the year of its production or theatrical release, and a rating on a four-star scale. Most entries also list some of the leading actors and actresses, and he notes the country of origin if it is not a Hollywood film. The "reviews" of each film typically range from fifteen to forty words in length. Scheuer provides a general description of the plot of the film, which he typically peppers with evaluative qualifiers. In many instances, he calls attention to certain highlights of a film, even movies that he otherwise criticizes, such as when he states that *Dark Victory* (1939) is "corny and a real tear-jerker but Miss [Betty] Davis' superb acting makes this one of the best handkerchief soakers."[23] In these assessments, Scheuer positions himself as arbiter of the film's quality and occasionally gestures toward the formal criteria on which he bases his judgments. In the context of the book as a whole, these judgments serve as a time-saving device, helping potential viewers improve the quality of their televisual experiences in advance of consumption.

On other occasions, Scheuer evaluates movies in ways that defer his own judgments. Sometimes he appears to concede that the value of some movies may lie outside conventional forms of artistic appreciation, such as when he writes of *Planet of Blood* (1966), "This sci-fi thriller is way, way out. Fans might get a kick out of it."[24] On other occasions, he asserts that a certain social group may appreciate a film. For instance, he writes that *Sweethearts on Parade* (1953) "might please the oldsters,"[25] that men will find *Blossoms in the Dust* (1940) "a bit too sweet and sentimental,"[26] and that "the ladies will love" *Enchantment* (1948).[27] He addresses movie fans from a variety of backgrounds, with a variety of tastes, who wish to make the most of their time watching movies on television. Here he judges people as much as he judges the movies, helping to find a match between the two. By helping this large and diverse group wade through the significant number of movies made available on television broadcast, he appeals to a desire for selectivity in movie selection.

Scheuer was prescient about the changing conditions of movie access by the mid-1970s. In the preface to the 1975–76 edition of his book, he writes, "Today's movie feast is becoming ever more varied thanks partially to the development, however slow, of pay TV; and, more particularly, cable TV which offers the possibility of an almost unlimited number of TV channels;

and the future of TV cartridges, cassettes and home video tape recorders and playback units, which will allow film buffs the opportunity to build home movie libraries in much the same way that we presently develop libraries of books and records."[28] He could not foresee that most video libraries would be in rental stores rather than private residences, or that his book would initiate a cycle of similar publications that would end up in many American homes.

LEONARD MALTIN AND THE DEVELOPMENT OF THE VIDEO GUIDE GENRE

The advent and widespread adoption of home video and video rental stores did not just alter the media landscape of the 1970s, 1980s, and 1990s; it also shifted the role, location, and function of movie recommendation and guidance. *TV Guide* began a section devoted to discussing and reviewing videos in the early 1980s. Although the magazine also featured a section about video technologies during this era, it is striking that it devoted pages to reviewing works that were exclusively released on a home video format; it demonstrates the magazine's responsiveness to a changing media landscape. By the early 1980s, the magazine not only had to tell people what was playing on television and review programs and movies but also had to contend with people's consumption of video products, which included nontheatrical movie content.[29] The magazine introduced "The Video Cassette Report" as a weekly feature in fall 1984, and this segment ran until 1996, when it was displaced by a column written by Gene Siskel. Here one could find reviews of straight-to-video releases as well as Hollywood films. The column also listed the top ten video rentals, as reported by *Billboard*, signaling the magazine's interest in attracting a readership of movie renters as well as broadcast viewers. In keeping with the general trends in VCR use, however, the reviews increasingly dealt with Hollywood movie releases, so that by the 1990s this is largely what a reader encountered.

With limited space and four-star ratings, the capsule video reviews found in *TV Guide* largely resemble those in Scheuer's *Movies on TV*. And indeed, film critics and movie guide writers were forced to contend with the advent of video just as was *TV Guide*. *Leonard Maltin's Movie Guide* is without question the most significant video recommendation metatext, in terms of dispersal and impact, through the 1980s and 1990s. This book, more than any other, popularized the video guide genre and crystallized the valorization of movie abundance and choice that pervaded movie culture at the time. Born in 1950 and raised in New Jersey, Maltin was a movie fanatic

from a very early age. He remembers going to New York and seeing movies regularly as a teenager and watching film endlessly on television.[30] He was an avid user of Scheuer's book, stating that he "virtually memorized it."[31] He began a mail-order movie fanzine while still in high school, which caught the attention of a publisher at Signet Books who wished to develop a book to compete with Scheuer's. In summer 1968, at the age of seventeen, Maltin was called into the offices of this publisher and asked, if he were to make a book like *Movies on TV*, what would he do differently than Scheuer? Maltin responded that he would include the name of the director, include more cast members' names, indicate whether it was in black-and-white or color, and indicate the original theatrical running time so that TV viewers would know whether a film was airing in abridged form. He was offered the job and spent the summer making a book of over eight thousand capsule reviews with precisely these improvements. In 1969 the first edition of Maltin's book was published under the title *TV Movies*.

"Our target audience was the person who sat at home a lot and watched endless movies on television," Maltin states.[32] In this respect, Maltin's guide began as a viewing guide rather than a shopping guide per se, but like Scheuer's book, it also coordinated the mass of television viewers, with their wide-ranging tastes in movies, with the vast number of movies playing on television in the late 1960s and 1970s. Instead of merely copying the titles from Scheuer's book and providing his own reviews, Maltin put together a team of reviewers to organize a new list of his own devising. Maltin and his team put together their list based on every major Hollywood film from the previous thirty-five years, every "important" foreign film, and every film that had won an Academy Award. Finally and vitally, he and his team actually looked at the TV listings to see what films were commonly playing and made sure to include those. Maltin claims that he never intended it to be a "serious reference guide" or "encyclopedia" but rather a "fingertip guide" for television browsers.[33] Yet the book demonstrated an editorial selectivity and critical voice that was recognized by media professionals as well as casual fans. The book gained popularity in the early 1970s among film programmers at repertory theaters as well as TV managers responsible for buying film rights for syndication. Sales were good enough that a second edition was published in 1974, and a new edition was published biannually from 1978 until 1986.

Two things happened in the early 1980s that fundamentally changed the impact of Maltin's guide. First, he became the resident film critic on *Entertainment Tonight* in spring 1982, a year after the television program first went on the air, aligning him with the televisualization of film criticism

in the 1980s more generally. Film critics had appeared on television to discuss and recommend movies as early as 1948 and regularly appeared on various programs throughout the 1950s and 1960s.[34] In some cases, a critic could become a regular component of a talk show, such as Gene Shalit, who appeared consistently on the daily morning show *The Today Show* beginning in 1969 and became their regular critic in 1974.[35] Most important, however, Gene Siskel and Roger Ebert popularized film criticism with their program *Sneak Previews* on PBS in the mid-1970s.[36] In 1982 they left PBS and started the immensely popular commercial television program *At the Movies*, where every week viewers could watch these two figures debate the merits of recent theatrical releases, drawing on their individual personal tastes as well as their knowledge of film history and aesthetics.[37] Their popularization of critical discourse was attended by their signature "thumbs up" and "thumbs down" ratings. However much they may have had nuanced discussions of a film's merits and flaws on their show, they always reduced their judgments to a clear binary, one that indicated whether it was worth spending time and money on a movie.

The confines of the television format similarly constrained Maltin's discussions and reviews on *Entertainment Tonight*. However much he may have added a new voice to the chorus of television critics, this venue only allowed for the briefest evaluations of films. Indeed, one writer framed the issue by saying, "TV reviewers are ruining a good thing, other print critics suggest. . . . [T]hese short, snappy reviews are not serious analyses. . . . It's as if movie criticism is coming full circle, these now middle-aged upstarts from the 1970s argue, moving away from lengthy, thoughtful newspaper analysis—won after years of battle—to snappy, 200-word video consumer reports."[38] Whether or not the stakes were ever this high, film reviewing did move increasingly onto television in the 1980s and 1990s and was reframed by the widespread use of VCRs. As part of these phenomena, Maltin's appearance on *Entertainment Tonight* brought him into the national spotlight and his *Movie Guide* quickly increased in sales.[39]

The second major event to generate popularity for his guide, of course, was the rapid growth of video rental stores in the late 1970s and early 1980s. Indeed, the popularization of movie criticism in general went hand in hand with the growth of video rental, suggesting that the new abundance of viewing options propelled an attendant explosion in the discourse about movies. Yet Maltin had not anticipated the growth of video rental or the impact it would have on his book. He made a number of comments during the era that were quite ambivalent about home video. He complained once that "videos have only hurt movies that aren't 'hot,'" gesturing toward his

appreciation for sleeper hits and films that history has neglected.[40] At another point he stated, "The thing that's irritating about it is that video was sold as the brave new world: everything would be available. . . . But that hasn't happened. And while video is nice, it's not the answer. Films were not meant to be seen on a box."[41] Nevertheless he admitted more recently, "By 1983 or 84 it was clear that home video was changing, and had already changed, the playing field" for movie viewing.[42] With regard to his book, he states that the advent of home video created "a new usefulness for the book" and that it had a "new audience and a new relevance for a lot of people."[43] The book began annual publication in 1986 due to the increased sales generated by the video store boom as well as to the lead time needed to include films from the current year, which would appear on video the following year, when the book came out. The 1987 edition, which capitalized on Maltin's celebrity by placing his name and picture on the cover, sold over 250,000 copies.[44] By the early 1990s, Maltin's guide was a common reference tool for video shoppers and clerks alike, and reviews referred to it as a "perennial best seller."[45]

Written by a friendly, accessible critic who was popular on television, Maltin's guide was well poised to serve the needs of viewers who watched movies according to their own schedules on the VCR. Maltin's complaint that the unfulfilled promise of home video was that "everything would be available" implicates how he envisioned his book's changing utility, namely, that it would survey all the movies worth surveying so as to help potential viewers, aka shoppers, find something to suit them. Here was a ready-made guide aimed at movie speculators, who wanted to know what a movie was about and get a sense of what a cultural authority thought of its quality.[46] Indeed, Maltin allowed readers to virtually shop at the video store before venturing out of the home. In this respect, Maltin transformed from film critic and historian into a video clerk who, given his credentials and celebrity, could perhaps be trusted better than the actual clerk down the street. Although not "everything" was made available for rent on VHS, Maltin's book encapsulated a huge number of the increasing number of movies that were. In this respect, he appealed to Americans' sense of media abundance as much as to their selective tastes. Whereas the first edition had around 8,000 entries in its 535 pages, in 1992 the guide had 19,000 entries in 1,487 pages; by this point it had also become *Leonard Maltin's Movie and Video Guide*.[47] The book's physical, material growth corresponded to and serves as an index of the increasing number of material commodities called "videos." Maltin recognized how his book had literally changed shape, as he opened the preface to the 1992 edition by writing, "For several years, people

have said to me, 'That book of yours can't get any thicker, can it?' You have the answer in your hands: it *has* gotten thicker."[48]

Within this increasingly unwieldy tome, the alphabetically organized entries provide a plot synopsis, some sort of evaluation of the film's quality, as well as a star ranking on a four-star scale; Maltin distinguished his ranking by giving no single stars, but rather a "BOMB."[49] Despite the extremely tight word limits, Maltin achieves a personal voice in many of his capsules. He displays his impulses as a film historian by regularly squeezing in some historical, contextual information about the production or reception of a film. When he likes a film, he regularly expresses admiration for some element of its formal craft, and he is often sharply humorous when he dislikes a film. For example, he writes about *Stewardess School* (1986), "A major studio financed this low-brow comedy, then kept in on the shelf for a year. It should've stayed there";[50] and his one-word review of *Isn't It Romantic* (1948) simply asserts, "No."[51]

Yet the plot synopses and evaluations only make up part of this book, and in many instances, this material comprises less than half the length of an entry. Maltin distinguished his book from Scheuer's by including more factual data about each film. In fact, Maltin states that although the book's increasing use as a video shopping guide "didn't change the outlook or style of reviewing . . . it changed the detail work."[52] With the abundance of movies on this new platform, he felt compelled to provide accurate information. By the time of the 1992 *Movie and Video Guide*, the entries include director's names, country of origin for foreign films, year of release, running time, MPAA (Motion Picture Association of America) rating, alternate titles, and whether the movie was available on video. Further, this edition included a star index and a director index, allowing readers to survey a list of the films in these people's careers and then go back to the main body of the book and read the individual entry. By augmenting the amount of historical, factual information about each movie, Maltin's book increasingly functioned as the encyclopedic reference guide that he had not intended to make.[53]

The success of Maltin's book heralded a new and expansive book genre, the video recommendation guide, which grew significantly through the late 1980s, 1990s, and early 2000s; this growth coincided with the growth in home video culture generally. During their heyday in the 1990s and early 2000s, in fact, numerous different film and video guides dominated the "Movie" reference sections in corporate bookstore chains. Just as Americans displayed a desire for choice in the videos they rented, the range of these guides indicates that Americans similarly desired a choice in the tools they used to make their movie selections. The different guides that appeared in

the 1980s, 1990s, and early 2000s altered the flavor of this genre and, more important, distinguished themselves by self-consciously addressing a video-renting readership. Roger Ebert began publishing *Roger Ebert's Movie Home Companion* in 1985, made up from his full-length film reviews from the *Chicago Sun-Times* along with interviews and original critical essays. Somewhat similarly, the publishers of *Time Out* magazine began publishing the annual *Time Out Film Guide* in 1989, comprising reviews culled from the magazine as well as a considerable number of new reviews of older movies. The introduction to the first *Time Out Film Guide* even noted the growth in the video guide genre: "Another movie guide? Admittedly the field is starting to look a little crowded as the demand for informed critical opinion escalates with more and more films becoming available on TV or videotape."[54] *VideoHound's Golden Movie Retriever* first appeared in 1992, and even Blockbuster Video entered the market with the *Blockbuster Video Guide to Movies and Videos* in 1995.

Each of these competing titles contended differently with the dual issues of cataloging and evaluation that all such guides encountered. Ebert's book, for instance, lacked the breadth of Maltin's coverage but offered longer and therefore more substantial film reviews. Several other guides had to overcome the fact that they did not have an established critical authority. They were not written by Leonard Maltin or Roger Ebert, nor were they associated with an established critical publication such as *Time Out*. The *Blockbuster Video Guide to Movies and Videos* gave ultimate editorial credit to Blockbuster Senior Vice President Ron Castell, although it was actually compiled by a number of different editors and assistants. What the book lacked in having an established critical voice, however, was overcome by the cultural power wielded by the Blockbuster brand name, at least so the book's producers' thought (the book never gained much popularity). In keeping with this, the book does distinguish itself by providing indexes of directors and actors and, most important, a section devoted to family and children's films by category. Here, the organization of the book aligns with the company's general mission to be "family friendly" and to provide a "service" to parents.

Second to Maltin's book, *VideoHound's Golden Movie Retriever* is the most interesting and impactful video guide of the era. Originally published in 1991, the book was a self-conscious effort on the part of its editors to create a competing work with Maltin's but to do so not through emulation but rather through differentiation. The book's origins lie in library reference publication. In 1989, the academic publisher GALE opened a line of popular-press reference works under the Visible Ink label. For years GALE

had already published the *Video Sourcebook,* which was used widely by reference librarians to order movies for their libraries. *VideoHound* was Visible Ink's first major endeavor. The editor, Martin Connors, tried to differentiate this book in three ways: comprehensiveness, tone, and indexing.

Although Maltin's book featured nearly 19,000 entries by the early 1990s, he was already making decisions to cut certain movies from the book to make room for others. (By the 2006 edition, Maltin's guide had around 16,000 entries.) Alternatively, the *VideoHound* editors sought to cover everything that existed on some video format. While the first edition covered around 20,000 videos, the 1995 edition covered 22,000, and the 2005 edition had over 26,000. Measuring 7 1/2 by 9 1/4 inches and weighing several pounds, the *VideoHound* guide was—physically—the biggest of the printed movie guides. On the one hand, this drive toward comprehensiveness comes from the editors' backgrounds in library reference publications, where being comprehensive is typically the measure of a work's utility. On the other hand, the total disregard for selectivity has somewhat egalitarian associations; by trying to consider everything, the book suggests that everything is worth considering. Vitally, the book's aim to cover everything *on video* indicates that it aimed at video shoppers and viewers and further suggests a lack of cinephilic purism tied to theatrical spectatorship. The introduction to the 1995 edition explains why it has so many new entries: "Along with theatrical features released to video, the direct to video business is booming, creating more diversity at the corner video store and supplying you with more choices."[55]

The *VideoHound* guide appeals to a general readership of video consumers with a broad range of tastes and also positions itself as a tool to help individuals find something of quality. But "quality" here does not mean the same thing it does in Maltin's guide. Like the Blockbuster guide, the editors at Visible Ink had to overcome the publication's lack of a cultural authority figure. Connors and the other writers and editors who worked on the book were movie fans but had no background in film criticism. They decided to emphasize their lack of authority and even to gently mock the conventions of critical judgment. They invented the Video Hound, who appears as a cartoon character on the book's cover and in its introduction. The Hound's "critical voice," which largely derived from the founding editor's personality, aims for irreverent humor more than authority. Rather than give star ratings, *VideoHound* ranks films in terms of "bones," ranging from four bones to a "Woof" rating, or what he calls "junk food video."

Some reviews also show this sensibility, such as a review of a "classic" *Speed Racer* episode, *Challenge of the Masked Racer* (1966), which ends with

the Hound saying, "Go, Speed Racer, go!"[56] Similarly, the review of *Angel Heart* (1987) reads, "[Lisa] Bonet sheds her image as a young innocent (no more Cosby Show for you, young lady)."[57] Yet the book does not maintain consistency with such attempts at snark. In fact, many reviews actually provide "typical" evaluations, especially of films that critics have previously established as "great."[58] The review of *Wages of Fear* (1953), for instance, asserts, "Complex, multi-dimensional drama concentrates on character development in the first half—crucial to the film's greatness,"[59] and the review of *The Bicycle Thief* (1948) reads, "A simple story that seems to contain the whole of human experience, and the masterpiece of Italian neo-realism."[60] Moreover, many of the "reviews" in the book offer no evaluative comments or assertions, merely a bare-bones plot synopsis. In these cases, it is likely that the editor had not actually seen the movie but rather relied on some marketing material to give a description. In all cases, however, the *VideoHound* guide presents a generalized, populist approach to movies on video, defying critical pretension and allowing readers to judge for themselves.

More important than the reviews, *VideoHound*'s indexes constitute a significant contribution to the video guide genre. Connors self-consciously aimed this book at video renters, and so one of his first tasks when conceiving of the book was to go into a video store to see what it carried and how it was arranged. Thinking that the broad generic categories that he saw were unhelpful and not in line with the way people actually look for movies, he and his team of writers created index categories that people actually use to guide their shopping. The practical logic of these indexes is explained in the "interview" with the Hound in the 1991 edition: "The five indexes will lead you to your dream movie in the flick of a lash or a Bic or a whip or a flea. Search by cast member. Search by director. Search by type of scene or category. Search by awards won. Search by country of origin. Search and Ye shall find. Yup, that's our motto."[61] In this manner, the guide defers to readers to pick the criteria that will guide their browsing, with the end result not being critical appreciation, necessarily, but rather a matching of individual desires with a particular movie title.

In addition to these broad indexes, the "Category Index" of the first edition divides movies into more than 350 different groups. Conforming to the book's "everyman" sensibility, these categories range from the supremely intuitive to the humorously obscure. It features traditional genres like "Film Noir" and "Horror" as well as less conventional genres like "Medieval Romps," "Rags to Riches," and "Vampire Spoof." Many categories appear for specific elements or themes within the films, such as "Big Battles," "Cats," "Fires," "Macho Men," "Politics," and "Travel." The 1995 edition increased

the number of such categories to nearly four hundred and also provided separate indexes of films based on availability on laser disc, captioning, country of origin, song titles, alternate titles, cast, director, writer, and composer, among others. All told, the 1995 edition is 1,574 pages long, with nearly 500 of them dedicated to indexes.

VideoHound's Golden Movie Retriever appealed to video shoppers by offering a variety of criteria that individuals might use to select a film.[62] It is a guide designed for the golden age of video rental, when it seemed that any movie not already available would be released soon and that all of this media should be cataloged because someone might want to watch it. The *VideoHound* was popular enough that the Hollywood Video chain made it the in-house movie reference book in the early 2000s.[63] The *VideoHound* brand expanded rapidly during the 1990s through the publication of numerous spinoffs, each of which covered a specific topic or genre, such as Horror, War Movies, and Cult Films.[64] Whereas the *Golden Movie Retriever* offered readers different means to discover or rediscover particular movies, these genre-specific publications appealed more concertedly to devoted fans with specific tastes. Indeed, these genre-based guides demonstrate how the "general" audience for movies was fractured in the era of home video into disparate, if sometimes overlapping, groups that identified themselves by their movie preferences. These books offered personalized shopping for the individualized media shopper.

As an extension of this logic, a handful of video guides appeared that did not focus on a genre but rather on particular forms of video spectatorship. *Cinematherapy: The Girl's Guide to Movies for Every Mood* was first published in 1999 and was so successful that the authors published several spinoffs. Whereas *Cinematherapy* "offered readers a panoply of movies to match their every emotional state," the follow-up book, *Advanced Cinematherapy*, categorized movies "according to some of the specific issues and dysfunctional dynamics that we all wrestle with every day."[65] This included such designations as the "Midlife Crisis Movie like *Shirley Valentine*" (1989), and the "Role Model Movie, like *Erin Brockovich*" (2000).[66] Offering a very different take on the video guide genre, *The Bare Facts Video Guide*, published from the late 1980s through the early 2000s, provided an extensive list of actors and, mostly, actresses who have displayed some level of nudity in a movie; the book only includes movies rated G through R.[67] Each entry is devoted to a performer, then lists the films in which he or she appears naked, gives the minute in which the nudity occurs (presumably for impatient viewers to fast-forward to these scenes), a note about the extent of the nudity, and a description of the action in which the

nudity occurs. The author also rates each moment of nudity, rather than the film as a whole, on a three-star scale.

Although the differences between *Advanced Cinema Therapy* and the *Bare Facts* guides are striking, they both illustrate the breadth and size of the video guide market in the 1990s and 2000s. More important, these guides appealed not simply to people with particular movie tastes but also to people's divergent means of *engaging* with videos. They appealed to and cultivated the different desires that motivated video consumption in the first place, in these cases, either helping viewers do some emotional problem solving or satisfy their puerile curiosities. These books give further proof that the era of tangible media fostered a sense that everyone's movie tastes were distinct and, at the same time, that the home video industry aimed to satisfy the incalculable multiplicity of media desires. More than index the new abundance of movies available on video, *Advanced Cinema Therapy* and *Bare Facts* index the increased fragmentation and compartmentalization of Americans' movie tastes and consumption, where people distinguish themselves not only by what they watch but also by how they watch.

Vitally, both these guides obviate the role of the video clerk, perhaps even more than Maltin's guide or the *VideoHound*. They offer methods for finding movies, and even different scenes, that customers would probably not expect of a clerk. These books allowed video shoppers to avoid asking a clerk to recommend a "Role Model Movie" for female viewers or "the movie in which Halle Berry appears topless." Browsers could thus personalize their video shopping and avoid some of the socially interactive element of video store culture. Yet several specialty video stores across the country began publishing their own video guides in the 1990s and 2000s, providing an avenue for the taste cultures generated within these stores to extend beyond their walls. Facets Multi-Media put out the mammoth *Facets Video Encyclopedia* in 1998.[68] Part video guide and part sales catalog, this book provided thousands of capsule reviews for all manner of nonmainstream videos, along with pricing information and notes about a movie's availability on different formats. TLA Entertainment in Philadelphia put out annual editions of the *TLA Film & Video Guide: The Discerning Film Lover's Guide* (later called *TLA Film, Video & DVD Guide: The Discerning Film Lover's Guide*) from the mid-1990s through the mid-2000s. Similarly, the managers and clerks of Scarecrow Video put together the *The Scarecrow Video Movie Guide* in 2004, effectively taking their opinions, conversations, and debates and transforming them into a printed text; the book's introduction states, "Compiled by current and former employees, friends, and customers of the store, it's as if we were able to take you by the hand and walk you through the store."[69]

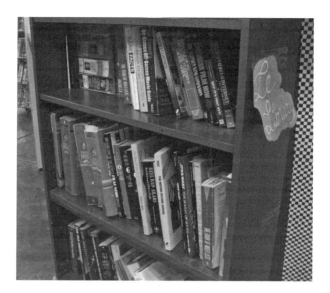

FIGURE 36. The Library at Le Video in San Francisco attests to the development of printed video guides as well as their utility to video clerks and browsers.

These guides drew from the prestige that the stores had already accrued, gave material form to the visions for cinematic quality that the stores nurtured, and packaged it all as a durable commodity (figure 36). In their introductions and in the style of their film reviews, these guides request that readers be discerning and tasteful in their video consumption. On the one hand, the tenor of the guides attests to their growth out of specialty video stores, where "good" and eclectic movie tastes are valorized by workers and customers alike. On the other hand, the store-generated video guides demonstrate that a certain attitude about movies and movie culture did not just flow into video stores but out of them as well. If Maltin, Ebert, *VideoHound,* and the many other video guides helped crystalize a genre in the 1980s and 1990s and helped institutionalize video store culture, then the *Facets Video Encyclopedia* and the *TLA* and *Scarecrow* guides made a certain kind of rarefied video culture a tangible strain within the chorus of contemporary film criticism.

THE DIGITALIZATION OF MOVIE INFORMATION AND RECOMMENDATIONS

The place and function of movie guides changed during the 1990s as a consequence of digital technologies in general and the growth of the Internet

in particular. Many video guides experimented with digital formats, especially CD-ROM technology, early in the decade. In 1992 Microsoft put together a CD-ROM called "Cinemania" and produced expanded editions each year from 1994 through 1997, when the Internet had made it obsolete. This interactive CD-ROM allowed computer users to click through a huge amount of movie information, reviews, still images, and sound clips; later editions also included short clips of famous movie scenes. The disc collected all the capsule reviews and factual information from Leonard Maltin's guide and included additional reviews by Roger Ebert and Pauline Kael.[70] Featuring sound effects and a "windows"-like graphical user interface, all these data were relatively easy to browse. One could search the database based on movie title or performer name, and there were hyperlinks embedded in entries so that browsers could hop from one item to a related item quickly and intuitively.[71]

Likewise, a CD-ROM version of *VideoHound's Golden Movie Retriever* came out in 1993, and Blockbuster produced one in 1995.[72] Although some people had problems with the Blockbuster disc, reviewers generally found both the Cinemania and the VideoHound discs helpful, interesting, and even fun.[73] Similar to Cinemania, the VideoHound disc made use of the multimedia capabilities of the CD-ROM format, supplementing its 22,000 capsule reviews with pictures of 3,500 actors and actresses, as well as sound clips from different films.[74] Also like Cinemania, the VideoHound disc allowed for searches according to a number of different criteria and also provided hyptertext links from one keyword to another, allowing for all manner of discovery through browsing. One reviewer of several CD-ROM movie guides lauded this capability in particular, saying it made browsing "an amazingly diverting experience."[75]

These CD-ROMs had two advantages over their print counterparts: integration of multiple media and intuitive navigation. One wonders which of the two characteristics held more appeal. If printed video guides catered to and even nurtured "curious readers," analogously to the way the space of the video store catered to curious browsers, then these searchable and hypertexting discs served the desires of curious computer users, or surfers. Rather than flip back and forth from entry to entry in a book, often with one's fingers jammed into multiple pages simultaneously, now one could have an analogous experience with the click of a finger, displayed on a glowing screen. The searchability and hypertexting capabilities of these guides made the "index" the same thing as the "text" itself, allowing surfers to hop from topic to topic relatively quickly, easily, and according to their desires and curiosities. Here movie information and reviews took

a turn toward the immaterial, packaged and presented as its own form of screen entertainment.[76]

Yet analogous services found on the Internet usurped these CD-ROMs. RottenTomatoes.com, for instance, was founded in 1998 and provided Internet browsers with links to movie reviews by a wide range of critics. More important, the website turns these evaluations into a numerical rating between 1 and 100, then averages them into a single score, creating a statistical generalization out of a mass of qualitative evaluations. Rotten Tomatoes was so popular that the video game review website IGN.com bought it in 2004 and Fox Interactive bought IGN the following year. Similarly, the website Metacritic.com was launched in 2001 and offers a statistical, numerical summary of movie critics' reviews of films. With both these sites, movie reviewing has not only gone online, but has been rationalized and aggregated. Moreover, Rotten Tomatoes, Metacritic, and similar websites do what no print-based or CD-ROM movie guide could ever do: aggregate multiple critics in a constantly updated, constantly growing manner, offering new levels of comprehensiveness and timeliness. These websites allow movie speculators to quickly and efficiently sift through their options; they help people shop with increased access to different movie titles and evaluations. The most important movie-related website, however, and the one that effectively killed the market for printed and CD-ROM video guides, is the Internet Movie (IMDb) Database.[77] Whereas the printed guides got increasingly bulky and required people to buy a new copy every year in order to stay up to date, IMDb took up no more space than the household PC already did. Further, whereas the CD-ROMs were quite expensive, ranging from $20 for the Blockbuster guide to over $50 for the Cinemania or VideoHound discs, almost all the analogous data found on the Internet, including IMDb, have been accessible at no charge.[78]

What turned into IMDb was started in 1990 by Col Needham, a researcher for Hewlett-Packard.[79] Needham was a movie fan and a personal computer user from a young age, and with IMDb he put these two passions together.[80] Whereas Leonard Maltin turned his movie fandom into a print publication, Needham turned his into a digital, networked file system. The first incarnation of IMDb was a simple list of films that he uploaded to a Usenet newsgroup called rec.arts.movies.[81] After other users began inputting lists of similar information, such as their favorite actors or directors, Needham compiled these lists and turned them into a searchable database.[82] Over time, the group expanded the database to include more information, including more credits, running times, plot synopses, and trivia about a movie or performer.[83] In 1993, the group put the list onto the World Wide

Web, and within a short span of years it gained widespread use and popularity.[84] In 1996, Needham turned the website into a business, Internet Movie Database Ltd., which aimed to generate revenue through advertising, and this quickly proved successful.[85] They were so successful, in fact, that Amazon.com bought IMDb in 1998.[86]

IMDb exists as a series of web pages devoted to specific movies and media workers, including actors, directors, composers, and production designers, among others.[87] Using the hyptertext links in each page, Internet browsers can jump from title to title, performer to performer. As one writer asserted, "The site lets you navigate the world of movies in ways never before possible. . . . [Y]ou can research film history with unprecedented speed, bouncing from David O. Selznick to Alfred Hitchcock to Grace Kelly with just a few mouse clicks."[88] In addition to making all these data searchable and interlinked, the website allowed users to search for films by genre, themes, and even lines of dialogue.[89] Further, each movie entry included plot summaries, technical details, locations used, errors, sound tracks, and links to related websites.[90] At the start, all of this information was entered by the Usenet group, but after IMDb went onto the web, it gathered and uploaded information supplied by everyday Internet users who wished to add to the site.[91] In this process, Internet users submit new data or corrections to the website, and the website's "expert editors" vet this information.[92] This "crowd-sourcing" of movie metadata has been critiqued for not being as accurate or comprehensive as might be desired, yet it allowed for an astronomical rate of growth for the database. As of 1996, IMDb had "more than a million entries on 81,000 films," as well as "300,000 cross-referenced entries on actors, directors and just about everybody who had anything to do with practically every movie."[93] In 2000, the site offered data on over 230,000 films,[94] and by 2010 IMDb listed information for "more than three million cast and crew members and more than 1.5 million entertainment programs."[95] IMDb thus quickly surpassed the amount of data a traditional, print-based guide could reasonably hold.

In addition to providing factual information, IMDb created an area for movie fans to post their reviews and commentary.[96] The website provided a space for written comments, collected ratings of films on a ten-point scale, and subsequently averaged these scores. In this way, the website provided a collective rather than a singular evaluation of each film, putting authority in the hands of self-selecting online voters rather than an individual film critic. Noting that he often disagreed with his film critic colleagues at the *New York Times*, a technology blogger lauded IMDb's process, saying "The wisdom of the masses on IMDb . . . very rarely misses."[97] In addition to

these methods for evaluating movies, the website implemented mechanisms to rate the popularity of a given movie or performer, called the "Moviemeter" and the "Starmeter," respectively. By collecting data on the amount of searches for a particular title or star, the website provides a constantly shifting rating of the public's interest. Not quite offering critical evaluation, IMDb put forth a system for collective value judgment nevertheless. Finally, the website features a list of the "Top 250" films, based on user rankings.[98] Here the site presents a new canon-making project, not unlike the "best of" lists offered by *Sight and Sound* and other cinematic taste-making publications. Unlike those lists, however, IMDb's Top 250 is subject to perpetual change and represents a populist sensibility, to the extent that anyone with an Internet connection can influence it.[99]

By integrating film facts with user reviews and ratings, the website encroached on the many print-based movie guides of the era. Like the CD-ROM versions of the video guides, IMDb provided the capability of hyptertexting through these data. It compounded this ability with several advantages, however, including the fact that it was free for users who had Internet access, and because it was on the Internet, it took up no more space than the computer one used to access it, making it appear intangible. One early reviewer of the website noted all these advantages quite succinctly and positioned IMDb in direct opposition to print-based guides. He wrote:

> Most film encyclopedias and home video guides we keep handy with the TV remote are cumbersome bricks of printed pages often better suited as doorstops than browsable reference tools. Whether looking for an evening video selection or trying to answer that nagging trivia question about "Citizen Kane," you may find that touring the exhaustive "Internet Movie Database" (IMDb) is a better choice than reaching for that dog-eared copy of "Leonard Maltin's Movie and Video Guide."[100]

This author celebrates IMDb's intangibility and denigrates print-based guides for being clunky and messy. Here the move to the digital is construed as fulfilling the wishes of curious browsers while relieving them of the burden of materiality. Never mind that this writer probably threw away his 1990s-era computer a long time ago.

Amazon did not purchase IMDb in 1998 simply to get into the market for video guides, of course, but rather to assist its efforts to retail videos, which it began doing that same year.[101] The sheer popularity of IMDb made the site attractive to Amazon, which sought ways to not only sell videos but also drive interested Internet browsers toward such purchases.[102] When one enters a movie title or name of a media professional into a website search

engine, IMDb is regularly the top link.[103] Whereas IMDb got around 1.2 million hits a day in 1996,[104] it attracted over 15 million visits in February 2006.[105] In this respect, Amazon owns the primary site through which people access information about movies on the Internet.[106] The interface for IMDb largely remained the same after the takeover but now provided links to Amazon where browsers could find the movie for purchase.[107] As Needham put it in an interview, "IMDb has always helped people make choices. . . . [W]hen we first added links to Amazon . . . you could go to any title page on IMDb; if that movie or TV show is available on DVD, you could buy it."[108]

Amazon and IMDb thus worked in combination to provide a unified fact-browsing/movie evaluation/media shopping experience. The commercialization of the database became even stronger when it was given an "interface lift" in 2010. Although much of the look of the site remained similar, this upgrade aimed to better integrate fact browsing with media shopping, particularly by emphasizing playable video clips so as to entice viewers to Amazon, Blockbuster.com, or a movie ticket website.[109] Thus, in addition to generating revenue from advertising and licensing its content to outside vendors, IMDb facilitated the commercial purchase of movies on video.[110] As noted in chapter 1, Amazon began offering movie download services in 2006, and in 2010, it entered the area of content production.[111] By integrating the movie facts and evaluations amassed on the Internet Movie Database with the sale of both tangible and digitally streaming movie commodities, Amazon has created an integrated system that aims to satisfy a wide range of desires on the part of contemporary movie fans, be it for trivia, contemplation, or consumption. Whereas critics in the past have asserted, or complained, that they have no real effect on people's viewing choices, Amazon has forged this connection as a literal, hypertextual link.

ROVI: THE MATERIAL OF METADATA

IMDb and Amazon have integrated movie facts, evaluation, shopping, and consumption. More astounding than this integration, however, is how automatic, quick, easy, and even invisible it all seems to Internet or media browsers. Indeed, the apparent seamlessness of the activities that these websites enable contributes to a sense that all this work is invisible and even intangible. Rovi Corp. is another business that facilitates such intangible shopping but perhaps is more remarkable than Amazon because it is largely unknown to the majority of people who use its services on a daily

basis and its operations have been largely unnoticed by, even invisible to, both video consumers and media scholars.

Rovi's history and current practices demonstrate that as movies have migrated from one delivery device to another, much effort has been made to control this migration. Rovi began as Macrovision in 1983, a company that capitalized on the Hollywood studios' fear of piracy on the advent of movies on video.[112] As Stephen Prince has put it, "To the [Hollywood studios], everyone with a VCR was now potentially a pirate. With the ease of home taping, studios could no longer control the distribution and consumption of their own films."[113] Whether or not Americans were really duplicating Hollywood films with their VCRs, the MPAA demonized VCR technology in the press while they simultaneously expanded into this market.

In 1985, Macrovision unveiled the anti-copy process (ACP), which created a technological impediment to VCR-to-VCR recording.[114] It functioned by flashing white pulses on to the video signal of a VCR that was hooked up to a second VCR, causing the second VCR to compensate for the additional "noise" by reducing the video signal.[115] In this way, any duplicate copy made on the second VCR would have a highly distorted image.[116] Hollywood responded enthusiastically and rapidly; by 1986 Macrovision had licensed its anti-copying process to most of the major studios.[117] In that same year, more than half of all videos released in North America used the process.[118] Although it is questionable whether this process actually saved Hollywood any money by curbing tape-to-tape transfers, it provided an economic boon to Macrovision. Charging ten cents per tape at the minimum, Macrovision was soon making millions of dollars per year just as Hollywood was continuing to expand the sale of their films on magnetic tape. By 1992, the company estimated that ACP had been applied to over 400 million videotapes.[119]

From the start, then, Macrovision's corporate identity centered on "information protection," in this case the visual and audio information embedded in magnetic tape. The company pursued this line of development in subsequent years by developing new patents or buying other companies that had done so. They created a system to block the copying of Pay-per-View transmissions in 1993,[120] and in 1998 they introduced "SafeDisc," a software that would inhibit the copying of CD-ROMs.[121] Thus by the late 1990s, Macrovision had expanded beyond the VCR market to provide anti-copying systems for a wide range of technologies and platforms, including cable and satellite transmissions.[122] Further, the company expanded into digital rights management in the 1990s, eventually becoming "the world's leading provider of software licensing technologies."[123] With this move, the

company did not just protect information by curtailing its duplication; it created systems whereby hardware "recognized" software and subsequently allowed it to function.

While the Hollywood studios propagated their movies on a variety of "ancillary" platforms, Macrovision moved in step to provide the mechanisms to limit or halt the unwanted proliferation of that content. This made the company well suited to address the digitalization of movies and other media content in the 1990s and 2000s. It developed anti-copying systems for DVDs, which were famously acknowledged as the industry standard and included in the terms of the Digital Millennium Copyright Act in 1998.[124] Because of its history of working with Hollywood studios and other major entertainment producers, Macrovision effectively held a monopoly over the information protection industry.[125] By the next year, over one hundred manufacturers of DVD and DVD-ROM devices had licensed Macrovision's system and the technology had been applied to over 20 million DVDs that year alone.[126] In 2005 the company introduced RipGuard, a technology designed to prevent copying of DVDs,[127] and later that year it acquired DVD Decrypter, a program allowing the bypassing of RipGuard technology.[128]

As the company continued to expand in the 2000s, primarily by acquiring other companies, it broadened its range of operations. Whereas in the 1980s and 1990s Macrovision functioned as an information protection company, its operations in the millennium are better described as "information management." Most of its activities involve metadata, or information about information, though this term can stand in for a wide range of such services. Two purchases in the late 2000s demonstrate the company's changing agenda and broad approach to information management: the All Media Guide in 2007 and Gemstar-TV Guide in 2008. The All Media Guide (AMG) started off as the brainchild of Michael Erlewine, an eccentric personality who developed a passion for music and astrology in the 1960s.[129] After founding a company that made software for astrological charts in 1977, Erlewine began exploring ideas about music guides and metadata in the early 1990s, just as the CD format was taking hold in the recorded music industry.[130] Frustrated by bad labeling on CDs, he endeavored to create a database of musical recordings that would provide accurate information as well as critical evaluations.[131] Thus AMG was originally founded as the All Music Guide in 1991 and the company had its makeshift headquarters in Big Rapids, Michigan.[132]

AMG expanded in scope and size over the course of the decade. In 1994 the company began producing the *All Movie Guide*, which largely

resembled other movie guides of the era and also put a version on the Internet.[133] They even coordinated with the editors of *VideoHound*, across the state in Detroit, on a volume of screen biographies. In 1998, the company added the *All Game Guide* to its list of publications/websites, putting it squarely in the business of multimedia reviews.[134] The company relocated to Ann Arbor in 1999, home to the University of Michigan, hoping to find a larger pool of educated pop culture fans for its labor force.[135] AMG continued to expand its operations in the 2000s, primarily moving into media recognition and metadata licensing. It unveiled the LASSO media recognition software in 2006, which enables different media devices to recognize the exact CD or DVD that is inserted into them.[136] For the consumer, this means that when you enter "Abbey Road" or *Pulp Fiction* (1994) into a hardware device, the device recognizes it as that particular disc, as if by magic.[137] In this respect, AMG facilitated the much-hyped technological convergence of the 2000s by allowing hardware devices to recognize software. Not only did AMG license this capability to a number of different electronics manufacturers, but it also expanded the licensing of its review material. As of 2007, AMG licensed material to over 25,000 different online and brick-and-mortar retail outlets.[138] It counted AOL, Yahoo, MSN, and the *New York Times* among its online customers and Amazon, Best Buy, Barnes & Noble, and Blockbuster Video among its retail customers.[139] Moreover, various parts of the AMG database were licensed by the radio giant Clear Channel and a range of computer-based media players, including iTunes, MusicMatch, Windows Media Player, and Napster.[140]

Thus by the time Macrovision bought AMG in 2007, both companies had large operations in the realm of entertainment metadata, including software protection, media recognition, and content reviews. With the purchase of Gemstar-TV Guide in 2008, Macrovision added significant capabilities to the business. Gemstar-TV Guide had its origins in the print-based *TV Guide*.[141] In its effort to serve television viewers for more than fifty years, *TV Guide* had amassed a huge amount of information about different television programs and feature films; at the time of the Macrovision acquisition, the company held "data on over 1 million TV series episodes since 1954 and over 190,000 movies since 1912."[142] In combining this collection with the data previously generated by AMG, Macrovision now held information on a huge number of movies, television programs, musical recordings, and video games. Just as importantly, Gemstar-TV Guide had expanded its services to the Internet, with TVGuide.com, and into televisions themselves with the TV Guide network. This expansion into electronic formats entailed a technology that was particularly valuable to Macrovision, the

Interactive Program Guide (IPG).[143] Simply put, the IPG is the gridlike interface that cable viewers see as the "Menu" of channels and programs playing at different times. Having patented this simple interface, Gemstar-TV Guide made money from every media company that used a gridlike, time-based menu for selecting content; it owned the very structure through which many people "shopped" for media on their TV sets. By the time Macrovision changed its name to Rovi in 2009, the company integrated a wide range of interlinking information services: copy protection, software licensing, and descriptive and evaluative information about countless television programs, musical recordings, and movies. Crucially, the company also now owned the *portal* through which many people would seek this content and thus could integrate its descriptive and evaluative data about this content into the very interface that people used to browse.

Two features of Rovi's historical trajectory are especially important. First, it represents a form of convergence that has largely been ignored. As is well known, over the 1980s, 1990s, and 2000s, the Hollywood studios underwent a near-perpetual series of mergers and acquisitions in a trend of "corporate convergences." An important aspect of this consolidation entailed the Hollywood studios merging with the major television networks in the 1990s and 2000s, and these large corporations also expanded into cable and the Internet. Rovi presents a parallel trajectory, where a company similarly expanded into multiple "horizontal" markets through corporate mergers and acquisitions. Yet whereas the Hollywood studios exploited their horizontal integration by deploying their content across different media outlets, Rovi exploited the need to control the spread of this material across different channels and platforms. Rovi did not make content, but it facilitated Hollywood's efforts at "media convergence" by providing control and connectivity mechanisms that allowed content to spread and be accessed.

Second, by integrating all these companies, patents, and capabilities into a digital environment, comprising mainly televisions but also computers and mobile devices connected to the Internet, Rovi encapsulates and effectively displaces a host of other activities. Its various technologies and databases allow the contemporary movie browser to access a menu on a television, computer, or mobile device, read a synopsis and evaluation of that movie, and then click through to access and view that movie—all on the same device. Consider that the back cover of the 1969–70 edition of Scheuer's *Movies on TV* advises readers: "Check your daily newspaper for time and channel—then consult *Movies on TV* for complete information on thousands of movies now being shown on TV." Thus the movie browser of

that era had to navigate multiple print objects to locate and review their options. Similarly, *VideoHound's Golden Movie Retriever* addresses a readership consisting specifically of video renters and purchasers, as it only reviews movies available on video and lists the format and price of each title.[144] Thus heavy, printed video guides like these point to a world of material objects called videos. Alternatively, Rovi tries to make the dream of intangible media shopping and consumption a smooth and uninterrupted process, where ideally one can find, contemplate, and consume a media text wherever and however one desires.

One of Rovi's greatest feats, in fact, is the extent to which the company has effaced its power to shape consumers' relations with media. Rovi has aimed to make its products and services invisible, from the Macrovision copy protection that did not mar the images on a videotape to the supposedly neutral and objective description of movies found on television menus to the very interfaces through which people select their movies. Yet achieving this suffusion throughout the digital media landscape requires a lot of work, even if that work is hidden to the vast majority of people. Likewise, Rovi's seemingly intangible products and services, which appear automatic and magical to the consumers who engage them, require a complex and concretely material infrastructure. However much Rovi is in the business of intangible media, the company and its workers actually have a deeply material relation to this media. By looking at the physical space and labor of Rovi, it is clear that although media shopping and consumption may seem intangible to the contemporary consumer, this is achieved with great material resources and effort.

Although Rovi maintains its corporate headquarters in Sunnyvale, California, its data solutions department operates out of Radnor, Pennsylvania, and Ann Arbor, Michigan. Whereas the Radnor site contends with television data and schedules, the Ann Arbor office deals with all the company's home video and music activities. This Ann Arbor operation is located in a nondescript structure in a large industrial and commercial district where a number of similarly indistinct buildings are loosely connected by roads that wind confusingly through fields of grass and shrubbery. The building itself occupies 32,000 square feet and consists mainly of large, open areas filled with modular cubicles and silent workers.[145] There are several conference rooms with large tables for meetings, as well as separate, glass-walled offices for division managers. The reception desk at the entrance is commanding and features a set of the print versions of AMG publications, including *The All Music Guide to Country* and *The All Music Guide to Hip-Hop*. Similarly, the company's investment in popular culture

is conveyed by the numerous posters for movies, musicians, and video games that line all the interior walls of the building. In this way, also, the space is invested with "entertainment" and "fun," diminishing but not eliminating entirely a sense of corporate drudgery. One wall of an extremely long passageway in the building is lined with a library of print publications. Among the thousands of items held here is the entire run of film reviews from *Variety*, numerous copies of video guides, including Maltin's, and numerous other reference works and individual magazines about movies and music. It is a material library that the company displaces in digital form.

About one hundred people work in this location.[146] Approximately seventy-five of them work in "data operations," which is the main activity of the company; the others work in client services, client support, on-site engineering, and other miscellaneous jobs. Data operations is largely divided into two areas: "content" and "matching." Content involves all the reviewing of music, movies, and video games. The cubicles for these workers are clustered toward the back of the structure, and there is a remarkably distinct vibe in this area. All of these cubicles are littered with toys, posters, artwork, and other miscellaneous items indicating the individual reviewer's taste and personality. These workers typically dress more informally, more "hip," than the workers in other parts of the building. These material particularities create an overall sense of fun in this area, a feeling that although what happens here may be important, it is not "work" in the sense that it is arduous. Yet like everyone else in the building, these workers sit and write their reviews quietly, many of them listening to music on headphones.

The "matching" work done at this location is how Rovi appears magical to the everyday media user, and it involves a large number of workers organized into a precise workflow. It requires entering every important detail about a media object into a digital database and linking the information in this database to digital codes embedded in the media object, so that different machines in different locations will uniformly recognize a media object as distinct. This area is then subdivided by media type or genre, including pop music, classical music, and video; to my eye, the video matching appeared to require the most intensive work. Even before a movie has been released on a home video format, data entry workers build a skeleton entry in the database for it, deriving their information from press releases and other studio-produced materials. Roughly ten weeks before a movie is released on home video, the distributor sends a material copy to Rovi for processing. In fact, there are multiple rooms devoted simply to holding and documenting new arrivals (figure 37).

FIGURE 37. Rovi gets a constant influx of material media commodities so that it can enter information about these products into its database.

At this point, a scanning worker makes high-resolution digital images of the packaging and artwork, so these can be used as thumbnail illustrations on various digital browsing platforms. Then, a data entry worker inputs all the relevant data about the content and the commodity itself into the database. This information includes title, manufacturer, release date, running time, language, MPAA rating, DVD bonus features, subtitle options, and so on. This information is then taken by someone in data processing and coordinated with the Rovi media database. Each media object is given a unique number code and related to all of the metadata about that object entered by the previous worker. Further, any editorial content or reviews written by someone in the content department is also linked to this data-object. In this manner, the companies that use Rovi's services can make it appear as though individual computers and other media delivery devices "know" what an object is, what its characteristics are, and even what a critic in southeastern Michigan thought of its quality. This material can be licensed in whole or in packages, so that some companies only use the cover art scans while others draw from the entire package of information. A user of Comcast On-Demand services, for instance, will engage Rovi content in at least three ways:

FIGURE 38. Rovi's warehouse of media. It is one of the biggest video "stores" in the world.

through the gridlike search menu, through a description of the contents of a movie, and through a description of its technical characteristics. They might also see promotional pictures or read a review. But what appears to the consumer as inherent qualities of these technologies and media objects was created and processed by a person working in a cubicle.

After each CD, DVD, and video game is put through this process, they are stored in a massive room at the very back of the building. When I last visited the location in July 2012, the room held 669,763 CDs, 140,652 DVDs, and 16,699 video games. The room is packed with high metal bureaus, the drawers of which are stuffed with discs (figure 38). There are cardboard boxes stacked on top of the shelves that hold the cover art for the music and movies. It is hard to describe the enormity of this room. When I first entered, it reminded me of the labyrinthine warehouse at the end of *Raiders of the Lost Ark* (1981). One might think that a company that makes its money by digitizing and integrating information about media would no longer have use of the physical objects once that information was attained, but this is not the case. For insurance purposes alone, Rovi's holdings in media commodities represent millions of dollars. (Indeed, the custom-made

fire mitigation system in this room promises to be very effective). More important, this material archive is maintained as backup for the digital archive the company has created out of it; should it ever lose information, it has the objects on hand to reenter what is needed. In this respect, Rovi's massive database of media metadata indexes an identifiable, real-world archive, stretched to the spatial limits demanded by the supposedly infinite virtual space of the digital world.

CONCLUSION

With the growth of the video industry and the video rental store, Americans could access movies as objects in a huge number of public retail locations, just like books or records. The growth of this industry propelled the growth of a related one, the production of thick movie catalogs that provided a balance of descriptive and evaluative information. As practical products, these guides allowed the individual to mediate their selection in advance of consumption, even in advance of the act of shopping. Like the movie on video itself, these guides took a material form. More recently, however, many Americans have accessed such metatextual information in digital form—or formlessness, as the case may be. Now that metadata have been integrated in the same televisions, computers, smart phones, and digital tablets through which we consume our movies, we also consume this metadata as intangible media in its own right.

Daniel Chamberlain has discussed how American television viewers spend an incredible amount of time navigating the many menus, windows, and content descriptions that "guide" them toward different programs.[147] Drawing from the work of Marc Augé and Mark Andrejevic, Chamberlain calls such interface displays of metadata "the non-places of asynchronous entertainment" and asserts that the control over content that these services promise hides the corporate and algorithmic control over media production and consumption that more truly defines the contemporary media environment. Indeed, both Amazon and Netflix developed software that would coordinate a vast amount of user-generated data in order to formulate a set of recommendations for additional sales and rentals, tailored to the individual. Here, the "invisible hand" guiding the market is a patented digital code but *appears* as an individualized set of media suggestions. In this respect, Amazon, Netflix, and similar long tail retailers have extended a process of personalizing movie shopping even while they have extended its spatial range. Whereas in the past we might have spent an afternoon wandering the aisles of Hollywood Video, now we kill time clicking through the many options "On Demand."

For all that these interfaces attempt to seamlessly integrate movie shopping and consumption, there remains a labor-intensive, somewhat clunky material infrastructure that supports them. This infrastructure has displaced the material publications that once monopolized this market. Whereas *TV Guide* had a circulation of nearly twenty million in 1975, the publisher had to reduce circulation to two million in 2009.[148] Speaking informally, Leonard Maltin and the editors of the *VideoHound* guide admitted that their sales have declined considerably in recent years, although they did not give exact numbers. *Bare Facts Video Guide* has been supplanted by similar lists of nude scenes found for free on the Internet, which often include still images or video clips.[149] By creating the sense of greater efficiency, seamlessness, and even intangibility, the current digital metadata services appear to unburden the contemporary media shopper from the bounds of materiality. These services have a material base, to be sure, yet the shopper now experiences this information as an extension of the medium itself. What becomes of the objects that once served similar purposes? Has Maltin's guide really become the doorstop that a writer described it as in 1996? Or is even that too much clutter? Have we thrown all these guides away or, if we were lucky, unloaded them in a garage sale? Writing from a moment when movies appear as intangible flows of digitized information, it strikes me that so many videos and video guides have been swept out of sight. The era of tangible media made garbage out of media.

Coda

The Value of the Tangible

The postapocalyptic film *I Am Legend,* starring Will Smith, arrived in theaters in December 2007. The premise of the movie is that sometime around 2012 the world is overtaken by a virus that turns everyone except the unnamed protagonist into zombielike creatures. After establishing that the protagonist is alone in a depopulated Manhattan, with only his dog as a companion, the film shows him enter a video store. Both outside and inside the store, there are mannequins placed strategically to mimic the social interactions one might have at such a place. Mannequins appear as customers entering the store, as a family browsing the aisles, and as a clerk behind the counter. As the protagonist peruses the aisles, he addresses a number of these figures by name as though he has interacted with them before. After returning two DVDs to their proper shelf, he grabs another title and reads the back cover. A female mannequin catches his eye. There is a pregnant silence as he debates whether to speak to her. Instead, he makes his way to the counter and says hello to "Hank," a mannequin in a baseball cap posing as the clerk. The protagonist rents the movie and asks Hank about the female mannequin at the back of the store. No answer forthcoming, he leaves.

Aside from the mannequins, the space of this video store is completely unremarkable. But the actions occurring within this space are strange. Many postapocalyptic films depict characters gleefully appropriating all the world's commodities after no one else is around to possess them. Such films are fantasies of boundless opportunities for consumption. And while *I Am Legend* occasionally indulges in this fantasy of conspicuous consumption, here it depicts the protagonist "renting" movies for no apparent reason. They are his to own if he wants them. It seems the videos are not as important as the position he takes in the store. Rather than possess the videos, he possesses the space and makes his own use of it. He brings this dead space

to life by performing the social rituals of browsing and renting. In this, *I Am Legend* highlights the video rental store as an interactional space, a public place where people come into contact around media commodities. The video store becomes a theater where the protagonist performs sociality itself. Crucially, he imagines "society" as a community of shoppers and salespeople.

The narrative of *I Am Legend* freezes America at a moment in time. With the removal of all other humans, society has been eliminated and history effectively ended. Likewise, the film itself stands as a time capsule through its dramatic treatment of certain places and behaviors. The appearance of the video store is remarkable in this respect. *I Am Legend* was released when DVD sales and rental revenues were beginning to fall and Netflix and Redbox were dramatically increasing their market penetration. Since that time, Movie Gallery closed all its stores, including all the Hollywood Video locations, and Blockbuster went bankrupt and shuttered the vast majority of its stores. As the business model of the brick-and-mortar video rental store becomes increasingly marginalized, nearly to the point of obsolescence, this cinematic representation takes on an uncanny resonance. *I Am Legend* functions as a historically contingent trace of the video store and video rental culture. Just as the film dramatizes a dead world, so too does it represent a way of life that used to be. Video stores were part of that world but less and less a part of ours. One can imagine a time when future viewers of *I Am Legend* will not get the point.

Rather than see *I Am Legend* as representing the world as the protagonist's personal shopping mall, we might better understand it as representing the future as a garbage heap. Sure, the protagonist can rent movies, drive a sports car, and so on, but much of the world in the film is in shambles. If it weren't for Will Smith's character, even the sports car and DVDs would soon gather dust. The social use of video rental stores is precisely what animated them. But now that the behaviors that these stores facilitated largely occur elsewhere and in mutated form, video stores face the possibility of similarly becoming the refuse of a life gone by. For all that *I Am Legend* may record something of video store culture, it remains a mere illustration of what was once a hard-and-fast reality. The film envisions a future of garbage, but something similar has actually already occurred. How can we calculate the material waste generated by the era of tangible media? What happened to all the VHS tapes that once filled thirty thousand video stores? What happened to all the DVDs that Blockbuster and Hollywood Video weren't able to sell from their Previously Viewed racks? How many movies now sit in landfills? How do we face the fact that

the invention of the movie on tape also made movies eventual pieces of garbage?[1]

It suddenly takes on greater meaning that some of the video industry's leaders had previously associated themselves with trash. As discussed in chapter 5, Bronson Ingram strived to enter the sewage transport business, and when that didn't work out, he founded the video distribution company Ingram Entertainment and moved movies instead.[2] A certain circle seems to have closed, as many of the videos originally shipped across the country by Ingram have been reshipped by waste disposal services. More famously, Blockbuster founder David Cook based his business model on Waste Management, the largest garbage collection and disposal company in the world.[3] Like a Nostradamus of capitalism, Cook said in 1988, "The model we wanted to follow was the garbage business."[4] Further, Waste Management founder Wayne Huizenga bought Blockbuster in 1987 and expanded the company using the same tactics that he had previously applied to the waste transportation business. Blockbuster's success was presaged by garbage, and its current troubles threaten a return to that state.

I began research for this book not long after seeing *I Am Legend.* At the time, I was confronted—and motivated—by the rapid changes in the home video industry. I read the news reports about the economic woes of the video chains and watched as the video stores around me closed for business. By the time I began my field research in earnest, the entire business model of brick-and-mortar video rental seemed to be on its way out. The first stop on my western road trip in summer 2010 was the Hollywood Video two miles from my house. It was shut down, although there were still about twenty signs advertising "70% OFF—GOING OUT OF BUSINESS" littered around the storefront. I took pictures and worried that this might signal what I would find over the next many weeks on the road: not video stores but their remains. This fear proved half true in the end. Over the course of my intermittent fieldwork from 2008 through 2012, I saw about half as many dead stores as open ones.

Although not as stylish as *I Am Legend,* a picture of a dead video store in Cozad, Nebraska, bears out a similar drama (figure 39). The sun-bleached VHS covers for kids' movies testify to a community that once frequented this store regularly enough to support this selection. I could not mark the date of the store's closure accurately. Some of the videos on the shelves had come out within the previous five years, but the fallen hunks of ceiling suggested many years of neglect. Attached to a movie theater, which was also closed, this video store was not merely shuttered but abandoned—as if one day the entire town said, "I'm not going there anymore," and the owners

FIGURE 39. My reflection in the window of this abandoned store implicates my desire to penetrate it and tell its story.

simply left. It is a video store frozen in time, showing us precisely how it was organized and suggesting the ways in which it was used. Yet as a material space full of material commodities, this place remains subject to the passage of time. Without use and upkeep, it has quickly fallen into disrepair. It looks like garbage.

In addition to the truly abandoned stores I saw, which always seemed to be small, independently owned operations, I saw a lot of closed corporate stores, particularly Hollywood Video and Movie Gallery (figure 40). These places typically still bore their signs, but their interiors had been stripped bare of all videos, shelves, posters—everything. Looking at these places, one might not know they ever had been video stores; only the logos hint at their former function. Now they are average, mundane strip mall locations that appear strange only because they are empty and have gaudy interior paint. Although these locations have lost all traces of "the video store" and any signs of their impact on movie culture, their emptiness speaks to the material cost of the decline in this industry. A story from February 2010 stated that before the company closed all its locations forever, Movie Gallery tried to remain afloat by canceling 856 of its real estate leases; the

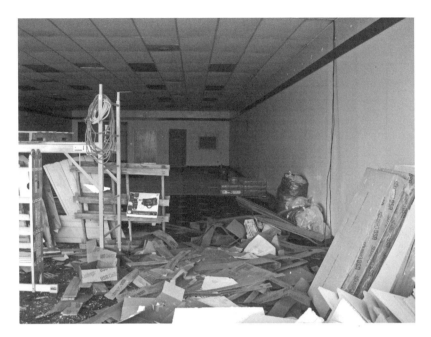

FIGURE 40. What was once a corporate video store is now an anonymous space.

story provided an online link to a list of the locations.[5] This record is daunting, listing addresses in strip malls and shopping centers in nearly forty states. Simply in economic terms, the sudden disappearance of these stores put a new burden on the real estate market in towns and cities across the country, already battered by the Great Recession.

The value of the video store always rested in part in its approach to public space. Video stores were convenient and part of our everyday public lives, whether we were coming home from work or going out on a date. The value of video stores was that they put movies into our habitual space and in turn produced new habits with new values concerning movies and movie culture. The objectification of movies on a material, portable format was only half the equation in the way home video transformed movie culture in America. Video stores taught us to shop for these things and thereby turned us into movie shoppers. They enabled us to exercise new levels of choice and control over movie consumption. In this way, they appealed to us as individuals who expressed our power through selectivity. But by situating these activities in a public retail space, they also socialized movie shopping. We might shop for a video alone, but we also might go to a video store with friends, a loved one, or the entire family. And we always had

some interaction with the clerk, no matter how minimal. Video stores were shared spaces, where people displayed their different values and tastes in their conversations and physical movements.

The decline in the brick-and-mortar rental industry could be reduced to a purely economic phenomenon. Whether for price, convenience, or greater personalization, people increasingly engage with movies as intangible media. As Americans go less and less to the video store, economic logic dictates that these businesses will close. Yet in this same scenario, there remains a great interest on the part of Americans to watch videos; we still value watching movies at home (or wherever), and we still like exercising choice over content. So if the value of video and video shopping remains high, then the decline in brick-and-mortar stores points to some other kinds of devaluation. It indicates a devaluation of public shopping. It indicates a devaluation of tangible media. It indicates a devaluation of material buildings holding material commodities and the social interactions they enabled.

Yet not all video stores appear to be suffering. The Family Video chain in particular seems to have bucked the industry trend. Whereas the company had only four hundred stores in 2004, as of 2013 it has more than twice that number; most heavily concentrated in the upper Midwest, the chain has locations in over nineteen states as well as Canada.[6] Yet it would have been difficult to predict that Family Video would be an industry outlier, as the company appears to embody the historical changes within the video rental industry as a whole. The chain began as Midstates Appliance and Supply Co., a hardware and electronics wholesaler in Springfield, Illinois.[7] Like many such operations, it began selling VCR equipment in the 1970s as well as tapes for these machines.[8] Sometime in the late 1970s, the company bought more videotapes than it could sell.[9] It repurposed the tapes and began operating a video rental club from the appliance store in 1978.[10] Its initial plan required a $25 membership fee, and individual movie rentals were $5 each.[11] This rental program proved successful enough that they dropped the wholesaling business and opened a smattering of new video stores in the region.[12] Although the company's growth during the 1980s and 1990s was quite slow compared to other chains of the era, it remained privately owned and spread farther through the American Midwest.[13]

Like Blockbuster and Hollywood, Family Video locations are clean, professional-looking stores, each of which looks the same as the others, and they offer a broad selection of mainstream movie titles. Also like Blockbuster and Hollywood, Family Video's growth entailed a geographic spread as it capitalized on economies of scale and spatial standardization. Yet the company distinguished itself in subtle ways that have had pronounced effects.

Unlike Hollywood and Blockbuster, Family Video offers XXX-rated movies. By doing so, Family Video situates this "un-family" genre in a "professional" ambience.[14] The company maintains its "family friendliness" by offering lower prices than many other chains and providing kids', educational, sports, and fitness videos for free.[15] It did not engage in the revenue-sharing schemes practiced by other chains, and resists entering the sell-through market.[16] In these respects, Family Video has maintained economic independence even while it has undercut other video stores' pricing.

The real secret to Family Video's pattern of growth, success, and ability to offer low prices lies in its approach to geography. Unlike Blockbuster and Hollywood, Family Video owns rather than rents all its locations, putting the company as much in the real estate business as in the video business.[17] Family Video highlights the importance of the "land" in "videoland." This practice, although leading to less rapid expansion than other chains, seems to have proven crucial to the company's long-term financial stability.[18] As the company opened each new location, it bought a property or existing strip mall, worked directly with local contractors and carpet mills to outfit the store, and rented out the adjacent spaces to other retailers—thus engaging in video rental *and* property rental.[19] (In fact, one can view properties for rent on the company's website.)[20] Many of these neighboring businesses complement Family Video's video business, to the extent that they provoke similarly casual and habitual use, such as liquor stores and pizza chains like Little Caesar's.[21] It seems likely that the revenue generated through these arrangements has allowed the company to subsidize its video locations and thus offer competitive rental prices.[22]

Family Video thus mitigates economic volatility in the home media market through commercial exploitation of geography itself. Although material media commodities may not always prove profitable, material commodities of some sort, and the material space needed to sell them, have a bright future. Family Video has engaged in business in this way precisely because the owners were dubious about the long-term viability of the video rental business.[23] The video chain is merely a specific manifestation of this company's engagement in commercial retail and property management. One can imagine that some day, when material video formats are truly dead and gone, Family Video could survive with some other type of retail business. From the early 2000s through the present, in fact, the company has engaged in a number of other ventures, including fitness gyms and take-out pizza shops, most of which are located in the retail structures adjoining the video locations.[24] Such activities point to the place of movie culture in the era of home video, where movies are treated as cheap commodities that

can be shopped for alongside other low-priced goods and services. Moreover, Family Video's success shows that although the contemporary media business requires incredible flexibility, this flexibility is quite literally grounded in the commercialization of tangible space.

Where Family Video derives economic value from tangible space (and, for the moment, media), the video store in general derived a more ephemeral value through its social character. As we adopt intangible media, our interactions around movies also become increasingly intangible, whether by using Netflix recommendations, reading IMDb ratings, or posting our thoughts to chatroom forum discussions. True, we may still debate with friends and lovers about what to watch on Netflix or what Blu-Ray to buy at Wal-Mart, but these conversations now only occur in a dispersed field and no longer inside the walls of a video store. We have also lost our clerks. Admittedly, most of us did not spend much time talking with them, but there were those whom we trusted and maybe even liked. (I hope I was one of these people.) More than 19,000 people worked for Movie Gallery alone,[25] and at one point over 150,000 people were employed at video rental stores.[26] There are about half as many today.[27] Where are these people, and what are they doing? Where will those conversations go? What record of these encounters will there be except our vague memories?[28]

There are pockets of people who continue to value the tangibility of video and the materiality of the video store. Like retro video gamers or vinyl collectors, these are the fans of video as it once existed. Drafthouse Films, Intervision, and several other distributors are releasing select titles, mainly horror films, on VHS for analog video aficionados.[29] In an inversion of the current logic driving the video market at large, here we see a demand for trash cinema generating a new supply of tangible media. Many other video fans make their presence known on the Internet.[30] VHSCollector.com, for instance, is devoted to gathering and posting information about "all the obscure little horror flicks" that captured the author's imagination in the 1980s.[31] Here one can find reviews and articles about the trashy videos of the 1980s as well as digital scans of the cover art for a huge variety of VHS releases. Similarly, the website VHShitfest.com provides ironic but loving reviews of some of the most obscure, lowbrow VHS titles from the 1980s and 1990s.[32] In addition, the website hosts a handful of interviews with people who performed in such movies, scans of the cover art, and even clips from the videos. The collaborators for this website appear to have accepted the garbage heap of tangible video and celebrate trashiness as a value all its own.[33]

Similarly, fans of rental stores have endeavored to propagate the cultural life of these places. Video Free Brooklyn is a particularly notable case. When

a local video store in Brooklyn was about to close, the film critic Aaron Hillis bought the location in June 2012 and has attempted to sustain it.[34] Treating the endeavor almost like a charity case, Hillis asked for funds to help resuscitate the store through the crowd-funding website Indiegogo.[35] In the promotional video, Hillis appeals to people's tastes for personalized shopping in public space. "The thing about video stores is that people think they're a failing industry," he says. "But what about the tactile quality of coming into a place that is well-curated and being able to browse movies?" Although the fund-raising campaign aimed to raise $50,000, it succeeded in garnering just $14,315.[36] Yet even this figure indicates a substantial out-pouring of support for this endeavor, a cultural value judgment expressed in economic terms. Still in operation at the time of this writing, Video Free Brooklyn promotes itself heavily online with both a Facebook page and a frequently updated Twitter account. The store coordinates its place-based geography of movie taste with the expansive yet individuated space of the Internet.

Like all video stores, Video Free Brooklyn's success will depend on whether there remains a desire among local residents to shop for tangible media in a public space. In this case, it seems that the movie taste in this area will also likely have to align with a taste for quirky or residual forms of socialization; many of this store's customers will have a taste for nostalgia and distinction as much as they do for movies. This sentimentality will not necessarily be shared by all the future shoppers in video stores across the country. In some places, the video store will endure because it remains a convenient and inexpensive option for accessing movies. Just as the video rental store fractured, localized, and particularized the geography of movie culture in a historical way, the video stores that survive will do so because they align with the particular tastes and values of local moviegoers. Some people will value the videos; others will value the store itself. I value the people, the shoppers and the clerks, who came together and made the video store a lively place.

Notes

INTRODUCTION

1. Taking aim at Netflix and other rent-by-mail services rather than brick-and-mortar video stores, another version of the ad states, "The video store just moved in. Rent new releases instantly, no waiting for the mail. Movies on demand."

2. For a discussion of the postmillennial development of video-on-demand services, see Lucas Hilderbrand, "The Art of Distribution: Video on Demand," *Film Quarterly* 64, no. 2 (Winter 2010): 24–28.

3. For a broad-minded discussion of the flow of media texts across multiple platforms, as well as the industrial and cultural contexts in which these flows occur, see Henry Jenkins, *Convergence Culture: Where Old and New Media Collide* (New York: New York University Press, 2006). Jenkins's discussion of contemporary media convergence is preceded by Marsha Kinder's discussion of media "supersystems," in which different icons and figures flow across different texts and platforms. Marsha Kinder, *Playing with Power in Movies, Television, and Video Games: From Muppet Babies to Teenage Mutant Ninja Turtles* (Berkeley: University of California Press, 1991), esp. 122–23. Many companies are not only making movies intangible but also seeking to make the technologies and interfaces through which we access movies and other media "invisible." Peter D. Schaefer and Meenakshi Gigi Durham explore this idea in relation to design and marketing of the iMac G5 personal computer. Peter D. Schaefer and Meenakshi Gigi Durham, "On the Social Implications of Invisibility: The iMac G5 and the Effacement of the Technological Object," *Critical Studies in Media Communication* 24, no. 1 (2007): 39–56.

4. From a certain perspective, my study could be seen as extending the scholarship on movie exhibition. Some important works in this area include the following: Charles Acland, *Screen Traffic: Movies, Multiplexes, and Global Culture* (Durham, NC: Duke University Press, 2003); John Belton, *Widescreen Cinema* (Cambridge, MA: Harvard University Press, 1992); Douglas Gomery, *Shared Pleasures: A History of Movie Presentation in the United States*, foreword by

David Bordwell (Madison: University of Wisconsin Press, 1992); Miriam Hansen, *Babel & Babylon: Spectatorship in American Silent Film* (Cambridge, MA: Harvard University Press, 1991); Ina Rae Hark, ed., *Exhibition: The Film Reader* (New York: Routledge, 2002); Richard Koszarski, *An Evening's Entertainment* (Berkeley: University of California Press, 1990); Richard Maltby, Melvyn Stokes, and Robert C. Allen, eds., *Going to the Movies: Hollywood and the Social Experience of the Cinema* (Exeter: University of Exeter Press, 2007); Ross Melnick and Andreas Fuchs, *Cinema Treasures* (St. Paul, MN: MBI Publishing, 2004); Kerry Segrave, *Drive-in Theaters* (Jefferson, NC: McFarland, 1992); Jacqueline Stewart, *Migrating to the Movies: Cinema and Black Urban Modernity* (Berkeley: University of California Press, 2005); Gregory A. Waller, *Main Street Amusements: Movies and Commercial Entertainment in a Southern City, 1896–1930* (Washington DC: Smithsonian Institution Press, 1995); Gregory A. Waller, ed., *Moviegoing in America: A Sourcebook in the History of Film Exhibition* (Malden, MA: Blackwell, 2002); Barbara Wilinsky, *Sure Seaters: The Emergence of Art House Cinema* (Minneapolis: University of Minnesota Press, 2001).

5. Sean Cubitt has characterized "video culture" in similar terms, defining it as "a set of relations around the uses of videotape, a set of practices and a set of possibilities concerning what these relations, uses and practices may become." Sean Cubitt, *Timeshift: On Video Culture* (London: Routledge, 1991), 1.

6. For instance, the advent and widespread adoption of the Walkman allowed individuals to listen to music anywhere. For a thorough discussion of the cultural significance of the Walkman, see Paul du Gay et al., *Doing Cultural Studies: The Story of the Sony Walkman* (London: Sage, 1997).

7. For an illuminating discussion of how cultural critics situated early home video technologies as a reprieve from the "bad object" of television in the 1960s and 1970s, see Max Dawson, "Home Video and the 'TV Problem': Cultural Critics and Technological Change," *Technology & Culture* 48, no. 3 (July 2007): 524–49. For an insightful overview of many of the theoretical frames, and pitfalls, of "shopping" as a research topic, see Pasi Falk and Colin Campbell, Introduction to *The Shopping Experience* (London: Sage, 1997), 1–14. The appendix of *The Shopping Experience* provides a vital historical overview of the scholarship on shopping that indicates how methods and research questions have changed since the 1960s: Paul Hewer and Colin Campbell, "Appendix: Research on Shopping—A Brief History and Selected Literature," 187–206.

8. Caetlin Benson-Allott, *Killer Tapes and Shattered Screens: Video Spectatorship from VHS to File Sharing* (Berkeley: University of California Press, 2013).

9. Mike Spector and Peter Lattman, "Hollywood Video Closes Doors—Chain's Remaining U.S. Stores to Shutter as Consumers' Viewing Habits Change," *Wall Street Journal*, 3 May 2010.

10. Wayne T. Price, "Dish Network Pulls Plug on 300 More Blockbuster Video Stores," *Florida Today*, 23 Jan. 2013; *2002 Annual Report on the Home Entertainment Industry* (n.p.: Video Software Dealers Association, 2002), 20.

11. This contrasts with the assessment of Frederick Wasser, who argues that Americans largely did not expand their viewing habits as a result of the broadening of movie options made possible by video stores. I do not disagree that Americans primarily consumed Hollywood movies on video. But I do show that video stores *appealed* to Americans' desire for abundant media options, just as Amazon, Netflix, etc., do. Frederick Wasser, "The Long Tail of the Video Store," *Media Fields Journal: Critical Explorations in Media and Space* no. 1 (2010), accessed 31 May 2012, www.mediafieldsjournal.org/the-long-tail-of-the-video-sto.

12. Chuck Tryon provides an expansive analysis of how digital technologies have affected cinema culture. Chuck Tryon, *Reinventing Cinema: Movies in the Age of Media Convergence* (New Brunswick, NJ: Rutgers University Press, 2009).

13. In addition to the numerous studies of video from within film and media studies, the video industry and video stores have gained some attention in fields outside the humanities, most notably in economics. Here are a few articles along these lines that may be interesting to scholars and students in the humanities: Hal R. Varian, "Buying, Sharing and Renting Information Goods," *Journal of Industrial Economics* 48, no. 4 (2000): 473–88; James D. Dana and Kathryn E. Spier, "Revenue Sharing and Vertical Control in the Video Rental Industry," *Journal of Industrial Economics* 49, no. 3 (2001): 223–45; Julie Holland Mortimer et al., "In the Video Rentals Industry: Positive or Negative?" *Yale Economic Review* 5, no. 2 (2009): 31–36; Yuliya Strizhakova and Marina Krcmar, "Mood Management and Video Rental Choices," *Media Psychology* 10, no. 1 (2007): 91–112; Neil Terry and Anne Macy, "The Determinants of Movie Video Sales Revenue," *Journal of American Academy of Business, Cambridge* 15, no. 1 (2009): 16–23.

14. Roy Armes, *On Video* (London: Routledge, 1988), 1.

15. Manuel Alvarado, ed., *Video Worldwide: An International Study* (London: John Libbey, 1988); Julia Dobrow, ed., *Social and Cultural Aspects of VCR Use* (Hillsdale, NJ: Lawrence Erlbaum, 1990); Gladys Ganley and Oswald Ganley, *Global Political Fallout: The First Decade of the VCR, 1976–1985* (Cambridge, MA: Harvard University Press, 1987); James Lardner, *Fast Forward: Hollywood, the Japanese, and the Onslaught of the VCR* (New York: W.W. Norton, 1987); Mark Levy, ed., *The VCR Age: Home Video and Mass Communication* (London: Sage, 1989).

16. Armes, *On Video;* Timothy Corrigan, *A Cinema without Walls: Movies and Culture after Vietnam* (New Brunswick, NJ: Rutgers University Press, 1991); Cubitt, *Timeshift;* Anne Friedberg, *Window Shopping: Cinema and the Postmodern* (Berkeley: University of California Press, 1994); Fredric Jameson, *Postmodernism, Or, The Cultural Logic of Late Capitalism* (Durham, NC: Duke University Press, 1991).

17. The discourse on "video art" has rarely been in dialogue with the other discourses on video, particularly those that consider the video industry or popular home video. The exceptions to this are the few scholars, like

Cubitt and Jameson, who discuss video and/or video art within a larger analysis of the postmodern. On "video art," see Catherine Elwes, *Video Art: A Guided Tour* (New York: Palgrave Macmillan, 2005); Doug Hall and Sally Jo Fifer, eds., *Illuminating Video: An Essential Guide to Video Art* (New York: Aperture Books, 1991); Chrissie Iles, ed., *Into the Light: The Projected Image in Contemporary Art, 1964–1977* (New York: Whitney Museum of American Art, 2001); Rosalind Krauss, "Video: The Aesthetics of Narcissism," *October*, no.1 (Spring 1976): 50–64; Chris Meigh-Andrews, *A History of Video Art: The Development of Form and Function* (Oxford: Berg, 2006); Michael Rush, *Video Art* (London: Thames & Hudson, 2003); Anne Wagner, "Performance, Video, and the Rhetoric of Presence," *October*, no. 91 (Winter 2000): 59–80. On "home movies," see James Moran, *There's No Place Like Home Video* (Minneapolis: University of Minnesota Press, 2002). The *Resolutions* series from University of Minnesota Press provides an expansive selection of essays that maintain wide-ranging interests in video as an art object, an aesthetic, a spectatorial condition, a theoretical conundrum, a tool for documentary practices, and an instrument for social and political engagements. Michael Renov and Erika Suderberg, eds., *Resolutions: Contemporary Video Practices* (Minneapolis: University of Minnesota Press, 1995); Erika Suderburg and Ming-Yuen S. Ma, eds., *Resolutions 3: Global Networks of Video* (Minneapolis: University of Minnesota Press, 2012). The precursor to these books looks more exclusively at "video art." Patti Podesta, ed., *Resolution: A Critique of Video Art* (Los Angeles: Los Angeles Contemporary Exhibitions, 1986).

18. Charles Tashiro, "Videophilia: What Happens When You Wait for It on Video," *Film Quarterly* 45, no. 1 (Autumn 1991): 7–17; Charles Tashiro, "The Contradictions of Video Collecting," *Film Quarterly* 50, no. 2 (Winter 1996–97): 11–18.

19. Paul McDonald, *Video and DVD Industries* (London: BFI, 2007); Stephen Prince, *A New Pot of Gold: Hollywood under the Electronic Rainbow, 1980–1989* (Berkeley: University of California Press, 2002); Janet Wasko, *Hollywood in the Information Age: Beyond the Silver Screen* (Austin: University of Texas Press, 1994); Frederick Wasser, *Veni, Vidi, Video: The Hollywood Empire and the VCR* (Austin: University of Texas Press, 2001).

20. Janet Wasko and Frederick Wasser examine video retail and rental from an industrial perspective. Wasko, *Hollywood in the Information Age*, 148–57; Wasser, *Veni, Vidi, Video*, 140–49. Douglas Gomery, in *Shared Pleasures*, devotes a chapter to home video, including a discussion of video rental stores, as part of his larger discussion of movie exhibition in America. Ann Gray's ethnographic study also includes a chapter about social subjects', specifically women's, use of video rental stores. Ann Gray, *Video Playtime: The Gendering of a Leisure Technology* (London: Routledge, 1992). Lardner discusses retail and rental business logics as well.

21. Lucas Hilderbrand, *Inherent Vice: Bootleg Histories of Videotape and Copyright* (Durham, NC: Duke University Press: 2009); Barbara Klinger,

Beyond the Multiplex: Cinema, New Technologies, and the Home (Berkeley: University of California Press, 2006).

22. Joshua Greenberg, *From Betamax to Blockbuster: Video Stores and the Invention of Movies on Video* (Cambridge, MA: MIT Press, 2008). Another major source for scholarship on video stores can be found in the inaugural issue of the online journal *Media Fields Journal: Critical Explorations in Media and Space*, which was devoted to the topic. In addition to an excellent introduction, written by the issue's editors, Jeff Scheible and Joshua Neves, the issue features analyses of video store back rooms, video stores in Fiji and France, and a critique of the "long tail" thesis by Frederick Wasser, among other fascinating contributions. *Media Fields Journal: Critical Explorations in Media and Space*, no. 1 (2010), accessed 28 June 2012, www.mediafieldsjournal.org/issue-1.

23. Greenberg, *From Betamax to Blockbuster*, 63.

24. Hilderbrand, *Inherent Vice*, 5–10.

25. My approach to video stores and media distribution aims to create a bridge between studies of media reception and of production cultures. If one accomplishment of media reception studies, primarily in "audience studies," has been to indicate how social subjects adapted media messages to their localized circumstances, this discourse nevertheless neglected the role of human subjects in the movement of media images through the world. And if the contemporary study of "production cultures" has complicated any monolithic portrait of "Hollywood" or of cultural producers' ideological dispositions, then this area of research has somewhat similarly neglected a large population of media workers who are not involved in "production" in the literal sense; Vicki Mayer's work provides a remarkable exception to this tendency. Rather than complicate the division between production and consumption by showing how producers are also consumers or vice versa, my examination of video stores and their workers aims to show that many things are "made" and "consumed" simultaneously, and indicates how "distribution" produces and consumes media texts and values. For an overview of the many trajectories within the large fields of media reception studies, see David Morley, *Television, Audiences and Cultural Studies* (London: Routledge, 1992); Will Brooker and Deborah Jermyn, eds., *The Audience Studies Reader* (London: Routledge, 2003); Janet Staiger, *Media Reception Studies* (New York: New York University Press, 2005). On production cultures, see John Thornton Caldwell, *Production Culture: Industrial Reflexivity and Critical Practice in Film and Television* (Durham, NC: Duke University Press, 2008); Vicki Mayer, Miranda Banks, and John Thornton Caldwell, eds., *Production Studies: Cultural Studies of Media Industries* (New York: Routledge, 2009); Vicki Mayer, *Below the Line: Producers and Production Studies in the New Television Economy* (Durham, NC: Duke University Press, 2011).

26. In her historical overview of the distribution of Hollywood films, Suzanne Mary Donahue writes, "Distribution is the means by which a film becomes available to the public." Suzanne Mary Donahue, *American Film Distribution: The Changing Marketplace* (Ann Arbor, MI: UMI Research Press, 1987), 1. Thus, in its industrially dominant form, distribution is the bottleneck

234 / Notes to Pages 5-6

through which the mass of productions must pass in order to reach their potentially vast audiences. This fact led Nicholas Garnham to identify distribution as the most important element for understanding the political economy of the media industries. Nicholas Garnham, *Capitalism and Communication: Global Culture and the Economics of Information*, edited by Fred Inglis (London: Sage, 1990), 161–62. Similarly, David Hesmendalgh points out that, due to their resemblance to "public goods," it is a regular tactic to create economic value for cultural commodities by creating "false scarcity," and this is primarily done at the level of distribution. David Hesmendalgh, *The Cultural Industries*, 2nd ed. (London: Sage, 2007), 21–23. Alisa Perren has surveyed the tendencies among studies of media distribution and notes the increasing sophistication with which the topic is discussed. Alisa Perren, "Rethinking Distribution for the Future of Media Industry Studies," *Cinema Journal* 52, no. 3 (Spring 2013): 165–71.

27. As Karl Marx writes, "In production the members of society appropriate (create, shape) the products of nature in accord with human needs; distribution determines the proportion in which the individual shares in the product." Alternatively, he writes, "exchange delivers the particular products into which the individual desires to convert the portion which distribution has assigned him," a definition that largely describes "distribution" as the term is commonly used in media industry studies. Karl Marx, *The Grundisse* (London: Penguin Books, 1993), 88–89.

28. Brian Larkin discusses media infrastructures in a related manner. He writes, "Infrastructures are the material forms that allow for exchange over space, creating the channels that connect urban places in wider regional, national, and transnational networks." Yet he further indicates that infrastructures "facilitate the flow of goods in a wider cultural as well as physical sense." He states, "*Infrastructure*, in my usage, refers to this totality of both technical and cultural systems that create institutionalized structures whereby goods of all sorts circulate, connecting and binding people into collectivities." Brian Larkin, *Signal and Noise: Media, Infrastructure, and Urban Culture in Nigeria* (Durham, NC: Duke University Press, 2008), 5–6.

29. As part of his study of "informal" modes of movie distribution, Ramon Lobato somewhat similarly retheorizes "distribution" in relational terms. Ramon Lobato, *Shadow Economies of Cinema: Mapping Informal Film Distribution* (London: Palgrave Macmillan, 2012), 9–19.

30. Corrigan, *A Cinema without Walls*, 1–7.

31. Space and geography have become key interests to the field of film and media studies, from the dispersal of film texts beyond the silver screen to discussions of television outside the domestic sphere. See, for instance, Klinger, *Beyond the Multiplex;* and Anna McCarthy, *Ambient Television: Visual Culture and Public Space* (Durham, NC: Duke University Press, 2001). David James provides a theoretical grounding for reading film aesthetics in terms of a "geocinematic hermeneutic." David James, *The Most Typical Avant-Garde: History and Geography of Minor Cinemas in Los Angeles* (Berkeley: University of California Press, 2005), 18.

32. David Harvey, *The Condition of Postmodernity: An Inquiry into the Origins of Cultural Change* (Cambridge, MA: Blackwell, 1990), 218–22. Harvey is drawing from the work of Henri Lefebvre, particularly Lefebvre's similar tripartite division of "space." Henri Lefebvre, *The Production of Space*, translated by Donald Nicholson-Smith (Malden, MA: Blackwell, 1991), 33.

33. In looking at video stores in terms of actual space, my analysis aligns most closely with the third level of "mediaspace" defined by Nick Couldry and Anna McCarthy: "the specific spaces at either end of the media process, the space of consumption and the space of production." Nick Couldry and Anna McCarthy, "Introduction: Orientations: Mapping MediaSpace," in *Mediaspace: Place, Scale and Culture in a Media Age*, edited by Nick Couldry and Anna McCarthy (London: Routledge, 2004), 6. Video stores disrupt this polarity. Video stores also disrupt the division between the third and second tier of "mediaspace," as the authors define this second tier as the flow of images across space and the transformation of social space that results from this.

34. Pierre Bourdieu, *Distinction: A Social Critique of the Judgment of Taste*, translated by Richard Nice (Cambridge, MA: Harvard University Press, 1984), 6, 466–79.

35. Ibid., 466; emphasis added.

36. For an overview of "consumer culture," see Celia Lury, *Consumer Culture* (New Brunswick, NJ: Rutgers University Press, 1996). For a wide-ranging selection of the different theoretical and historical approaches to American consumer culture, see Lawrence B. Glickman, ed., *Consumer Society in America: A Reader* (Ithaca, NY: Cornell University Press, 1999).

37. David Desser and Garth S. Jowett, Introduction to *Hollywood Goes Shopping*, edited by David Desser and Garth S. Jowett (Minneapolis: University of Minnesota Press, 2000), xii. This collection provides theoretically and historically expansive analyses of the intersections between cinema and consumerism. However, the essays largely look at particular films and metatextual and paratextual discourses in order to show how American cinema promoted or aligned with "consumerism," construed here as an ideology that promotes capitalist-style consumption of commodities.

38. Ellis Cashmore, *. . . And There Was Television* (New York: Routledge, 1994), 6–7, 79–80; Lynn Spigel, *Make Room for TV* (Chicago: University of Chicago Press, 1992), 31–35; Ella Taylor, *Prime-Time Families: Television Culture in Postwar America* (Berkeley: University of California Press, 1989), 20; Roger Silverstone, "Television and Consumption," in *Television and Everyday Life* (New York: Routledge, 1994), 104–31; Lynn Spigel, "Television in the Family Circle," In *Logics of Television: Essays in Cultural Criticism*, edited by Patricia Mellencamp (Bloomington: Indiana University Press, 1990), 78–81; Bernard McGrane and John Gunderson, "Consumerism TV," in *Watching TV Is Not Required* (New York: Routledge, 2010), 71–95.

39. Harvey, *The Condition of Postmodernity*, 147.

40. For all that I want to emphasize the historically specific contexts in which video stores arose, became normalized, and declined, I do not want to

overstate the importance of "consumerism" in contemporary society. Kevin Hetherington is keen to show the intersections of space and consumerism in the nineteenth century. Kevin Hetherington, *Capitalism's Eye: Cultural Spaces of the Commodity* (New York: Routledge, 2007). The historian Michael Kammen has written that "scholars from a broad range of disciplines do seem to agree ... that the flowering of consumer culture dates from the 1920s," and, further, that "most observers with a historical orientation seem to agree that the commercialization of culture accelerated rapidly after World War II." Michael Kammen, *American Culture, American Tastes: Social Change in the 20th Century* (New York: Basic Books, 1999), 53, 58. For a rich and thorough examination of the post–World War II period in American consumer society, see Lizbeth Cohen, *A Consumer's Republic: The Politics of Mass Consumption in Postwar America* (New York: Vintage, 2003).

41. David Harvey elaborates a general theory of "uneven geographic development," in *Spaces of Global Capitalism: Towards a Theory of Uneven Geographical Development* (London: Verso, 2006), 69–116.

42. Lizbeth Cohen charts how consumerism and social fragmentation were interwoven, as well as the historical shift from "mass to segmented markets," in postwar America. Cohen, *A Consumer's Republic*, 257–344.

43. Charles Acland, "Theatrical Exhibition: Accelerated Cinema," in *The Contemporary Hollywood Film Industry*, edited by Paul McDonald and Janet Wasko (Malden, MA: Blackwell, 2008), 83.

44. A comparison could be made between the video store and the nickelodeon, as films were initially exhibited in a wide variety of spatial contexts but, by 1905–7, were increasingly shown in spaces dedicated to cinema. Charles Musser, *The Emergence of Cinema: The American Screen to 1907* (Berkeley: University of California Press, 1994), 417–33.

45. I recognize that the nickelodeon was largely accessed as a "local" site for movie culture and that during the 1930s and 1940s many people watched movies in their local theaters rather than in the major downtown palaces. Yet as Charles Musser notes, nickelodeon operators did not exert much power in terms of the films they showed. Musser, *The Emergence of Cinema*, 438. Unlike theatrical venues, video stores localized movie culture by providing access to a larger number of movie choices at any given moment, thus better enabling the local population to express their individual and collective tastes.

46. This book does not examine the many video stores that have served various ethnic minorities throughout the country, such as the many grocery store/restaurant/video shops run by South Asians or the numerous mixed-use shops serving Latinos throughout the country. This omission primarily resulted from the fact that many such operations do not advertise themselves as video stores, and thus I and my research assistants could not locate them in advance of going into a city or region. This necessarily skews my generalizations about "the American video store" toward those stores owned and run primarily by English speakers. Lucas Hilderbrand provides a brief but conceptually rich analysis of video stores serving diasporic East Asians in Southern California.

Tracing how such operations connect an ethnic population dispersed across a wide space, this study suggests there is much work to be done in the area of ethnic video stores in the United States. Hilderbrand, *Inherent Vice*, 27–32.

47. Jennifer Holt and Alisa Perren, "Introduction: Does the World Really Need One More Field of Study?," in *Media Industries: History, Theory, and Method* (Malden, MA: Wiley-Blackwell, 2009), 1–16.

48. Caldwell, *Production Culture*.

49. My documentation consisted of photographs and interviews with clerks and owners; I also conducted a handful of follow-up interviews over the phone. I engaged these subjects with a set of open-ended questions about their commercial and social experiences. Due to the open nature of the questions, the subjects were fairly free to speak about issues and topics as they occurred to them in the course of the conversation, and I also would pursue items of conversation that arose on the spot. Typical questions included the following:

How long have you owned/worked at this video store?

How long has this store been in business?

What changes have you seen in the video industry since you began working here?

What is the geographic range of your customers?

Are there any particular genres that your renters prefer?

How did you come up with the organization of the store?

How many regular customers do you have?

In addition to movie recommendations, what other topics of conversation do you have with customers?

What is the most surprising part about working in a video store?

What is your favorite part about working here?

What is your least favorite part about working here?

Are you a movie buff? Was there some film that made you love movies?

How many other people work at this video store?

Do you socialize with your coworkers or customers outside of work?

50. Ann Gray's *Video Playtime* sets the precedent for this kind of work, as she conducted an extensive ethnographic study related to gender and video technologies in England in the late 1980s. For a discussion of the intersection between media studies and anthropology, see Kelly Askew, Introduction to *The Anthropology of Media: A Reader*, edited by Kelly Askew and Richard R. Wilk (Malden, MA: Blackwell, 2002), 1–13. For a historical overview of the theoretical frames that have been used to do anthropological studies of the media, see Mihai Coman and Eric W. Rothenbuhler, "The Promise of Media Anthropology," in *Media Anthropology*, edited by Eric W. Rothenbuhler and Mihai Coman (Thousand Oaks, CA: Sage, 2005), 1–11. Ellen Seiter describes the "ethnographic method" as "involving extended periods of participant observation." Consequently, I would say that although my fieldwork for this book was "ethnographic," the end result is not an "ethnography" in the richest and strictest sense of the term. Ellen Seiter, *Television and New Media Audiences* (Oxford: Clarendon Press, 1999), 10. Seiter's work in that text is part of a decades-long

project at complicating media reception studies with ethnographic analysis. For a thorough and critical overview of the field of media ethnography, see Shaun Moores, *Interpreting Audiences: The Ethnography of Media Consumption* (London: Sage, 1993).

51. In fact, a story from 2010 indicated that public libraries lent out more movies than Netflix on a daily basis. Carolyn Kellog, "Libraries: A Bigger Source of DVDs than Netflix," *Los Angeles Times,* 30 July 2010, accessed 15 May 2012, http://latimesblogs.latimes.com/jacketcopy/2010/07/libraries-dvds-netflix.html.

CHAPTER 1

1. I have access to the University of Michigan library system as well, including the Donald Hall Collection, a library dedicated to serving the needs of my department.

2. Joshua Greenberg, *From Betamax to Blockbuster: Video Stores and the Invention of Movies on Video* (Cambridge, MA: MIT Press, 2008), 64–65; James Lardner, *Fast Forward: Hollywood, the Japanese, and the Onslaught of the VCR* (New York: W.W. Norton, 1987), 176–77; Frederick Wasser, *Veni, Vidi, Video: The Hollywood Empire and the VCR* (Austin: University of Texas Press, 2001), 98.

3. Wasser, *Veni, Vidi, Video,* 153.

4. Ibid., 101.

5. "Number of U.S. Movie Screens," National Association of Theater Owners, accessed 15 Aug. 2012, www.natoonline.org/statisticsscreens.htm.

6. Greenberg, *From Betamax to Blockbuster,* 84–85; Wasser, *Veni, Vidi, Video,* 19, 102.

7. In a related vein, Will Straw explores how home video and the video store extended the cultural life span of particular movie titles but simultaneously propelled the "first-run" film culture developed initially at movie theaters. Will Straw, "Embedded Memories," in *Residual Media,* edited by Charles Acland (Minneapolis: University of Minnesota Press, 2007), 3–15.

8. For a thorough analysis of the cultural and economic logics of Redbox, see Chuck Tryon, "Redbox vs. Red Envelope, or What Happens When the Infinite Aisle Swings through the Grocery Store," *Canadian Journal of Film Studies* 20, no. 2 (Fall 2011): 38–54.

9. Chris Anderson, "The Long Tail," *Wired,* October 2004, accessed 2 May 2010, www.wired.com/wired/archive/12.10/tail.html.

10. Greenberg, *From Betamax to Blockbuster,* 55–77; Wasser, *Veni, Vidi, Video,* 98–103.

11. Greenberg, *From Betamax to Blockbuster,* 84–85; Wasser, *Veni, Vidi, Video,* 19, 102.

12. Barbara Klinger connects contemporary "home theaters" to a long history of commercial home entertainments. Barbara Klinger, *Beyond the Multiplex: Cinema, New Technologies, and the Home* (Berkeley: University of California Press, 2006), 6–7, 55.

13. Paul McDonald, *Video and DVD Industries* (London: BFI, 2007), 15–16.

14. Haidee Wasson, "Electric Homes! Automatic Movies! Efficient Entertainment!: 16mm and Cinema's Domestication in the 1920s," *Cinema Journal* 48, no. 4 (Summer 2009): 1–21.

15. McDonald, *Video and DVD Industries*, 16–17.

16. E.g., Kristin Thompson and David Bordwell, *Film History: An Introduction*, 2nd ed. (Boston: McGraw-Hill, 2003), 328–29, 333.

17. Michel Hilmes, *Hollywood and Broadcasting: From Radio to Cable* (Urbana: University of Illinois Press, 1999), 156–163; Derek Compare, *Rerun Nation: How Repeats Invented American Television* (New York: Routledge, 2005), 40–60; William Lafferty, "Feature Films on Prime-Time Television," in *Hollywood in the Age of Television,* edited by Tino Balio (Boston: Unwin Hyman, 1990), 239–42.

18. Hilmes, *Hollywood and Broadcasting,* 166; Lafferty, *Hollywood in the Age of Television,* 245; Christopher H Sterling and John Michael Kittross, *Stay Tuned: A History of American Broadcasting,* 3rd ed. (Mahwah, NJ: Lawrence Erlbaum, 2002), 437.

19. Lafferty, *Hollywood in the Age of Television,* 246.

20. Ibid.

21. Sterling and Kittross, *Stay Tuned,* 437.

22. McDonald, *Video and DVD Industries,* 18–32.

23. Greenberg, *From Betamax to Blockbuster,* 20, 48–49; McDonald, *Video and DVD Industries,* 28–32; Wasser, *Veni, Vidi, Video,* 60–63, 70–71. Max Dawson surveys how advertisements and marketing materials situated different pre-Betamax video technologies as the anodynes for the "cultural wasteland" found on contemporaneous television, thereby showing that a narrow and proscriptive vision for "good taste" circulated through culture at the time. Max Dawson, "Home Video and the 'TV Problem': Cultural Critics and Technological Change," *Technology & Culture* 48, no. 3 (July 2007): 524–49.

24. Greenberg, *From Betamax to Blockbuster,* 17–40.

25. Lardner, *Fast Forward,* 96–97; Greenberg, *From Betamax to Blockbuster,* 41; Wasser, *Veni, Vidi, Video,* 70–74.

26. Greenberg, *From Betamax to Blockbuster,* 41; Wasser, *Veni, Vidi, Video,* 70–74.

27. Greenberg, *From Betamax to Blockbuster,* 51–52; Lardner, *Fast Forward,* 183–184; Wasser, *Veni, Vidi, Video,* 71, 92–95. Peter Alilunas charts the industrial and cultural changes that attended the shift of pornographic media from celluloid to videotape and from theatrical to domestic exhibition. Chapter 2 in particular provides a detailed account of how adult movie producers and distributors created an increasingly sophisticated industrial network. Peter Alilunas, "Smutty Little Movies: The Creation and Regulation of Adult Video, 1976–1986" (PhD diss., University of Michigan, 2013).

28. Lardner, *Fast Forward,* 168–69, 172–75; Greenberg, *From Betamax to Blockbuster,* 52–56; Wasser, *Veni, Vidi, Video,* 95–98. Greenberg, Lardner, and Wasser discuss Blay in great detail. My account here integrates their findings

with material from a memoir written by Blay. Andre Blay, *Pre-Recorded History: Memoirs of an Entertainment Entrepreneur* (Centennial, CO: Deer Track Publishing, 2010), 38.

29. Blay, *Pre-Recorded History,* 51–53.

30. Ibid., 57–58.

31. Ibid., 66–67.

32. Ibid., 68.

33. Ibid., 75.

34. Ibid., 89–90.

35. Greenberg, *From Betamax to Blockbuster,* 64.

36. Ibid., 53–54.

37. Blay, *Pre-Recorded History,* 90.

38. Greenberg, *From Betamax to Blockbuster,* 84–85; Wasser, *Veni, Vidi, Video,* 19, 102.

39. Greenberg, *From Betamax to Blockbuster,* 65–66; Lardner, *Fast Forward,* 176–77; Wasser, *Veni, Vidi, Video,* 98.

40. Magnetic Video had licensed 1,100 movies by the end of 1978. Blay, *Pre-Recorded History,* 56.

41. Greenberg, *From Betamax to Blockbuster,* 66–77.

42. Ibid., 72–75.

43. Ibid., 68–71; Blay, *Pre-Recorded History,* 113.

44. Tracy Stevens, ed., *International Television & Video Almanac,* 48th ed. (New York: Quigley, 2003), 17.

45. "Daily Rental Fees," *Video Store Magazine: 1990 Video Store Retailer Survey* (1990), 14.

46. The retailing of books in the United States developed as an extension of the publishers themselves. Laura Miller, *Reluctant Capitalists: Bookselling and the Culture of Consumption* (Chicago: University of Chicago Press, 2006), 25.

47. Hellmut Lehmann-Haupt, *The Book in America: A History of the Making, the Selling, and the Collecting of Books in the United States* (New York: R.R. Bowker, 1939), 192–200.

48. Ibid., 240–41.

49. Ibid., 241–43; Miller, *Reluctant Capitalists,* 35–38.

50. Miller, *Reluctant Capitalists,* 40–52. With the aim of streamlining customer service, Barnes & Noble innovated book retailing in the middle of the twentieth century by modernizing its interior and implementing a modular system of organization and display. Ted Striphas, *The Late Age of Print: Everyday Book Culture , from Consumerism to Control* (New York: Columbia University Press, 2009), 62–64.

51. Miller, *Reluctant Capitalists,* 91–94.

52. Russel Sanjek and David Sanjek, *American Popular Music Business in the 20th Century* (New York: Oxford University Press, 1991), vi–ix.

53. Ibid., 90, 130.

54. Ibid., 264.

55. Ibid.

56. Advertisement, *TV Guide*, 8–14 Nov. 1980.

57. Ibid., 10–16 Oct. 1981.

58. Frederick Wasser notes the appeal to convenience as well. Frederick Wasser, "The Long Tail of the Video Store," *Media Fields Journal: Critical Explorations in Media and Space* no. 1 (2010), accessed 31 May 2012, www .mediafieldsjournal.org/the-long-tail-of-the-video-sto.

59. Advertisement, *TV Guide*, 8–14 Nov. 1980.

60. Ibid., 12–18 Dec. 1981.

61. Barry Monush, ed., *International Television & Video Almanac*, 40th ed. (New York: Quigley, 1995), 697.

62. "Competition," *Video Store Magazine: 1990 Video Store Retailer Survey*, 25.

63. Ibid., 24.

64. From the mid-1980s on, more than half of all video stores were in "small cities" or suburbs, according to one report. This conforms to Wasser's description of the way that video stores spread. Interestingly, however, there appears to have been significant growth of video stores in rural areas during the second half of the 1980s, likely because the stores had already saturated urban areas. "Competition," *Video Store Magazine: 1990 Video Store Retailer Survey*, 25; Wasser, *Veni, Vidi, Video*, 140–41.

65. *Video Store* was founded by Stuart Karl, who soon left the magazine to produce videos, including Jane Fonda's successful workout tape. *Video Store* changed its name to *Home Media Retailing* in 2005, reflecting the increased range of media and media devices used in American homes.

66. Initially, each issue discussed only a few of the possible regions, which included "East," "West," "South," Northwest," "North Central," "Pacific," and "Midwest"; later, this section always covered all regions, labeled simply "Western," Central," and "Eastern." The publication sometimes had a "Canada" section.

67. *Video Store*, Nov. 1981, 36.

68. Ibid., Feb. 1982, 37.

69. Ibid., Apr. 1982, 32.

70. In the mid-1980s, the magazine also began to do several "Storefronts" stories in the "American Marketplace" section, each of which devoted an entire page or more to the business practices of a specific store.

71. Lisa Lilienthal, ed., "Regional Reports," *Video Store*, June 1984, 112.

72. Greenberg talks about the importance of the VSDA show in a larger discussion about the formation of video industry trade groups in the 1980s. Greenberg, *From Betamax to Blockbuster*, 118–22.

73. Adriene D. Corbin, "Regions; St. Louis: Supermarkets and a Changing Economy," *Video Store*, Nov. 1988, 102–6.

74. Ibid., 102.

75. Kevin Brass, "Regions: Frisco Video: Complex Culture," *Video Store*, May 1990, 72.

76. Ibid., 72, 74.

77. Ibid., 74.

78. Ibid.

79. Thomas K. Arnold, "Regions: Atlanta's Ready for Peaches and Cream," *Video Store*, Oct. 1991, 88–89.

80. Stephen Advokat, "Add 'Movie Mad' to Detroit Passions," *Video Store*, Nov. 1990, 66.

81. Ibid.

82. Ibid.

83. Greenberg establishes this as the historical limit of his study. Greenberg, *From Betamax to Blockbuster*, 126–29. Somewhat similarly, Janet Wasko and Frederick Wasser close their discussions of video retail and rental with the rise of Blockbuster. Janet Wasko, *Hollywood in the Information Age: Beyond the Silver Screen* (Austin: University of Texas Press, 1994), 151–55; Wasser, *Veni, Vidi, Video*, 146–49.

84. In *Retail Entertainment*, Martin Pegler provides brief descriptions and copious photographs of "cutting edge" retail spaces of the late 1990s. He emphasizes that retail spaces offering all sorts of goods seek to draw customers by providing an exciting "entertainment" experience. A Blockbuster Video location is among the many stores he documents. Martin M. Pegler, *Retail Entertainment* (New York: Retail Reporting Corp., 1998), 70–73.

85. Anonymous, "Video Rental License Awarded to Bolin," *Houston Chronicle*, 12 Apr. 1986.

86. Ibid.

87. "Inventory," *Video Store Magazine: 1990 Video Store Retailer Survey*, 14.

88. Ibid.

89. Stan Bullard, "Big Video Chains Imperil Little Guys," *Crain's Cleveland Business* 8, no. 45 (9 Nov. 1987): 1; Carol Cling, "Aggressive Bid to Be No. 1 Puts Blockbuster at the Top," *Las Vegas Review-Journal*, 24 Feb. 1991.

90. *2002 Annual Report on the Home Entertainment Industry*, (Video Software Dealers Association, 2002), 20.

91. Ron Castell, quoted in Carol Cling, "Aggressive Bid to Be No. 1 Puts Blockbuster at the Top."

92. Ibid.

93. Lee Teeboom, "Hollywood Invasion," *Orange County Register*, 21 Aug. 1997.

94. Samantha Cook, "Retailer of the Year: Movie Gallery: Finding Fruit through Its Grass Roots," *Video Business*, 18 Dec. 2000.

95. Geoffrey Fattah, "No 'Porn' for Video Stores, Suitor Says," *Deseret News* (Salt Lake City), 27 Jan. 2005.

96. See Jennifer Holt, *Empires of Entertainment* (New Brunswick, NJ: Rutgers University Press, 2011).

97. There remained nearly 25,000 independently owned video stores as of 1999, 49 percent of which were single-store operations. Yet this was 2,000 fewer independents than in 1998, while the corporate chains increased their number by

1,000 stores during the same period. *An Annual Report on the Home Entertainment Industry, 1999* (n.p.: Video Software Dealers Association, 1999), 8.

98. Ibid., 5.

99. Wasko, *Hollywood in the Information Age,* 158.

100. For a discussion of the *Universal v. Sony* case, see Greenberg, *From Betamax to Blockbuster,* 2–3, 35–36, 56–57; Lucas Hilderbrand, *Inherent Vice: Bootleg Histories of Videotape and Copyright* (Durham, NC: Duke University Press, 2009), 16–17, 56, 79, 89, 93–101, 111; Wasser, *Veni, Vidi, Video,* 83–85, 87–89. Much of Lardner's *Fast Forward* is devoted to this case.

101. *An Annual Report on the Home Entertainment Industry, 1999,* 4–5, 9–12.

102. Kevin Brass, "Rental Control; Video Distributor Takes Industry Down Controversial Path," *Los Angeles Times,* 28 Nov. 1997; Anonymous, "Blockbuster Launches Guaranteed Availability of New Releases," *Business Wire,* 27 Apr. 1998; Lorrie Grant, "Rentals Soar as Stores Do Battle; Customers Reap Benefits of Fight for Dominance," *USA Today,* 19 Nov. 1998; Dave McNary, "Erasing Mom and Pop: Independent Video Stores Feeling Squeezed by Big-Chain Rental Barns," *Daily News* (Los Angeles), 28 Mar. 1999.

103. Further, bookstore chains like Barnes & Noble and Borders added elements such as wood fixtures and puffy chairs to the well-lit, well-labeled, sprawling aisles and shelves in order to create a sense of "comfort" and "homeyness." Miller, *Reluctant Capitalists,* 50.

104. "Fiscal 2000 Summary Annual Report," Hastings Entertainment, Amarillo, TX, 2.

105. Ed Christman, "Suncoast Rises to Sell-Thru Challenge," *Billboard* 102, no. 12 (16 May 1990).

106. Ibid.

107. Ibid.

108. Barbara Pokela, "Musicland Hits Different Note with Area's First Sam Goody," *Star Tribune* (Minneapolis, MN), 21 Nov. 1988; Tony Kennedy, "Musicland Plans $60 Million Expansion Program," *Star Tribune* (Minneapolis, MN), 12 May 1993.

109. Associated Press, "Musicland Sees Future of Industry in Superstores," *Orlando Sentinel,* 17 Sept. 1995.

110. Ed Christman, "Retail Track," *Billboard* 119, no. 19 (3 Mar. 2007).

111. Joshua Greenberg has argued that the corporatization of video rental culture entailed a desocialization of the video rental experience, as the corporate stores were owned by people who didn't care about movie culture and were internally organized for economic efficiency at the expense of casual banter between clerk and browser. Greenberg, *From Betamax to Blockbuster,* 127–29.

112. *The Home Video Market: 1997* (n.p.: Video Software Dealers Association, 1997), 3.

113. "Statistics of US Businesses Data: 2001," accessed 12 Nov. 2012, www.census.gov/econ/susb/historical_data.html.

114. *2002 Annual Report on the Home Entertainment Industry,* 22.

115. For a selection of insightful analyses of the ways in which DVD technologies affected movie culture, see James Bennett and Tom Brown, eds., *Film and Television after DVD* (New York: Routledge, 2008).

116. McDonald, *Video and DVD Industries,* 55–57; *The Home Video Market: 1997,* 17.

117. McDonald, *Video and DVD Industries,* 144–52.

118. *An Annual Report on the Home Entertainment Industry, 1999,*10; *2002 Annual Report on the Home Entertainment Industry,* 3.

119. Klinger, *Beyond the Multiplex,* 58–60.

120. McDonald, *Video and DVD Industries,* 59–68.

121. Greenberg, *From Betamax to Blockbuster,* 84–85; Hilderbrand, *Inherent Vice,* 58–59; Wasser, *Veni, Vidi, Video,* 134–135.

122. Hilderbrand, *Inherent Vice,* 59; Wasser, *Veni, Vidi, Video,* 132.

123. Wasser, *Veni, Vidi, Video,* 134–135.

124. Hilderbrand, *Inherent Vice,* 59.

125. *The Home Video Market: 1997,* 3. By 1998, the overall revenue generated by the video market was $8 billion while the sell-through market reached $8.7 billion. *An Annual Report on the Home Entertainment Industry, 1999,* 3, 5.

126. Of this, $7 billion remained in VHS rentals, and the rest was DVD rental revenue. *2002 Annual Report on the Home Entertainment Industry,* 2.

127. Ibid., 13.

128. *The Home Video Market: 1997,* 10–11.

129. Bruce Orwall, "A 'Disposable' Videodisk May Hurt DVD Market," *Wall Street Journal,* 9 Sept. 1997.

130. Marilyn A. Gillen, "Young Format a Hit—Internet Sales, DVD Are Key Topics for Retailers," *Billboard* 110, no. 13 (28 Mar. 1998).

131. *2002 Annual Report on the Home Entertainment Industry,* 20; Robert Scally, "Mass Makes Room for DVD; Format Shows Future Promise," *Discount Store News* 37, no 7 (6 Apr. 1998); Gillen, "Young Format a Hit."

132. Doug Desjardins, "DVD Set to Leapfrog VHS after Hugely Successful Holiday," *Retailing Today* 40, no. 1 (2001): 43–45.

133. David Kirkpatrick, "Shaping Cultural Tastes at Big Retail Chains," *New York Times,* 18 May 2003.

134. *2002 Annual Report on the Home Entertainment Industry,* 20.

135. Ibid., 22.

136. Klinger, *Beyond the Multiplex,* 58–64; McDonald, *Video and DVD Industries,* 68–70.

137. *The Home Video Market: 1997,* 18.

138. Robert Scally, "DVD Rental Key to Broader Market Penetration," *Discount Store News,* 6 Sept. 1999.

139. Laura Hughes, "Blockbuster Aims to Prove DVD Devotion," *Advertising Age,* 27 Nov. 2000.

140. Lorraine Mirabella, "Blockbuster Fast-Forwards Its Inventory; Fewer Tapes Means More Room for DVDs," *The Sun* (Baltimore, MD), 11 Sept. 2001.

141. Jennifer Netherby, "DVD Making Up for Lost Time at Gallery," *Video Business*, 10 Nov. 2003.

142. Jennifer Netherby, "Movie Gallery Puts the Hits Up for Sale," *Video Business*, 12 Aug. 2002; Greg Hernandez, "Blockbuster Making Retail Move Video Renter Eye Sales Market," *Daily News* (Los Angeles), 21 Nov. 2002.

143. "Video Sees 'Monster' 2002 Sales; DVD Boom Sparks Profits," *Daily News*, 9 Jan. 2003.

144. Paul Sweeting, "Hollywood sign: Growth," *Video Business*, 25 Feb. 2002.

145. Paul Sweeting, "Holidays Are Rather Harsh on Hollywood Video," *Video Business*, 2 Feb. 2004.

146. Rong-Gong Lin, "Blockbuster Ends Bid for Rival Firm," *Los Angeles Times*, 26 Mar. 2005.

147. The author found that his ideas had such appeal that he expanded them into a book published later that year; a revised and expanded edition came out in 2008. Chris Anderson, *The Long Tail: Why the Future of Business Is Selling Less of More* (New York: Hyperion, 2006).

148. Thomas Haines, "Amazon Launches CD-Sales Venture—Online Book Retailer Adds Music to Lineup," *Seattle Times*, 11 June 1998; Peter M. Nichols, "Home Video; Amazon Joins the Film Fray," *New York Times*, 20 Nov. 1998.

149. Peter M. Nichols, "Home Video; Amazon Joins the Film Fray"; Peter M. Nichols, "If It's on Video, You Can Find It Someplace in Your Computer," *New York Times*, 7 June 2000.

150. Nichols, "If It's on Video, You Can Find It Someplace in Your Computer."

151. For an analysis of long tail retailers' revenue from "hit" products, see Anita Elberse, "Should You Invest in the Long Tail?" *Harvard Business Review* 86, nos. 7–8 (July–Aug. 2008): 88–96.

152. Anderson, "The Long Tail."

153. "Netflix Annual Report: 2002" (Netflix, Inc., Los Gatos, CA), 2.

154. Martin Peers and Nick Wingfield, "Getting the Video-Store Guy Out of Your Life—Rival Movie Services Target People Who Hate Late Fees; Blockbuster vs. Wal-Mart," *Wall Street Journal*, 24 Oct. 2002.

155. "Netflix Annual Report: 2002"; "Netflix Annual Report: 2005," Netflix, Inc., Los Gatos, CA, 2005; "Q1 2009 Netflix Earnings Conference Call—Final," *Fair Disclosure Wire*, 23 Apr. 2009.

156. Anderson, "The Long Tail."

157. Ibid.

158. "Netflix 2009 Annual Report,"(Netflix, Inc., Los Gatos, CA, 1–2.

159. Anonymous, "Amazon.com Launches Amazon Unbox™, a Digital Video Download Service with DVD-Quality Picture," *Business Wire*, 7 Sept. 2006; May Wong and Jordan Robertson, "Jobs Takes Wraps off Ultrathin Laptop; Apple Launches iTunes Movie Rental Service in U.S.," *Toronto Star*, 16 Jan. 2008; Joseph Palenchar, "iTunes Times Movie Downloads with DVD Sales," *TWICE* 23, no. 11 (19 May 2008): 134.

160. "The Speed of Life: How Consumers Are Changing the Way They Watch, Rent, and Buy Movies," *PricewaterhouseCoopers*, 1 Feb. 2011.

161. Blockbuster tried to compete with Redbox by putting out a huge number of their own DVD vending machines, called Blockbuster Express, starting in 2007. Anonymous, "Blockbuster Tries Out Video Rental Kiosks," *Los Angeles Times*, 22 Nov. 2007. In June 2012, however, these kiosks were purchased by Redbox, which now runs these machines but maintains the Blockbuster Express logo. Kyle Daly, "Redbox Closes Purchase of Blockbuster Express Kiosks," *SNL Kagan Media and Communications Report*, 26 June 2012.

162. "Redbox Fun Facts," Redbox.com, accessed 15 Jan. 2012, www.redbox .com/facts.

163. James Bates, "Wayne's World: Blockbuster's Huizenga Dominates Video Rentals, but Technology Threatens to Erase His Lead," *Los Angeles Times*, 6 June 1993; Eben Shapiro, "Heard on the Street: Chief Redstone Tries to Convince Wall Street There's Life beyond Blockbuster at Viacom," *Wall Street Journal*, 24 Apr. 1997; Eben Shapiro, "The Big Picture: How Viacom's Deal for Blockbuster Chain Went Sour So Fast—Synergies Proved Illusory and Cultures Clashed," *Wall Street Journal*, 21 Feb. 1997; Martin Peers, "Viacom Nears Decision on Divesting Blockbuster; Video-Rental Titan, Beset by Rise of Cheap DVDs, Could Go to Equity Firms," *Wall Street Journal*, 2 Dec. 2003.

CHAPTER 2

1. Guy Debord argued for the need to understand the relation between material spaces, memories, and emotions. He calls such analysis "psychogeography." Guy-Ernst Debord, "Introduction to a Critique of Urban Geography," trans. and ed. Ken Knabb, in *Situationist International Anthology* (New York: Bureau of Public Secrets, 2002), 8–11.

2. Although speaking in general terms, this chapter grounds its description of video stores in field observation conducted from 2008 to 2012. Many of my historical claims are based on interviews with video workers. My analysis also draws on industrial print materials, such as advertisements and employee training manuals, to augment and confirm historical claims.

3. Joshua Greenberg, *From Betamax to Blockbuster: Video Stores and the Invention of Movies on Video* (Cambridge, MA: MIT Press, 2008).

4. Some of these differences derive from the political economy of each stratum of stores. In this respect, video distribution is a vital consideration. As the corporate chains dealt primarily with large, corporate distributors, they took their cues from the divisions indicated in the catalogs provided by the distributors. Alternatively, independent stores relied on a wider variety of distributors, some of which—most notably Facets—classified their movies in many discrete categories. Chapter 5 explores home video distributors in detail.

5. Greenberg, *From Betamax to Blockbuster*, 64–72.

6. Kelly Lane, "Blockbuster Plans a Move into Japan," *Sun Sentinel*, 5 Oct. 1990.

7. I have confirmed the lack of distinction among corporate stores by surveying real estate property listings that feature the structures that once housed Blockbuster and Hollywood Video stores. These listings demonstrate that corporate video stores had a large amount of square footage, which may make it difficult to entice future tenants to rent the space. Otherwise, these listings show that corporate stores occupied nondescript buildings that could accommodate many types of business.

8. That is, "you have to experience it in order to know what it is," and hence to be able to evaluate it. Carl Shapiro and Hal Varian, *Information Rules: A Strategic Guide to the Network Economy* (Boston: Harvard Business School Press, 1999), 22.

9. This issue of store design, layout, and display has an incredibly long history, one that is concomitant with modernity itself. A 1924 report by the U.S. Department of Commerce, for instance, discusses the issue of retail store design in some detail. In addition to emphasizing the need for "attractiveness" inside and outside the store, the report makes recommendations about how to organize a store internally in order to increase sales while lowering operating costs; generally this means facilitating a flow of people toward underselling and/or high-priced items. United States Department of Commerce, "Supplement to Commerce Reports: Retail Store Planning," *Trade Information Bulletin*, no. 291 (Nov. 1924). In his book about store design and layout, published in England in 1939, A. Edward Hammond emphasizes that, due to changed and increasingly competitive economic conditions, shop design needs to be increasingly aimed at display, mobility, and flexibility. Shops, in his recommendation, need to facilitate customers' unimpeded inspection and evaluation of commodities firsthand so as to facilitate impulse purchases as well as to efface class differences within the store itself. (In the past, upper-class shoppers were attended to personally). A. Edward Hammond, *Store Interior Planning and Display* (London: Blandford Press, 1939), 17–27. David Mun confirms this historical change, writing in 1981 that "personal service has given way to self service or assisted service; display techniques have developed for mass display with customer inspection and self selection." David Mun, *Shops: A Manual of Planning and Design* (London: Architectural Press, 1981), 1. Writing about department store design, Lawrence Israel asserts that in the 1980s "merchandising moved from mass presentation to preselected, coordinated themes and expressions of lifestyles." Lawrence Isael, *Store Planning/Design: History, Theory, Process* (New York: John Wiley & Sons, 1994), 52.

10. In his book about retail space, intended to help prospective retail planners and entrepreneurs, William R. Green writes, "Because the retail business is constantly changing, flexibility of design is very important. Styles and product lines go in and out of fashion in rapid-fire sequence. . . . Total flexibility may not be necessary or desirable in every store, but should be considered." William R. Green, *The Retail Store: Design and Construction* (New York: Van Nostrand Reinhold, 1986), 32.

11. *Video Store* (Jan. 1987): 98.

12. The producers and distributors of the videos provided the "cover art," which aimed to advertise the movie. At this point there are a number of websites that curate the "best" cover art of video genres. See Fred Adelman, "Critical Condition: Obscure & Bizarre Films on Video & DVD," accessed 11 July 2010, www.critcononline.com,

13. Although there may have been no direct relationship between bookstores' organization and that of video stores, the transformation in book retail is an important precursor to the way in which video stores are arranged. As Janice Radway notes, chains such as B Dalton helped reconfigure the sale of cultural goods. They divided books into semirationalized categories and, more important, made the experience of shopping less elitist, more akin to being at the supermarket. Janice Radway, *Reading the Romance: Women, Patriarchy, and Popular Literature* (Chapel Hill: University of North Carolina Press, 1991), 37–38.

14. Greenberg, *From Betamax to Blockbuster*, 86–87.

15. Roger Beebe engages in a somewhat similar analysis of video store arrangement in "Pedagogical Spaces, or, What We've Lost in the Post-Video-Store Era," *Media Fields Journal: Critical Explorations in Media and Space* no. 1 (2010), accessed 3 May 2012, www.mediafieldsjournal.org/pedagogical-spaces.

16. For a fascinating discussion of the logic of "the collection," see Susan Stewart, *On Longing: Narratives of the Miniature, the Gigantic, the Souvenir, the Collection* (Durham, NC: Duke University Press, 1993), 151–54. Stewart makes two assertions that resonate with the logic of the video rental store. She writes, "The collection replaces history with *classification*, with order beyond the realm of temporality," and that the collection makes "temporality a spatial and material phenomenon" (151, 153; original emphasis).

17. I am not suggesting that the arrangement of videos on the shelves presents a clear and rigid ideological position. Instead, the arrangement of videos and the forms of categorizing movies suggest "lay theories" about the artistic and social value of movies. As described by Adrian Furnham, "lay theories" are the commonsense, everyday explanations that people use to describe human behavior. Although they often overlap with scientific and other, more rigorously generated theories, they differ from them to the extent that they are implicit, flexible, often inconsistent, and, more often than not, used to explain discrete phenomena and not able to be generalized. Adrian Furnham, *Lay Theories: Everyday Understandings of Problems in the Social Sciences* (Oxford: Pergamon, 1988), 3, 6–7.

18. In making this proposal, I follow Pierre Bourdieu, who has asserted that one can classify a social group by the manner in which they classify cultural objects. Pierre Bourdieu, *Distinction: A Social Critique of the Judgment of Taste*, translated by Richard Nice (Cambridge, MA: Harvard University Press, 1984), 6, 466–79. Bourdieu was particularly deft in pointing out how cultural taste and education intersected with social status and power. He was sensitive to the ways in which groups of divergent backgrounds and means related to cultural commodities and experiences. Bourdieu asserts that the researcher must try to understand his or her object of analysis according to the principles in

which this object understands itself. Thus the researcher ought not to classify social phenomena or a group strictly according to the categories they inherit from academic training but rather according to the principles of division generated within the social sphere ("habitus") itself. This is elliptical, of course, because the researcher approaches this social realm *within* a social realm that also obeys certain regular patterns of understanding, behavior, and categorization. Bourdieu, *Distinction*, 482–84.

19. The prevalence and proportion of each type of store have changed considerably during the life span of the video rental business. Nevertheless, I find it more important here to emphasize the different types of stores than their historical modulations, as each kind has taken a different approach to movie classification. Similarly, this classification of stores neglects those that have served immigrant and non-English-speaking populations in the United States. Within the industry itself, stores are typically classified by their form of ownership: corporate, independently owned, and small chains. Market research reports published by IBISWorld Inc., for instance, differentiate between "chain" or "franchise" operations and "independent" stores; they also discuss "Major Companies" as a distinct stratum of chains. Casey Thormahlen, "IBISWorld Industry Report 53223: DVD, Game & Video Rental in the US" (IBISWorld Inc., Oct. 2010).

20. This was particularly true at Blockbuster Video after the chain reached "revenue sharing" agreements with the Hollywood studios in the 1990s, as well as at independently owned stores that used the revenue sharing distribution system provided by the Rentrak company. I discuss Rentrak in detail in chapter 5.

21. Max Horkheimer and Theodor Adorno, *Dialectic of Enlightenment*, translated by John Cumming (New York: Continuum, 2002), 134.

22. The standardization of this classificatory scheme is confirmed by a 2003 Hollywood Video employee training manual. It lists twenty-six different categories that can be found in "older stores," the most particular of which include "Academy Awards," "Cult Classics," and "Instructional." It states that there are only eleven categories in "newer stores," which are all broad-based genres, including a "Special Interest" section with eight subdivisions. It states that the "New Releases" area is the most important due to the revenue that it generates. The manual lists no "Directors" category. *Store Training Manual for Guest Service Representatives* (n.p.: Hollywood Entertainment Corporation, 2003), 41–44.

23. Jeffrey Sconce, "'Trashing' the Academy: Taste, Excess, and an Emerging Politics of Cinematic Style," *Screen* 36, no. 4 (Winter 1995): 372.

24. "Percentage of Stores Carrying Adult/X-Rated Films," *Video Store Magazine: 1990 Video Store Retailer Survey* (1990), 16.

25. Joshua Greenberg has discussed how, historically, Back Rooms have been located as far from the general floor space of the video store as possible, and especially far from the "Kids" section. Greenberg, *From Betamax to Blockbuster*, 95.

26. For an analysis of the organization of "the Back Room" and its situation vis-à-vis the rest of the video store, see J. Steven Witkowski, "Mapping Hardcore

Space," *Media Fields Journal: Critical Explorations in Media and Space,* no. 1 (2010), accessed 3 May 2012, /www.mediafieldsjournal.org/mapping-hardcore-space.

27. Frederick Wasser, *Veni, Vidi, Video: The Hollywood Empire and the VCR* (Austin: University of Texas Press, 2001), 147.

28. "Genre Contribution to Rental Revenue," *Video Store Magazine: 1990 Video Store Retailer Survey,* 19; "Genre Composition of Total Inventory," *Video Store Magazine: 1990 Video Store Retailer Survey,* 18.

29. Barbara Bry, "Studios Spark Shakeup in TV Cassette Rentals," *Los Angeles Times,* 26 Jan. 1982; Nick Ravo, "A Fact of Life: Sex-Video Rentals," *New York Times,* 16 May 1990.

30. Examples of this type are Le Video in San Francisco, Movie Madness in Portland, and Odd Obsession in Chicago. Reel Video in Berkeley was a rare exception to the independent model, as it was owned by the Hollywood Video chain from around 2000 to 2009, when it closed.

31. Examples of the cult store are Mondo Video A-Go-Go in Los Angeles and Wavy Brain in Albuquerque. Both stores are now closed. Alphaville Video was a video art house in Albuquerque; it is also now closed. Scarecrow Video in Seattle is an example of the alternative store. For a thorough examination of art house theaters in the United States, see Barbara Wilinsky, *Sure Seaters: The Emergence of Art House Cinema* (Minneapolis: University of Minnesota Press, 2001).

32. Sconce, "'Trashing' the Academy," 372.

33. Pierre Bourdieu uses the phrase "cultural capital" to signify "accumulated labor" in the cultural realm. Pierre Bourdieu, "The Forms of Capital," in *Handbook of Theory and Research for the Sociology of Education,* edited by John G. Richardson (New York: Greenwood Press, 1986), 241–44. However, as Jon Beasley-Murray has shown, Bourdieu's use of the term *capital* more accurately coincides with Karl Marx's terms *value* and/or *wealth,* as for Marx "capital" specifically designates the process whereby surplus value is extracted from alienated labor. Jon Beasley-Murray, "Value and Capital in Bourdieu and Marx," in *Pierre Bourdieu: Fieldwork in Culture,* edited by Nicholas Brown and Imre Szeman (Lanham, MD: Rowman and Littlefield, 2000), 100–101. Hence, I consciously use the phrase "cultural capital" to signify cultural wealth or value in the manner popularized by Bourdieu.

34. This practice evokes David Andrews's call for an analogous approach to "art cinema," where the "art" of a cinema, no matter what its cultural echelon, is determined in relation to the standard examples of the given genre. David Andrews, "Toward an Inclusive, Exclusive Approach to Art Cinema," in *Global Art Cinema: New Theories and Histories,* edited by Rosalind Galt and Karl Schoonover (New York: Oxford University Press, 2010), 64, 71–73.

35. Andrew Sarris, "Notes on the Auteur Theory in 1962," in *Film Theory and Criticism: Introductory Readings,* edited by Gerald Mast and Marshall Cohen (New York: Oxford University Press, 1974), 500–516. This practice accords with Sconce's observation that paracinema enthusiasts generally adhere

to principles of evaluation similar to those of taste makers in more rarefied cultural arenas. Sconce, "'Trashing' the Academy," 381.

36. Charles Tashiro, "The Contradictions of Video Collecting," *Film Quarterly* 50, no. 2 (Winter 1996–97): 13.

37. Michel de Certeau, *The Practice of Everyday Life,* translated by Steven Rendall (Berkeley: University of California Press, 1984), 100.

38. Bourdieu, *Distinction,* 477.

39. Ibid., 1–2.

40. Although this document is designed for workers at a corporate store and thus is intended to rationalize a labor force in different stores in diverse locations, many of the tasks it describes are common to most video workers due to the common features and needs of most video stores.

41. *Store Training Manual for Guest Service Representatives,* 58.

42. Ibid., 20.

43. Ibid., 25.

44. One section of the application quiz is "fill in the blank" for film titles, including "_____ by Law," "Farewell My _____," and "The Cook, _____, _____, _____," among others. Another section asks the applicant to name a single film by specific directors ("Orson Welles," "Hayao Miyazaki"), actresses ("Katherine Hepburn," "Tilda Swinton"), and actors ("Gregory Peck," "Chiwetel Ejiofor"). In addition, the quiz contains questions that solicit an indication of taste: "What is your favorite film?" "What was the last film you saw in a theater?" "What was the last film you saw on video?" Finally, some questions integrate evaluations of taste with information that might have some practical value in the store, for example, "Name at least 2 documentaries you have seen" and "Name a silent film."

45. One section asks the clerk to watch a few movies and assess what kinds of people might like it. The quiz also asks the clerk to name one movie in each of the store's sections. In these passages, the manual indicates how the clerk's movie knowledge is, at a minimum, tied to the layout of the store and geared to aligning individual movies with the diverse needs and tastes of a renting public. In terms of film history, the quiz asks, "What are the names of the actors in *Sleepless in Seattle* [1993]?" and "Name as many Kevin Bacon films as you can." Beyond that, the clerk is told that "the best way to increase product knowledge is to watch the movies," suggesting that film knowledge is not a prerequisite for attaining the clerk position.

46. Greenberg has asserted a similar point in *From Betamax to Blockbuster,* 104–6.

47. *Store Training Manual for Guest Service Representatives,* 26.

48. Ibid., 26.

49. Matthew Pustz describes somewhat similar interactions in comic book shops, although these sites are vexed by different cultural politics. As described by Pustz, comic shops have more of a "club house" atmosphere than most video stores I have seen and are much more prone to creating an atmosphere where women feel unwelcome. The issue of cultural elitism and snobbery does occur

occasionally in some boutique rental stores, but it is generally not linked to overt sexism. Matthew Pustz, *Comic Book Culture: Fanboys and True Believers* (Jackson: University Press of Mississippi, 1999), 3–9, 23.

50. "Stores Computerized and Intending to Computerize," *Video Store Magazine: 1990 Video Store Retailer Survey*, 12.

51. "VS Spreadsheet," *Video Store*, Feb. 1987, 198.

52. *Store Training Manual for Guest Service Representatives*, 54.

53. Greenberg, *From Betamax to Blockbuster*, 86.

54. Martha Groves, "Wherehouse Moves to Halt Thefts," *New York Times*, 15 Oct. 1985; Mike Duff, "Supermarkets Turn to Electronic Security," *Supermarket Business* 43, no. 11 (Nov. 1988): 53; John Hughes, "Attention Shoppers: Big Brother Is Watching Retailers, Fed Up with the 20 Million Americans Who Want Something for Nothing, Are Fine-tuning Technology to Steal a March on Shoppers," *Sun Sentinel* (Ft. Lauderdale), 7 Feb. 1990. In fact, the invention and implementation of these devices is largely synchronous with the development and growth of the video rental industry. Originally invented in the 1960s, "electronic article surveillance" technologies involved large, clunky tags until the late 1970s. By the early 1980s, however, the tags were much smaller, allowing video store operators to install them in video boxes. Raymond A. Joseph, "Shoplifting Becomes a Growth Business—For Device Makers," *Wall Street Journal*, 21 Apr. 1981; Andrew Pollack, "Technology: A New Assault on Shoplifters," *New York Times*, 28 Jan. 1982.

55. *Store Training Manual for Guest Service Representatives*, 29–30.

56. Ibid., 29, 31.

57. Notably, the Video Privacy Protection Act was passed into law in 1988. It mandates that video stores cannot release the rental histories of specific browsers. In this way, the rental choices recorded on these POS terminals have become a secret archive of the American geography of movie taste.

58. *Store Training Manual for Guest Service Representatives*, 57. Clerks are also told not to keep too much cash in the drawer at a single time, presumably for security reasons.

59. Ibid., 23–24, 34–35.

CHAPTER 3

1. Lucas Hilderbrand provides a fantastic portrait of Eddie Brandt's, which includes an interview he conducted with one of the owners, Claire Brandt. Lucas Hilderbrand, "Eddie Brandt's Saturday Matinee: An Accidental Institution," *Spectator: University of Southern California Journal of Film and Television Criticism* 27, no. 1 (Spring 2007): 42–47.

2. Andrew Testerman, "Local Gaming Store Specializes in Classic Games, Obscure Products," *Bozeman Daily Chronicle*, 16 Mar. 2012, accessed 3 June 2012, www.bozemandailychronicle.com/go/games/article_9b3bc528–6edf-11e1-b348–0019bb2963f4.html; Sean L. Maloney, "Well, This Just Sucks Dept.:

Video Culture to Close in Murfreesboro Aug. 14," *Nashville Scene,* 29 July 2012, accessed 20 Nov. 2012, www.nashvillescene.com/pitw/archives/2011/07/29 /well-this-just-sucks-dept-video-culture-to-close-in-murfreesboro-aug-14.

3. Curtin defines *media capital* as a process that combines economic, social, and cultural factors: "media capital operates according to (1) a logic of accumulation, (2) trajectories of creative migration, and (3) forces of sociocultural variation." Michael Curtin, *Playing to the World's Biggest Audience: The Globalization of Chinese Film and TV* (Berkeley: University of California Press, 2007), 10. Although these qualities also inform my understanding of "video capital," Curtin's later description of media capital as location *and* process is more suitable to my purposes in this chapter.

4. Michael Curtin, "Media Capitals: Cultural Geographies of Global TV," in *Television after TV: Essays on a Medium in Transition,* edited by Lynn Spigel and Jan Olsson (Durham, NC: Duke University Press, 2004), 274.

5. Curtin is careful to note that the specificity of such places is defined by complexity rather than homogeneity, stating that media capitals are "bound up in a web of relations that exist at the local, regional, and global levels" and that they are "positioned at the intersection of economic, social, and cultural flows." Curtin, "Media Capitals," 272–73.

6. Pierre Bourdieu, "The Forms of Capital," in *Handbook of Theory and Research for the Sociology of Education,* edited by John G. Richardson (New York: Greenwood Press, 1986), 241–48.

7. Sarah Thornton, *Club Cultures: Music, Media, and Subcultural Capital* (Hanover, NH: Wesleyan University Press, 1996), 10–14.

8. Ibid., 12–13.

9. This is analogous to the relation between a media capital and the audiences for the media produced there. As Curtin says, "The past history of media capitals most crucially hinges on their ability to register and articulate the social experiences of their audiences." Curtin, "Media Capitals," 273.

10. This zigzag formation was turned into linear aisles in late 2012.

11. Times Staff, "Video Tour—Some Favorite Places to Find That Fine Foreign Film or That Obscure Documentary," *Seattle Times,* 29 Dec. 1990.

12. Paul Andrews, "Scarecrow Protects Territory from Video Store Giants— Class, Unusual Movies Lure Customers," *Seattle Times,* 1 Dec. 1993.

13. Mary Farley, "Landmark Locations in Their Communities," *Video Business* 18, no. 39 (1999): 21.

14. Matthew Craft, "George Latsios: 1958–2003; Scarecrow Video Founder Did 'Whatever He Felt,'" *Seattle Post-Intelligencer,* 13 Mar. 2003.

15. Mark Rahner, "Scarecrow Expands Reach into Cult-Film Niche," *Seattle Times,* 7 Nov. 2004.

16. Andrews, "Scarecrow Protects Territory from Video Store Giants— Class, Unusual Movies Lure Customers."

17. Joe Heim, "Love and Loss at Scarecrow Video—Bankrupt Founders' Passion Is Film, Not Finances," *Seattle Times,* 21 Nov. 1997; Andy Spletzer, "Goodbye, My Friend: The Dream of George Latsios Lives On," *Stranger*

(Seattle), 19 Mar. 2003; Andrews, "Scarecrow Protects Territory from Video Store Giants—Class, Unusual Movies Lure Customers."

18. Rahner, "Scarecrow Expands Reach into Cult-Film Niche."

19. Andrews, "Scarecrow Protects Territory from Video Store Giants—Class, Unusual Movies Lure Customers."

20. Ian Ith, "George Latsios, Who Started Revered Video Business, Dies at 44," *Seattle Times*, 8 Mar. 2003; Craft, "George Latsios: 1958–2003; Scarecrow Video Founder Did 'Whatever He Felt.'"

21. Heim, "Love and Loss at Scarecrow Video—Bankrupt Founders' Passion Is Film, Not Finances."

22. Ith, "George Latsios, Who Started Revered Video Business, Dies at 44;" Craft, "George Latsios: 1958–2003; Scarecrow Video Founder Did 'Whatever He Felt'"; Spletzer, "Goodbye, My Friend: The Dream of George Latsios Lives On"; "About Us," Scarecrow.com, accessed 9 Nov. 2011, www.scarecrow.com/8/aboutus.html.

23. Ith, "George Latsios, Who Started Revered Video Business, Dies at 44;" Craft, "George Latsios: 1958–2003; Scarecrow Video Founder Did 'Whatever He Felt'"; Heim, "Love and Loss at Scarecrow Video—Bankrupt Founders' Passion Is Film, Not Finances."

24. Craft, "George Latsios: 1958–2003; Scarecrow Video Founder Did 'Whatever He Felt'"; Heim, "Love and Loss at Scarecrow Video—Bankrupt Founders' Passion Is Film, Not Finances."

25. Heim, "Love and Loss at Scarecrow Video—Bankrupt Founders' Passion Is Film, Not Finances."

26. Joshua Greenberg, *From Betamax to Blockbuster: Video Stores and the Invention of Movies on Video* (Cambridge, MA: MIT Press, 2008), 65–66, 72–77; James Lardner, *Fast Forward: Hollywood, the Japanese, and the Onslaught of the VCR* (New York: W.W. Norton, 1987), 176–86; Frederick Wasser, *Veni, Vidi, Video: The Hollywood Empire and the VCR* (Austin: University of Texas Press, 2001), 98–103.

27. Heim, "Love and Loss at Scarecrow Video—Bankrupt Founders' Passion Is Film, not Finances."

28. Craft, "George Latsios: 1958–2003; Scarecrow Video Founder Did 'Whatever He Felt.'"

29. "Scarecrow Unleashes Cult Videos," *Washington Times*, 7 Sept. 1995; Heim, "Love and Loss at Scarecrow Video—Bankrupt Founders' Passion Is Film, not Finances."

30. John Hartl, "Screenings of Rare Older Films on Tap," *Seattle Times*, 28 Mar. 1997.

31. Although the store generated more than $1 million in revenue during this period, Latsios did not pay his taxes and other debts. Craft, "George Latsios: 1958–2003; Scarecrow Video Founder Did 'Whatever He Felt.'" One source reported that the tax bill had reached $140,000 and that the store's total debt at the time was $240,000. Heim, "Love and Loss at Scarecrow Video—Bankrupt Founders' Passion Is Film, Not Finances."

32. Quoted in Heim, "Love and Loss at Scarecrow Video—Bankrupt Founders' Passion Is Film, not Finances." Because the store was not an incorporated business, George and Rebecca were personally liable for this debt. Ibid.

33. Ibid.

34. Ibid.; Spletzer, "Goodbye, My Friend: The Dream of George Latsios Lives On." For example, according to Spletzer, he planned and hosted an animated films festival, which lost a significant amount of money, and this alienated a number of workers at the store when they realized that Latsios's actions jeopardized their livelihoods.

35. Heim, "Love and Loss at Scarecrow Video—Bankrupt Founders' Passion Is Film, Not Finances." In 1997, it appeared as though another local entrepreneur, Lyle Holmes, would buy the store. Holmes's family ran a company called Directors Ltd., which operated two other video stores in the area. Ibid; Joe Heim, "Judge Won't Block Sale of Scarecrow Video," *Seattle Times*, 28 Mar. 1998. Holmes indicated that he would make significant changes to Scarecrow's operations, stating that he planned to sell any videos that didn't rent well, buy fewer obscure titles in general, and eliminate the theater on the second floor. Heim, "Love and Loss at Scarecrow Video—Bankrupt Founders' Passion Is Film, not Finances." The sale to Holmes fell through when it came to light that he had been convicted of and had served jail time for defrauding the U.S. Department of Housing and Urban Development for around $1 million. Because a stipulation of Holmes's parole was that he could not be self-employed, the sale of Scarecrow began to look shaky. George and Rebecca began to look for new buyers even as a judge ruled that the sale to Holmes could proceed. Heim, "Judge Won't Block Sale of Scarecrow Video." Holmes never followed through with the purchase of the store, likely due to his legal problems and the bad publicity generated by the situation. Roger Downey, "Breaking the Code at the *Times*," *Seattle Weekly*, 22 Apr. 1998. Because the deal with Holmes fell through, the store remained with George and Rebecca, who were able to oversee its purchase by people who shared their vision for video store culture.

36. Craft, "George Latsios: 1958–2003; Scarecrow Video Founder Did 'Whatever He Felt'"; Marshall Wells, "Movie Buffs Buy Scarecrow Video—Microsoft Duo Rescues Popular U District Store," *Seattle Times*, 17 Feb. 1999; Roger Downey, "Scarecrow Video Sold to Microsoftie Film Fans," *Seattle Weekly*, 10 Feb. 1999. According to the latter article, in addition to paying for the store, the new owners paid the store's numerous creditors.

37. Wells, "Movie Buffs Buy Scarecrow Video—Microsoft Duo Rescues Popular U District Store."

38. Craft, "George Latsios: 1958–2003; Scarecrow Video Founder Did 'Whatever He Felt.'"

39. Spletzer, "Goodbye, My Friend: The Dream of George Latsios Lives On."

40. This figure for the turnover was given by a manager at Scarecrow in a personal interview on 6 Mar. 2012.

41. A large amount of Scarecrow's inventory came from buying videos from stores in western Washington that went out of business during the late

1990s and early 2000s. Often, the owners of these stores would call Scarecrow's workers and allow them to inspect their collection before the general public.

42. Hartl, "Screenings of Rare Older Films on Tap."

43. Eric Fredericksen, "Deal's Off," *Stranger* (Seattle), Apr. 1999, 1–7.

44. Ibid.

45. Ibid.

46. Ibid.

47. In 1999, Cinema Seattle brokered a deal with Blockbuster Video that would make Blockbuster the exclusive video store sponsor of the SIFF in exchange for a donation of $50,000, a much larger amount than the $1,000 Scarecrow had previously donated. Blockbuster expected such exclusivity based on the track record of its previous partnerships with the Austin, Fort Lauderdale, and Sundance festivals. Scarecrow was not the only video store threatened with being denied festival partnership, and a handful of other independent stores in the area also expressed their displeasure with the situation. The workers at Scarecrow were characterized as being "bewildered, hurt, and mad as hell." Another video store, Island Video, organized a picket line at the opening night. However, due to public pressure and careful negotiations, Blockbuster consented to allow Scarecrow to continue its sponsorship of the festival, with the justification that it had sponsored the festival previously. However, the other independent stores in the area remained excluded, causing a deep rift between them and Scarecrow. Although these other stores had bought advertisements in the festival program in the past, and thus were allowed to continue to do so, they were not allowed to sponsor the festival or specific screenings. This situation prompted some of the owners of the other independent stores to publicly denigrate Blockbuster, SIFF, and Scarecrow in very harsh terms. Fredericksen, "Deal's Off"; Roger Downey, "Seattle Blockbuster International Film Festival?," *Seattle Weekly*, 24 Mar. 1999; Eric Sciglioano, "Blockbusted," *Seattle Weekly*, 2 June 1999; Eric Fredericksen, "Happy Ending?," *Stranger* (Seattle), 8–14 Apr. 1999.

48. Spletzer, "Goodbye, My Friend: The Dream of George Latsios Lives On."

49. U.S. Census Bureau, "2006–2010 American Community Survey," accessed 16 Mar. 2012, http://factfinder2.census.gov/faces/tableservices/jsf /pages/productview.xhtml?pid = ACS_10_5YR_DP02.

50. Wells, "Movie Buffs Buy Scarecrow Video—Microsoft Duo Rescues Popular U District Store."

51. Rebecca (Latsios) Soriano, "Scarecrow Video: A History of Sorts; Part One," in *The Scarecrow Video Movie Guide* (Seattle: Sasquatch Books, 2004), xi–xii.

52. Edward Soja, *Postmodern Geographies: The Reassertion of Space in Critical Social Theory* (London: Verso, 1989). Although not part of her initial study of the type, Los Angeles aligns with much of what Saskia Sassen observes among "global cities" in the era of transnational capitalism. Saskia Sassen, *The Global City: New York, London, and Tokyo*, 2nd ed. (Princeton: Princeton University Press, 2001). Sassen defines global cities as concentrated command

points in the world economy, key locations for financial and service industries, sites of production and innovation in finance and service industries, and key markets for these innovations. Sassen, *The Global City*, 3–4. She also details how they are key sites for the production of specialized services needed by "complex organizations for running a spatially dispersed network of factories, offices, and service outlets" (5). Finally, such cities demonstrate a bifurcation between low-wage and extreme high-wage labor as well as a decline in the manufacturing sector (9).

53. As Toby Miller has indicated, although Hollywood may be global, Los Angeles remains central to the management of the "new international division of cultural labor." Toby Miller et. al., *Global Hollywood* (London: British Film Institute, 2001), 4, 18, 46. Susan Christopherson similarly writes, "'the suits' (entertainment industry bankers and lawyers as well as the conglomerate headquarters) still rule [Hollywood], and they are located in Los Angeles. Thus, pre-production and post-production remain in the L.A. orbit." Susan Christopherson, "Divide and Conquer: Regional Competition in a Concentrated Media Industry," in *Contracting Out Hollywood: Runaway Productions and Foreign Location Shooting*, edited by Greg Elmer and Mike Gasher (Lanham, MD: Rowman and Littlefield, 2005), 34.

54. Allen J. Scott, *On Hollywood: The Place, the Industry* (Princeton: Princeton University Press, 2005), 122–23.

55. Ibid., 1–10.

56. Greenberg, *From Betamax to Blockbuster*, 65–66; Lardner, *Fast Forward*, 176–77; Wasser, *Veni, Vidi, Video*, 98.

57. Terry Atkinson, "Big Stores Best Bet for Hard-to-Find Tapes," *Los Angeles Times*, 3 Jan. 1986.

58. Hilderbrand, "Eddie Brandt's Saturday Matinee: An Accidental Institution; An Interview with Claire Brandt," 42–77.

59. R.J. Johnson and Ginger Myers, "Collector's Mementos of Silver Screen Turn to Gold," *Los Angeles Times*, 8 May 1986.

60. Ibid.

61. Ibid.

62. David Wharton, "Vintage Videos Gem of a Store in N. Hollywood Rents Anything from 'Twilight Zone' Shows to USFL Clips," *Los Angeles Times*, 6 Dec. 1991.

63. Ibid.

64. Bob Strauss, "North Hollywood's Saturday Matinee Video Rental Store Still Going Strong," *Los Angeles Daily News*, 2 Sept. 2009, accessed 20 Nov. 2012, www.dailynews.com/news/ci_13254853.

65. Fred Rubin, "Film Buffs Can Get Their Fill at Eddie's," *Los Angeles Times*, 7 Feb. 2002; Strauss, "North Hollywood's Saturday Matinee Video Rental Store Still Going Strong."

66. Rubin, "Film Buffs Can Get Their Fill at Eddie's."

67. Laura Randall, "Which Film Remake Is Next? Eddie Brandt Knows," *Christian Science Monitor*, 12 Dec. 2003; Rubin, "Film Buffs Can Get Their Fill at Eddie's."

68. Jon Matsumoto, "To Find the Impossible Find," *Los Angeles Times,* 28 Apr. 1996.

69. Valerie J Nelson, "Eddie Brandt Dies at 90; Hollywood's Go-To Guy for Film History, Memorabilia," *Los Angeles Times,* 10 Mar. 2011.

70. Wharton, "Vintage Videos Gem of a Store in N. Hollywood Rents Anything from 'Twilight Zone' Shows to USFL Clips"; Randall, "Which Film Remake Is Next? Eddie Brandt Knows."

71. Wharton, "Vintage Videos Gem of a Store in N. Hollywood Rents Anything from 'Twilight Zone' Shows to USFL Clips"; Rubin, "Film Buffs Can Get Their Fill at Eddie's."

72. Randall, "Which Film Remake Is Next? Eddie Brandt Knows."

73. "Going to Video Extremes in Cinephile's Oasis: 'We Have One Copy of "Rambo: First Blood Part II," and I'm Surprised We Have That Many,'" *Los Angeles Times,* 7 Aug. 1988.

74. Kevin Allman, "A Gourmet Guide to Video Stores," *Los Angeles Times,* 19 Apr. 1987; Atkinson, "Big Stores Best Bet for Hard-to-Find Tapes"; "Going to Video Extremes in Cinephile's Oasis."

75. Eileen Fitzpatrick, "Only in L.A.," *Billboard* 108, no. 28 (13 July 1996): 60.

76. Donald Liebson, "Companies Testing the DVD Waters," *Los Angeles Times,* 5 May 1997.

77. David James, *The Most Typical Avant-Garde: History and Geography of Minor Cinemas in Los Angeles* (Berkeley: University of California Press, 2005), 3–4, 14–18.

78. Brenda Rees, "The Best Video Store Category," *Los Angeles Times,* 9 Mar. 2000.

79. "Going to Video Extremes in Cinephile's Oasis."

80. Advertisement, *Los Angeles Times,* 20 Mar. 1986, K7.

81. Ibid., 24 Sept. 1986, J4.

82. Hank Rosenfeld, "Fixations; McLuhan's Minion; One Man's Quest to Raise a Junked Toy to the Level of Art," *Los Angeles Times,* 18 Feb. 2001; Lynn Smith, "Coming to You in Glorious Pixelvision," *Los Angeles Times,* 9 Nov. 2002.

83. Ed Hulse, "A Little Push Sets Indie Titles into Action," *Video Business* 25, no. 5 (2005); Nicole Laporte, "The Video Store, Reinvented by Necessity," *New York Times,* 31 July 2011; Fitzpatrick, "Only in L.A.," 60.

84. Matsumoto, "To Find the Impossible Find."

85. Adam Bergman, "The Alternatives," *Los Angeles Times,* 15 Oct. 2003; David Cotner, "Watching the Apocalypse," *LA Weekly,* 4 Oct. 2007.

86. Hadrian Belove commented on the split personality of the store: "One is the classy side [and] . . . then there's the B-loving, drive-in, European exploitation side—the dark wing." Bergman, "The Alternatives"; Cotner, "Watching the Apocalypse."

87. David Cohen, "Stores Adding Foreign Flavor with Import DVDs," *Video Business* 23, no. 38 (2003): 8.

88. Bergman, "The Alternatives"; Cohen, "Stores Adding Foreign Flavor with Import DVDs," 8.

89. Cohen, "Stores Adding Foreign Flavor with Import DVDs," 8.

90. Jesse Walker, "Copy Catfight," *Reason*, Mar. 2000.

91. Cotner, "Watching the Apocalypse."

92. For a number of interesting discussions of Alan Smithee, see Jeremy Braddock and Stephen Hock, eds., *Directed by Alan Smithee* (Minneapolis: University of Minnesota Press, 2001).

93. In some cases, these sections have been devised after the owners and clerks debate the merits of a filmmaker, genre, or period; in other cases, these sections come about as a way to generate rentals. Often a section is created because a Cinefile worker is a fan of certain material or because a clerk observes an odd connection between movies or even between the video boxes.

94. In one instance, Cinefile's owners and managers made an overt political statement by offering free rentals of the film *Fahrenheit 9/11* (2004) during the week preceding the 2004 presidential election, following a public plea to do so from director Michael Moore. A manager at the store stated at the time, "We agreed to do it because we want Bush out of office." Robert Silvey, quoted in Cynthia Hubert, "Heat Rises in 'Fahrenheit'-'Celsius' Battle," *Sacramento Bee*, 21 Oct. 2004.

95. Cinefile inspired and was featured in the independently produced and distributed film *Good Dick* (2008). Writer-director Marianna Polka states that she conceived of the film while browsing Cinefile's aisles and overhearing the banter among the store's clerks and customers. After premiering at the Sundance Film Festival, the film was exhibited at the NuArt in 2008. Mark Olsen, "To the Store for Film Idea," *Los Angeles Times*, 15 Oct. 2008.

96. Rees, "The Best Video Store Category."

97. Ibid.

98. Cohen, "Stores Adding Foreign Flavor with Import DVDs," 8.

99. U.S. Census Bureau, "Profile of General Population and Housing Characteristics: 2010 Demographic Profile Data," accessed 1 May 2011, http://factfinder2.census.gov/faces/tableservices/jsf/pages/productview.xhtml?pid = DEC_10_DP_DPDP1&prodType = table.

100. U.S. Census Bureau, "2008–2010 American Community Survey 3-Year Estimates," accessed 1 May 2011, http://factfinder2.census.gov/faces/tableservices/jsf/pages/productview.xhtml?pid = ACS_10_3YR_DP03&prodType = table; U.S. Census Bureau, "2006–2010 American Community Survey 5-Year Estimates"; http://factfinder2.census.gov/faces/tableservices/jsf/pages/productview.xhtml?pid = ACS_10_5YR_DP02&prodType = table.

101. "Quick Facts: 2012–2013," accessed 12 Sept. 2012, www.montana.edu/opa/facts/quick.html#Demo and www.montana.edu/opa/facts/quick.html#Employees.

102. "About BFF," accessed 12 Sept. 2012, www.bozemanfilmfestival.org/about.php.

103. Testerman, "Local Gaming Store Specializes in Classic Games, Obscure Products."

104. U.S. Census Bureau, "2010 Demographic Profile Data," accessed 12 Sept. 2012, http://factfinder2.census.gov/faces/tableservices/jsf/pages/productview.xhtml?pid = DEC_10_DP_DPDP1&prodType = table.

105. U.S. Census Bureau, "2010 American Community Survey 1-Year Estimates," accessed 12 Sept. 2012, http://factfinder2.census.gov/faces/tableservices/jsf/pages/productview.xhtml?pid = ACS_10_1YR_DP03&prodType = table.

106. "Middle Tennessee State University 2011 Fact Book," accessed 12 Sept. 2012, www.mtsu.edu/iepr/factbook/factbook11/Fact_Book_Fall_2011.pdf.

107. "About," accessed 17 Aug. 2012, http://boroarts.org/welcome/about-2/.

108. Erin Edgemon, "Video Culture seeks to enter adult biz suit," *Murfreesboro Post*, 3 July 2007, accessed 20 Nov. 20, 2012, www.murfreesboro-post.com/video-culture-seeks-to-enter-adult-biz-suit-cms-5148.

109. Melinda Hudgins, "Internet Killed the Video Star," *Murfreesboro Post*, 31 July 2011.

110. Laporte, "The Video Store, Reinvented by Necessity."

111. Scott Foundas, "Come Back into the Dark," *LA Weekly*, 25 Oct. 2007. This theater had previously exhibited silent film classics with live musical accompaniment.

112. Elina Shatkin, "Rehabbed Silent Movie Theater Gives 'Em Something to Talk About," *Los Angeles Times*, 25 Oct. 2007.

113. Sarah Sluis, "LA Revival: Classic Films Find Audiences in Classic Cinemas," *Film Journal International* 112, no. 6 (June 1009): 16–18.

114. Ed Leibowitz, "The Revivalists," *Los Angeles Magazine* 54, no. 2 (Feb. 2009).

115. Ibid.

116. Sluis, "LA Revival: Classic Films Find Audiences in Classic Cinemas"; "About," Cinefamily.com, accessed 28 Mar. 2013. www.cinefamily.org/about.

117. Mark Olsen, "A Telethon for Cinema; Cinefamily Throws an Online Fundraiser. Robert Downey Jr. and More Help Out," *Los Angeles Times*, 15 Dec. 2012; "About: Cinefamily Advisory Board," Cinefamily.com, accessed 28 Mar. 2013, www.cinefamily.org/about.

118. Olsen, "A Telethon for Cinema."

CHAPTER 4

1. Robert C. Allen, "Relocating American Film History: The 'Problem' of the Empirical," *Cultural Studies* 20, no. 1 (Jan. 2006): 64–65.

2. For a robust description of this branch of film studies, see Kathryn H. Fuller-Selley and George Potamianos, "Introduction: Researching and Writing the History of Local Moviegoing," in *Hollywood in the Neighborhood: Historical Case Studies of Local Moviegoing*, edited by Kathryn H. Fuller-Seeley (Berkeley: University of California Press, 2008), 3–19.

3. In general, the towns I visited had populations of between 2,000 and 20,000. Some towns were larger than this but were still located in rural areas, often isolated from major cities, and exhibited signs of cultural "ruralness."

4. This chapter draws on fieldwork conducted in Alabama, Colorado, Georgia, Idaho, Iowa, Kansas, Michigan, Mississippi, Montana, Nebraska, Ohio, Pennsylvania, Tennessee, and Wyoming, where I visited and interviewed workers at over one hundred video stores. In general, my interview procedure was the same with these workers as it was with those in large cities or college towns. Although I sought out video stores that served local Hispanic and/or Spanish-speaking audiences, I actually visited very few of these. There are several reasons for this. First, such stores were difficult to locate in the same manner I used to find all the other stores, perhaps indicating they do not advertise themselves in conventional ways. Second, several of the Hispanic-oriented stores that I did visit had stopped renting videos a few years before or only sold videos and did no rental. Finally, and as mentioned below, some of the owners of these stores were cautious and chose not to speak with me.

5. See David Harvey, *Spaces of Global Capitalism: Towards a Theory of Uneven Geographical Development* (London: Verso, 2006), 69–116.

6. My use of the term *locality* and my broader interest in demonstrating the complexity of small-town video stores is inspired by Arjun Appadurai and Doreen Massey. Appadurai characterizes "locality" as "primarily relational and contextual rather than as scalar or spatial[,] . . . as a complex phenomenological quality, constituted by a series of links between the sense of immediacy, the technologies of interactivity, and the relativity of contexts." Arjun Appadurai, *Modernity at Large: Cultural Dimensions of Globalization* (Minneapolis: University of Minnesota Press, 1996), 178. In my assertion that these small-town video stores are vital to the "local" movie culture of their small towns, I take a similarly relational approach to "locality." Yet, to my mind, one of the striking things about these stores and the "local audience" that they serve lies in the way they complicate the relations between an experience of locality and physical geography, which still appears to matter. Somewhat similarly, Massey has intervened in cultural geography in general and locality studies in particular through a reconceptualization of "place." Her discussion of "place" aligns with my use of "locality" and accords with my characterization of these small towns and the video cultures they service. She writes, "The identities of place are always unfixed, contested and multiple. And the particularity of place is, in these terms, constructed not by placing boundaries around it and defining its identity through counter-position to the other which lies beyond, but precisely (in part) through the specificity of the mix of links and interconnections *to* that 'beyond.' Places viewed this way are open and porous." Doreen Massey, *Space, Place, and Gender* (Minneapolis: University of Minnesota Press, 1994), 5; original emphasis.

7. John Thornton Caldwell, *Production Culture: Industrial Reflexivity and Critical Practice in Film and Television* (Durham, NC: Duke University Press, 2008), 77–79.

8. These conversations provide a mechanism for these people to reflect on and orient themselves in relation to their work and communities and thus function similarly to the "deep texts" of media workers in Southern California described by John Caldwell, in *Production Culture*, 345–49.

9. Pierre Bourdieu, "The Forms of Capital," in *Handbook of Theory and Research for the Sociology of Education*, ed. John G. Richardson (New York: Greenwood Press, 1986), 243–52.

10. Joshua Greenberg, *From Betamax to Blockbuster: Video Stores and the Invention of Movies on Video* (Cambridge, MA: MIT Press, 2008), 73

11. The NATO member mentioned above said she loved movies and even thought of her videos as her "babies." She had very strong and emotional memories of specific titles, such as *Risky Business* (1983), which was among the tapes in the first box of videos she bought for her store.

12. Bourdieu, "The Forms of Capital," 243.

13. American FactFinder, "Community Facts: Medicine Lodge city, Kansas," U.S. Census Bureau, 2010, accessed 12 May 2012, http://factfinder2.census.gov/faces/nav/jsf/pages/searchresults.xhtml.

14. There is another video store in town that deals exclusively in Spanish-language material. The owner of the store refused to be interviewed.

15. There are numerous historical precedents for these stores' admixture of movies and other commodities, as movie theaters and drive-ins have promoted and sold other types of goods as a means of drawing audiences and building excitement. See, for instance, Douglas Gomery's discussion of "giveaway" prizes offered by movie theaters during the Great Depression and after. Douglas Gomery, *Shared Pleasures: A History of Movie Presentation in the United States*, foreword by David Bordwell (Madison: University of Wisconsin Press, 1992), 70–71. Analogously, Kerry Segrave discusses how drive-in theater operators would turn their spaces into mixed-use locations during the 1950s. He writes, "More and more drive-ins turned to selling an evening of fun in which the film being screened was only a part—and not necessarily the most important one." Kerry Segrave, *Drive-in Theaters: A History from Their Inception in 1933* (Jefferson, NC: McFarland, 1992), 78. Along these lines, Phillip Hallman presented a paper at the 2012 SCMS conference that argued that the food offerings at drive-in theaters in the 1950s helped pave the way for the fast-food industry. Phillip Hallman, "From Drive-In to Drive-Thru: How Drive-In Theaters Changed Where (and What) We Eat," paper presented at the 2012 Conference of the Society of Cinema and Media Studies, Boston, MA, 22 Mar.

16. Greenberg, *From Betamax to Blockbuster*, 68–71.

17. Historically, whites with tanned skin were associated with agricultural labor. Conversely, pale skin was associated with the upper classes and with feminine beauty. After the Industrial Revolution, labor was largely moved indoors, so light skin was not so easily associated with wealth and leisure. Although popular legend has it that Coco Channel popularized the suntan in the 1920s, the truth is that exposure to the sun was advocated during the early part of the

twentieth century in medical discourses. Kerry Segrave, *Suntanning in 20th-Century America* (Jefferson, NC: McFarland, 2005), 3–5, 8, 9.

18. Ibid., 32–35, 125–31.

19. Ibid., 153–61. There had been some efforts to use ultraviolet lights for artificial tanning as early as the 1920s (45). Despite health warnings from doctors and regular threats of increased governmental regulation, artificial tanning quickly became a multibillion-dollar industry employing over 100,000 workers. Market research reports state that as of 2011, 28 million Americans used artificial tanning services per year. Despite the size of this industry, in terms of customers and revenue, the vast majority of tanning salons are independently owned and operated. Caitlin Moldvay, "IBISWorld Industry Report81219c: Tanning Salons in the US" (IBISWorld Inc., July 2011), 4, 19.

20. "Video Rental Stores," in *Sun Business: The Complete Guide to the Business of Indoor Tanning* (n.p.: Sun Ergoline, Inc., 2008), 65.

21. "In Good Company: Surrounding Businesses," in *Sun Business*, 19.

22. Brian O'Connor, "Tanning Salons Find Day in the Sun," *South Florida Sun-Sentinel*, 17 Mar. 1986; Phil Galewitz, "Tanning Salons Popular Even in Sunny Florida," *McClatchy-Tribune Business News*, 15 Oct. 2007.

23. Joshua Greenberg notes that some movie theaters tried to sell or rent movies from their lobbies in the early days of the industry. Greenberg, *From Betamax to Blockbuster*, 71–72.

24. Ibid., 68–70.

25. Somewhat similarly, a store owner in Kansas said that his soda machine was a primary draw for his store. Although this video store only offered popcorn, candy, and soda in the way of food, the owner said, "There's hardly no video store's got a concession stand. . . . This is the real money-maker." In his explanation for why people would come in for a soda and nothing else, he stated, "We got the good ice, the crushed ice, and I set the [soda] machine real sweet." This soda machine produced the best Dr. Pepper I have ever had.

CHAPTER 5

1. Joshua Greenberg, *From Betamax to Blockbuster: Video Stores and the Invention of Movies on Video* (Cambridge, MA: MIT Press, 2008); Paul McDonald, *Video and DVD Industries* (London: BFI, 2007); Janet Wasko, *Hollywood in the Information Age: Beyond the Silver Screen* (Austin: University of Texas Press, 1994); Frederick Wasser, *Veni, Vidi, Video: The Hollywood Empire and the VCR* (Austin: University of Texas Press, 2001).

2. Wasko, *Hollywood in the Information Age*, 138. I try to distinguish between video "distributors" and "wholesalers," depending on which term best describes their function and place in the distribution system, although at times I use the terms interchangeably. My intention is not to conflate these terms, as they describe specific functions and practices: distributors might sell videos directly to retailers or to a wholesaler, while wholesalers exclusively buy videos from distributors and sell these tapes and discs to retailers.

3. Ibid., 138.

4. Ibid., 114, 142; Wasser, *Veni, Vidi, Video*, 10, 95; Greenberg, *From Betamax to Blockbuster*, 2–3, 56–59. Wasser has profiled the development and fates of some of the more interesting independent video distributors, including Media Home Entertainment and Vestron. Wasser, *Veni, Vidi, Video*, 106–7.

5. Wasko, *Hollywood in the Information Age*, 138–39, 143; Wasser, *Veni, Vidi, Video*, 143–52; Greenberg, *From Betamax to Blockbuster*, 56–59.

6. For example, the Nostalgia Merchant released public domain classic films, while Goodtimes Home Video released the *Sweatin' to the Oldies* series of workout tapes. This followed the success of *Jane Fonda's Workout* in 1982, as detailed by Wasser, *Veni, Vidi, Video*, 125.

7. The fan website *Critical Condition*, built and operated by Fred Adelman, provides well-researched visual documentation of a vast number of these companies, as well as brief narratives about their beginnings and eventual fates. Notably, Lionsgate Home Entertainment holds the rights to a large number of titles originally distributed by the independents. "Critical Condition: Obscure & Bizarre Films on Video & DVD," accessed 11 July 2010, www.critcononline.com.

8. Greenberg, *From Betamax to Blockbuster*, 56–57. Wasser, *Veni, Vidi, Video*, 96, has an excellent chart of the "stages" in which the studios entered video distribution.

9. Wasser, *Veni, Vidi, Video*, 95.

10. Wasko, *Hollywood in the Information Age*, 147–48.

11. Wasser, *Veni, Vidi, Video*, 131–35.

12. Ibid., 183–84; McDonald, *Video and DVD Industries*, 123.

13. Greenberg, *From Betamax to Blockbuster*, 7, 52–56.

14. Ibid., 79.

15. Pierre Bourdieu, *The Field of Cultural Production* (New York: Columbia University Press, 1993), 115.

16. Ibid.

17. Ibid., 134.

18. Kino Lorber was created in 2009 through a merger of Kino International and Lorber Films. Most of the research for this chapter was conducted in 2008 and 2009, when the company was Kino International, but all of my assertions about Kino Lorber are accurate as of 2013.

19. Daniel Frankel, "Distribs Dwindled Again," *Video Business*, 31 Dec. 2001.

20. Marcy Magiera, "It's All about the Margin," *Video Business*, 11 Apr. 2005.

21. Ingram Bronson was cleared, but his brother was convicted of 29 counts. Jonathan Gaw, "The Spine of the Ingram Empire," *Los Angeles Times*, 6 June 1999.

22. Gaw, "The Spine of the Ingram Empire."

23. Kristen Hallam, "Ingram Division Goes Independent," *Nashville Banner*, 27 June 1997.

24. Wasser, *Veni Vidi, Video*, 140; Paul Sweeting, "Ingram/Commtron: Sign of Times," *Billboard*, 29 Feb. 1992.

25. Sweeting, "Ingram/Commtron: Sign of Times."

26. Ibid.

27. Ibid.

28. Earl Paige, "Vista Group, Management Purchase VPD," *Billboard*, 25 Mar. 1989.

29. Tim Shannahan, who was VPD's president, took over as president and CEO. Before working at VPD, Shannahan was head of the Video Software Division of Commtron from 1980 to 1985. Earl Paige, "Vista Group, Management Purchase VPD," *Billboard*, 25 Mar. 1989; Dale Kasler, "Reel Business—Video Distributor VPD Has Spliced Together a Going—and Growing—Concern, Despite Many Obstacles," *Sacramento Bee*, 31 Aug. 1997; Anonymous, "Tim Shannahan: Pioneering Video Executive President, Video Products Distributors," *Video Business*, 22 Nov. 1999.

30. Paige, "Vista Group, Management Purchase VPD."

31. Paul Sweeting, "Regional Distribs Merge into New Video Holding Co.," *Billboard*, 18 Nov. 1989.

32. Paul Sweeting, "RCA/Col Reinstates Dropped Distribs," *Billboard*, 21 Oct. 1989; Sweeting, "Regional Distribs Merge into New Video Holding Co."

33. Sweeting, "RCA/Col Reinstates Dropped Distribs."

34. Telephone interview, 1 June 2011; telephone interview, 10 June 2011.

35. Telephone interview, 14 June 2011.

36. Sweeting, "RCA/Col Reinstates Dropped Distribs."

37. In 1994, the Vista Group divested themselves of VPD, forcing Shannahan and several other VPD executives to buy the company themselves. Kasler, "Reel Business."

38. As of 1997, it only employed 120 people in its Sacramento headquarters. Kasler, "Reel Business."

39. Ibid.

40. Ibid.

41. Tom Arnold, quoted in Kasler, "Reel Business."

42. Kasler, "Reel Business."

43. Anonymous, "Tim Shannahan."

44. Bob Walter, "Folsom's VPD in Deal with Universal—Video Distribution Plan Set," *Sacramento Bee*, 10 Oct. 2000.

45. The company was split into three different companies, Ingram Micro, which in the mid-1990s was the "world's largest supplier of Microsoft software"; Ingram Industries Inc.; and Ingram Entertainment. Associated Press, "Ingram Industries Splitting into Three," *News Sentinel*, 28 Sept. 1995. Ingram Industries would remain comprised of Ingram Barge Group, Ingram Merchandising Services, Ingram Book Group, Ingram Cactus, and Permanent General/Tennessee Insurance, while Ingram Entertainment would be an independent company. Seth Goldstein, "Ingram to Spin off Distributor," *Billboard*, 14 Oct. 1995.

46. Associated Press, "Ingram Industries Splitting into Three."

47. Hallam, "Ingram Division Goes Independent.".

48. David Ingram, quoted in Goldstein, "Ingram to Spin off Distributor."

49. Goldstein, "Ingram to Spin off Distributor."

50. Wasko, *Hollywood in the Information Age,* 143, 147.

51. Kasler, "Reel Business."

52. Wasser, *Veni, Vidi, Video,* 125–27.

53. Bill Bryant, Ingram Entertainment, quoted in Randy Weddington, "Mixing It Up," *Supermarket News,* 23 Aug. 2001.

54. Ibid.

55. Ibid.

56. When Ingram Entertainment became independent from Ingram Industries, in fact, one of its aims was to develop Monarch's business. Goldstein, "Ingram to Spin off Distributor."

57. Moira McCormick, "Monarch Enters Sell-Thru with 'Mowgli,'" *Billboard,* 2 May 1998.

58. The negative or cheap association with direct-to-video movies is not universally true, as seen for instance with the "Original Video (OV)" and "V-cinema" industries in Japan. Mark Schilling, *Contemporary Japanese Film* (New York: Weatherhill, 1999), 29.

59. Rentrak Corp., May 26, 1995, Form 10-K405 (filed 29 June 1995), via investor.rentrak.com, accessed 25 June 2011.

60. Clay Chandler, "West Coast Holdings Inc. Says It Will Acquire National," *Washington Post,* 2 July 1988.

61. Rentrak Corp., May 26, 1995 Form 10-K405 (filed June 29, 1995), via investor.rentrak.com, accessed 25 June 2011.

62. Lisa Gubernick, "If at First You Don't Succeed . . . ," *Forbes,* 5 Dec. 1994.

63. Ibid.; Rentrak Corp., May 26, 1995 Form 10-K405 (filed June 29, 1995), via investor.rentrak.com, accessed 25 June 2011.

64. Rentrak Corp., May 26, 1995 Form 10-K405 (filed June 29, 1995), via investor.rentrak.com, accessed 25 June 2011.

65. Ibid.

66. Paul Sweeting, "Rentrak Getting PPT Message Through," *Billboard,* 1 June 1991; Adam Sandler, "Disney Suddenly Makes Rentrak a Video Player," *Variety,* 1 Aug.–7 Aug. 1994.

67. Don Jeffrey, "Rentrak Reports First-Ever Profit," *Billboard,* 18 May 1991.

68. Other mainstream distributors, such as Ingram, also experimented with revenue-sharing. In the case of Ingram, however, this was on a very limited scale and was not enacted until the late 1990s, likely in direct response to Rentrak's success. Eileen Fitzpatrick, "Distributors Call for Copy-Depth Reform," *Billboard,* 15 May 1999; Brett Sporich, "Change of Heart," *Video Business,* 25 May 1998.

69. This is noted by Douglas Gomery, *Shared Pleasures: A History of Movie Presentation in the United States* (Madison: University of Wisconsin Press, 1992), 285.

70. Ken Dorrance, quoted in "Rentrak's Nab of 'Wolves' a Big Catch," *Billboard,* 3 Aug. 1991. Rentrak chairman Ron Berger countered this assessment by discussing how there was a sliding scale for hit films versus "B and C"

movies. The story states that "stores are required to fork over 55% of an A title's rental take, with the retailer keeping the remaining 45%. On B and C titles, the studio only charges a rate of 30%-35%." In this way, Rentrak would encourage clients to purchase non–hit films as well.

71. Charles Acland confirms the increased importance of opening weekends by the turn of the millennium. "Theatrical Exhibition: Accelerated Cinema," in *The Contemporary Film Industry,* edited by Paul McDonald and Janet Wasko (Malden, MA: Blackwell, 2008), 95.

72. From the outset, other major video distributors were opposed to Rentrak's model and the competition it posed. Consequently, they encouraged the studios to boycott Rentrak or to make their movies available to them on a revenue-sharing basis as well. Sweeting, "Rentrak Getting PPT Message Through." For a number of years, Rentrak's relations with the studios were shrouded in secrecy, as they did not typically declare the identities of their suppliers and participating studios did not disclose their arrangements with Rentrak. Earl Paige, "Rentrak Is Diversifying," *Billboard,* 27 June 1992; Sweeting, "Rentrak Getting PPT Message Through." From Rentrak's perspective, such secrecy simply would have been a matter of not showing weaknesses to competitors or potential clients.

73. Jeffrey, "Rentrak Reports First-Ever Profit"; Sweeting, "Rentrak Getting PPT Message Through"; Sandler, "Disney Suddenly Makes Rentrak a Video Player."

74. Sandler, "Disney Suddenly Makes Rentrak a Video Player."

75. Ibid. Notably, Disney entered the revenue-sharing distribution business soon after signing a deal with Rentrak, as it purchased SuperComm, a smaller company that had a similar business model.

76. Ibid.

77. Sporich, "Change of Heart."

78. Seth Goldstein, "Rentrak Sees Long-Term Gains for PPT Business," *Billboard,* 5 Oct. 1996; Peter Newcomb, "Fast Forward," *Forbes* 161, no. 11 (1 June 1998).

79. Fitzpatrick, "Distributors Call for Copy-Depth Reform."

80. Ibid.

81. Ibid.

82. Ibid.

83. McDonald, *Video and DVD Industries,* 150–52; Barbara Klinger, *Beyond the Multiplex: Cinema, New Technologies, and the Home* (Berkeley: University of California Press, 2006), 58–60.

84. Wendy Wilson, "Ingram Cuts Staff, Revenue Projections," *Video Business,* 16 July 2001; Diane Garret, "VPD Rewrites Record Books," *Video Business,* 8 Oct. 2001.

85. This same distribution worker suggested that the price of DVDs was partly informed by the expectations of retailers, who had grown used to the "cheap" prices of VHS tapes under revenue-sharing programs.

86. Fitzpatrick, "Distributors Call for Copy-Depth Reform."

87. Greenberg, *From Betamax to Blockbuster,* 79.

88. Klinger, *Beyond the Multiplex,* 58–60.

89. Jennifer Netherby, "VPD Fires up Sales," *Video Business,* 26 Aug. 2002.

90. Ibid.

91. Magiera, "It's All about the Margin."

92. Wilson, "Ingram Cuts Staff, Revenue Projections."

93. Frankel, "Distribs Dwindled Again."

94. Magiera, "It's All about the Margin."

95. Netherby, "VPD Fires up Sales."

96. Ibid.

97. Ibid.

98. James Kendrick, "What Is the Criterion? The Criterion Collection as an Archive of Film as Culture," *Journal of Film and Video* 53, no. 2–3 (Summer–Fall 2001): 125. In her assertion that the Criterion Collection was influential in connoting a "high art" quality in certain DVD releases, Klinger has written that Criterion helped create "the perception that the digital era in theatrical cinema has finally found its aesthetic equivalent on the domestic front in DVD." Klinger, *Beyond the Multiplex,* 61.

99. Kendrick focuses on Criterion's peculiar selectivity as a means by which archival practices and values have been transferred and democratized to some degree. Klinger focuses on the production of "collectability" as a quality of DVD cinema that is subsequently taken up by domestic media consumers. She highlights how the transfer of cinephilia into domestic movie consumption has been paired with technophilia. *Beyond the Multiplex,* 56, 75.

100. Klinger, *Beyond the Multiplex,* 60, makes a similar argument regarding The Criterion Collection.

101. Eugene Hernandez, "Positioned for the Digital Future, Lorber and Krim Still Favor the Big Screen," Indiewire.com, 9 Dec. 2009, accessed 11 July 2010, www.indiewire.com/article/positioned_for_the_digital_future_krim_lorber_still_favor_the_big_screen.

102. Bourdieu, *The Field of Cultural Production,* 115.

103. Exclusivity is not unique to "high-quality" cultural production in the contemporary period, but it does play a significant role. Lowbrow video distributors such as Something Weird Video regularly make similar claims to exclusivity. Jeffrey Sconce has discussed the use of highbrow strategies by lowbrow cultural producers in his article, "'Trashing' the Academy: Taste, Excess, and an Emerging Politics of Cinematic Style," *Screen* 36, no. 4 (Winter 1995): 371–93.

104. Although Kino International collaborated with the George Eastman House for many years, as of 2013 Kino Lorber no longer worked with them.

105. Kendrick, "What Is the Criterion?," 125.

106. Bourdieu, *The Field of Cultural Production,* 77–78.

107. Milos Stehlik, quoted in Jason Guerassio, "Facets Multi Media," *Independent Film and Video Monthly,* July–Aug. 2003.

108. "Browse All Genres," Facetsmovies.com, accessed 17 June 2010, www.facetsmovies.com/user/movieBrowseByType.php.

109. Stehlik, quoted in Guerassio, "Facets Multi Media."

110. Ibid.

111. Ibid.

112. Virginia Boyle, ed., *Facets Non-Violent, Non-Sexist Children's Video Guide* (Chicago: Academy Chicago Publishers, 1996).

113. "About Us," Facets.org., accessed 17 June 2010, www.facets.org/pages/aboutus.php.

114. "National Film Preservation Board: National Film Registry," accessed 17 June 2010, www.loc.gov/film/filmnfr.html.

115. TLA Entertainment, based in Philadelphia, makes an interesting comparison to Facets. Like Facets, TLA originated as a venue for experimental theater and eventually branched out into film exhibition, video rental, video distribution, film festivals, and online video sales. Also like Facets, TLA is a nonprofit organization. While TLA also offers a selection of movies that aligns with the same intellectual and cosmopolitan vision for film culture seen at Kino, Zeitgeist, and Facets, it also specializes in queer media. In this respect, TLA similarly builds and sustains a cinema culture that lies outside of mainstream Hollywood, but its case is more clearly aligned with identity politics than any of the other companies discussed above. In addition, TLA has offered adult videos aimed at all types of tastes and sexual preferences. In this respect, they offer highbrow and lowbrow movies as equal to and equally different from mainstream corporate media. Perhaps most strikingly, TLA began offering a video streaming service in 2005 through a subscription website, where one can watch queer narrative features or adult movies of many varieties. Positioning themselves like a Netflix for niche movies exclusively, TLA has transitioned to intangible media.

116. Ben Fritz, "Sony Pictures' David Bishop: In the Thick of Home Entertainment's Evolution," *Los Angeles Times*, 18 Feb. 2010, accessed 2 May 2010, http://articles.latimes.com/2010/feb/18/business/la-fi-ct-facetime18–2010feb18.

117. Chris Anderson, "The Long Tail," *Wired*, October 2004, accessed 2 May 2010, www.wired.com/wired/archive/12.10/tail.html.

118. "Redbox Fun Facts," Redbox.com, accessed 15 Jan. 2012, www.redbox.com/facts.

119. "Company Facts," netflix.com, accessed 17 May 2012, https://account.netflix.com/MediaCenter/Facts.

120. Todd Wasserman, "Netflix Takes up 32.7% of Internet Bandwidth," CNN.com, 28 Oct. 2011, accessed 17 May 2012, www.cnn.com/2011/10/27/tech/web/netflix-internet-bandwith-mashable/index.html.

121. Lucas Hilderbrand, "The Art of Distribution: Video on Demand," *Film Quarterly* 64, no. 2 (Winter 2010): 24–28.

122. The Auteurs changed its name to MUBI on 13 May 2010. Anne Thompson, "The Auteurs Is Now Mubi," Indiewire.com, 13 May 2010, accessed 14 July 2010, http://blogs.indiewire.com/thompsononhollywood/2010/05/13/the_auteurs_is_now_mubi.

123. "About," Mubi.com, accessed 12 Aug. 2010, http://mubi.com/about.

124. "Frequently Asked Questions," Mubi.com, accessed 31 Mar. 2013, http://mubi.com/faq.

125. Interestingly, one can "shop" the Netflix library of titles through the Mubi website interface.

126. Jennifer Netherby, "Retail Embraces WHV Rev-Share," *Video Business*, 11 Aug. 2003.

127. Boaz Herzog, "Portland, Ore.–Based Firm's Software Scores Big Hit in Hollywood," *Knight Ridder Tribune Business News*, 7 Jan. 2003.

128. Jennifer Netherby, "Rentrak in First VOD Pact," *Video Business*, 29 Mar. 2004.

129. Ibid.

130. Anonymous, "Rentrak to Have Global Footprint with Acquisition of Nielsen EDI," Rentrak.com, 15 Dec. 2009, accessed 16 May 2012; Anonymous, "Rentrak Completes Acquisition of Nielsen EDI," Rentrak.com, 1 Feb. 2010, accessed 16 May 2012.

CHAPTER 6

1. Jonathan Gray draws from the work of Gérard Genette to provide a robust study of how paratexts, or those tertiary objects like titles, advertisements, etc., orient consumers in their approach to and consumption of media texts proper. Jonathan Gray, *Show Sold Separately: Promos, Spoilers, and Other Media Paratexts* (New York: New York University Press, 2010). Although video guides similarly orient potential movie viewers, the term that describes video guides' particular intertextual relation to movies is *metatext*, which Genette defines as "commentary" on a text. Gérard Genette, *Palimpsests: Literature in the Second Degree*, translated by Channa Newman and Claude Dubinsky (Lincoln: University of Nebraska Press, 1982, 1997), 4.

2. Jerry Roberts, *The Complete History of American Film Criticism* (Santa Monica, CA: Santa Monica Press, 2010), 17.

3. Ibid., 21, 22.

4. Ibid., 25.

5. Ibid., 90–91.

6. Ibid., 95–96.

7. Haden Guest has detailed how several film journals published during the 1950s informed the evolution of film studies. As part of his broader analysis of the changing discourse on cinema during the era, Guest writes, "postwar film critics [attempted] to break free from the limitations of the traditional film review and [explored] film criticism as a type of expansive and deeply personal artistic practice." Haden Guest, "Experimentation and Innovation in Three American Film Journals of the 1950s," in *Inventing Film Studies*, edited by Lee Grieveson and Haidee Wasson (Durham, NC: Duke University Press, 2008), 236.

8. Manny Farber, *Negative Space: Manny Farber on the Movies* (New York: Praeger, 1971); Andrew Sarris, *The American Cinema: Directors and Directions, 1929–1968* (New York: Dutton, 1968).

9. Roberts, *The Complete History of American Film Criticism*, 28.

10. Dana Polan, "Auteur Desire," *Screening the Past* 12 (Mar. 2001).

11. Vincent Canby, "Read Any Good Movie Books Lately?," *New York Times*, 19 May 1974. In a review of the third edition, Charles Champlin stated, "It is the best and most useful single-volume reference work on the movies I've yet come across." Charles Champlin, "Film Book You Can't Put Down," *Los Angeles Times*, 30 Oct. 1970.

12. Leslie Halliwell, "Introduction to the First Edition," in *The Filmgoer's Companion*, 6th ed. (New York: Hill and Wang, 1977), viii. Admittedly, it is a populist cinephilia that he appeals to, as he also writes: "The book is aimed at the general filmgoer, not the egghead student of film culture who shuns commercial entertainments in favor of middle-European or Oriental masterpieces which never get further than the National Film Theatre or a very few art houses" (ix).

13. Halliwell, "Introduction to the First Edition," viii.

14. Ibid.

15. Champlin, "Film Book You Can't Put Down."

16. In fact, reviewers of the encyclopedia often mentioned and frequently heralded Halliwell's tone and voice. In his review of the fourth edition, Champlin wrote, "The pleasure of the 'Companion' is that it is a valuable tool, but also outspoken and often quirky in its quick judgments," and Clifford Terry's review of the second edition quoted a number of entries as evidence of Halliwell's "pithy personality." Charles Champlin, "A Filmgoer's Companion," *Los Angeles Times*, 4 May 1979; Clifford Terry, "Film Book Incisive, but Where's Harve, Heather, Foghorn?," *Chicago Tribune*, 14 Jan. 1968.

17. Halliwell, "Introduction to the First Edition," viii.

18. Leslie Halliwell, Introduction to *Halliwell's Film Guide: A Survey of 8,000 English-Language Movies* (London: Granada Publishing, 1977), vii.

19. Steven H. Scheuer, *Movies on TV: 1969–1970 Edition* (New York: Bantam, 1969), vii.

20. Ibid.

21. Ibid.

22. The 1969–70 edition has over 7,000 entries, while the 1975–76 edition features several thousand more.

23. Scheuer, *Movies on TV: 1969–1970 Edition*, 86.

24. Ibid., 272.

25. Ibid., 339.

26. Ibid., 44.

27. Ibid., 108.

28. Steven H. Scheuer, *Movies on TV: 1975–1976 Edition* (New York: Bantam, 1974), ix.

29. The issue from 17–23 July 1982, for instance, looked at Jane Fonda's first workout tape. David Handler, "Cassettes and Discs in Review," *TV Guide*, 17–23 July 1982, 1. Similarly, this same section covered a video of Duran Duran music videos in July 1983. David Handler, "Cassettes and Discs in Review," *TV Guide*, 23–29 July 1983, 40.

30. Henry Mietkiewicz, "Dedicated Maltin Guides the Way for Film Fanatics," *Toronto Star*, 29 Jan. 1989, C6.

31. Leonard Maltin, personal interview, 17 June 2010.

32. Ibid.

33. Ibid.

34. Roberts, *The Complete History of American Film Criticism*, 250–51.

35. Ibid., 255.

36. The program was originally titled *Coming Soon to a Theater New You*. It aired until 1995, with a number of different critics serving as hosts.

37. David Itzkoff, "'At the Movies' Is Cancelled," *New York Times*, 24 Mar. 2010, accessed 8 Jan. 2013, http://artsbeat.blogs.nytimes.com/2010/03/24/at-the-movies-is-canceled. Although Siskel and Ebert left *At the Movies* in 1986 due to a contract dispute, the program continued with different hosts. Simultaneously, Siskel and Ebert changed production companies and started yet another program, titled *Siskel & Ebert & the Movies* and later simply *Siskel & Ebert*, from 1986 until 1999, when Siskel died. Roger Ebert continued on the show, and the critic Richard Roeper was his regular cohost from 2000 to 2007. The show was canceled in 2010; A.O. Scott and Michael Phillips hosted the show at the time.

38. Sid Smith, "Differences of Opinion as the Movies Grew Up, So Did the Art of Criticism," *Chicago Tribune*, 19 Mar. 1995.

39. John Hartl, "TV Appearances Spark Interest in Maltin's Film Books," *Seattle Times*, 14 Oct. 1987.

40. Patricia Brennan, "Leonard Maltin: The TV Fan's Guide to the Movies," *Washington Post*, 5 July 1987.

41. Hartl, "TV Appearances Spark Interest in Maltin's Film Books."

42. Leonard Maltin, personal interview, 17 June 2010.

43. Ibid.

44. Brennan, "Leonard Maltin: The TV Fan's Guide to the Movies."

45. Carrie Rickey and Ryan Desmond, "Hollywood's Big Role on the Holiday Shelf," *Philadelphia Inquirer*, 8 Dec. 1991.

46. A video store owner in New York actually organized his store according to Maltin's ratings so as to lead browsers to neglected or forgotten gems. Peter Nichols, "Home Video," *New York Times*, 15 Apr. 1994.

47. Susan Wloszczyna, "Maltin's Film Guide Still ****," *USA Today*, 4 Oct. 1994, 04D.

48. Leonard Maltin, "Introduction to the 1992 Edition," in *Leonard Maltin's Movie and Video Guide 1992*, edited by Leonard Maltin (New York: Plume, 1991), ix; original emphasis.

49. Examples include *Fools* (1970) and *The Hunter* (1980).

50. Maltin, *Leonard Maltin's Movie and Video Guide 1992*, 1160.

51. Ibid., 596.

52. Leonard Maltin, personal interview, 17 June 2010.

53. In this regard, Maltin's book competed with *The Film Encyclopedia* by Ephriam Katz, an enormous volume that appeared in 1979 and provided substantial information about an immense number of cinema-related people and subjects. Ephraim Katz, *The Film Encyclopedia* (New York: Crowell, 1979).

54. Tom Milne, Foreword to *The Time Out Film Guide* (London: Penguin Books, 1989), vii.

55. Introduction to *VideoHound's Golden Movie Retriever* (Detroit: Visible Ink, 1995), vii.

56. *VideoHound's Golden Movie Retriever* (Detroit: Visible Ink, 1991), 563.

57. *VideoHound's Golden Movie Retriever* (1995), 149.

58. The review of *Casablanca* (1942) reads, "Can you see George Raft as Rick? Jack Warner did, but producer Hal Wallis wanted Bogart. Considered by many to be the best film ever made and one of the most quoted movies of all time, it rocketed Bogart from gangster roles to romantic leads as he and Bergman (who never looked lovelier) sizzle on screen.... Without a doubt, the best closing scene ever written." Ibid., 244.

59. Ibid., 972.

60. Ibid., 189.

61. Introduction to *VideoHound's Golden Movie Retriever* (1991), x.

62. The *VideoHound* guide gained appreciation among critics and everyday users. The *Providence Journal* wrote in 1994 that "VideoHound's blurbs are generally the wittiest" among video guides, and the *Houston Chronicle* wrote that it was "by far the best reference work." Michael Janusonis, "Video Reference Books Make a Great Gift for Movie Fans," *Providence Journal*, 1 Dec. 1994; Bruce Westbrook, "'VideoHound' Book a Four-Bone Guide," *Houston Chronicle*, 15 Oct. 1993. Similarly, a number of different publications stated the book was especially good for movie "fans" and "buffs," particularly as a holiday gift. Michael Janusonis, "Video Reference Books Make a Great Gift for Movie Fans"; John Hartl, "Video Guides Get Up to Date for Holiday," *Milwaukee Journal Sentinel*, 4 Dec. 1998; Laurence Chollet, "A Home Video Fan's Best Friend," *The Record*, 28 Sept. 1997.

63. *Store Training Manual for Guest Service Representatives* (Hollywood Entertainment Corporation, 2003), 18.

64. Some of these are Martin Connors and Hilary Weber, eds., *VideoHound's Idiot's Delight: The 100 Dumbest Movies of All Time* (Detroit: Visible Ink Press, 1995); Carol Forget, *VideoHound's Laugh Lines: Quips, Quotes, and Clever Comebacks*, edited by Hilary Weber (Detroit: Visible Ink Press, 1995); Carol Schwartz, ed., *VideoHound's Sci-Fi Experience: Your Quantum Guide to the Video Universe* (Detroit: Visible Ink Press, 1996); Martin F Kohn, ed., *VideoHound's Family Video Guide* (Detroit: Visible Ink Press, 1996); J. Gordon Melton, *VideoHound's Vampires on Video* (Detroit: Visible Ink Press, 1997); Mike Mayo, *VideoHound's Horror Show: 999 Hair-Raising, Hellish, and*

Humorous Movies (Detroit: Visible Ink Press, 1998); Glenn Hopp, *VideoHound's Epics: Giants of the Big Screen* (Detroit: Visible Ink Press, 1998); Elliot Wilhelm, *VideoHound's World Cinema: The Adventurer's Guide to Movie Watching* (Detroit: Visible Ink Press, 1998); Mike Mayo, *VideoHound's War Movies: Classic Conflict on Film* (Detroit: Visible Ink Press, 1999); Monica Sullivan, *VideoHound's Independent Film Guide* (Detroit: Visible Ink Press, 1999); Carol Schwartz and Jim Olenski, eds., *VideoHound's Cult Flicks and Trash Pics* (Detroit: Visible Ink Press, 2001); Brian Thomas, *VideoHound's Dragon: Asian Action & Cult Flicks* (Detroit: Visible Ink Press, 2003); Irv Slifkin, *VideoHound's Groovy Movies: Far-Out Films of the Psychedelic Era* (Detroit: Visible Ink Press, 2004).

65. Nancy Peske and Beverly West, Introduction to *Advanced Cinematherapy: The Girl's Guide to Finding Happiness One Movie at a Time* (New York: Dell, 2002), xi.

66. Ibid.

67. Tom Sabulis, "A Peeping Tom's Guide to Home Video," *Toronto Star*, 26 Aug. 1989; Craig Hosoda, *The Bare Facts Video Guide*, 3rd ed. (Santa Clara, CA: Bare Facts, 1992); Craig Hosoda, "Welcome to Bare Facts," Barefacts.com, accessed 3 Apr. 2013, www.barefacts.com/intro.html.

68. Catherine Foley and Milos Stehlik, eds., *Facets Video Encyclopedia* (Chicago: Academy Chicago Publishers, 1998).

69. Kevin Shannon, "Introduction / User's Guide," in *The Scarecrow Video Movie Guide* (Seattle: Sasquatch Books, 2004), xvii.

70. Steven Rea, "Leonard Maltin's Exhaustive 'Movie and Video Guide' Goes High-Tech," *Salt Lake Tribune*, 16 Oct. 1994, E2.

71. Maltin also put out his guide on floppy discs in 1994, which allowed for a greater number of search criteria and capabilities. Ibid.

72. Chris McGowan, "'VideoHound' Bow-Wows on CD-ROM," *Billboard* 105, no. 39 (25 Sept. 1993): 75.

73. Dan Smith, "Video Guide Does Little to Help the Clueless," *Orlando Sentinel*, 10 May 1996.

74. James Coates, "Movie Guides on Disc Entertain, Teach," *Chicago Tribune*, 27 May 1994, 65.

75. Coates also stated that *VideoHound* provided the best hyptertexting of the three movie guides he reviewed. Ibid.

76. Apparently these CD-ROMS were troubled by issues of speed, as it could take some time to go from entry to entry or find the results of your search because your computer may have had less memory or a slower-playing CD-ROM drive. "Don't Discard Your Movie Books Yet," *Austin American Statesman*, 15 July 1994.

77. Peter M. Nichols, "Lights, Camera, Surf for Film Buffs," *New York Times*, 21 Oct. 1996.

78. Smith, "Video Guide Does Little to Help the Clueless"; McGowan, "'VideoHound' Bow-Wows on CD-ROM"; "Don't Discard Your Movie Books Yet."

79. Cade Metz, "The Flick Files; Inside the making of the Internet Movie Database," *PC Magazine* 23, no. 13 (3 Aug. 2004): 60; Richard Siklos, "From a Small Stream, a Gusher of Movie Facts," *New York Times*, 28 May 2006.

80. Peter M. Nichols, "Lights, Camera, Surf for Film Buffs," *New York Times*, 21 Oct. 1996; Amy Kaufman, "Company Town; Facetime; His film database informs millions; Col Needham's boyhood obsession of compiling details of movies and actors led to IMDb.com, a go-to resource for fans," *Los Angeles Times*, 14 Oct. 2010.

81. Metz, "The Flick Files."

82. Ibid.

83. Ibid.

84. Ibid.

85. Ibid..

86. Noam Cohen, "Obsession with Minutiae Thrive as Databases," *New York Times*, 3 Oct. 2010; Siklos, "From a Small Stream, a Gusher of Movie Facts."

87. Ted Fry, "Site Seeing," *Seattle Times*, 14 Apr. 1996.

88. Metz, "The Flick Files."

89. Fry, "Site Seeing."

90. Ibid.

91. Kaufman, "Company Town; Facetime." IMDb continued to draw from user-submitted information even after it became a commercial enterprise. Nichols, "Lights, Camera, Surf for Film Buffs." As of 2010, however, most of the "users" that submitted such data were increasingly media professionals, including agents and publicists. Cohen, "Obsession with Minutiae Thrive as Databases."

92. Nichols, "Lights, Camera, Surf for Film Buffs"; Kaufman, "Company Town; Facetime."

93. Nichols, "Lights, Camera, Surf for Film Buffs."

94. Peter M. Nichols, "If It's on Video, You Can Find It Someplace in your Computer," *New York Times*, 7 June 2000.

95. Cohen, "Obsession with Minutiae Thrive as Databases."

96. Nichols, "If It's on Video, You Can Find It Someplace in your Computer."

97. David Pogue, "When Movies Don't Live Up to the Trailer," *New York Times*, 3 Jan. 2008, accessed 8 Jan. 2013, http://pogue.blogs.nytimes. com/2008/01/03/when-movies-dont-live-up-to-the-trailer/?scp = 7&sq = %22Internet+movie+database%22&st = nyt.

98. Fry, "Site Seeing."

99. The list comprises a mix of contemporary hits and acknowledged classics. Interestingly, most films that are "classics" typically have significantly fewer votes than the "hits," yet their scores are remarkably high, suggesting that the fans of these films are few but especially devoted and aligned in their admiration. For instance, as of 10 January 2012, *The Dark Knight Rises* (2012) was ranked #40 and had an 8.5 rating based on 510,813 votes, while *City Lights* (1931) was ranked #41 with an 8.5 rating based on 52,070 votes. www.IMDb.com/chart/top.

100. Fry, "Site Seeing."

101. Peter M. Nichols, "Home Video; Amazon Joins the Film Fray," *New York Times*, 20 Nov. 1998.

102. Siklos, "From a Small Stream, a Gusher of Movie Facts"; Metz, "The Flick Files."

103. Siklos, "From a Small Stream, a Gusher of Movie Facts."

104. Nichols, "Lights, Camera, Surf for Film Buffs."

105. Richard Siklos, "Amazon Considering Downloads," *New York Times*, 10 Mar. 2006.

106. IMDb operated relatively independently from Amazon, and Needham has stayed with the company as managing director. Metz, "The Flick File"; Siklos, "From a Small Stream, a Gusher of Movie Facts."

107. Siklos, "From a Small Stream, a Gusher of Movie Facts."

108. Quoted in Cohen, "Obsession with Minutiae Thrive as Databases."

109. Ryan Nakashima, "IMDb Turns 20 with a Refreshed, Video-Full Website," *Seattle Times*, 28 Sept. 2010.

110. Richard Siklos, "From a Small Stream, a Gusher of Movie Facts." In addition, the subscription site IMDb Pro was put online in 2002, designed to be used by media professionals; it features details about films and television programs currently in production and has contact information for leading agencies, studios, and production companies. One article suggested that IMDb Pro would replace trade publications much in the way the primary database eclipsed print-based movie encyclopedias, saying, "Forget Variety. All you need is the IMDb." Metz, "The Flick Files."

111. Anonymous, "Amazon.com Launches Amazon Unbox™, a Digital Video Download Service with DVD-Quality Picture," *Business Wire*, 7 Sept. 2006; Anonymous, "Amazon.com Launches Amazon Studios—A New Online Business to Discover New Talent and Develop Motion Pictures," *Business Wire*, 17 Nov. 2010.

112. For an astute discussion of how video technologies have been ensnarled in copyright issues over the past forty years, see Lucas Hilderbrand, *Inherent Vice: Bootleg Histories of Videotape and Copyright* (Durham, NC: Duke University Press, 2009).

113. Stephen Prince, *A New Pot of Gold: Hollywood under the Electronic Rainbow, 1980–1989* (Berkeley: University of California Press, 2002), 99.

114. Grace Wayne Jones, "Irishman Finds Multimillion Dollar Answer to Video Piracy," *Irish Times*, 29 July 1986.

115. Roderick Woodcock, "Second Look: Macrovision," *Video* 11, no. 2 (May 1987): 34.

116. Hilderbrand, *Inherent Vice*, 106. Wasko details how the MPAA tried to make it law that anti-copying devices had to be installed in all VCRs. She also looks at some of the more extreme technologies that have been implemented to track and limit the amount of times a videotape can be played. Janet Wasko, *Hollywood in the Information Age: Beyond the Silver Screen* (Austin: University of Texas Press: 1994), 134–35. Stephen Prince also describes these "counter" systems in *A New Pot of Gold*, 107.

117. Wayne Jones, "Irishman Finds Multimillion Dollar Answer to Piracy."
118. Ibid.
119. "The Copy-Cat Killer," *Screen International,* 6 Nov. 1992, 13.
120. Sean Scully, "New Chip to Foil Home PPV Taping," *Broadcasting & Cable*123, no. 17 (26 Apr. 1993): 33.
121. "Macrovision Introduces Anti-Piracy CD-ROM Solution," *CD Computing News* 12, no. 10 (1 Oct. 1998).
122. "Macrovision Announces SafeDisc Production Release," *Business Wire,* 4 Sept. 1998.
123. "Macrovision Equips Leading Software Companies with Strategic Licensing Solutions as IT Spending Rebounds in 2004," *Business Wire,* 23 Feb. 2004.
124. "President Clinton Signs Digital Millennium Copyright Act," *Business Wire,* 30 Oct. 1998.
125. "Joint Study of Section 1201(g) of The Digital Millennium Copyright Act." copyright.gov, May 2000, accessed 10 Jan. 2013, www.copyright.gov /reports/studies/dmca_report.html.
126. "Macrovision DVD Licensing Program Reaches Historic Milestone; DVD Copy Protection Now Licensed to 100 DVD Manufacturers," *Business Wire,* 19 Apr. 1999.
127. "RipGuard DVD Is World's First Rip Control Product to Feature THX Verified Status," Macrovision: Press Release, 15 Feb. 2005, accessed 27 Dec. 2012, webarchive.org, http://web.archive.org/web/20071013170824 /http://macrovision.com/company/newscenter/pressreleases/1434_ pr2005_11.htm.
128. Petteri Pyyny, "DVD Decrypter to Be Removed," *News by Afterdawn,* 24 Nov. 2005, accessed 27 Dec. 2012, www.afterdawn.com/news/article. cfm/2005/11/24/dvd_decrypter_to_be_removed.
129. Brian J. Bowe, "Make It or Break It: How a Small-Town Music Fetishist Turned an Obsession into a Multimillion-Dollar All Media Guide," *Metro Times* (Detroit), 24 Jan. 2007, accessed 13 Nov. 2012, www2.metrotimes.com /editorial/story.asp?id = 10087.
130. Ibid.
131. Ibid.
132. Ibid.
133. Ibid. In 1996 Alliance Entertainment, a distributor of music and movies, purchased AMG for $3.5 million.
134. Ibid.
135. It was acquired by Yucaipa, a private equity fund, in the same year. Ibid.
136. "AMG and QNX Demonstrate Latest Digital Media Capabilities at CES," *PR Newswire,* 5 Jan. 2006; "AMG LASSO Music Media Recognition Service Adopted for PLAYSTATION(R)3," *PR Newswire,* 17 Nov. 2006; "AMG LASSO (TM) Adopted for Sony's Home Entertainment Server," *PR Newswire,* 6 Sept. 2007.

137. The primary competitor in this market is Gracenote, formerly known as the Compact Disc Data Base (CDDB), used by Apple for the iTunes platform. Unlike the Gracenote system, LASSO is able to recognize individual songs by identifying sound wave characteristics. Bowe, "Make It or Break It."

138. Ibid.

139. Ibid.

140. Ibid.

141. This publication began as *TeleVision Guide* in 1948 and appeared as a national publication, under the current name, in 1953. Diane Wertz, "A Small Wonder, TV Guide Is Now Living Large, But Its Best Days Were When Size (and Glitz) Didn't Matter," *Newsday*, 16 Oct. 2005.

142. "Macrovision Agrees to Acquire Gemstar-TV Guide," *Fair Disclosure Wire*, 7 Dec. 2007.

143. Ibid.

144. Moreover, this guide provides a list of video distributors so that readers can try to find what they desire. Interestingly, the guide notes when a movie is no longer being distributed on video. It states, "Since a title enjoying this status was once distributed, it may well linger on your local video store shelf." *VideoHound's Golden Movie Retriever* (Detroit: Visible Ink, 1995), 1569.

145. Bowe, "Make It or Break It."

146. As of 2007, when it was the headquarters for AMG, there were about 150 people in this location. Ibid.

147. Daniel Chamberlain, "Scripted Spaces: Television Interfaces and the Non-Places of Asynchronous Entertainment," in *Television as Digital Media*, edited by James Bennett and Niki Strange (Durham, NC: Duke University Press, 2011), 230–54.

148. Anonymous, "TV Guide Gets Haircut—Circulation at Weekly to Be Cut by 30% to 2M," *New York Post*, 13 Sept. 2009.

149. *Bare Facts* author Craig Hosoda maintained a website for a short time after the turn of the millennium through which he sold copies of his book. Barefacts.com, accessed 3 Apr. 2013, www.barefacts.com.

CODA

1. Within the growing subfield of eco-cinema studies, there are a number of works that look explicitly at the media industries' production of waste. Much of this work focuses on television and digital technologies and commonly details how this garbage is disproportionately located in developing nations. A few of such works are Nadia Bozak, *The Cinematic Footprint: Lights, Camera, Natural Resources* (New Brunswick, NJ: Rutgers University Press, 2012); Richard Maxwell and Toby Miller, *Greening the Media* (Oxford: Oxford University Press, 2012); Lisa Parks, "Falling Apart: Electronics Salvaging and the Global Media Economy," in *Residual Media*, edited by Charles Acland (Minneapolis: University of Minnesota Press, 2007), 32–47; Jonathan Sterne, "Out with the Trash: On the Future of New Media," in Acland, *Residual Media*, 16–31.

2. Jonathan Gaw, "The Spine of the Ingram Empire," *Los Angeles Times,* 6 June 1999.

3. Kelly Lane, "Video Chain Founder Went against Advice," *Sun Sentinel* (Ft. Lauderdale), 19 June 1988; Daniel Cuff, "Head of Video Chain Expects Consolidation," *New York Times,* 13 June 1988.

4. Lane, "Video Chain Founder Went against Advice."

5. Sasha Pardy, "Movie Gallery Files for Bankruptcy, Closes 800+ Stores," CoStar.com, 3 Feb 2010, accessed 29 Dec. 2012, www.costar.com/News/Article /Movie-Gallery-Files-Bankruptcy-Closing-800+-Stores/118067.

6. Kevin Barrett, "Video Chain Eager for Expansion into Lisle," *Daily Herald* (Arlington Heights, IL), 3 May 1998; Peter Rebhaun, "Family Video to Build Store," *Green Bay Press Gazette,* 16 Aug. 2000; Jennifer Netherby, "Family Video," *Video Business* 24, no. 51 (20 Dec. 2004): 20.

7. William Mussetter, "Family Video Opens along Broadway," *Quincy Herald-Whig,* 31 Oct. 1996; Steve Tarter, "Changes Are in Store for Video Industry," *McClatchy-Tribune Business News,* 1 Apr. 2003; Jennifer Netherby, "More Mouths to Feed: Family Video Growing up Fast," *Video Business* 24, no. 3 (19 Jan. 2004).

8. Stephanie Irwin, "Family Video Expanding," *Dayton Daily News,* 26 June 2005.

9. Anonymous, "2006 Ernst and Young Entrepreneur of the Year: Charles R. Hoogland," *Smart Business* (Chicago) 3, no. 9 (1 July 2006): S13; Jaclyn Giovis, "Family Video Adds Outlet," *Dayton Daily News,* 19 Aug. 2004; Mussetter, "Family Video Opens along Broadway."

10. Andrew Chow, "Family Video to Open 2 Fairborn Stores," *Dayton Daily News,* 20 Jan. 2001; Gregory Weaver, "Video Chain Quietly Expands," *Indianapolis Star,* 20 Feb. 2003; Giovis, "Family Video Adds Outlet."

11. Steve Tarter, "Changes Are in Store for Video Industry."

12. Netherby, "Family Video."

13. As of 1996, there were merely eighty Family Video stores. Mussetter, "Family Video Opens along Broadway."

14. Representatives from one location reported in 1998 that it rented about seven hundred adult movies per month and earned between 10 and 20 percent of its overall revenue from adult movies. Robert Goodrich, "Belleville Jury Rules Two Videos Are Obscene, Store Is Fined for Renting Movies," *St. Louis Post-Dispatch,* 9 Oct. 1998; Roy Malone, "Chain to Keep Adult Movies in Belleville Stores," *St. Louis Post-Dispatch,* 13 Oct. 1998. This practice occasionally caused legal and public relations troubles for individual Family Video locations, but the company held firm in carrying adult tapes. Goodrich, "Belleville Jury Rules Two Videos Are Obscene"; Roy Malone, "Belleville Stores Still Rent X-Rated Videos, Despite Fines Levied in Obscenity Decision," *St. Louis Post-Dispatch,* 10 Oct. 1998.

15. Barrett, "Video Chain Eager for Expansion into Lisle."

16. Netherby, "More Mouths to Feed: Family Video Growing up Fast"; Netherby, "Family Video."

17. Tarter, "Changes Are in Store for Video Industry"; Netherby, "More Mouths to Feed: Family Video Growing up Fast."

18. Gregory Weaver, "Video Chain Quietly Expands."

19. Mussetter, "Family Video Opens along Broadway"; Netherby, "Family Video"; Anonymous, "2006 Ernst and Young Entrepreneur of the Year."

20. "Locate a Retail Space," FamilyVideo.com, accessed 13 May 2012, www.familyvideo.com/property.php?source = gateway.

21. Heidi Prescott, "Family Video, Landlord," *South Bend Tribune*, 17 Apr. 2009.

22. One report stated that the properties earned back the initial investment amount within five years of being purchased. Anonymous, "2006 Ernst and Young Entrepreneur of the Year."

23. Ibid.

24. In the early 2000s, for instance, Family Video began selling dial-up Internet service requiring no contract. This service was aimed at "a demographic that can only afford the internet sporadically." Kelly Lantau, "Video Store Makes the Cut in Twin Cities," *Pantagraph* (Bloomington, IL), 19 Feb. 2000; Giovis, "Family Video Adds Outlet"; Irwin, "Family Video Expanding." More recently, the company has started a new chain of fitness gyms, Stay Fit 24, next door to many of their video stores. Prescott, "Family Video, Landlord." In early 2012, Family Video invested $100 million in the already existing Marco's Pizza franchise, intending to open around 250 such locations next door to or very near its video rental stores over the next four years. Kathy Bergen, "Family Video Partners with Marco's Pizza Chain," *McClatchy-Tribune Business News*, 10 Feb. 2012. There are already 280 Marco's Pizza locations in existence.

25. Pardy, "Movie Gallery Files for Bankruptcy."

26. "Historical Data Tabulations by Enterprise Size—1998," *Statistics of U.S. Businesses*, accessed 15 Aug. 2012, www.census.gov//econ/susb/data/susb1998.html.

27. "Historical Data Tabulations by Enterprise Size—2010," *Statistics of U.S. Businesses*, accessed 15 Aug. 2012, www.census.gov//econ/susb/data/susb2010.html.

28. As part of the research for his book, Joshua Greenberg created the Video Store Project, a website that gathered a huge number of personal memories of video stores operating between 1975 and 1990 from owners, clerks, and customers. Although the website was inactive at the time of writing, it provided a treasure trove of amazing insights and novel tidbits about video store culture as it once was. http://echo.gmu.edu/old/workshops/jgreenberg/.

29. Eric Piepenburg, "Like the Best Zombies, VHS Just Won't Die," *New York Times*, 26 Oct. 2011, accessed 29 Dec. 2012, www.nytimes.com/2011/10/30/movies/horror-film-goes-back-to-vhs-tape.html?_r = 2&hpw&.

30. Iain Robert Smith discusses the online fetishization of material video "trash," in "Collecting the Trash: The Cult of the Ephemeral Clip from VHS to YouTube," *FLOW*, 16 Sept. 2011, flowtv.org/2011/09/collecting-the-trash.

31. "About," *VHSCollector.com: Your Analogue Video Resource,* accessed 29 Dec. 2012, http://vhscollector.com/content/about.

32. VHShitfest.com, accessed 29 Dec. 2012, www.vhshitfest.com /post/14988842910/interview-with-author-and-actor-david-henry-sterry.

33. Jeff Scheible discusses similar cultural practices as a kind of "redistribution" of video and video culture in chapter 4 of his dissertation. He also presented material from this chapter at the 2010 Society of Cinema and Media Studies Conference. Jeff Scheible, "Digital Contingencies: Textuality and Moving Image Cultures after New Media" (PhD diss., University of California, Santa Barbara, 2011); Jeff Scheible, "Video Store Closures: Field Notes on the Death of Cinema," paper presented at the Society for Cinema and Media Studies conference, Los Angeles, 20 Mar. 2010.

34. "Best Video Store—2012: Video Free Brooklyn," *Village Voice,* accessed 30 Dec. 2012, www.villagevoice.com/bestof/2012/award/best-video-store-3764579/#livefyre.

35. "Video Free Brooklyn," accessed 30 Dec. 2012, Indiegogo.com, www .indiegogo.com/vfb.

36. Ibid.

Selected Bibliography

This bibliography includes all academic publications and all vital corporate documents. Because this book draws from hundreds of individual articles from newspapers and trade publications that are cited in my notes, I list only some of the most crucial of these here.

Acland, Charles. "Introduction: Residual Media." In *Residual Media*, edited by Charles Acland, xiii–xxvii. Minneapolis: University of Minnesota Press, 2007.

————. *Screen Traffic: Movies, Multiplexes, and Global Culture*. Durham, NC: Duke University Press, 2003.

————. "Theatrical Exhibition: Accelerated Cinema." In *The Hollywood Contemporary Film Industry*, edited by Paul McDonald and Janet Wasko, 83–105. Malden, MA: Blackwell, 2008.

Advokat, Stephen. "Add 'Movie Mad' to Detroit Passions." *Video Store*, November 1990.

Alilunas, Peter. "Smutty Little Movies: The Creation and Regulation of Adult Video, 1976–1986." Ph.D. diss., University of Michigan, 2013.

Allen, Robert C. "Relocating American Film History: The 'Problem' of the Empirical." *Cultural Studies* 20, no. 1 (January 2006): 64–65.

Alvarado, Manuel, ed. *Video Worldwide: An International Study*. London: John Libbey, 1988.

Anderson, Chris. "The Long Tail." *Wired*, October 2004. Accessed 2 May 2010. www.wired.com/wired/archive/12.10/tail.html.

————. *The Long Tail: Why the Future of Business Is Selling Less of More*. New York: Hyperion, 2006.

An Annual Report on the Home Entertainment Industry, 1999. Video Software Dealers Association, 1999.

Andrews, David. "Toward an Inclusive, Exclusive Approach to Art Cinema." In *Global Art Cinema: New Theories and Histories*, edited by Rosalind Galt and Karl Schoonover, 62–74. New York: Oxford University Press, 2010.

Appadurai, Arjun. *Modernity at Large: Cultural Dimensions of Globalization.* Minneapolis: University of Minnesota Press, 1996.

Armes, Roy. *On Video.* London: Routledge, 1988.

Arnold, Thomas K. "Regions: Atlanta's Ready for Peaches and Cream." *Video Store,* October 1991.

Askew, Kelly. Introduction to *The Anthropology of Media: A Reader,* edited by Kelly Askew and Richard R. Wilk, 1–13. Malden, MA: Blackwell, 2002.

Beasley-Murray, Jon. "Value and Capital in Bourdieu and Marx." In *Pierre Bourdieu: Fieldwork in Culture,* edited by Nicholas Brown and Imre Szeman, 100–119. Lanham, MD: Rowman and Littlefield, 2000.

Beebe, Roger. "Pedagogical Spaces, or, What We've Lost in the Post-Video-Store Era." *Media Fields Journal: Critical Explorations in Media and Space* 1 (2010). Accessed 3 May 2012. www.mediafieldsjournal.org/pedagogical-spaces.

Belton, John. *Widescreen Cinema.* Cambridge, MA: Harvard University Press, 1992.

Bennett, James, and Tom Brown, eds. *Film and Television after DVD.* New York: Routledge, 2008.

Benson-Allott, Caetlin. *Killer Tapes and Shattered Screens: Video Spectatorship from VHS to File Sharing.* Berkeley: University of California Press, 2013.

Bergman, Adam. "The Alternatives." *Los Angeles Times,* 15 October 2003.

Blay, Andre. *Pre-Recorded History: Memoirs of an Entertainment Entrepreneur.* Centennial, CO: Deer Track Publishing, 2010.

Bourdieu, Pierre. *Distinction: A Social Critique of the Judgment of Taste.* Translated by Richard Nice. Cambridge, MA: Harvard University Press, 1984.

———. *The Field of Cultural Production.* New York: Columbia University Press, 1993.

———. "The Forms of Capital." In *Handbook of Theory and Research for the Sociology of Education,* edited by John G. Richardson, 241–58. New York: Greenwood Press, 1986.

Boyle, Virginia, ed. *Facets Non-Violent, Non-Sexist Children's Video Guide.* Chicago: Academy Chicago Publishers, 1996.

Bozak, Nadia. *The Cinematic Footprint: Lights, Camera, Natural Resources.* New Brunswick, NJ: Rutgers University Press, 2012.

Braddock, Jeremy, and Stephen Hock, eds. *Directed by Alan Smithee.* Minneapolis: University of Minnesota Press, 2001.

Brass, Kevin. "Regions; Frisco Video: Complex Culture." *Video Store,* May 1990.

Brooker, Will, and Deborah Jermyn, eds. *The Audience Studies Reader.* London: Routledge, 2003.

Caldwell, John Thornton. *Production Culture: Industrial Reflexivity and Critical Practice in Film and Television.* Durham, NC: Duke University Press, 2008.

Cashmore, Ellis. *. . . And There Was Television.* New York: Routledge, 1994.

Certeau, Michel de. *The Practice of Everyday Life*. Translated by Steven Rendall. Berkeley: University of California Press, 1984.

Chamberlain, Daniel. "Scripted Spaces: Television Interfaces and the Non-Places of Asynchronous Entertainment." In *Television as Digital Media*, edited by James Bennett and Niki Strange, 230–54. Durham, NC: Duke University Press, 2011.

Christopherson, Susan. "Divide and Conquer: Regional Competition in a Concentrated Media Industry." In *Contracting out Hollywood: Runaway Productions and Foreign Location Shooting*, edited by Greg Elmer and Mike Gasher, 21–40. Lanham, MD: Rowman and Littlefield, 2005.

Cohen, Lizbeth. *A Consumer's Republic: The Politics of Mass Consumption in Postwar America*. New York: Vintage, 2003.

Coman, Mihai, and Eric W. Rothenbuhler. "The Promise of Media Anthropology." In *Media Anthropology*, edited by Eric W. Rothenbuhler and Mihai Coman, 1–11. Thousand Oaks, CA: Sage, 2005.

Compare, Derek. *Rerun Nation: How Repeats Invented American Television*. New York: Routledge, 2005.

Connors, Martin, and Julia Furtaw, eds. *VideoHound's Golden Movie Retriever*. Detroit: Visible Ink, 1995.

Corbin, Adriene D. "Regions; St. Louis: Supermarkets and a Changing Economy." *Video Store*, November 1988.

Corrigan, Timothy. *A Cinema without Walls: Movies and Culture after Vietnam*. New Brunswick, NJ: Rutgers University Press, 1991.

Cotner, David. "Watching the Apocalypse." *LA Weekly*, 4 October 2007.

Couldry, Nick, and Anna McCarthy. "Introduction: Orientations: Mapping MediaSpace." In *Mediaspace: Place, Scale and Culture in a Media Age*, edited by Nick Couldry and Anna McCarthy, 1–18. London: Routledge, 2004.

Craft, Matthew. "George Latsios: 1958–2003; Scarecrow Video Founder Did 'Whatever He Felt.'" *Seattle Post-Intelligencer*, March 13, 2003.

Cubitt, Sean. *Timeshift: On Video Culture*. London: Routledge, 1991.

Curtin, Michael. "Media Capitals: Cultural Geographies of Global TV." In *Television after TV: Essays on a Medium in Transition*, edited by Lynn Spigel and Jan Olsson, 270–302. Durham, NC: Duke University Press, 2004.

———. *Playing to the World's Biggest Audience: The Globalization of Chinese Film and TV*. Berkeley: University of California Press, 2007.

Dana, James D., and Kathryn E. Spier. "Revenue Sharing and Vertical Control in the Video Rental Industry." *Journal of Industrial Economics* 49, no. 3 (2001): 223–45.

Dawson, Max. "Home Video and the 'TV Problem': Cultural Critics and Technological Change." *Technology & Culture* 48, no. 3 (July 2007): 524–49.

Debord, Guy-Ernst. "Introduction to a Critique of Urban Geography." In *Situationist International Anthology*, translated and edited by Ken Knabb, 8–11. New York: Bureau of Public Secrets, 2002.

Desser, David, and Garth S. Jowett. Introduction to *Hollywood Goes Shopping,* edited by David Desser and Garth S. Jowett, xi–xxi. Minneapolis: University of Minnesota Press, 2000.

Dobrow, Julia, ed. *Social and Cultural Aspects of VCR Use.* Hillsdale, NJ: Lawrence Erlbaum, 1990.

Donahue, Suzanne Mary. *American Film Distribution: The Changing Marketplace.* Ann Arbor, MI: UMI Research Press, 1987.

Elberse, Anita. "Should You Invest in the Long Tail?" *Harvard Business Review* 86, nos. 7–8 (July–August 2008): 88–96.

Elwes, Catherine. *Video Art: A Guided Tour.* New York: Palgrave Macmillan, 2005.

Falk, Pasi, and Colin Campbell. Introduction to *The Shopping Experience,* edited by Pasi Falk and Colin Campbell, 1–14. London: Sage, 1997.

Farber, Manny. *Negative Space: Manny Farber on the Movies.* New York: Praeger, 1971.

Fitzpatrick, Eileen. "Distributors Call for Copy-Depth Reform." *Billboard,* 15 May 1999.

Foley, Catherine, and Milos Stehlik, eds. *Facets Video Encyclopedia.* Chicago: Academy Chicago Publishers, 1998.

Friedberg, Anne. *Window Shopping: Cinema and the Postmodern.* Berkeley: University of California Press, 1994.

Fuller-Selley, Kathryn H., and George Potamianos. "Introduction: Researching and Writing the History of Local Moviegoing." In *Hollywood in the Neighborhood: Historical Case Studies of Local Moviegoing,* edited by Kathryn H. Fuller-Seeley, 3–19. Berkeley: University of California Press, 2008.

Furnham, Adrian. *Lay Theories: Everyday Understandings of Problems in the Social Sciences.* Oxford: Pergamon, 1988.

Ganley, Gladys, and Oswald Ganley. *Global Political Fallout: The First Decade of the VCR, 1976–1985.* Cambridge, MA: Harvard University Press, 1987.

Garnham, Nicholas. *Capitalism and Communication: Global Culture and the Economics of Information.* Edited by Fred Inglis. London: Sage, 1990.

Gay, Paul du, Stuart Hall, Linda Janes, Hugh Mackay, and Keith Negus. *Doing Cultural Studies: The Story of the Sony Walkman.* London: Sage, 1997.

Genette, Gérard. *Palimpsests: Literature in the Second Degree.* Translated by Channa Newman and Claude Dubinsky. Lincoln: University of Nebraska Press, [1982] 1997.

Glickman, Lawrence B., ed. *Consumer Society in America: A Reader.* Ithaca, NY: Cornell University Press, 1999.

"Going to Video Extremes in Cinephile's Oasis: 'We have one copy of "Rambo: First Blood Part II," and I'm surprised we have that many.'" *Los Angeles Times,* 7 August 1988.

Gomery, Douglas. *Shared Pleasures: A History of Movie Presentation in the United States.* Foreword by David Bordwell. Madison: University of Wisconsin Press, 1992.

Gray, Ann. *Video Playtime: The Gendering of a Leisure Technology.* London: Routledge, 1992.

Gray, Jonathan. *Show Sold Separately: Promos, Spoilers, and Other Media Paratexts.* New York: New York University Press, 2010.

Green, William R. *The Retail Store: Design and Construction.* New York: Van Nostrand Reinhold, 1986.

Greenberg, Joshua. *From Betamax to Blockbuster: Video Stores and the Invention of Movies on Video.* Cambridge, MA: MIT Press, 2008.

Guerassio, Jason. "Facets Multi Media." *Independent Film and Video Monthly,* July–August 2003.

Guest, Haden. "Experimentation and Innovation in Three American Film Journals of the 1950s." In *Inventing Film Studies,*e dited by Lee Grieveson and Haidee Wasson, 235–63. Durham, NC: Duke University Press, 2008.

Hall, Doug, and Sally Jo Fifer, eds. *Illuminating Video: An Essential Guide to Video Art.* New York: Aperture Books, 1991.

Halliwell, Leslie. *The Filmgoer's Companion.* 6th ed. New York: Hill and Wang, 1977.

———. *Halliwell's Film Guide: A Survey of 8,000 English-Language Movies.* London: Granada Publishing, 1977.

Hammond, Edward. *Store Interior Planning and Display.* London: Blandford Press, 1939.

Hansen, Miriam. *Babel & Babylon: Spectatorship in American Silent Film.* Cambridge, MA: Harvard University Press, 1991.

Hark, Ina Rae, ed. *Exhibition: The Film Reader.* New York: Routledge, 2002.

Harvey, David. *The Condition of Postmodernity: An Inquiry into the Origins of Cultural Change.* Cambridge, MA: Blackwell, 1990.

———. *Spaces of Global Capitalism: Towards a Theory of Uneven Geographical Development.* London: Verso, 2006.

Hesmendalgh, David. *The Cultural Industries.* 2nd ed. London: Sage, 2007.

Hetherington, Kevin. *Capitalism's Eye: Cultural Spaces of the Commodity.* New York: Routledge, 2007.

Hilderbrand, Lucas. "The Art of Distribution: Video on Demand." *Film Quarterly* 64, no. 2 (2010): 24–28.

———. "Eddie Brandt's Saturday Matinee: An Accidental Institution." *Spectator: The University of Southern California Journal of Film and Television Criticism* 27, no. 1 (Spring 2007): 42–47.

———. *Inherent Vice: Bootleg Histories of Videotape and Copyright.* Durham, NC: Duke University Press, 2009.

Hilmes, Michel. *Hollywood and Broadcasting: From Radio to Cable.* Urbana: University of Illinois Press, 1999.

Holt, Jennifer. *Empires of Entertainment.* New Brunswick, NJ: Rutgers University Press, 2011.

Holt, Jennifer, and Alisa Perren. "Introduction: Does the World Really Need One More Field of Study?" In *Media Industries: History, Theory, and Method,* edited by Jennifer Holt and Alisa Perren, 1–16. Malden, MA: Wiley-Blackwell, 2009.

The Home Video Market: 1997. n.p.: Video Software Dealers Association, 1997.

Horkheimer, Max, and Theodor Adorno. *Dialectic of Enlightenment*. Translated by John Cumming. New York: Continuum, 2002.

Hosoda, Craig. *The Bare Facts Video Guide*. 3rd ed. Santa Clara, CA: Bare Facts, 1992.

Iles, Chrissie, ed. *Into the Light: The Projected Image in Contemporary Art, 1964–1977*. New York: Whitney Museum of American Art, 2001.

Isael, Lawrence. *Store Planning/Design: History, Theory, Process*. New York: John Wiley & Sons, 1994.

Ith, Ian. "George Latsios, Who Started Revered Video Business, Dies at 44." *Seattle Times*. 8 March 2003.

James, David. *The Most Typical Avant-Garde: History and Geography of Minor Cinemas in Los Angeles*. Berkeley: University of California Press, 2005.

Jenkins, Henry. *Convergence Culture: Where Old and New Media Collide*. New York: New York University Press, 2006.

Johnson, R. J., and Ginger Myers. "Collector's Mementos of Silver Screen Turn to Gold." *Los Angeles Times*, 8 May 1986.

Kammen, Michael. *American Culture, American Tastes: Social Change in the 20th Century*. New York: Basic Books, 1999.

Kasler, Dale. "Reel Business—Video Distributor VPD Has Spliced Together a Going—and Growing—Concern, Despite Many Obstacles." *Sacramento Bee*, 31 August 1997.

Katz, Ephraim. *The Film Encyclopedia*. New York: Crowell, 1979.

Kendrick, James. "What Is the Criterion?: The Criterion Collection as an Archive of Film as Culture." *Journal of Film and Video* 53, no. 2–3 (Summer–Fall 2001): 124–39.

Kinder, Marsha. *Playing with Power in Movies, Television, and Video Games: From Muppet Babies to Teenage Mutant Ninja Turtles*. Berkeley: University of California Press, 1991.

Klinger, Barbara. *Beyond the Multiplex: Cinema, New Technologies, and the Home*. Berkeley: University of California Press, 2006.

Koszarski, Richard. *An Evening's Entertainment*. Berkeley: University of California Press, 1990.

Krauss, Rosalind. "Video: The Aesthetics of Narcissism." *October* 1 (Spring 1976): 50–64.

Krcmar, Marina, and Yuliya Strizhakova. "Mood Management and Video Rental Choices." *Media Psychology* 10, no. 1 (2007): 91–112.

Lafferty, William. "Feature Films on Prime-Time Television." In *Hollywood in the Age of Television*, edited by Tino Balio, 239–42. Boston: Unwin Hyman, 1990.

Lane, Kelly. "Video Chain Founder Went against Advice." *Sun Sentinel* (Ft. Lauderdale), 19 June 1988.

Laporte, Nicole. "The Video Store, Reinvented by Necessity." *New York Times*, 31 July 2011.

Lardner, James. *Fast Forward: Hollywood, the Japanese, and the Onslaught of the VCR.* New York: W.W. Norton, 1987.

Larkin, Brian. *Signal and Noise: Media, Infrastructure, and Urban Culture in Nigeria.* Durham, NC: Duke University Press, 2008.

Lattman, Peter, and Mike Spector. "Hollywood Video Closes Doors—Chain's Remaining U.S. Stores to Shutter as Consumers' Viewing Habits Change." *Wall Street Journal,* 3 May 2010.

Lefebvre, Henri. *The Production of Space.* Translated by Donald Nicholson-Smith. Malden, MA: Blackwell, 1991.

Lehmann-Haupt, Hellmut. *The Book in America: A History of the Making, the Selling, and the Collecting of Books in the United States.* New York: R.R. Bowker, 1939.

Levy, Mark, ed. *The VCR Age: Home Video and Mass Communication.* London: Sage, 1989.

Lobato, Ramon. *Shadow Economies of Cinema: Mapping Informal Film Distribution.* London: Palgrave Macmillan, 2012.

Lury, Celia. *Consumer Culture.* New Brunswick, NJ: Rutgers University Press, 1996.

Macy, Anne, and Neil Terry. "The Determinants of Movie Video Sales Revenue." *Journal of American Academy of Business, Cambridge* 15, no. 1 (2009): 16–23.

Maltin, Leonard, ed. *Leonard Maltin's Movie and Video Guide 1992.* New York: Plume, 1991.

Maltby, Richard, Melvyn Stokes, and Robert C. Allen, eds. *Going to the Movies: Hollywood and the Social Experience of the Cinema.* Exeter: University of Exeter Press, 2007.

Marx, Karl. *The Grundisse.* London: Penguin Books, 1993.

Massey, Doreen. *Space, Place, and Gender.* Minneapolis: University of Minnesota Press, 1994.

Maxwell, Richard, and Toby Miller. *Greening the Media.* Oxford: Oxford University Press, 2012.

Mayer, Vicki. *Below the Line: Producers and Production Studies in the New Television Economy.* Durham, NC: Duke University Press, 2011.

Mayer, Vicki, Miranda Banks, and John Thornton Caldwell, eds. *Production Studies: Cultural Studies of Media Industries.* New York: Routledge, 2009.

McCarthy, Anna. *Ambient Television: Visual Culture and Public Space.* Durham, NC: Duke University Press, 2001.

McDonald, Paul. *Video and DVD Industries.* London: British Film Institute, 2007.

McGrane, Bernard, and John Gunderson. "Consumerism TV." In *Watching TV Is Not Required,* 71–95. New York: Routledge, 2010.

Meigh-Andrews, Chris. *A History of Video Art: The Development of Form and Function.* Oxford: Berg, 2006.

Melnick, Ross, and Andreas Fuchs. *Cinema Treasures.* St. Paul, MN: MBI Publishing, 2004.

Metz, Cade. "The Flick Files; Inside the Making of the Internet Movie Database." *PC Magazine*, 3 August 2004.

Miller, Laura. *Reluctant Capitalists: Bookselling and the Culture of Consumption.* Chicago: University of Chicago Press, 2006.

Miller, Toby, Nitin Govil, John McMurria, and Richard Maxwell. *Global Hollywood.* London: British Film Institute, 2001.

Milne, Tom, ed. *The Time Out Film Guide.* London: Penguin Books, 1989.

Moldvay, Caitlin. "IBISWorld Industry Report 81219c: Tanning Salons in the US." IBISWorld Inc., July 2011.

Monush, Barry, ed. *International Television & Video Almanac.* 40th ed. New York: Quigley, 1995.

Moores, Shaun. *Interpreting Audiences: The Ethnography of Media Consumption.* London: Sage, 1993.

Moran, James. *There's No Place Like Home Video.* Minneapolis: University of Minnesota Press, 2002.

Morley, David. *Television, Audiences and Cultural Studies.* London: Routledge, 1992.

Mortimer, Julie Holland, Katherine Ho, Justin Ho, and Atish Sawant. "In the Video Rentals Industry: Positive or Negative?" *Yale Economic Review* 5, no. 2 (2009): 31–36.

Mun, David. *Shops: A Manual of Planning and Design.* London: Architectural Press, 1981.

Musser, Charles. *The Emergence of Cinema: The American Cinema to 1907.* Berkeley: University of California Press, 1994.

Nelson, Valerie J. "Eddie Brandt Dies at 90; Hollywood's Go-to Guy for Film History, Memorabilia." *Los Angeles Times*, 10 March 2011.

Netherby, Jennifer. "Family Video." *Video Business*, 20 December 2004.

Nichols, Peter M. "Lights, Camera, Surf for Film Buffs." *New York Times*, 21 October 1996.

Parks, Lisa. "Falling Apart: Electronics Salvaging and the Global Media Economy." In *Residual Media*, edited by Charles Acland. 32–47. Minneapolis: University of Minnesota Press, 2007.

Pegler, Martin M. *Retail Entertainment.* New York: Retail Reporting Corporation, 1998.

Perren, Alisa. "Rethinking Distribution for the Future of Media Industry Studies." *Cinema Journal* 52, no. 3 (Spring 2013): 165–71.

Peske, Nancy, and Beverly West. *Advanced Cinematherapy: The Girl's Guide to Finding Happiness One Movie at a Time.* New York: Dell, 2002.

Podesta, Patti, ed. *Resolution: A Critique of Video Art.* Los Angeles: Los Angeles Contemporary Exhibitions, 1986.

Polan, Dana. "Auteur Desire." *Screening the Past* 12 (March 2001). Accessed 15 November 2010. www.latrobe.edu.au/www/screeningthepast/firstrelease/fr0301/dpfr12a.htm.

Prince, Stephen. *A New Pot of Gold: Hollywood under the Electronic Rainbow, 1980–1989.* Berkeley: University of California Press, 2002.

Pustz, Matthew. *Comic Book Culture: Fanboys and True Believers*. Jackson: University Press of Mississippi, 1999.

Radway, Janice. *Reading the Romance: Women, Patriarchy, and Popular Literature*. Chapel Hill: University of North Carolina Press, 1991.

Randall, Laura. "Which Film Remake Is Next? Eddie Brandt Knows." *Christian Science Monitor*, 12 December 2003.

Renov, Michael, and Erika Suderberg, eds. *Resolutions: Contemporary Video Practices*. Minneapolis: University of Minnesota Press, 1995.

Rentrak Corp. May 26, 1995 Form 10-K405. Filed 29 Jun 1995. Via investor.rentrak.com. Accessed 25 June 2011.

Roberts, Jerry. *The Complete History of American Film Criticism*. Santa Monica, CA: Santa Monica Press, 2010.

Rush, Michael. *Video Art*. London: Thames & Hudson, 2003.

Sanjek, Russel, and David Sanjek. *American Popular Music Business in the 20th Century*. New York: Oxford University Press, 1991.

Sarris, Andrew. *The American Cinema: Directors and Directions, 1929–1968*. New York: Dutton, 1968.

———. "Notes on the Auteur Theory in 1962." In *Film Theory and Criticism: Introductory Readings*, edited by Gerald Mast and Marshall Cohen, 500–516. New York: Oxford University Press, 1974.

Sassen, Saskia. *The Global City: New York, London, and Tokyo*. 2nd ed. Princeton: Princeton University Press, 2001.

Schaefer, Peter D., and Meenakshi Gigi Durham. "On the Social Implications of Invisibility: The iMac G5 and the Effacement of the Technological Object." *Critical Studies in Media Communication* 24, no. 1 (2007): 39–56.

Scheible, Jeff. "Digital Contingencies: Textuality and Moving Image Cultures after New Media." PhD diss., University of California, Santa Barbara, 2011.

Scheuer, Steven H. *Movies on TV: 1975–1976 Edition*. New York: Bantam, 1974.

———. *Movies on TV: 1969–1970 Edition*. New York: Bantam, 1969.

Schilling, Mark. *Contemporary Japanese Film*. New York: Weatherhill, 1999.

Sconce, Jeffrey. "'Trashing' the Academy: Taste, Excess, and an Emerging Politics of Cinematic Style." *Screen* 36, no. 4 (Winter 1995): 371–93.

Scott, Allen J. *On Hollywood: The Place, The Industry*. Princeton: Princeton University Press, 2005.

Segrave, Kerry. *Drive-in Theaters: A History from Their Inception in 1933*. Jefferson, NC: McFarland, 1992.

———. *Suntanning in 20th-Century America*. Jefferson, NC: McFarland, 2005.

Seiter, Ellen. *Television and New Media Audiences*. Oxford: Oxford University Press, 1999.

Shapiro, Carl, and Hal Varian. *Information Rules: A Strategic Guide to the Network Economy*. Boston: Harvard Business School Press, 1999.

Siklos, Richard. "From a Small Stream, a Gusher of Movie Facts." *New York Times*, 28 May 2006.

Silverstone, Roger. "Television and Consumption." In *Television and Everyday Life*, 104–31. New York: Routledge, 1994.

Smith, Iain Robert. "Collecting the Trash: The Cult of the Ephemeral Clip from VHS to YouTube." *FLOW*, 16 September 2011, http://flowtv.org/2011/09/collecting-the-trash.

Soja, Edward. *Postmodern Geographies: The Reassertion of Space in Critical Social Theory*. London: Verso, 1989.

Spigel, Lynn. *Make Room for TV*. Chicago: University of Chicago Press, 1992.

———. "Television in the Family Circle." In *Logics of Television: Essays in Cultural Criticism*, edited by Patricia Mellencamp, 78–81. Bloomington: Indiana University Press, 1990.

Staff and Friends of Scarecrow Video. *The Scarecrow Video Movie Guide*. Seattle: Sasquatch Books, 2004.

Staiger, Janet. *Media Reception Studies*. New York: New York University Press, 2005.

Sterling, Christopher H., and John Michael Kittross. *Stay Tuned: A History of American Broadcasting*. 3rd ed. Mahwah, NJ: Lawrence Erlbaum, 2002.

Sterne, Jonathan. "Out with the Trash: On the Future of New Media." In *Residual Media*, edited by Charles Acland, 16–31. Minneapolis: University of Minnesota Press, 2007.

Stevens, Tracy, ed. *International Television & Video Almanac*. 48th ed. New York: Quigley, 2003.

Stewart, Jacqueline. *Migrating to the Movies: Cinema and Black Urban Modernity*. Berkeley: University of California Press, 2005.

Stewart, Susan. *On Longing: Narratives of the Miniature, the Gigantic, the Souvenir, the Collection*. Durham, NC: Duke University Press, 1993.

Store Training Manual for Guest Service Representatives. n.p.: Hollywood Entertainment Corporation, 2003.

Straw, Will. "Embedded Memories." In *Residual Media*, edited by Charles Acland, 3–15. Minneapolis: University of Minnesota Press, 2007.

Striphas, Ted. *The Late Age of Print: Everyday Book Culture, from Consumerism to Control*. New York: Columbia University Press, 2009.

Strizhakova, Yuliya, and Marina Krcmar. "Mood Management and Video Rental Choices." *Media Psychology* 10, no. 1 (2007): 91–112.

Suderburg, Erika, and Ming-Yuen S. Ma, eds. *Resolutions 3: Global Networks of Video*. Minneapolis: University of Minnesota Press, 2012.

Sun Business: The Complete Guide to the Business of Indoor Tanning. n.p.: Sun Ergoline, Inc., 2008.

Sweeting, Paul. "Ingram/Commtron: Sign of Times." *Billboard*, 29 February 1992.

Tashiro, Charles. "The Contradictions of Video Collecting." *Film Quarterly* 50, no. 2 (Winter 1996–97): 11–18.

———. "Videophilia: What Happens When You Wait for It on Video." *Film Quarterly* 45, no. 1 (Autumn 1991): 7–17.

Taylor, Ella. *Prime-Time Families: Television Culture in Postwar America.* Berkeley: University of California Press, 1989.

Terry, Neil, and Anne Macy. "The Determinants of Movie Video Sales Revenue." *Journal of American Academy of Business, Cambridge,* 15, no. 1 (2009): 16–23.

Thompson, Kristin, and David Bordwell. *Film History: An Introduction.* 2nd ed. Boston: McGraw Hill, 2003.

Thormahlen, Casey. "IBISWorld Industry Report 53223: DVD, Game & Video Rental in the US." IBISWorld Inc., October 2010.

Thornton, Sarah. *Club Cultures: Music, Media, and Subcultural Capital.* Hanover, NH: Wesleyan University Press, 1996.

Tryon, Chuck. "Redbox vs. Red Envelope, or What Happens When the Infinite Aisle Swings through the Grocery Store." *Canadian Journal of Film Studies* 20, no. 2 (Fall 2011): 38–54.

————. *Reinventing Cinema: Movies in the Age of Media Convergence.* New Brunswick, NJ: Rutgers University Press, 2009.

2002 Annual Report on the Home Entertainment Industry. n.p.: Video Software Dealers Association, 2002.

United States Department of Commerce. "Supplement to Commerce Reports: Retail Store Planning." *Trade Information Bulletin,* no. 291, November 1924.

Varian, Hal R. "Buying, Sharing and Renting Information Goods." *Journal of Industrial Economics* 48, no. 4 (2000): 473–88.

VideoHound's Golden Movie Retriever. Detroit: Visible Ink, 1991.

Video Store Magazine: 1990 Video Store Retailer Survey. 1990. n.p.

Wagner, Anne. "Performance, Video, and the Rhetoric of Presence." *October* 91 (Winter 2000): 59–80.

Waller, Gregory A. *Main Street Amusements: Movies and Commercial Entertainment in a Southern City, 1896–1930.* Washington DC: Smithsonian Institution Press, 1995.

————, ed. *Moviegoing in America: A Sourcebook in the History of Film Exhibition.* Malden, MA: Blackwell, 2002.

Wasko, Janet. *Hollywood in the Information Age: Beyond the Silver Screen.* Austin: University of Texas Press, 1994.

Wasser, Frederick. "The Long Tail of the Video Store." *Media Fields Journal: Critical Explorations in Media and Space* 1 (2010). Accessed 31 May 2012. www.mediafieldsjournal.org/the-long-tail-of-the-video-sto.

————. *Veni, Vidi, Video: The Hollywood Empire and the VCR.* Austin: University of Texas Press, 2001.

Wasson, Haidee. "Electric Homes! Automatic Movies! Efficient Entertainment! 16mm and Cinema's Domestication in the 1920s." *Cinema Journal* 48, no. 4 (Summer 2009): 1–21.

Wharton, David. "Vintage Videos Gem of a Store in N. Hollywood Rents Anything from 'Twilight Zone' Shows to USFL Clips." *Los Angeles Times,* 6 December 1991.

Wilinsky, Barbara. *Sure Seaters: The Emergence of Art House Cinema.* Minneapolis: University of Minnesota Press, 2001.

Witkowski, J. Steven. "Mapping Hardcore Space." *Media Fields Journal: Critical Explorations in Media and Space* 1 (2010). Accessed 3 May 2012. www .mediafieldsjournal.org/mapping-hardcore-space.

Index

Page numbers in *italics* denote illustrations.

and, 167; dependence on Hollywood films, 168–169; and devaluation of video, 180; and DVD adoption, 167–168; geographic scope and, 13, 158; hits as selling themselves, 162, 163; as inventing home video, 157; as knowledge brokers, 157, 166–167; and large-scale vs. restricted production, 157–159; licenses held by, 156; material commodity of, vs. knowledge brokering of Rentrak, 181–182; overview, 13, 246n4; promotions for Hollywood hits, 162, 163; and Redbox kiosks, growth of, 180; regional focus of, 160–161; rifts with content suppliers, 160–161; seasonal consumption patterns and, 163; "side-stream" content of, 156, 264n6; taste and value and, 157–158, 163; and two-tiered pricing scheme of Hollywood studios, 156–157. *See also* Rentrak

distribution companies, specialty: and auteurism, 173–174, 177; and "circle of belief," 174–176; and cosmopolitanism, 172–173, 177, 178; cultural capital of, 176, 178; as division of Hollywood studios, 172, 173; and educational institutions, 174; intellectualist approach of, 173–174, 177, 178–179; multiple business activities of, 176–179, 269n115; and national cinema, 170, 171, 173–174, 177, 178; overview, 13, 246n4; and quality, 158, 169, 170–171, 175–176, 268nn98, 99; and recentralization of movie culture, 171; and restricted cultural production (exclusivity), 170–173, 177–178, 268n103; social activism and, 175; and taste, 174–176; workers of, 174, 175, 176

DivX format, 41

Dobrow, Julie, 4

"Documentaries" section and titles, 62, 65, 105, 107, 171, 174, 175

Dollar per Day Video (Ellisville, MS), 124, 144

domestic viewing of movies: early encouragement for, 21; normalization of, 21–23. *See also* televised movies

Drafthouse Films, 226

Dreiske, Nicole, 176

drive-in theaters, 142, 262n15

drop box/slot, 53–55, 54, 73

Dubois Super Foods (Dubois, WY), 148

DVD Decrypter, 209

DVDs (digital versatile discs): anti-copying systems and, 209; big-box stores and, 40, 41, 43, 167–168; Cinefile opening and promotion of, 109–110; collectors and, 40, 41, 268n98; damage to, 73; decline in sales of, 179; distribution companies and adoption of, 167–168; invention of, 40; marginalization of video rental industry and, 39–43, 109, 134, 168; price of, 40, 42; region-free, and foreign films, 110; sell-through market stimulated by, 20, 40–41, 167–168, 244nn25–26; sideways selling of, 168; used, sale of, 168; VHS replaced by, 42, 109–110, 133, 134, 244n126; volatility in the rental market created by, 39–43

Dykes, Tim, 132

Ebert, Roger, 13–14, 177, 194, 203, 272nn36,37; *Roger Ebert's Movie Home Companion*, 197

economics: of adult movies, 63–64; of CD-ROM movie guides, 204; copy depth and, 167; costs of rentals, 26–27, 36; DVDs and, 40–41, 42, 244nn125–126; initial price point of videos and rental business model, 21; number of store locations as indicator of, 3, 18, 34, 35, 242–243n97; overall income, 3, 244n125; rental revenue overtaking theatrical, 17–18; Rentrak's revenue sharing system, 163, 164–167, 249n20, 267–268nn70–72,75; sales, 244nn125–126; Scarecrow Video and difficulties with, 92, 96, 100–101, 254n31,